Winslow Homer
Paintings of the Civil War

Unidentified photographer. *Winslow Homer*, 1867.
Carte de visite photograph. Bowdoin College
Museum of Art, Brunswick, Maine. Gift of the
Homer Family

Winslow Homer Paintings of the Civil War

Marc Simpson

With contributions by

Nicolai Cikovsky, Jr. Lucretia Hoover Giese

Kristin Hoermann Sally Mills

Christopher Kent Wilson

The Fine Arts Museums of San Francisco

Bedford Arts, Publishers

This catalogue has been published in conjunction with the exhibition *Winslow Homer: Paintings of the Civil War*.

The Fine Arts Museums of San Francisco
M. H. de Young Memorial Museum
2 July through 18 September 1988

Portland Museum of Art
8 October through 18 December 1988

Amon Carter Museum
7 January through 12 March 1989

The exhibition has been organized by The Fine Arts Museums of San Francisco. This project is made possible by a generous grant from Bernard and Barbro Osher and with the support of the National Endowment for the Arts, a Federal agency. The accompanying catalogue has been funded by The Luce Fund for Scholarship in American Art, a program of the Henry Luce Foundation, Inc.

Library of Congress Cataloging-in-Publication Data
Simpson, Marc.
Winslow Homer: Paintings of the Civil War / Marc Simpson with contributions by Nicolai Cikovsky, Jr. . . . [et al.]. Catalogue of an exhibition held at The Fine Arts Museums of San Francisco, July 2-Sept. 18, 1988, Portland Museum of Art, Oct. 8-Dec. 18, 1988, and the Amon Carter Museum, Jan. 7-Mar. 12, 1989.
Bibliography
1.Homer, Winslow, 1836-1910-Exhibitions. 2.United States-History-Civil War, 1861-1865-Art and the war — Exhibitions. I.Fine Arts Museums of San Francisco. II.Portland Museum of Art. III.Amon Carter Museum. IV.Title.
ND237.H7A4 1988
759.13-dc19 88-80734
ISBN 0-88401-060-0 (paper)
ISBN 0-938491-15-6 (cloth)

Cover: Winslow Homer, *The Bright Side*, 1865. The Fine Arts Museums of San Francisco. Gift of Mr. and Mrs. John D. Rockefeller 3rd. *Cat.no.13*

Contents

Lenders to the Exhibition

Mr. and Mrs. Joe L. Allbritton

Amon Carter Museum, Fort Worth, Texas

Canajoharie Library and Art Gallery, Canajoharie, New York

The Cleveland Museum of Art, Cleveland, Ohio

Cooper-Hewitt Museum, the Smithsonian Institution's National Museum of Design, New York, New York

The Detroit Institute of Arts, Detroit, Michigan

The Fine Arts Museums of San Francisco, San Francisco, California

Harvard University Art Museums (Fogg Art Museum), Cambridge, Massachusetts

Hirshhorn Museum and Sculpture Garden, Smithsonian Institution, Washington, D.C.

Joslyn Art Museum, Omaha, Nebraska

Lyndon Baines Johnson Library-Museum, Austin, Texas

The Metropolitan Museum of Art, New York, New York

Museum of Fine Arts, Boston

National Gallery of Art, Washington, D.C.

The Newark Museum, Newark, New Jersey

The New Britain Museum of American Art, New Britain, Connecticut

J. Nicholson

Peggy and Harold Osher Collection, Courtesy of the Portland Museum of Art, Portland, Maine

Harold T. Pulsifer Memorial Collection on loan to Colby College Museum of Art, Colby College, Waterville, Maine

Robert Hull Fleming Museum, University of Vermont, Burlington, Vermont

Jeannette Scott

Estate of William E. Weiss

Yale University Art Gallery, New Haven, Connecticut

Anonymous lenders

Directors' Foreword

Winslow Homer: Paintings of the Civil War is the first in-depth examination by a museum of this artist's career as a painter of war. With two exceptions, all of the major paintings on the subject of the Civil War from the first decade of Homer's activity are in the exhibition. Drawings and prints that are closely related to these paintings, and that demonstrate Homer's development of his themes, are clustered around these central images. Exhibition and catalogue together attempt to explicate the growth of the artist in terms of his technique and ambition, as well as to provide a context for understanding the subject of his work.

The purpose of the exhibition is a simple one: to examine these earliest paintings by Winslow Homer with the hope of exploring both how a master artist taught himself to paint, and how this sensitive observer responded to one of the great traumas of our nation's history. Bringing together the necessary works, which include some of the major icons of American art, has called for sacrifice and great generosity on the part of our lenders. These private collectors and public institutions are listed elsewhere. Two institutions merit our particular thanks for the number and importance of their loans to the exhibition. Without the participation of The Metropolitan Museum of Art and the Cooper-Hewitt Museum, the Smithsonian Institution's National Museum of Design, *Winslow Homer: Paintings of the Civil War* could not have moved beyond the planning stage.

It is appropriate that The Fine Arts Museums of San Francisco organize the exhibition. When Mr. and Mrs. John D. Rockefeller 3rd gave a superb group of American paintings to The Fine Arts Museums in 1979, a group that included Homer's small but important *The Bright Side*, they did so with the express hope that the collection would foster the growth of a scholarly community in the area. Ednah Root's decision in that same year to sponsor a curatorship in American painting allowed the development of the staff to bring this aim into being. *Winslow Homer: Paintings of the Civil War*, which explores a crucial aspect of the history of American art, justifies the faith of these enlightened patrons.

The joint enterprise of exhibition and catalogue is an increasingly costly one to undertake. We owe profound gratitude to those who have made *Winslow Homer: Paintings of the Civil War* possible. The exhibition has been largely supported by a generous grant from Bernard and Barbro Osher, which is the most recent manifestation of their continuing commitment to American art programs. The Luce Fund for Scholarship in American Art, a program of The Henry Luce Foundation, has underwritten the costs for the exhibition's research and the production of this catalogue. Finally, the National Endowment for the Arts has also contributed toward the costs of the exhibition.

A complicated project such as *Winslow Homer: Paintings of the Civil War* calls upon the skills and enthusiasm of many people. The scholars who have contributed essays to the catalogue bring new insights to works that, for all their fame, have experienced surprisingly little scholarly focus until now. Marc Simpson, as curator of the exhibition, has ably led the whole effort. Within The Fine Arts Museums, nearly every department has

been involved in bringing this project to fruition. We particularly want to acknowledge this effort as well as the cooperative involvement of the staffs at the Portland Museum of Art and the Amon Carter Museum.

Harry S. Parker III
Director of Museums
The Fine Arts Museums of San Francisco

Jane N. Begert
Interim Director
Portland Museum of Art

Jan Keene Muhlert
Director
Amon Carter Museum

Acknowledgments

This work on Winslow Homer is based on the pioneering studies of Lloyd Goodrich. Mr. Goodrich's scholarship and insight set the basic parameters of Homer's career clearly in view, with his research toward a catalogue raisonné of the artist signalling most clearly his decades-long interest and commitment to Homer's work. I was especially pleased, therefore, when Mr. Goodrich agreed to write the introduction to this catalogue. He wrote in late January 1987 that he wanted to discuss how important the Civil War work was in the development of Homer's career, the artist's "first-hand, unconventional choice of subjects," and the "artistic and stylistic qualities of his war paintings." We are all the poorer that Mr. Goodrich's death in March 1987, before he could write what would surely have been a stimulating essay, brought his long career to a close. This effort is respectfully dedicated to his memory.

Many people are responsible for the fruition of *Winslow Homer: Paintings of the Civil War*. This is the third major show of American art underwritten by Bernard and Barbro Osher for The Fine Arts Museums of San Francisco, joining *American Sculpture* (1982) and *Venice: The American View, 1860-1920* (1984). We are deeply grateful for their continuing and generous commitment to the growth of the Museums' American program.

The Luce Fund for Scholarship in American Art, too, has played a crucial role in the development of the American Paintings department, earlier supporting the catalogue to *Venice: The American View, 1860-1920* and providing a major grant to undertake research on the permanent collection of American paintings. The grace and good cheer with which the Luce Fund has supported worthwhile projects from around country is laudable; I am honored that *Winslow Homer: Paintings of the Civil War* joins that roster.

Likewise, the National Endowment for the Arts has consistently assisted projects at this institution and across the country. We are grateful for its support of this exhibition.

The genesis for this project was a painting in the permanent collection at The Fine Arts Museums – *The Bright Side*, our only oil by Winslow Homer. The work was the gift of Mr. and Mrs. John D. Rockefeller 3rd, who gave it and over one hundred other American paintings and drawings to the museum in 1979, anticipating that the presence of an important American collection on the West Coast would foster the growth here of a center for the study and appreciation of American art. In that same year Ednah Root accepted the challenge for providing local support and, until her death in 1987, enthusiastically funded the curatorship of the American paintings collection. The Foundation that she endowed to support American art at The Fine Arts Museums of San Francisco promises to carry her vision into the future. I hope that this effort helps to justify the generosity of these individuals.

Within The Fine Arts Museums of San Francisco, Director Harry S. Parker III and Director Emeritus Ian McKibbin White have wholeheartedly supported the idea of the exhibition. I am grateful for their encouragement, as well as for that offered by the Board of Trustees, especially Mrs. W. Robert Phillips, President of the Board, and Mrs. William B. MacColl, Chairman of the Trustee Exhibition Committee.

As this catalogue demonstrates, Assistant Curator Sally Mills has played a crucial role in all aspects of the project, from research to writing. Quite literally it could not have happened without her insights, skills, and diligence; I can imagine no better teammate. Under her direction, NEA Intern Derrick Cartwright has been a model of efficient good cheer in dealing with the administrative details of the project as well as serving as a critical and informed reader. Koren Sawyer, the previous NEA Intern in the department, had established an admirable base for him to build upon. Kristin Hoermann's insight and sensitivity to the paintings, as well as her research and acuity concerning Homer's technique, have greatly enriched our perception of Homer's works. We have all worked together on this project — whatever strengths it has grows from this collaboration.

Debra Pughe, Paula March, and Ann Karlstrom have guided the exhibition and catalogue from dream to reality. Karen Kevorkian's thoughtful editing of the text has been enlightening.

Other staff members, past and present, who have contributed to the exhibition and catalogue include: Kathy Baldwin, Ruth Berson, Elizabeth Boone, Max Chance, Therese Chen, Antonette De Vito, Alan Fausel, James Forbes, Kittu Gates, Mary Haas, Robert Flynn Johnson, Mardi Leland, Margaretta Lovell, Brian Marston, Joseph McDonald, Charles S. Moffett, Jane Nelson, Lynn Orr, Gloria Ravitch, Ron Rick, Frances Roebke, Maxine Rosston, Jennifer Saville, Thomas K. Seligman, Gus Teller, Jim Wright, Bill White and the technicians, the Security force, the Docent Council, and the Volunteer Council.

The catalogue has been given its form by Jack Werner Stauffacher, whose design, as always, I find handsome and appropriate. I am also grateful to the staff at Wilsted & Taylor for their customary care and professionalism.

The exhibition will travel to two venues after the opening in San Francisco. Jane N. Begert, Barbara J. Redjinski, and Martha R. Severens of the Portland Museum of Art, and Anne Adams, Linda Ayres, and Jan Keene Muhlert of the Amon Carter Museum have been a pleasure to work with.

Institutions and individuals across the country have been of substantial help in gathering the material for this exhibition and publication. While there are far too many to list individually, we are especially grateful to: Archer M. Huntington Art Gallery, University of Texas at Austin — Sara McElroy; Archives of American Art, Smithsonian Institution, West Coast Regional Center — Paul J. Karlstrom, Jack von Euw, Victoria Ricciarelli; Bowdoin College Museum of Art — Henrietta Tye; Brooks Memorial Library — George R. Lindsey — Butterfield & Butterfield — Patricia Tracy-Nagle; Canajoharie Library and Art Gallery — Edward W. Lipowicz, Marie Moore; Century Association — Rodger Friedman; The Cleveland Museum of Art — Bruce Miller, Bruce Robertson, William S. Talbot, Evan H. Turner; Colby College Museum of Art — Denise Donahue, Hugh J. Gourley III, Margaret V. Wickes; Cooper-Hewitt Museum, the Smithsonian Institution's National Museum of Design — Phoebe Barnard, Lisa Taylor; Davis & Langdale Gallery — Melinda Kahn Tally; The Detroit Institute of Arts — Barbara Heller, Samuel Sachs II, Nancy Rivard Shaw, Jim Tottus; Dianne Dwyer; Getty Center for the History of Art and the Humanities — Robert Tieman; Lois Homer Graham; Harvard University Art Museums — Edgar Peters Bowron, Teri Hensick, Jane Montgomery, Phoebe Peebles, Kate Olivier, Rachel Vargas; Hirshhorn Museum and Sculpture Garden, Smithsonian Institution — Clark Bedford, James Demetrion, Lawrence Hoffman, Deborah Knott, Phyllis Rosenzweig, Judith Zilczer; Hirschl & Adler Galleries — Stuart Feld, M. P. Naud; Kim Jackson; Joslyn Art Museum — Marsha V. Gallagher, Ellen Simak; Los Angeles County Museum of Art — Joe Fronek, Marcelle Andreasson, Michael Duffy, Virginia Rasmussen; Lyndon Baines Johnson Library-Museum — Patricia Burchfield, Harry J. Middleton, Gary A. Yarrington; Kennedy Galleries — Russell Burke; Jeanne Lawver; Mead Art Museum, Amherst College — Judy Barter; The Metropolitan Museum of Art — Maryan Ain-

sworth, John Brealey, John K. Howat, Dorothy Mahon, Philippe de Montebello; Mount Vernon Ladies' Association – Karen Van Epps Peters; Museum of Fine Arts, Boston – Clifford Ackley, Rita Albertson, Sue W. Reed, Alan Shestack, Brigitte Smith, Theodore E. Stebbins, Jr., Carol Troyen; National Academy of Design – Abigail Booth Gerdts; National Gallery of Art – J. Carter Brown, Carlotta J. Owens, Andrew Robison; The Newark Museum – Margaret C. DiSalvi, Samuel C. Miller, Gary A. Reynolds; The New Britain Museum of American Art – Daniel C. DuBois, M. F. Ellis, Will Golabosky, Janice LaMotta; The North Point Gallery – Alfred C. Harrison, Jr.; Dawn Perlin; Jonathan T. Pulsifer; Robert Hull Fleming Museum – Ildiko Heffernan, David Penney; Santa Barbara Museum of Art – Barry Heisler; Diane Shapiro; Greg Shephard; Sotheby's – Rachel Perry, Peter Rathbone; Taggart, Jorgensen & Putnam – Carl W. Jorgensen; Peter Tillou; Union League Club – Jane Reed; Vermont Historical Society – Barney Bloom, Mary Pat Brigham, Mary Labate Rogstad; Judith C. Walsh; William D. Weiss; Virginia White; Wildenstein & Co. – Joseph Baillio, Harry A. Brooks, Susan A. Quade; Rudolph Wunderlich; Yale Center for British Art – Theresa Fairbanks; Yale University Art Gallery – Helen Cooper, Paula B. Freedman, Susan Frankenbach, Anthony Hirschel, Mary Gardner Neill; James Yarnell; as well as the library staffs at the University of California at Berkeley; Stanford University; The New York Public Library; the Library of Congress; and the San Francisco Public Library.

Abigail Booth Gerdts was exceptionally generous in sharing material concerning the provenance of Homer's works from The Lloyd and Edith Havens Goodrich/Whitney Museum of American Art Record of Works by Winslow Homer, now on deposit at the City University of New York. R. Lockwood Tower reviewed the Civil War material in the catalogue entries and kindly offered solid advice to sharpen the edge of our military references.

The authors of the essays in this catalogue, Nicolai Cikovsky, Jr., Curator, American Art, National Gallery of Art; Lucretia Hoover Giese, Lecturer, Rhode Island School of Design; Kristin Hoermann, Conservator of Paintings, The Fine Arts Museums of San Francisco; and Christopher Kent Wilson, Professor of Art, Middlebury College; have brought to bear much fresh research and new insights on their subjects. They were, moreover, models of promptness, responsibility, and cooperation.

Most important, without the lenders of these handsome and important objects, the exhibition would not be. The generous response and interest of nearly all the owners of Homer's Civil War works, private and institutional, were everything a curator could wish. Three people, whose enthusiasm and support for the exhibition were especially noteworthy, merit particular thanks. At The Metropolitan Museum of Art, Lewis Sharp and Natalie Spassky encouraged the idea of the exhibition from the start, although it called upon the extended loan of three major works from their collection. Elaine Evans Dee, of the Cooper-Hewitt Museum, was likewise notably generous with her time, expertise, and in sharing a large number of the Homer drawings that are in her care.

My deepest personal thanks go to my wife, Fronia.

M.S.

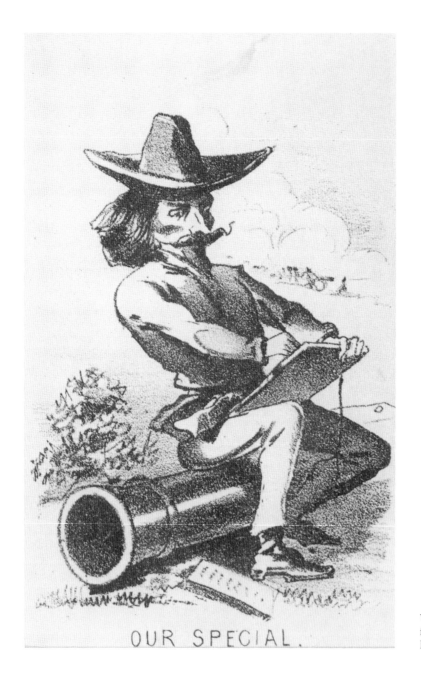

OUR SPECIAL.

Winslow Homer. *Our Special*, 1864. Lithograph from *Life in Camp* (part 2), 4 1/8 × 2 1/2 in. The Butler Institute of American Art, Youngstown, Ohio

Introduction

In 1865 the English critic and philosopher John Ruskin began his address to the cadets at The Royal Military Academy, Woolwich, with a startling proposition:

. . . no great art ever yet rose on earth, but among a nation of soldiers. . . . There is no great art possible to a nation but that which is based on battle.[1]

Across the Atlantic Ocean at just this time, a young American artist was illustrating Ruskin's provocative words with his own career. Winslow Homer (1836-1910), illustrator and wood engraver, in late 1862 reflected upon the sketches he had made while observing General George McClellan's Peninsular Campaign in Virginia and embarked upon his first exhibited paintings. Over the next ten years (but most frequently during the next four) he turned again more than twenty times to Civil War themes for his works in oil. These earned him an immediate and steady appreciation from critics and collectors alike, including praise as "the best chronicler of the war."[2]

Admittedly, the competition among painters for such epithets was not particularly keen. "The war itself has not inspired many works," noted one critic in the middle of 1862. "One of the most remarkable circumstances connected with the existing war," wrote another two years later, "is the very remote and trifling influence which it seems to have exerted upon American art."[3] Homer apparently sought to fill this perceived void with his earliest paintings. To an astonishing degree for an artist at the outset of his career, he did so with a marked success. In these, his earliest works, we can see glimmerings of the themes of mortality, isolation, and nature's adversity that

would come to dominate his later art. But tempering these dark truths are camp-life scenes of humor and comradeship. Uniting all the paintings, whether they show desperate bravery or reflective good cheer, is a truthfulness derived from close observation, spiced with a native flavor that provided at least a part of their appeal:

And so in our own dear land we like best the men who paint America, and American men and women; we like the homely fields, the native hills, red shirts, plain ways, refinement not borrowed from abroad – the men who give us these, as they are, we count our best men; we will forgive much in their work for the savor of that salt.[4]

Not all historians and critics have responded to the Civil War paintings favorably. One early writer went so far as to note of them, *The Bright Side* and *Prisoners from the Front* (which has since achieved a prominent place in the canon of American art masterpieces) in particular:

They are works from which Homer's future could scarce have been predicted, and they would be already forgotten had not that future brought forth things of very different and vastly greater quality.[5]

Even for those writers more positively disposed to them, these early works are but preludes to the main tale of the career – the full life of the artist culminating in the late, masterful seascapes. Thus in their books William Howe Downes, Lloyd Goodrich, Albert Ten Eyck Gardner, Philip Beam, John Wilmerding, and Gordon Hendricks all moved quickly over the early works.[6]

Only within the last fifteen years have the Civil War paintings received the concentrated scrutiny that they merit. Scholars such as Nicolai Cikovsky, Jr., Natalie Spassky, and Christopher Kent Wilson

have published monographic essays on the larger and better-known paintings. In 1974 Julian Grossman reproduced many of the Civil War works in all media, with choice comparative material and pithy historical commentaries, in *Echo of a Distant Drum: Winslow Homer and the Civil War*. Most important, in 1985 Lucretia Hoover Giese submitted to Harvard University a doctoral dissertation on the subject, "Winslow Homer: Painter of the Civil War." In her thesis and in subsequent articles, Giese combined extensive archival research and a close study of the known drawings and paintings with a thorough review of the literature on the artist. The result was a full and admirable picture of Homer's work during the mid-1860s.

The present exhibition and catalogue build on this recent activity. For the first time, the vast majority of Homer's known Civil War paintings from 1862 to 1871 are exhibited together, along with the drawings and prints closely related to them. The works testify to Homer's keen powers of observation and the great skill of his hand. Simultaneously, they trace the inventive economy of Homer's working method – how he used and reused the same motifs in works of various media. There is as well (as is observable throughout his later career) a sense of fullness in the way Homer thoroughly worked a theme, exploring and testing its limits until he evolved a coherent and culminating view of it.

Within this book an annotated chronology of the years 1859 to 1866 begins the text, integrating the sparse (and sometimes contradictory) contemporary testimony of Homer's activities with what relevant works and documents are now known. There follow four essays that examine the most resonant of the Civil War paintings – *Sharpshooter, The Bright Side, Prisoners from the Front,* and *The Veteran in a New Field*. The essays' principal aim is to establish the context in which each work was produced, reconstructing some of the meanings that Homer's contemporaries might have evolved in their readings of the works, and exploring as best we are able Homer's own ambitions. Since these are Homer's earliest paintings, works that record the phenomenal

progress of the largely self-taught painter, the fifth essay grows from an intensive examination of the majority of the paintings and concentrates on Homer's technique and working practice. It ponders the most basic and difficult of questions: how and why the artist painted as he did.

The catalogue entries that follow, one for each principal painting in the exhibition (and for the two paintings from private collections that could not be included), describe the work and the objects related to it. Lloyd Goodrich wrote of Winslow Homer's oils:

These were not military subjects in the usual sense, but genre pictures of military life. But with all his avoidance of the tragic aspects of war, no other artist left so authentic a record of how the Civil War soldier looked and acted.[7]

Many of the commonplace activities and situations that Homer so faithfully described are no longer a part of daily life, and the facts that he could assume his viewers would know are now not part of our general knowledge. Therefore we have tried to construct a framework of references to the war (and other pertinent matters) when it seemed that such digressions would be useful or enlightening. The catalogue entries also include separate sections about changes in the principal painting's composition, a record of its early exhibition history, a digest of corresponding critical references, and as complete a history of ownership as we have been able to assemble.

Such close scrutiny of these early oils seems appropriate, not only for their intrinsic quality, but also to help us appreciate the care and deliberation that Homer lavished upon them. Seemingly quick passages in his works reveal a complexity of detail that hides from all but the most minute inspection. On another level entirely, apparently simple scenes unfold layered meanings of great resonance. Even the most arguably minor of details – such as the position, size, or color of his signature on the canvas – were subject to the artist's multiple revisions and elaborations.

And yet all this self-consciousness and deliberation hid from the viewers of the 1860s. One of his critics in 1865 wrote of Homer's lack of artifice:

It is invigorating to find boldness and truth amidst the trivial and false. In the works of Winslow Homer we have a direct style and faithful observation of nature. . . . Welcome this hearty energy of life; and if the painter shows that he observes more than he reflects, we will forget the limitation and take his work as we take nature, which, if it does not think is yet the cause of thought in us.[8]

The writer is not quite correct. As we hope to demonstrate in the following essays and catalogue entries, Homer certainly pondered his work and infused into it a highly synthetic and reflective meaning. But in one regard the critic is absolutely right. After over one hundred twenty years, the paintings, drawings, and prints included in this exhibition still have a provocative relevance and power, are "yet the cause of thought in us."

Marc Simpson
*The Ednah Root Curator of
American Paintings*

1. John Ruskin, "War," *The Crown of Wild Olive* (New York: Thomas Y. Crowell, 189[?]), 92.

2. "National Academy of Design," *The New-York Daily Tribune*, 3 July 1865.

3. "Painting and the War," *The Round Table* 2, no. 32 (23 July 1864): 90. "The Lounger," *Harper's Weekly* 6, no. 279 (3 May 1862): 274.

4. *The New Path* 2, no. 5 (May 1865): 80.

5. Kenyon Cox, *Winslow Homer* (New York: privately printed, 1914), 19.

6. See the Selected Bibliography for references to these and other works here mentioned.

7. Lloyd Goodrich, *Winslow Homer* (New York: published for the Whitney Museum of Art by Macmillan, 1944), 19-20.

8. "National Academy of Design/Fortieth Annual Exhibition/Concluding Article," *The Evening Post*, 31 May 1865.

A Chronology
of Homer's Early Career, 1859-1866

*with particular reference to
the Civil War paintings*

Sally Mills

fig. 1 Unknown photographer. *Winslow Homer in 1867* (from Homer Family Photograph Album). *Carte de visite* photograph. Collection of Bowdoin College Museum of Art, Brunswick, Maine. Gift of the Homer Family

This chronology describes Homer's early career on the basis of dated drawings, exhibition notices, published letters, and known facts about the artist from 1859, the year he moved from Boston to New York, through 1866, the year he left New York for Europe. It emphasizes Homer's Civil War paintings and the role they played in his development as a professional, critically successful artist. As a means of gauging Homer's proximity to specific events in the Civil War, major actions of the Army of the Potomac are indicated, specifically those battles and movements involving the Army's Second Corps. This Corps included the Sixty-first New York Infantry Regiment to which Homer maintained a special attachment.

Homer was and is still well known for his steadfast refusal to offer particular information about his personal life and biography. Much remains hidden or unknown about the events in his career, and even the most specific information is subject to varying interpretations. The earliest nineteenth-century sources disagree on basic questions such as the number of times Homer visited the front or the amount of time he spent in Europe in 1866-1867. However, by chronicling the development of Homer's skills as a painter and the rise of his critical reputation through the available notices of his activity, a provisional outline evolves.

This chronology begins with and builds upon contemporary exhibition records and newspaper references, as well as the work of subsequent critics and scholars; these sources are fully cited in this volume's bibliography and are referred to by short titles throughout this chronology. Considering and cross-referencing the information made available by these sources permits the following, most plausible, scenario of Homer's activities from 1859 to 1866.

1859

Fall 1859 Homer moves from Boston to New York, taking a room in the boarding house of Mrs. Alexander Cushman, 52 East 16th Street, where the Boston artist Alfred C. Howland, Alfred's brother Henry, and Charles Voorhees already reside. In New York, Homer apparently receives an offer from *Harper's Weekly* to become a staff artist, but declines it, "the slavery" of his apprenticeship in Boston "too fresh in my recollection to let me care to bind myself again. From the time that I took my nose off that lithographic stone, I have had no master, and never shall have any" (Sheldon 1878, 226). Homer continues to work for *Harper's Weekly* on a freelance basis.

October 1859 Homer registers in the Life School of the National Academy of Design. This is an unusual step, implying the admission committee's approval for the young artist to bypass the traditional preliminary class of drawing from plaster casts of antique sculptures (Goodrich and Gerdts 1986, 14).

1860

April 1860 For the first time, a work by Homer – presumably a work on paper – appears in the Annual Exhibition of the National Academy of Design, listed as follows: "145. *Skating on the Central Park*." Homer's address is given as 52 E. 16th Street.

By July 1860 Homer has taken a studio (no. 8) in the University Building on Washington Square.

10 July 1860 Charles Homer, Winslow's older brother, presents Homer with a copy of M. E. Chevreul's *The laws of the contrast of colour*.

October 1860 Homer again enrolls in the Life School of the National Academy of Design.

1861

Sheldon recounts that after attending the night school of the National Academy of Design and studying under Thomas Seir Cummings, in 1861 Homer
determined to paint. For a month, in the old Dodworth Building near Grace Church, he took lessons in painting of [Frederick] Rondel, an artist from Boston, who, once a week, on Saturdays, taught him how to handle his brush, set his palette, &c. The next summer he bought a tin box containing brushes, colours, oils, and various equipments, and started out into the country to paint from Nature. Funds being scarce, he got an appointment from the Harpers as artist-correspondent at the seat of war, and went to Washington.
(Sheldon 1878, 227)

March 1861 On assignment from *Harper's Weekly*, Homer is in Washington, making sketches of the ceremonies surrounding Lincoln's inauguration on 4 March (see *Harper's Weekly*, 16 March 1861).

12 April 1861 Confederate fire on Fort Sumter signals the beginning of the Civil War

Summer 1861 Two engravings in *Harper's Weekly* – *Crew of the U. S. Steam-Sloop "Colorado" Shipped at Boston, June 1861* (13 July 1861) and *Filling Cartridges at the United States Arsenal, at Watertown Massachusetts* (20 July 1861) – indicate that Homer was spending the summer with his family in Belmont, Massachusetts. It was customary practice for New York artists to leave the city in the summer: "Our artists generally leave their studios by the 1st of June, and work hard out of doors until late in the fall" (*The Round Table* 1, no. 23 [21 May 1864]: 354).

21 July 1861 Battle of First Bull Run, or Manassas, Virginia

20 August 1861 Major General George B. McClellan assumes command of the newly established Army of the Potomac; he spends most of the fall around Washington, organizing and drilling this army; engages in no significant military action until the spring of 1862

October ? 1861 A letter from Homer to his father, dated only "Saturday," says:
I am off next week as you know I am instructed to go with the skirmishers in the next battle. Bonner [John Bonner, managing editor of Harper's Weekly *from 1858 to 1863] thinks Homer is smart and will do well if he meets no pretty girls down there, which he thinks I have a weakness for. I get $30. per week RR fare paid but no other expenses[.] Any Letters you can give me to parties in Washington I should like[.] I shall have some from Harpers to McClellan etc, perhaps you can get one to Genl Banks [Major General Nathaniel P. Banks, who commanded the Union forces in the upper Potomac valley from Washington to Harper's Ferry in the fall of 1861] . . . P.S. I go on Wednesday afternoon*
(Hendricks 1979, 46-47)

8 October 1861 An open letter from Fletcher Harper, publisher/editor of *Harpers Weekly*, identifies Homer as a "special artist attached to Harpers Weekly . . . detailed for duty with the Army of the Potomac," and asks the recipient to "confer a favor by granting to Mr. Homer such facilities as the interests of the service will permit for the discharge of his duties as our artist-correspondent" (*fig.2*).

36 acres. Sketched from Hunting Creek / This is the largest fort south of the Potomac / Near Alexandria" indicates one focus of Homer's visits to the army (Giese 1985, 210-211 and fig. 21).

21 October 1861 A letter from Charles Homer, Sr., to Arthur indicates that Homer was in Belmont for their Thanksgiving meal: the family dined on "the usual Turkey, Plumb pudding, Pies &c all of which were done in Mothers best style. Win came on this morng" (Hendricks 1979, 44).
Battle of Ball's Bluff, or Leesburg, Virginia

26 October 1861 *A Night Reconnoissance on the Potomac* appears in *Harper's Weekly*, suggesting that Homer had already seen such activity.

By 28 October 1861 Homer is back in Washington, D.C., as indicated by a letter from his mother, Henrietta Benson Homer, to his brother Arthur:
We hear often from Win he is in Washington 331 F St. Mrs. Foster's. He scaled a parapet while out sketching & was [– ? –] for a prisoner when they saw his Book, & the only wonder was that he was not shot his head popping up on such high places . . . he is very happy & collecting material for future greatness.
(Hendricks 1979, 44-45)

fig.2 Letter in Fletcher Harper's handwriting, dated 8 October 1861. Courtesy of the Mount Vernon Ladies' Association, Mount Vernon, Virginia

9 October 1861 A letter from Charles Savage Homer, Sr. (Winslow's father), to his son (and Winslow's younger brother) Arthur, mentions that Winslow had a "better chance of being shot" than did Arthur, who was then serving in the United States Navy (Arthur had enlisted on 13 September 1861, and boarded ship on 1 October) (Hendricks 1979, 43-44).

15 October 1861 Date of a pass issued to Homer by an adjutant to General George B. McClellan, which reads "[Pass] Mr. Homer within the line of main guards one week . . . [signed] A. Williams [Assistant Adjutant General to McClellan]" (*fig.3*). A undated drawing of Fort Lyon, inscribed by Homer "Fort Lion [*sic*] - Covers

fig.3 Winslow Homer's Civil War pass, dated 15 October 1861. Pasted on the fly-leaf of Jared Sparks' *Life and Treason of Benedict Arnold*, vol. 3 of the *Library of American Biography* (Boston: Hilliard, Gray, 1835), originally in the library of Winslow Homer. Courtesy of the Margaret Woodbury Strong Museum, Rochester, New York

21 December 1861 Another letter from Henrietta Homer to Arthur tells him that Homer has returned to New York and wants to go to Europe for further study: *Win is well & happy & back again to Mrs. Cushmans. . . . Perhaps you, even you, will be able to contribute towards a loan I hope to get up for him this winter to go abroad in the Spring, as he so desires to go for improvement, & he will be able to repay with principal & interest before many years, so write me about it.*
(Hendricks 1979, 45)

1862

18 February 1862 A letter from Lieutenant Colonel Francis Channing Barlow, of the Sixty-first New York Infantry, written to his mother from his quarters in Virginia, says, "I should be glad to see Homer here & if we are farther out he must come out there – Tell Charles I will write him" (Tatham 1979, 86-87).
"Charles" is presumably Charles Homer, who graduated from Harvard College in the same year as Barlow, 1855. Charles Homer attended the Lawrence Scientific School, then a division of Harvard College.

17 March 1862 From Alexandria, Virginia, General McClellan begins to move the Army of the Potomac toward Richmond, heading for the Yorktown Peninsula via the Potomac River and the Chesapeake Bay, in anticipation of the Peninsular Campaign

1 April 1862 Date of a second pass, issued by the provost marshall's office and good through "the expiration of orders," extending to Homer the "permission to pass to and from VIRGINIA for the purpose of Business" (*fig.4*).
Also the date of Homer's drawing of "soldiers leaving Alexandria for Fortress Monroe" (private collection, repr. in Giese 1985, fig. 29), on the verso of which Homer wrote:
J. Bonner Esq. / Dear Sir I make this sketch from / life – Troops have been / leaving here from Fortress / Monroe for two weeks past. / I am off tomorrow / for Genl Sumner's Division / Homer.
(Giese 1985, 231)
General Edwin Vose Sumner commanded the Army of the Potomac's Second Corps during McClellans' Peninsular Campaign; Barlow's Sixty-first New York Infantry was included in this Corps.

2 April 1862 Homer still at Alexandria; another dated drawing is inscribed:
The 6th Penn Cavalr[y] / Embarking at Alexandr[ia] / for Old Point Comfort / This is a full Regt. All the men have / Lances which they use with great ski[ll] / This being the only Regt. of the kind in the Serv[ice] / I thought you would like it / H.

(Cooper-Hewitt Museum, the Smithsonian Institution's National Museum of Design, New York, 1912-12-137)

5 April 1862 Homer's dated drawing inscribed: "The Ocean Queen with Irish Bregade [sic] on board going down the Potomac" (private collection, repr. Hendricks 1979, fig.57) may have been sketched from a dock or from Homer's own ship.
McClellan begins his siege of Yorktown

16 April 1862 Homer's dated drawing illustrates [as inscribed]: "Assault on Rebel Battery at Lee's Mill April 16th / Motts Battery supporting Hancocks Brigade" (collection of Karl M. Sandecki, repr. in Goodrich and Gerdts 1986, 4).

18 April 1862 A letter from Francis Channing Barlow (who had been promoted to colonel four days earlier) to his brother Edward, from "before Yorktown," speaks of a visit from their brother Richard and says
I have enjoyed his [Richard's] & Homer's visit exceedingly. It seemed quite like home to have them here & I have not laughed so much since I left home. . . . It is impossible to get a servant here. . . . R and Homer have done the cooking. Tell R . . . that I have got a man to help Homer with cooking & scullion Dpt & taking R's place.
(Tatham 1979, 87)

fig.4 Winslow Homer's Civil War pass, dated 1 April 1862. Collection of Bowdoin College Museum of Art, Brunswick, Maine. Gift of the Homer Family

23 April 1862 Another letter from Barlow to his brother Edward, from "before Yorktown," says
[Homer] now does not dare go to the front having been an object of suspicion even before. He says he will go home after the battle.
Tatham adds, "The battle Homer was staying to see was the expected Union assault on the fortifications of Yorktown, a battle which failed to materialize" (Tatham 1979, 87).

3 May 1862 *Confederate General Joseph E. Johnston evacuates his troops from Yorktown, avoiding a major confrontation with McClellan's army. The Battle of Williamsburg, which occurred two days later on 5 May, did not involve the Army of the Potomac's Second Corps*

31 May-1 June 1862 *Battle of Seven Pines (or Fair Oaks), Virginia, in which General Sumner's Second Corps played a major role in defusing the Confederate assault*
The text accompanying Homer's *The War for the Union, 1862 – A Bayonet Charge* (*fig.2*, Wilson, this volume), which appeared in *Harper's Weekly* on 12 July 1862, ties this illustration to the Battle of Fair Oaks. However, nothing in the engraving denotes a particular battle; Alfred Waud, who spent much more time at the front than Homer, gave his "correct version" of the bayonet charge at Fair Oaks on 16 August 1862 (Goodrich 1944, 230).

7 June 1862 A letter from Homer's mother to Arthur indicates that Homer had left the front and had been back in New York for some time:
Winslow went to the war front of Yorktown & camped out about two months. He suffered much, was without food 3 days at a time & all in camp either died or were carried away with typhoid fever – plug tobacco & coffee was [sic] the Staples. . . . He came home so changed that his best friends did not know him, but is well & all right now will be home [i.e., to Belmont] 4th of July. . . . Win is not doing much just paying his expenses.
(Hendricks 1979, 50)

25 June-1 July 1862 *The Seven Days' Campaign before Richmond, including the battles of Mechanicsville, Gaines' Mill, First Cold Harbor (or Chickahominy), and Malvern Hill*

17 September 1862 *Battle of Antietam, in which Colonel Francis Channing Barlow is wounded; for his valiant conduct in this and preceding battles, however, he is appointed brigadier general on 19 September 1862*

15 November 1862 *The Army of the Potomac – A Sharpshooter on Picket-Duty* appears in *Harper's Weekly* with the caption, "From a Painting by W. Homer, Esq."

13 December 1862 *Battle of Fredericksburg, Virginia*

1863

April 1863 Homer is represented by two paintings in the National Academy of Design's Thirty-eighth Annual Exhibition, listed as follows: "255. *The Last Goose at Yorktown.* For sale. . . . 371. '*Home, Sweet Home.*' For sale." Homer's address is given as N. Y. University.
Aldrich later recalled,
We think it was in 1863 that Mr. Homer received his first general recognition as a painter. In that year he contributed to . . . the National Academy of Design two small pictures, which attracted considerable attention, and were at once purchased by a well-known connoisseur.
(Aldrich 1866, 397)

1-4 May 1863 *Battle of Chancellorsville, Virginia*

1-3 July 1863 *Battle of Gettysburg, Pennsylvania (in which General Francis Channing Barlow is severely wounded). In the west, the town of Vicksburg, Mississippi, surrenders on 4 July to the Federal forces of General Ulysses S. Grant*

Summer 1863 Presumably during his summer residence in Belmont, Homer and the Boston lithographer Louis Prang collaborate on the lithographic series "Campaign Sketches"; in December Homer sees the finished product and writes to Prang, "The cover is very neat and the pictures look better than they would in color, but why did you not get a copyright?" (Hendricks 1979, 50).

October 1863 Homer enrolls in the life class at the National Academy of Design (Cikovsky essay, this volume).

26-30 November 1863 *Heavy skirmishing around Mine Run, Virginia*

November 1863 Homer exhibits two works in the Artists' Fund Society's Fourth Annual Exhibition, listed as follows: "108. *Playing Old Soldier*, For sale . . . 144. *The Sutler's Tent*, For sale."

December 1863 Prang and Homer agree to a second lithographic project, with images the size of souvenir cards (4 $\frac{1}{8}$ × 2 $\frac{1}{2}$ inches each). This becomes the *Life in Camp* series of twenty-four prints, published in 1864.

1864

2 January 1864 A critic for *The Round Table*, making the customary winter rounds of artists' studios, reports on a visit to Homer's studio where he noticed "a picture of

camp-life, representing a couple of soldiers seated on an old pine log, making brier-wood pipes."

Mid-January 1864 Homer exhibits *In Front of the Guard-House* in the Artists' Reception at Dodworth's Studio Building, New York.

28 January 1864 *Evening Post* reviewer reports on a visit to Homer's studio, noting "two unfinished pictures, the subjects of which are drawn from camp life. One is 'Making Brier-root Pipes' and the other 'Before the Guard-House.'"

Before 30 January 1864 Homer exhibits *Sharpshooter* at the Atheneum Club in New York.

19 February 1864 Artists' Reception for the Benefit of the Brooklyn and Long Island Fair; Homer's *Sharpshooter* is on view.

22 February 1864 Homer exhibits in the Brooklyn and Long Island Fair, in aid of the United States Sanitary Commission: "85. *Berdan Sharp-Shooter*," owned by the artist.

9 March 1864 Ulysses S. Grant is officially commissioned lieutenant general, a rank held by no officer since George Washington, and given command of the collected Union armies

Before 25 March 1864 Homer exhibits *The Brierwood Pipe* at the Fourth Artists' Reception in Dodworth's Studio Building.

April 1864 Homer exhibits a painting at The Metropolitan Fair in aid of the United States Sanitary Commission, New York, a work that is auctioned on 19-21 April: "74. *Study from Nature*" [unidentified].

April 1864 Homer exhibits a painting in the "Art Exhibition" of the Maryland State Fair (in aid of the United States Sanitary Commission), Baltimore, listed as follows: "97. '*Playing old Soldier*,'" for sale; owned by the artist.

April 1864 Homer exhibits two paintings in the National Academy of Design's Thirty-ninth Annual Exhibition, New York, listed as follows: "73. *In Front of the Guard-House* . . . 140. *The Brierwood Pipe*," owned by the artist. Homer's address is given as N. Y. University.

5-7 May 1864 Battle of the Wilderness
Presumably Homer witnessed this battle; the artist reported that his painting *Skirmish in the Wilderness*, shown in the Artists' Fund Society exhibition of Novem-

ber-December 1864, had been painted from sketches made on the spot (see *cat.no.9*). Sheldon reported that after traveling to the front "with the first batch of soldier-volunteers," Homer "twice again made a trip to the Army of the Potomac, these times independently of the publishers." These would seem to be the April 1862 visit, and a third, as yet undocumented visit, presumably at the beginning of Grant's Richmond campaign.

8-19 May 1864 Battle of Spotsylvania Court House; General Barlow, who had returned to service on 1 April 1864, leads one of two divisions in the 12 May assault on the Confederate salient (a battle later known as "The Bloody Angle of Spotsylvania"), reportedly capturing four thousand prisoners, including two generals

May 1864 Homer is elected an Associate Academician of the National Academy of Design; he is required to present to the Academy a portrait of himself. Rather than the standard self-portrait, Homer will give the Academy his portrait painted by Oliver Lay (see Hendricks 1979, fig.73).

1-3 June 1864 Battle of Cold Harbor, Virginia

June 1864 Homer exhibits a painting at The Great Central Fair, Philadelphia (also called "The Philadelphia Sanitary Fair"), Art Department, listed as follows: "203. *Playing Old Soldier*," owned by the artist.

15-18 June 1864 Grant's planned attack and subsequent assaults on Petersburg, Virginia, fail; on 18 June Grant decides to lay siege to the city
Presumably Homer painted *Inviting a Shot before Petersburg, Virginia*, on the basis of sketches made around this date (see *cat.nos.10* and *10a*).

November 1864 Artists' Fund Society Fifth Annual Exhibition, New York; Homer exhibits five paintings including: "10. *Cabbage Garden*" [possibly a foraging scene] and "47. *Skirmish in the Wilderness*."

1865
10 January 1865 A letter to the editor of *The New-York Times* informs that a work by Homer will be included in "The Artists' Sale" to be held "Wednesday next" at the Old Dusseldorf Gallery, 548 Broadway [catalogue unlocated, work unidentified].

16 February 1865 Following a visit to Homer's studio, the critic for *The Evening Post* reports that Homer has "several pictures in progress," including *The Bright Side* and *Pitching Quoits*.

11 March 1865 Following a visit to Homer's studio, George Arnold, critic for *The New York Leader*, remarks extensively upon *The Bright Side* and *Pitching Quoits*.

22-25 March 1865 Homer exhibits at the Brooklyn Art Association's Spring Exhibition (at the Brooklyn Academy of Music): "129 *The Bright Side*, For Sale."

2 April 1865 Federal forces drive through and capture the Confederate lines at Petersburg; Confederate Government evacuates Richmond

9 April 1865 General Robert E. Lee surrenders his Army of Northern Virginia at Appomattox Court House

14 April 1865 President Abraham Lincoln is shot

26 April 1865 In North Carolina, Confederate General Joseph E. Johnston surrenders to Union General William T. Sherman

Late April* 1865 Homer exhibits three paintings at the National Academy of Design's Fortieth Annual Exhibition, New York, including: "190. *The Bright Side*. Wm. H. Hamilton. . . . 460. *Pitching Quoits*. For sale."
*Note: The National Academy of Design generally opened its annual exhibition around 15 April of each year. Because of the assassination of President Abraham Lincoln on 14 April, the Academy postponed the opening of the 1865 exhibition as well as the dedication of their new building. See *The New-York Times*, 16 April 1865.

10 May 1865 Confederate President Jefferson Davis is captured in Georgia; a proclamation from President Andrew Johnson declares that "armed resistance to the authority of the Government in the said insurrectionary States may be regarded as virtually at an end"

May 1865 Homer is elected a full Academician of the National Academy of Design; this election requires him to present to the Academy within a year a representative example of his work.

9 September 1865 *The Round Table* reports that Homer "has been dividing his summer between labor and recreation at Newport and Saratoga, whence he has sent many excellent contributions to the illustrated journals of the city."

November 1865 Sixth Annual Exhibition of the Artists' Fund Society of New York includes two works by Homer: "46. 'Army Boots' . . . 300. *The Veteran in a New Field*." Homer donated no. 46 for the benefit of the Fund; no. 300 was for sale.

30 November 1865 Homer is elected a member of the Century Club in New York; his nomination is proposed by William Oliver Stone and Eastman Johnson.

1866

16 February 1866 Auction sale of "Fine Modern Pictures by the most celebrated European and American Artists" at Leeds & Miner, 548 Broadway (The Old Dusseldorf Gallery), includes: "98 Winslow Homer *Playing Old Soldier*."

20-21 February 1866 Critics for *The New York Commercial Advertiser* and *The Evening Post* report on visits to Homer's studio, each remarking upon the artist's progress on *Prisoners from the Front*

April-July 4 1866 Homer exhibits two paintings at the Forty-first Annual Exhibition of the National Academy of Design, New York, including: "490. *Prisoners from the Front*."

19 April 1866 Auction, "American Artists' Sale," Miner & Somerville (Somerville Art Gallery, 845 Broadway), includes six works by Homer, apparently all Civil War paintings: "7. *Watching the Shot*. . .23. *Extra Rations* [*The Sutler's Tent*] . . .51. *The Quoit Players* [*Pitching Quoits*] . . .76. *At Rest* . . .85. *On the Picket Line* . . .92. *Near Andersonville*."
Note: Nos. 7, 76, and 85 cannot yet be associated definitively with known paintings.

9 May 1866 Date of diploma conferring upon Homer the status of full Academician of the National Academy of Design (*fig. 5*), and indicating the Academy's acceptance of his diploma picture (*Croquet Player* [National Academy of Design, New York], on the reverse of which the artist inscribed "Winslow Homer would like to have the privilege of painting a better picture").

19 May 1866 In an article, "Addresses of Artists," *The Round Table* notes that "W. Homer, whose capital character picture of the war is so admired at the Academy, remains for most of the summer at Belmont, Massachusetts."

July 1866 *Our Young Folks* publishes an extensive article on Homer, written by Thomas B. Aldrich, former editor of *The New-York Illustrated News*, which provides biographical information, a description of Homer's studio, and reference to several paintings.

fig.5 Diploma from the National Academy of Design, certifying that Winslow Homer had achieved the rank of Academician, 9 May 1866. Collection of Bowdoin College Museum of Art, Brunswick, Maine. Gift of the Homer Family

15 November 1866 Russell Sturgis, critic for *The Nation*, notices three paintings on view "at Mr. Avery's rooms"; he names *Waverly Oaks* and a croquet scene, but not the third painting.

17 November 1866 Auction, Leeds' Art Galleries (Leeds & Miner, Auctioneers), of "The Entire Collection of the Works of Messrs. Winslow Homer and Eugene Benson, who are leaving for Europe." A catalogue of this exhibition has not been located. From critical reviews its contents can be somewhat reconstructed. Among nineteen paintings by Homer, at least one Civil War work was offered: *The Veteran in a New Field*.

The most informative of these reviews are given below:
To-morrow evening a sale of pictures by Mr. Eugene Benson and Mr. Winslow Homer will take place at Leed's New Galleries. . . . The catalogue includes thirty-six paintings. Among these are the following by Mr. Homer: "The trap Cage," "Among the Daisies," a pretty outdoor scene; "The Initials," a girl carving her name upon the trunk of a tree; two pictures of "Croquet," fine studies of figures and costumes, and "The Waverly Oaks," a picture full of power.
("Art Sale," *The New York Commercial Advertiser*, 16 November 1866)

Concerning [Homer's] pictures which were sold the other night, the more important of them were old friends. The "Brush Harrow" was there, and the admirable "Veteran in a New Field," which we hope brought a thousand dollars, hasty and slight as it is; and the "Waverley [sic] Oaks," noticed last week. There were nineteen pictures of his, but some them were very small, and valuable mainly as curiosities or illustrations of practice.
("Pictures on Exhibition," *The Nation* 3, no. 73 [22 November 1866]: 416)

5 December 1866 Homer sails from Boston to Europe on the *Africa* (Hendricks 1979, 72).

Note: Civil War paintings for which no firm exhibition or sale record can be found, 1859–1866:
In Front of Yorktown, 1862–63
Inviting a Shot before Petersburg, Virginia, 1864
Portrait of Albert Post, ca. 1864
Halt of a Wagon Train, ca. 1864
Trooper Meditating beside a Grave, 1865
Sounding Reveille, 1865 [first exhibited in 1871]

Titles of works exhibited between 1859 and 1866 that presumably have Civil War subject matter, but which cannot now be associated with known paintings:
Cabbage Garden [exhibited at the Artists' Fund Society, November 1864]
Watching the Shot [auctioned by Miner & Somerville, 19 April 1866]
On The Picket Line [auctioned by Miner & Somerville, 19 April 1866]
At Rest [auctioned by Miner & Somerville, 19 April 1866; appears again for sale at the Utica Art Association in Utica, N. Y., in 1867]

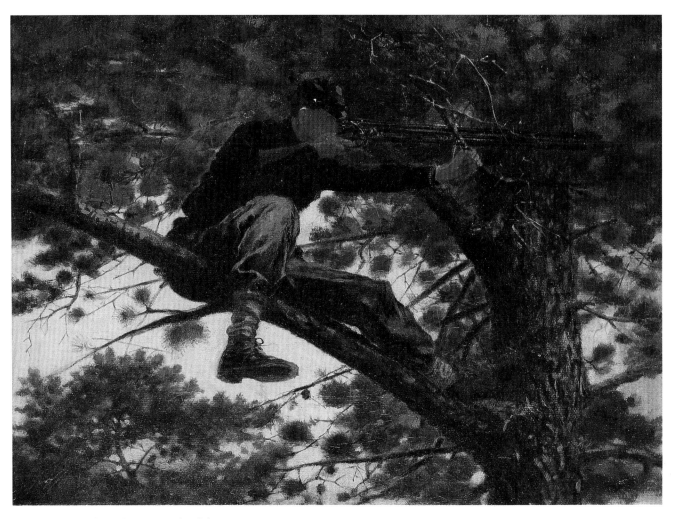

Winslow Homer. *Sharpshooter*, 1862/63. Oil on
canvas, 12 ¼ × 16 ½ in. Signed and dated lower left:
W Homer *63*. Private collection. *Cat.no.1*

Marks of Honor and Death:
Sharpshooter *and the*
Peninsular Campaign of 1862

Christopher Kent Wilson

A few days after the Union debacle at Bull Run, President Abraham Lincoln appointed Major General George B. McClellan as the new commander of the Union forces. Over the next several months McClellan transformed a tattered and humiliated army into a highly trained fighting force of over one hundred thousand men. In January 1862, Lincoln and McClellan began formulating plans for the long-awaited invasion of Virginia and the capture of the Confederate capital of Richmond. Although they envisioned different plans and tactics, both agreed that a successful campaign would break the back of the Confederacy and eventually end the war. After carefully weighing the merits of each plan, they decided to pursue McClellan's Peninsular Campaign, which called for an amphibious invasion of the Virginia peninsula at Fortress Monroe seventy miles to the southeast of Richmond. Under this plan the Army of the Potomac would march up the peninsula while employing the York and James rivers as supply lines.[1]

In late March 1862 after months of preparation, the grand army assembled along the banks of the Potomac to embark on their historic mission. Army chaplain A. M. Stewart captured the excitement and pageantry of the departure in his journal:

The scene from Georgetown to Alexandria, on the river, was enlivening beyond comparison. A fleet, of at least a hundred vessels, had been assembled, and those of all shapes and sizes, from the immense steamboat down to the sloop. These were either filled or filling with regiments, brigades, whole divisions of the great army; trains and artillery, pontoons, baggage, forage, and ammunition. At

the passing of some general or other exciting event, ten thousand voices would well up in shouts together, while numerous bands of martial music made river, hills, and adjacent cities vocal. The multitudes had come from their camps and long confinement, and were wild with excitement.[2]

For most of the soldiers, the picturesque journey down the Potomac and up the York rivers took less than twenty-four hours, reinforcing their belief that they were participating in a carefully planned campaign and a great military adventure. George Stevens of the Sixth Army Corps described the arrival of the Union armada on the Virginia shore:

The whole army was pouring out upon this shore, and at Fortress Monroe. Dense masses of infantry, long trains of artillery and thousands of cavalry, with unnumbered army wagons and mules, were mingled in grand confusion along the shore; the neighing of horses, the braying of mules, the rattle of wagons and artillery, and the sound of many voices, mingled in one grand . . . concert.[3]

By 2 April most of the army, including General McClellan and his staff, were preparing for their march on Richmond. With the public clamoring for news of the invasion, leading American illustrators such as Alfred and William Waud, Edwin Forbes, and Thomas Nast journeyed to the front to record the drama and heroism of the impending battles. Among these artists was the New York illustrator Winslow Homer who on 1 April in Washington had been issued a pass authorizing his presence at the front.[4] Like Chaplain Stewart, Homer tried to capture the excitement and pageantry of the departing troops at Alexandria. In a pencil-and-wash sketch Homer portrayed the

fig.1 Winslow Homer and Alfred R. Waud (1828-1891). *Our Army before Yorktown, Virginia.* Wood engraving, 13³/₄ × 20³/₄ in. *Harper's Weekly* 6, no. 279 (3 May 1862): 280-281. The Metropolitan Museum of Art, New York. Harris Brisbane Dick Fund, 1929

Sixth Pennsylvania Cavalry Regiment mounted straight in their saddles, dressed in full military gear, and holding ornamental spears as they moved forward in unison to the bugler's call embodying the new pride and discipline of McClellan's army.[5] In another drawing dated 5 April, Homer recorded the departure of the famous Irish Brigade aboard the steamer *The Ocean Queen.* Homer would later incorporate this drawing into one of his larger prints entitled *Our Army before Yorktown, Virginia,* which *Harper's Weekly* published on 3 May 1862 (*fig.1*).

During his peninsular sketching tour Homer worked as an independent artist, covering his own expenses and gathering material, some of which he submitted to *Harper's Weekly.* On an earlier sketching tour at the front near Washington in October 1861, Homer worked directly for *Harper's Weekly,* which paid him thirty dollars per week and railroad fare. During this tour the

journal instructed him to record a military skirmish. Unfortunately Homer did not encounter any battles and *Harper's* had to settle for a series of less dramatic but highly spirited scenes of camp life, including *The Songs of the War* and *A Bivouac Fire on the Potomac.*[6] In light of the uneventful nature of his 1861 sketching tour, Homer must have entertained great hopes for the peninsular campaign. As he boarded a boat for Fortress Monroe some time around 5 April, Homer probably felt a sense of exuberance and anticipation like that of the soldier, for within a few days he would not only be exposed to the fury and heroism of arms but also afforded an opportunity to record the great, decisive battle of the American Civil War.

On the morning of 4 April, McClellan's army opened its campaign by marching on the fortified defenses of Yorktown under the control of the Confederate Brigadier General John B. Magru-

der. As the first line of defense Magruder was supposed to delay the advance of the Union Army. Although he commanded only five thousand troops, Magruder skillfully arranged them to create the illusion of a larger force. To complete the illusion he had his men march back and forth past openings in the woods. By varying their direction and pace Magruder convinced McClellan that he commanded a large and heavily fortified army. To make matters worse, as McClellan was about to wire Washington for his remaining thirty-five thousand troops he received word from the War Department that General McDowell's corps were being detached from his command and stationed in Washington to defend the capital. Although his army was substantially larger than the enemy's, McClellan decided not to attack Yorktown but instead to prepare for a lengthy siege. This delay provided the Confederate army with valuable time to build and organize its forces around Richmond while, at the same time, it infuriated the president and his cabinet, who wanted a quick, decisive blow struck against an ill-prepared enemy.

As McClellan began building fortifications in front of Yorktown, he received a strongly worded letter from his commander-in-chief:

Washington
April 9. 1862

Major General McClellan
My dear Sir.
Your despatches complaining that you are not properly sustained, while they do not offend me, do pain me very much. . . .

After you left, I ascertained that less than twenty thousand unorganized men, without a single field battery, were all you left for the defence of Washington, and Manassas Junction. . . . Do you really think I should permit the line from Richmond, via Manassas Junction, to this city to be entirely open, except what resistance could be presented by less than twenty thousand unorganized troops? This is a question which the country will not allow me to evade

And, once more let me tell you, it is indispensable to you that you strike a blow. I am powerless to help this But you must act. Yours very truly.

A. Lincoln[7]

Because of McClellan's popularity and the president's reluctance to change commanders in the midst of a campaign, McClellan continued with his siege operations. For the next month the Army of the Potomac built elaborate fortifications and artillery emplacements in preparation for a massive bombardment. Instead of a great battle Homer witnessed several days of sniping and skirmishing as well as the monotonous routine of camp life. During some of his tour Homer stayed with the Sixty-first New York Volunteers led by Lieutenant Colonel Francis Channing Barlow, a friend of the Homer family. In an 18 April letter to his brother, Edward, Barlow wrote:
I have enjoyed his [Barlow's brother Richard] & Homer's visit exceedingly. It seemed quite like home to have them here & I have not laughed so much since I left home.[8]

In his print, *Our Army before Yorktown, Virginia*, Homer honored Barlow and his comrades by portraying the Sixty-first during religious services, emphasizing their devotion to God and country.[9] In this same print he also made detailed renderings of the Yorktown encampments, which were a continuing source of concern for the military. During the previous week the Union army confiscated the recent issue of *Harper's Weekly* because it contained some detailed views of the Union fortifications. In a letter of 23 April Lieutenant Colonel Barlow commented upon the incident and its impact upon Homer.
We have yesterday's Herald. . . . We were much amused to read that Harper's of last week had been suppressed. It had nothing of Homer's in it but we regard his occupation [as an illustrator] as gone. He now does not dare go to the front having been an object of suspicion even before. He says he will go home after the battle.[10]

There never was a battle at Yorktown. On the evening of 3 May, just before the Union began their massive artillery and mortar barrage, the Confederates opened with their own artillery attack. The rebels, however, were not trying to drive away the enemy but rather to conceal their own retreat. The prince de Joinville, a member of McClellan's staff, recalled the Union's surprise and disappointment on the following morning:

On the 4th, at daybreak, the men in the rifle-pits . . . saw no signs of the foe before them. A few of them ventured cautiously up to the very lines of the enemy. All was as silent as death. Soon suspicion grew into certainty. . . . The confederates had vanished, and with them all chances of a brilliant victory. . . . We had spent a whole month in constructing gigantic works now become useless, and now, after all this, the confederates fell back, satisfied with gaining time to prepare for the defence of Richmond, and henceforth relying on the season of heats and sickness for aid against the federal army encamped among the marshes of Virginia.[11]

Although there are no extant, dated drawings from May 1862, Homer evidently remained in Virginia until the beginning of June and, like many of the soldiers, suffered from the "season of heats and sickness." In a 7 June letter to Homer's brother Arthur, their mother described the hardships of camp life on the peninsula:
Winslow went to the war front of Yorktown & camped out about two months. He suffered much, was without food for 3 days at a time & all in camp either died or were carried away with typhoid fever – plug tobacco & coffee was [sic] the staples. . . . He came home so changed that his best friends did not know him, but is well & all right now. . . .[12]

Having regained his strength, Homer again began submitting his work to *Harper's Weekly*. On 5 July the journal published his wood engraving, *The War for the Union, 1862 – A Cavalry Charge*, which portrayed the Union cavalry routing and trampling the enemy (see Giese, this volume, *fig.6*). This triumphant portrayal of the Union cavalry was an idealized and distorted view, for by late June, the Union army was retreating on the peninsula, having just been defeated by Confederate forces at the battle of Fair Oaks. Moreover, during the first few years of the war the cavalry was a continual source of embarrassment rather than pride. Unlike the Confederate army, which boasted many fine cavalry units, the Union army was comprised mostly of farmers and city dwellers who possessed little experience in handling fast, spirited horses. Although the northern cavalry did improve during the war, a Union soldier as late as October 1863

could write in his journal,
We have considerable cavalry with us but they are the laughing stock of the army and the boys poke all kinds of fun at them. I really have as yet to see or hear of their doing anything of much credit. . . .[13]

The following week *Harper's Weekly* published a pictorial pendant to Homer's cavalry charge entitled *The War for the Union, 1862 – A Bayonet Charge* (*fig.2*). Another Homer wood engraving of a field hospital staff, entitled *The Surgeon at Work at the Rear during an Engagement*, appeared in this same issue of *Harper's Weekly* (*fig.3*). This print is yet another glorification of the Union war effort designed to mask the realities of a failed military campaign. In this scene Homer depicts an army surgeon supported by his staff and an ambulance corps fighting to save the lives of the wounded. This view of the fallen soldier receiving prompt, individual attention is a gross distortion of fact intended to reassure the North that, in spite of increasingly large and alarming casualty rates, the Union soldier was receiving care worthy of his sacrifice.

Unfortunately this was not the case. As the casualties from the peninsular campaign soared, the quality of medical care plummeted. In striking contrast to Homer's print, the wounded often lay unattended on the battlefield, suffering for three or four days. In some instances after Yorktown, the wounded were even abandoned as the Union army pressed forward in pursuit of their retreating foe. For those fortunate enough to be removed to a field hospital, often several more hours or even days passed before a tired and overworked surgeon could examine their wounds.

J. H. Brinton, a Union medical director, described the lack of medical attention after the battle of Shiloh in April 1862:
[Lying on the fields were] thousands of human beings . . . wounded and lacerated in every conceivable manner, on the ground, under a pelting rain, without shelter, without bedding, without straw to lay upon, and with but little food . . . the circumstances . . . were fearful, and the agonies of the wounded were beyond all description. They were, moreover, fearfully increased by the dearth of

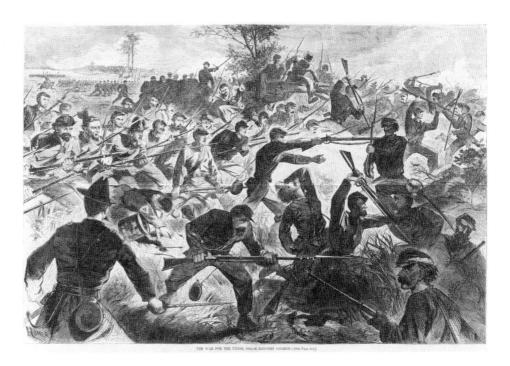

fig.2 Winslow Homer. *The War for the Union,*
1862 – A Bayonet Charge. Wood engraving,
13⅝ × 20⅝ in. *Harper's Weekly* 7, no. 289 (12 July
1862): 440-441. The Metropolitan Museum of Art,
New York. Harris Brisbane Dick Fund, 1929

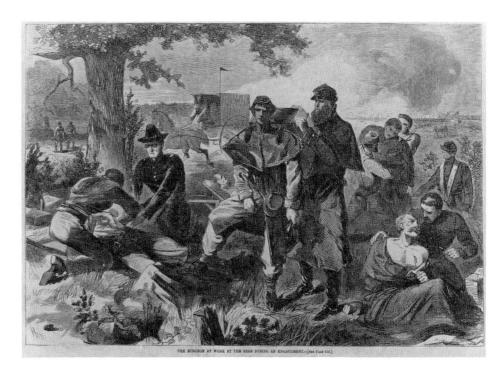

fig.3 Winslow Homer. *The Surgeon at Work at the*
Rear during an Engagement. Wood engraving,
9⅛ × 13¾ in. *Harper's Weekly* 7, no. 289 (12 July
1862): 436. The Metropolitan Museum of Art, New
York. Harris Brisbane Dick Fund, 1929

*those nourishments and stimulants essential to
relieve the shock of injury.*[14]

After the battle of Fair Oaks on the peninsula,
the wounded were slowly moved to a railroad
depot to await the hospital trains. The soldiers
"lay by the hundreds on either side of the railway
track," their wounds filled with maggots, "as
though a swarm of bees had settled" on them,
and their bodies "exposed to a drenching rain . . .
shivering from the cold, calling for water, food,
and dressings . . . the most heart-rending specta-
cle. Many died from this exposure and others
prayed for death to relieve them from their
anguish."[15]

We do not know whether Homer was responsi-
ble for the propagandistic nature of these scenes;
however, it is clear that *Harper's Weekly* was a
strong supporter of the Union war effort. Although
Homer may have tailored his wood engravings
for journalistic purposes, his early oil paintings
are more accurate reflections of the war. In one of
his earliest oil paintings, *In Front of Yorktown*,
Homer depicted a small group of soldiers gathered
around a campfire (*cat.no.2*). During the siege of
Yorktown several units would spend two or three
days on the front lines digging trenches and
building artillery emplacements under the unre-
lenting fire of enemy rifles and artillery. At night,
because of their proximity to the enemy, these
soldiers were not allowed to build fires either to
cook or to keep warm. After a few days of "fatigue
duty" the soldiers returned to the safety of the
rear lines where they could enjoy warm food and
the comfort of an evening fire.

*A stillness reigned around, broken now and then
by the occasional boom from the guns. . . . The
men lay grouped around the camp-fires, some
seated on logs, others reclining on the green pine-
boughs that served them for a couch. Around the
blazing fire was a wall of pine-tops, giving the
place a most comfortable appearance, and defining
more strongly the dark figures grouped inside.*[16]

George Stevens of the Sixth Corps described
the changing mood and spirit of the Union army
before Yorktown when he wrote, "[The] men
had lost the enthusiasm which had prevailed
when we landed upon the Peninsula, and a smile

was seldom seen; but a fixed and determined
purpose to succeed still appeared in their faces."[17]
Homer's nocturnal encampment perfectly cap-
tured the dampened enthusiasm as well as the
quiet determination of McClellan's army as it
learned to endure the hardships and boredom of
a weary and monotonous struggle.

Most soldiers describing the peninsular cam-
paign years later would not only recall the cold
and damp of those "accursed swamps" but also
another plague which threatened them: the
deadly bullets of hidden snipers. Interestingly
enough, after his return from the peninsula,
Homer depicted one of these sharpshooters on
duty (*cat.no.1*). This picture was Homer's first oil
painting and the inspiration for one of his finest
wood engravings. On 15 November 1862 *Harper's
Weekly* published Homer's print *The Army of the
Potomac – A Sharp-Shooter on Picket Duty*
(*cat.no.1a*). At the bottom of the print are
inscribed the words, "From a Painting by W.
Homer, Esq." The painting of the sharpshooter,
however, is dated 1863, which suggests either that
Homer began the painting before November and
finished it the following year or that he may
have used the print as an opportunity to announce
his new commitment to oil painting. The year
after Homer's death, Russell Shurtleff, who knew
the artist, referred to the *Sharpshooter* as Homer's
"very first picture in oils."[18] He recalled that it
*was painted in [Homer's] studio in the old Univer-
sity Building in Washington Square. It represented
a "Sharpshooter" seated in a brig top, aiming at
a distant "Reb," a canvas about 16 × 20. I sat with
him many days while he worked on it, and remem-
ber discussing with him how much he could ask
for it. He decided not less than sixty dollars, as that
was what Harper paid him for a full page drawing
on the wood.*[19]

The *Sharpshooter* apparently did not sell, for in
January and February 1864 Homer exhibited it at
the Atheneum Club of New York and the Brook-
lyn and Long Island Fair with the catalogue
designation "a.o." or artist-owned.[20] To encour-
age the young painter, Charles Homer, the artist's
older brother, anonymously bought the painting
and eventually sold it to Samuel Barlow of Law-
rence, Massachusetts.[21]

There are only minor differences between the oil and the print. In the engraving Homer has added a canteen and a letter A to the sharpshooter's cap, designating his company affiliation. The compositional focus has also been tightened and the foliage reduced to emphasize the sharpshooter. Unlike other Civil War illustrations that had appeared in *Harper's Weekly*, Homer's engraving is a startling image that stands in striking contrast to the typical war illustration with its emphasis upon large figural compositions and narrative content. This bold, singular image of a Yankee sharpshooter perched high on the branches of a tree, aiming at a distant target, is one of the artist's most powerful and dramatic works, its meaning intimately tied to the history and military tactics of the peninsular campaign. Viewed in its historical context, Homer's portrayal of the sharpshooter is a symbol of pride and efficiency as well as a disturbing portrait embodying the new tactics and grim realities of the war.

Sharpshooters were first extensively employed by the Union during the peninsular campaign. Although the Confederates possessed skilled marksmen, the Union army organized its riflemen into two highly trained regiments comprised of eighteen companies enlisted from eight states. Colonel Hiram Berdan of New York proposed and organized these regiments during summer 1861 according to strict standards of character and marksmanship. To qualify for admission each candidate had to fire ten consecutive shots from two hundred yards into a target, the average distance from the center of the bullseye not exceeding five inches.[22] These admission standards were all the more remarkable when compared to the marksmanship of the average infantry soldier, who rarely had target practice and was surprisingly unfamiliar with the maintenance and operation of his weapon. For example, at the beginning of the war a number of soldiers were killed or wounded in their tents by accidental discharge as they cleaned their muskets.[23] After six months of service, a squad of Illinois soldiers

fig.4 Unidentified artist. *Colonel Berdan of the Berdan Sharp-Shooters, Practicing at a Target at Weehawken, New Jersey.* Wood engraving, 6¼×14 in. *Harper's Weekly* 5, no. 243 (24 August 1861): 540. Collection of Abernethy Rare Book Room, Starr Library, Middlebury College, Vermont

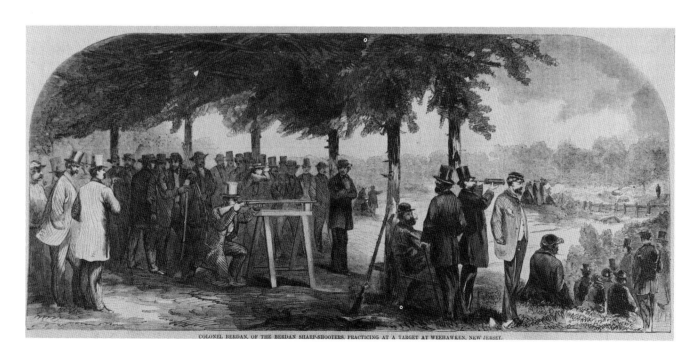

COLONEL BERDAN, OF THE BERDAN SHARP-SHOOTERS, PRACTICING AT A TARGET AT WEEHAWKEN, NEW JERSEY.

during target practice fired one hundred sixty shots at a flour barrel one hundred eighty yards away and recorded only four hits.[24] This poor marksmanship was painfully apparent during any number of bungled executions, which required two and sometimes three volleys before killing the prisoner.[25]

After the humiliating lack of discipline at Bull Run, the Union army and public enthusiastically embraced Berdan's highly trained and exceptionally skilled soldiers. During summer and autumn 1861 many of the New York newspapers and illustrated journals extolled the skill and discipline of Berdan's new units. For example, on 24 August 1861 *Harper's Weekly* highlighted Colonel Berdan and his marksmen in a large illustration (*fig.4*).[26] In the accompanying article the journal proudly recorded the exploits of the sharpshooters at a shooting demonstration in Weehawken, New Jersey. During these exhibitions, the colonel would often fire five consecutive shots within a ten-inch circle at a distance of six hundred yards.[27] He accomplished this with the aid of a large telescopic target rifle, which became the symbol of the sharpshooters and a mark of honor for all those who fired it.

The giving of these telescopic rifles . . . was in the nature of a mark of honor, as the sharpshooter thus armed was considered an independent character, used only for special service, with the privilege of going to any part of the line where in his own judgment he could do the most good. It is therefore sufficient, in naming the men carrying these ponderous rifles, to show that they were among our most trusty soldiers and best shots.[28]

On 5 October 1861 *Harper's Weekly* devoted a large front-page illustration and article to another Berdan unit from New Hampshire under the leadership of Captain A. B. Jones (*fig.5*).[29] During the autumn months, President Lincoln paid tribute to the sharpshooters by visiting their camp near Washington on three occasions. On his first visit, he witnessed a shooting exhibition and then "to the great delight of the soldiers" demonstrated his own skills by firing three rounds, "handling the rifle like a veteran marksman."[30] Later, Lincoln described the sharpshooters as "universally

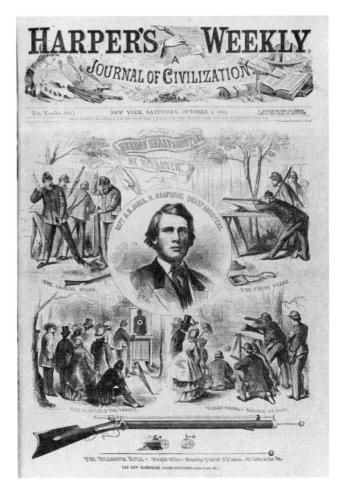

fig.5 E. W. *The Berdan Sharpshooters at Weehawken.* Wood engraving, 14 × 9½ in. *Harper's Weekly* 5, no. 249 (5 October 1861): 625. Collection of Abernethy Rare Book Room, Starr Library, Middlebury College, Vermont

appreciated" and directed the secretary of war "to put [Berdan's] corps into the most effective form regardless of existing regulations."[31]

Not surprisingly, the army issued Berdan's regiments distinctive uniforms and the best equipment:

Our uniform was of fine material, consisting of dark green coat and cap with black plume, light blue trousers (afterward exchanged for green ones) and leather leggins, presenting a striking contrast to the regular blue of the infantry. The knapsack was of hair-covered calfskin, with cooking kit attached, considered the best in use, as it was the handsomest, most durable and complete . . . when fully uniformed and equipped, the sharpshooters made a very handsome appearance.[32]

The Berdan sharpshooters arrived at Fortress Monroe on 24 March 1862 and within a few weeks their reputation as an elite corps had spread to the enemy. On 6 April General Porter of the Third Army Corps wrote to Colonel Berdan,

[I am] glad to learn, from the admission of the enemy themselves, that they begin to fear your sharpshooters. Your men have caused a number of rebels to bite the dust. The Commanding General is glad to find your corps are proving themselves so efficient.[33]

Because of their valuable skills, the sharpshooters were not required to perform fatigue duty in the trenches. Their reputation as a favored corps, however, soon grew to outlandish proportions as reflected in the southern newspaper, *Petersburg Express*, which described the death of a Union marksman:

A McClellan Sharpshooter had been picked off by a Kentucky hunter, at two hundred yards distance, and on approaching the pit where the Sharpshooter lay, it was found to contain a cushioned arm chair, choice liquors and segars, and food of the best description.[34]

This distortion of fact reflects an underlying jealousy and fear of the Union sharpshooters, which quickly developed at Yorktown. From their concealed positions in rifle pits and from behind trees and bushes, Berdan's men established control over the rebel fortifications with their long-range rifles. The sharpshooters' deadly fire pinned the enemy within their trenches, "captured" their gun emplacements by harassing and killing artillery crews, provided cover fire for advancing and retreating troops, and killed Confederate officers both on the battlefield and behind enemy lines.[35]

During the siege of Yorktown the sharpshooters occupied firing positions in rifle pits near the Confederate lines and in the tops of tall, distant pine trees.[36] After establishing their lines in front of Yorktown, the Union army under the cover of night constructed rifle pits between their own lines and the Confederate fortifications. Each night new sharpshooters would occupy the rifle holes. From their concealed positions, beginning with the break of dawn, the sharpshooters would direct their deadly fire at the enemy. Throughout the siege the Union army constructed rifle pits ever closer to enemy lines, which enhanced the sharpshooters' effectiveness but also increased their danger of being overrun or struck by an enemy bullet. Captain Henry Blake of the Massachusetts Volunteers described some of these dangers when he wrote in his journal:

The sharpshooters . . . were concealed in little pits in the extreme front [and] were always relieved in the night. . . . There was no relief [however] for those that were wounded in these hazardous positions, until the sun sank beneath the horizon; and some of these unfortunate heroes languished and died, while their comrades were unable to alleviate their sufferings.[37]

In spite of these obvious dangers the sharpshooters relished the opportunity to work in the rifle pits. Captain Stevens in his history of the sharpshooters recalled a celebrated member of the New Hampshire company who "evinced the greatest dislike to laying around camp, and, if not detailed to go to the front, would sulk away to his tent, disappointed and soured at the 'blamed luck' that prevented him from keeping his pet rifle barrel warm."[38] In contrast, when assigned to the rifle pits, he was "in his glory" and would sometimes spend several days and nights in these dangerous holes.[39]

The rifleman's perch in the branches of a distant tree was one of the most feared and deadly

positions. From the tops of tall pines, wielding their telescopic rifles, Berdan's marksmen could fire down into the enemy fortifications, inflicting great damage. Major Robert Stiles of a Confederate artillery unit at Yorktown recalled the destructive effects of treetop sharpshooting: *Our positions were commanded by those on the other side, our earth-works were utterly insufficient, we were heavily outnumbered in guns, and the Federal sharpshooters were as audacious and deadly as I ever saw them. For the most part they were concealed in the tops of tall pine trees and had down shots upon us, against which it was almost impossible to protect ourselves.*[40]

This type of sharpshooting was not without risk, for it presented a clear challenge to the skill of the Confederate marksman, eagerly scanning the distant trees for the telltale puff of smoke. Once spotted, the Union sharpshooter, who was concealed but not fully protected by the thin branches, became an inviting and challenging target as the hunter became the hunted. If the sharpshooter ventured outside his own lines to secure a better shot, he would often lash himself to a tree so that were he hit he might avoid capture.[41] This was particularly important during the peninsular campaign when sharpshooters feared that if captured they would not be afforded prisoners' rights and would be executed.[42] Even those marksmen who were not struck by enemy bullets were in a precarious position, for if the enemy advanced rapidly, the sharpshooter seated in his treetop post was always the last to flee and, if fortunate, to escape.[43]

After their initial success on the Virginia peninsula Berdan's sharpshooters became the embodiment of the skilled and daring soldier, a kind of Union counterpart to the southern cavalrymen. Not surprisingly, throughout spring and summer 1862 the illustrated journals extolled the exploits of Berdan's men. For example, in the Homer and Alfred R. Waud print, *Our Army before Yorktown, Virginia*, Berdan's sharpshooters were singled out for their service during the siege (*fig. 1*). In the following *Harper's Weekly* issue of 10 May, Berdan's men were again honored by an illustration and article recording their most

fig. 6 Winslow Homer. *Soldier on Horseback.* Black chalk on brown paper, 14⅛ × 9½ in. Cooper-Hewitt Museum, the Smithsonian Institution's National Museum of Design, New York. Gift of Charles Savage Homer. 1912-12-107

*fig.*7 Winslow Homer. *Cavalry Officer on Horse-back*, ca. 1863. Charcoal and white chalk on blue paper, 13⅞ × 8⅜ in. Museum of Fine Arts, Boston. Anonymous gift

recent accomplishments.[44] On 2 August 1862 *Harper's Weekly* published an illustration and story about "California Joe," the almost legendary sharpshooter who had reportedly killed an enemy soldier at a distance of two miles. The journal began by describing him as "the famous sharp-shooter, [and] one of the best shots and most efficient men in that most efficient and admirable corps, Berdan's Sharpshooters."[45]

In light of Berdan's popularity, it is not surpris-ing that Homer selected a sharpshooter for the subject of his first oil painting and subsequent wood engraving.[46] Homer's picture stands as a pictorial tribute to Berdan's elite corps, but it is not in any sense a romanticized or idealized depiction. In a tightly cropped composition viewed from a dramatic perspective, Homer creates a striking nonnarrative portrait of the sharpshooter. As the marksman concentrates his attention on the distant target, so we as viewers focus our attention on the sharpshooter. The converging diagonal lines of the soldier's cap and rifle stock direct our eyes toward the telescopic sight in the same way that the sight itself funnels and directs the rifleman's aim. In the print the motionless canteen hanging from the tree enhances our sense of poised anticipation as the sharpshooter, with a steady eye and hand, pre-pares to fire upon a distant, unseen target.

This suspended moment is a theme that Homer explored in some of his finest Civil War drawings. For example, in *Soldier on Horseback* and *Cavalry Officer on Horseback*, he portrays two soldiers in the midst of battle (*figs.*6,7). Homer, however, does not focus upon the fury and passion of the moment, but rather upon the precision and con-centration of the soldiers as they coolly and dis-passionately attack the enemy.

As with his drawings, Homer's sharpshooter is also imbued with a remote and detached quality. This unsettling mood is further enhanced by Homer's subtle juxtaposition of the curving pine branches with their soft, pliable needles and the hard, straight, steel barrel of the thirty-two-pound target rifle. This contrast between the beauty and tranquility of nature and the destruc-tive force of man was a recurring theme in con-

temporary journals. For example, in describing a battlefield from summer 1862, Captain Henry Blake wrote,

When the eye excluded the smoke and havoc of the conflict, and gazed upon the scenery, – the green belts of the forest, the undulations and heights upon the field, the cloudless skies . . . the soul was enchanted with the unsurpassed beauty of Nature. In the midst of this loveliness, the scenes of horror upon the plain – the mutilated forms of suffering men, the prolonged roll of musketry, the reverberations of the artillery, the yells of the rebels when they charged . . . and the sulphurous smoke that at times enveloped the combatants – presented a terrible contrast.[47]

Homer's cropped composition and narrative also embody the grim realities of sharpshooting, for just as we, the viewer, cannot see the enemy target, the enemy cannot see the sharpshooter. Homer explored this same idea from a different vantage point in his 1864 painting *Inviting a Shot before Petersburg, Virginia* (cat. no. 10). In this instance, a young soldier weary of trench warfare and its endless sniping defiantly jumps upon the ramparts in a bold challenge to enemy rifles. This action is all the more startling because it was not until the siege of Petersburg that continual fortifications were constructed, providing the soldier with safe passage all along the line.[48] As foolhardy as this may seem, it was not an unusual event. Even as early as Yorktown, soldiers on both sides would challenge the skills of the enemy marksmen:

While some of our men were at work on one of the earthworks, one of them more venturesome than the rest, mounted the magazine [sic] of the fort in plain sight of the rebels. In a moment the shells were flying around lively.[49]

Some of these soldiers who thumbed their noses at the enemy paid dearly for their defiance:

One of the Union marksmen saw by means of his telescopic rifle a man upon the ramparts of Yorktown, who amused his companions by making significant gestures towards the lines, and performed queer flourishes with his fingers, thumbs, and nose. The distance between them was so great, that the buffoon supposed he was safe; but the unerring ball pierced his heart, and he fell inside the works.[50]

These soldiers knowingly and unwisely challenged the sharpshooter. In contrast, most of the sharpshooter's victims were unaware of his presence until the very moment of death. At distances of several hundred yards, the enemy soldier rarely saw or heard the sharpshooter's fire but almost always felt the agonizing crash and pain of his bullet.

Some of those Yankee sharpshooters . . . had little telescopes on their rifles that would fetch a man up close until he seemed to be only about 100 yards away from the muzzle. I've seen them pick a man off who was a mile away. They could hit so far you couldn't hear the report of the gun. You wouldn't have any idea anybody was in sight of you, and all of a sudden, with everything as silent as the grave and not a sound of a gun, here would come . . . one of those "forced" balls and cut a hole clear through you.[51]

The great accuracy of the sharpshooters made life in the trenches almost unbearable. If a soldier exposed any part of his body for only one or two seconds, he was a likely candidate for a sharpshooter's bullet.[52] Because of this unrelenting fire, soldiers often coveted those small areas of earth that were sheltered from the lethal bullets.

There was but one spot in the hollow, and that only a few yards square, where bullets never struck; and by some awkward providence it rarely fell to the lot of my company, no matter when we came off duty. I used to look with envy and longing at this nasty but wholesome patch of gutter. It was a land of peace, a city of refuge, thirty feet long by ten feet broad. Turning my back on its charmed tranquility, where the dying never gasped and the wounded never groaned, I spread my rubber blanket in the mud . . . lighted my pipe, and wondered when my bullet would come.[53]

Trench warfare, unlike a great clash of arms, slowly erodes the nerves and courage of even the bravest soldier. The psychological effects of constant sharpshooting were evident even at the beginning of the peninsular campaign. Major Robert Stiles of the Confederate army recalled its effect at Yorktown, where

the pressure of the Federal sharpshooters became intolerable [and] one of our detachments broke

*down utterly from nervous tension and lack of rest.
I went in as one of the relief party to bring them out
and take their places. It was, of course, after night-
fall, and some of these poor lads were sobbing in
their broken sleep, like a crying child just before it
sinks to rest. It was really pathetic. The men
actually had to be supported to the ambulances
sent down to bring them away.*[54]

The sharpshooter's silent but lethal fire was
quite different from the great noise and smoke-
filled clashes that characterized most battles.
In his history of the Civil War soldier, Bell Wiley
describes the direct and brutal nature of these
armed encounters: "In the Civil War . . . fighting
was an intimate, elemental thing. . . . The enemy
could be seen with the naked eye . . . and contests
usually culminated in head-on clashes of yelling,
shooting [and] striking masses"[55] (*fig. 2*; Giese,
this volume, *fig. 6*). In contrast, Homer's sharp-
shooter is a remote and isolated figure who attacks
but never confronts his enemy.

This cool detachment from the inherent passion
and emotion of killing was an important trait of
the sharpshooter. In the midst of battle the sharp-
shooters always remained cool-headed as they
performed their jobs in a calm and methodical
way. Captain Stevens of Company G describes
this important characteristic, noting that
*with the utmost coolness the [sharpshooters] went
to work. . . . Their greatest care was given to the
proper loading of their pieces, to aiming, and in
firing; and though hurried shots were made, there
was no flurry or undue excitement. Rather, [there
was] a premeditated calculation in making every-
thing count in our favor. There was very little
talking . . . such was the spirit in which they
engaged in this fight.*[56]

Although the sharpshooters were "universally
appreciated" by both the public and the Union
military leaders, the infantry soldier developed a
very different attitude toward these renowned
marksmen.[57] For many foot soldiers, as reflected
in their journals and diaries, sharpshooting
was an unceremonious and vicious tactic that
amounted to nothing more than murder. From
their perspective, sharpshooting never affected
the outcome of a major battle but instead only

killed individual soldiers for no real gain. It
is clear from a historical perspective that the
sharpshooters made a number of important and
sometimes decisive contributions, such as at
Gettysburg, but it is also true that, when not
performing an important role, the sharpshooters
would often kill not for tactical advantage but
for the sake of killing:[58]
*Every day we shot at each other across the ravine
from morning to night. It was a lazy, monotonous,
sickening, murderous, unnatural, uncivilized mode
of being. . . . Some of the officers tried sharpshoot-
ing, but I could never bring myself to what seemed
like taking human life in pure gayety.*[59]

Even Captain Stevens, the chronicler of the
Berdan sharpshooters, acknowledged that they
had some "vicious fellows" in their midst.[60] As
early as Yorktown, some of Berdan's men had
acquired unenviable reputations:
*Here the Berdan sharpshooters began to show that
unerring aim that sent many a man to his long
account. One of these fellows, who was a dead-
shot, was also remarkable for his cruel disposition.
He carried a stick, and whenever he shot a man
he made a notch in it. He would sit for hours behind
a stump or clump of earth until he got sight of a
rebel's head, when bang went the rifle, and down
dropped the rebel, and out came the stick to receive
its notch.*[61]

Even brief descriptive passages about the
sharpshooters often revealed negative feelings.
For example, Private Bellard, describing his post
at Yorktown, equated the marksmen with hunters
stalking prey, "On each of our posts was stationed
one of Berdan's sharp shooters, who were always
on the look out for game, and woe to the rebel
who put himself in their way."[62] Other soldiers
made the analogy in stronger, more vivid terms.
*Sharpshooting, at best . . . is a fearful thing. The
regular sharpshooter often seemed to me little
better than a human tiger lying in wait for blood.
His rifle is frequently trained and made fast bearing
upon a particular spot, – for example, where the
head of a gunner must of necessity appear when
sighting his piece, – and the instant that object
appears and, as it were, "darkens the hole," crash
goes a bullet through his brain.*[63]

After serving several weeks at Yorktown, Homer undoubtedly would have been aware of these feelings. In fact, several years later in a letter to a friend Homer revealed that he indeed shared these negative feelings about sharpshooting: *I looked through one of their [Berdan sharpshooters'] rifles once when they were in a peach orchard in front of Yorktown in April 1862 – [As] I was not a soldier – but a camp follower & artist, the above impression struck me as being as near murder as anything I ever could think of in connection with the army & I always had a horror of that branch of the service.*[64]

In his wood engraving, Homer alludes to the special status of the sharpshooter and his lethal methods through the simple depiction of the soldier's canteen. For the sharpshooter, a canteen was a standard part of his gear, but for the infantry soldier, his canteen often posed a dilemma. Although it was a soldier's only source of refreshment, a filled canteen was too heavy on long marches, too noisy on covert assaults, and too unwieldy on the field of battle. As a result many soldiers discarded their canteens in favor of small bottles that provided little relief when needed most after a battle. The dust, the exertion, and the tension of battle created enormous thirsts that were often described by the infantry soldier. For instance, after the battle of Antietam, a young soldier wrote to his father, "I was so dry . . . I could have drank out of a mud puddle," while another soldier after Manassas wrote, "As we were retiring I stopped to take a mouthful of mud – scarcely could it be called water – my mouth was awfully hot and dry."[65] The problem of thirst was even greater for the wounded: "On going round on that battlefield with a candle searching for my friends I could hear on all sides the dreadful groans of the wounded and their heart-piercing cries for water and assistance."[66] A few years after the war a member of the Irish Brigade recalled his feelings as a wounded soldier: "Oh, what a boon is even a drink of water to the maimed soldier, lying on the battlefield, tortured with pain and thirst! How gladly would I . . . have drank the veriest sink that could flow."[67] Homer was certainly aware of these feelings, for in one of his later battle drawings he created a dramatic pictorial variation on this theme (*cat.no.18c*). When viewed in this context, the canteen in Homer's sharpshooter is transformed into a symbol of the sharpshooter's favored status, not unlike the "choice liquors and segars" described in the *Petersburg Express*.

There is also another disturbing dimension to the canteen, for according to Major Robert Stiles the canteen was a source of death as well as refreshment. On many occasions, sharpshooters would train their sights upon soldiers laden with canteens, making the dangerous journey to the spring. In his journal, Major Stiles writes that "the spring was perhaps the point of greatest power and pathos in all the weird drama of 'The Lines' . . . [where] a man's life [was] often exacted as the price of a cup of water from the spring."[68] Stiles then recounts the story of one of his fellow soldiers:

[We were talking of the good old times] when someone said, "Scott, isn't it your turn to go to the spring?" "Yes," said Scott submissively, "I believe it is. Pass up your canteens," and he loaded up and started out. There was a particularly exposed spot on the way to water, which we had tried in vain to protect more perfectly, and we heard, as usual, two or three rifle shots as Scott passed that point. In due time we heard them again as he returned, and one of the fellows said, "Ha! they are waking up old Scott, again, on the home stretch."

The smile had not died upon our faces when a head appeared above the traverse and a business-like voice called: "Hello, Company I; a man of yours dead out here!" We ran around the angle of the work, and there lay poor Scott, prone in the ditch and covered with canteens. We picked him up and bore him tenderly into the trench, and, as we laid him down and composed his limbs, . . . tears dropped upon his still face. Each man disengaged and took his own canteen from the . . . water-carrier.[69]

In Homer's print, the canteen is not only a mark of the sharpshooter's special status but also a visual metaphor for his skills and deadly tactics. The canteen's dark circle surrounded by a light concentric band suggests a target not unlike the

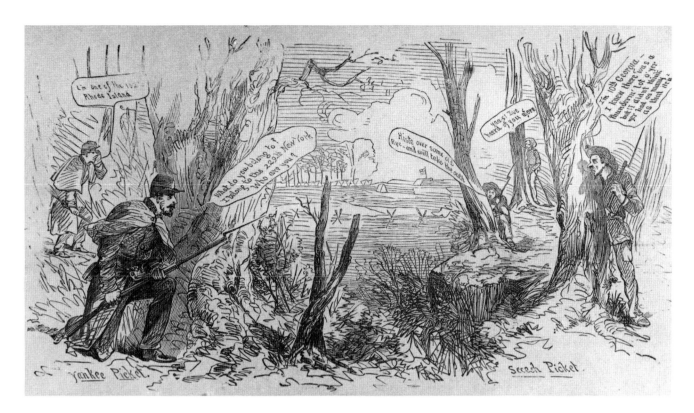

fig.8 Larkin Goldsmith Mead (1835-1910).
*Pickets Conversing before Yorktown – A Common
Scene.* Wood engraving, 4³⁄₄ × 9 in. *Harper's Weekly*
6, no. 281 (17 May 1862): 311. Collection of
Abernethy Rare Book Room, Starr Library,
Middlebury College, Vermont

target circle used to test the skills and qualifications of Berdan's marksmen. Ironically, the canteen also alludes in a subtle and cruel way to the enemy whose canteens are literally and figuratively among the sharpshooter's favorite targets.

Homer also conveys something of his attitude toward the sharpshooter through the title of his wood engraving, *The Army of the Potomac – A Sharp-Shooter on Picket Duty*. With his military knowledge acquired during spring 1862, Homer certainly would have known the contradictory nature of sharpshooting and picket duty. In contrast to the sharpshooter who often roamed freely "on the look out for game," the picket soldier performed a passive, defensive role within traditionally prescribed boundaries that rarely involved aggressive action. During the war on both sides, pickets ranging in number from a few

to several hundred were stationed in front of their encamped armies as lookouts. If attacked, the pickets returned fire that immediately warned their own camp of an enemy advance. By firing, the pickets would also slow the enemy charge, providing their own army with valuable time to prepare for battle.[70] In his history of the peninsular campaign, the prince de Joinville describes life along the picket line as "an uninterrupted line of sentinels supported by strong reserves, which never move far from the corps to which they belong." He further describes an incident where

two armies were now so near together, and so determined to cede no inch of ground that their pickets were stationed within hailing distance of one another. Generally, they got along very amicably together, and contented themselves with a

reciprocal watchfulness. Sometimes friendly communications took place between them – they trafficked in various trifles, and exchanged the Richmond newspapers for the New York Herald.[71]

As a staff officer, the prince de Joinville was not aware of how often opposing pickets gathered together to swap equipment and gear as well as food, tobacco, and stories. The journals of the infantry soldier are filled with stories of friendly meetings between enemy pickets (*fig.8*). For instance, a member of the Eighth New York Volunteers recalled, "The rebel pickets used to trade quite often with our boys, but we were obliged to be shy and not let our officers know it, for it was strictly against orders."[72] Fraternization with enemy pickets was prohibited because it could undermine a soldier's fighting spirit. *We generally end [these picket meetings with the enemy] by mutually wishing we had let those who made the quarrel be the very ones to fight. If the question was left to the two contending armies here, we would restore the Union tomorrow and hang both cabinets at our earliest convenience.*[73]

Although fighting certainly took place between the lines, the pickets often agreed not to fire upon each other unless ordered and, when possible, the fire would be directed at enemy officers. Private Bellard captured the spirit of these skirmishes when he wrote, "Picket skirmishing seemed to be indulged in more for amusement than anything else."[74]

In light of these differences between sharpshooting and picket duty, the title of Homer's print should be read with a degree of irony, for clearly Homer's sharpshooter is not on picket duty, at least not in the traditional sense. In spring 1862 the sharpshooter was operating under a new set of rules and standards that were redefining military strategy and ritual. Unlike picket duty, which engendered a degree of civility and understanding between enemy soldiers, sharpshooting reduced the enemy to a distant target and transformed the marksman into a cool and aloof figure who killed and terrorized without passion or warning. By denying others the opportunity to rise above the horrors of war through acts of courage and compassion, the sharpshooter

diminished his own humanity. For the infantry soldier the sharpshooter was little more than a murderer – a cold and passionless extension of his distant and deadly weapon.

Homer's visual interpretation of the sharpshooter is strikingly similar to Herman Melville's poetic response to the Union's new ironclad battleship the *Monitor*, launched in spring 1862. In his poem, "A Utilitarian View of the Monitor's Fight," Melville describes a new age of warfare stripped of banners and glory. In this new mechanized age human valor has been replaced by "plain mechanic power, plied cogently"; "warriors are now but operatives." In this world battles are won by the heat of machines rather than emotions.
Yet this was battle, and intense –
 Beyond the strife of fleets heroic;
Deadlier, closer, calm 'mid storm;

No passion; all went on by crank,
 Pivot, and screw,
 And calculations of caloric.[75]
This dichotomy between man and machine is at the heart of Homer's *Sharpshooter*, for this is a picture without banners and glory in which the warrior has indeed become the operative cogently plying his weapon beyond the strife of heroic battle.

By August 1862 the Union's peninsular campaign had failed and with it went a quick and glorious end to the war. The campaign produced neither victory nor defeat but only the realization for both sides that the war was just beginning. On 5 August a correspondent for the London *Times* wrote, "The first bloom of war excitement is over. . . . They were ready for a short, sharp and decisive conflict. They were not ready for an obstinate struggle to last for years."[76] By autumn President Lincoln had fired McClellan and called for three hundred thousand new soldiers to be enlisted for three years instead of ninety days.

When Homer's engraving appeared on 15 November many readers of *Harper's Weekly* interpreted the marksman as a symbol of Union pride and honor. For others, such as the infantry soldier and the artist, the sharpshooter marked a disturbing and deadly new direction in the war. Ironi-

cally, even as they were criticizing the cool indifference of the sharpshooter, the infantry soldiers were already beginning to develop this same trait, acquired not through training and discipline but through experience on the battlefield.

I saw the body [of a man killed the previous day] . . . and a horrible sight it was. Such sights do not affect me as they once did. I cannot describe the change nor do I know when it took place, yet I know that there is a change for I look upon the carcass of a man now with pretty much [the same] feeling as I would . . . were it a horse or hog.[77]

Another puzzled soldier described similar feelings and then posed a serious question:

I am astonished at my own indifference as I never pretended to be brave; it distresses me at times when I am cool and capable of reflection to think how indifferent we become in the hum of battle when our fellow men fall around us by scores. . . . My God what kind of a people will we be?[78]

In his picture of the sharpshooter Homer also poses the soldier's anguished question but in a more subtle, pictorial form. After the humiliations of Bull Run and the peninsular campaign, Homer's *Sharpshooter* stands as a beacon of pride and efficiency in the midst of a tarnished and shaken army. On a deeper level, however, it conveys a more disturbing message. With its ironic title, its emphasis on the poised moment of death, and its stark isolation of the soldier as operative, Homer's picture parallels the perceptive realization in Melville's poem that the tools of modern warfare create irreparable changes in the men who wield them. In autumn 1862 this deadly portrait foreshadows the advent of new military tactics and strategies that would be employed from the wheatfields of Gettysburg to the scorched plains of Georgia and that would forever alter and shape the kind of people we would be.

1. I want to thank Kirsten Powell, John McCardell, Marc Simpson, and Claire Wilson for their advice and encouragement on this essay. I also want to thank Fleur Laslocky, Martha Dier, and Joan Allen of the Inter-Library Loan Department at Middlebury College for their patience, efficiency, and good humor. My research for this project was funded in part by a grant from the Middlebury College Faculty Research Fund.

For historical accounts of the peninsular campaign, see Bruce Catton, *Terrible Swift Sword* (New York: Doubleday, 1963), 250-374, and Richard Wheeler, *Sword over Richmond* (New York: Harper & Row, 1986). For representative first-hand accounts of the campaign, see Henry N. Blake, *Three Years in the Army of the Potomac* (Boston: Lee and Shepard, 1865), 50-119; Captain D. P. Conyngham, *The Irish Brigade and Its Campaigns* (New York: William McSorley & Co., 1867), 93-285; Prince de Joinville, *The Army of the Potomac: Its Organization, Its Commander, and Its Campaign* (New York: Anson D. F. Randolph, 1862), 20-100; Robert Stiles, *Four Years under Marse Robert* (New York: The Neale Publishing Company, 1903), 73-117; J. H. Stine, *History of the Army of the Potomac* (Washington, D.C.: Gibson Brothers, 1893), 42-98; Regis de Trobriand, *Four Years with the Army of the Potomac* (Boston: Ticknor and Company, 1889), 152-307; Alexander S. Webb, *McClellan's Campaign of 1862* (New York: Scribner, 1881); and *Gone for a Soldier, The Civil War Memoirs of Private Alfred Bellard*, ed. David Herbert Donald (Boston: Little, Brown, 1975), 49-123.

2. A. M. Stewart, *Camp, March and Battle-Field; or Three Years and a-Half with the Army of the Potomac* (Philadelphia: Jas. B. Rodgers, 1865), ch. 4, "Friday Noon, March 28th, 1862," n.p.

3. George T. Stevens, *Three Years in the Sixth Corps* (Albany, N.Y.: S. R. Gray, 1866), 27-28.

4. Homer's pass from the provost marshall's office is now at the Bowdoin College Museum of Art. The pass is reproduced in Chronology, this volume.

5. *General McClellan's Sixth Pennsylvania Cavalry Regiment Ready to Embark at Alexandria*, 1862, pencil and gray wash, 8⅝ × 15⅞ inches, Cooper-Hewitt Museum of Decorative Arts and Design, New York City. Homer's drawing is reproduced in Julian Grossman, *Echo of a Distant Drum* (New York: Abrams, 1974), 58.

6. For Homer's letter describing his activities, see Chronology, this volume.

7. *The Collected Works of Abraham Lincoln*, ed. Roy P. Basler, 9 vols. (New Brunswick, N.J.: Rutgers University Press, 1953), 5: 184-185.

8. Lieutenant Colonel Francis Channing Barlow to Edward Barlow, letter, 18 April 1862, Massachusetts Historical Society, as cited by David Tatham, "Winslow Homer at the Front in 1862," *The American Art Journal* 11, no. 3 (July 1979): 87.

9. Homer and A. R. Waud are responsible for the 3 May engraving. Based on extant drawings, we know that Homer created the two top scenes and the illustration of the *Ocean Queen*. Given his ties to the Sixty-first Volunteers, it is likely that Homer also created this scene.

10. Lieutenant Colonel Francis Channing Barlow to Edward Barlow, letter, 23 April 1862, Massachusetts Historical Society, as cited and discussed by Tatham, 87.

11. Prince de Joinville, 47. For contemporary photographs of the Union fortifications, see *Gardner's Photographic Sketch Book of the Civil War* (1865-1866; New York: Dover, 1959), pls. 12-14 and accompanying texts.

12. For Henrietta Benson Homer's letter to her son, Arthur, see Chronology, this volume.

13. Philip Smith, diary, 22 October 1863, as cited by Bell Irvin Wiley, *The Life of Billy Yank* (New York: Bobbs-Merrill, 1951), 327. General Hooker was responsible for transforming the cavalry into an effective fighting force: "Our cavalry is something to talk about now. . . . Hooker is entitled to the credit of making the cavalry of use instead of ornament" (MS letters of John W. Chase, as cited by Bruce Catton, *This Hallowed Ground* [New York: Doubleday, 1955], 257; see also Grossman, 80).

14. *Medical and Surgical History of the War of the Rebellion* (Washington, D.C.: Surgeon General's Office, 1870-1888), Medical volume, part 1, appendix 31, as cited by Wiley, 143.

15. Mrs. E. N. Harris to Mrs. Joel Jones, 5 June 1862, in "Anecdotes of Our Wounded and Dying Soldiers in the Rebellion," MS, Historical Society of Pennsylvania, as cited by Wiley, 144.

16. Conyngham, 179-180.

17. Stevens, 46.

18. R. M. Shurtleff, "Shurtleff Recalls Homer," *American Art News* 9, no. 3 (29 October 1910): 4.

19. Shurtleff, 4.

20. For the exhibition records, see Lucretia Hoover Giese, *Winslow Homer: Painter of the Civil War*, Ph.D. diss., Harvard University, 1985, appendix 3, 354, and *cat. no. 1*, this volume.

21. Giese, 54-55, 279, note 3. See also William Howe Downes, *The Life and Work of Winslow Homer* (Boston: Houghton Mifflin, 1911), 46-47.

22. For a brief history of the founding of the Berdan sharpshooters, see Captain C. A. Stevens, *Berdan's United States Sharpshooters in the Army of the Potomac 1861-1865* (1892; Dayton, Oh.: Morningside Press, 1972), 1-6. Colonel Fox in his *Regimental Losses in the Civil War* summarized both the character and contributions of Berdan's men:
Berdan's United States Sharpshooters were the best known of any regiments in the army. It would have been difficult to have raised in any one state a regiment equal to Berdan's requirements. The class of men selected were also of a high grade in physical qualifications and intelligence. They were continually in demand as skirmishers on account of their wonderful proficiency. . . . In skirmishing they had no equal (William F. Fox, *Regimental Losses in the Civil War 1861-1865* [Albany, N.Y.: Albany Publishing Company, 1893], 419).

23. After visiting Union camps near Washington in July 1861, W. H. Russell wrote, "The number of accidents from the carelessness of the men is astonishing; in every day's paper there is an account of deaths and wounds caused by the discharge of firearms in the tents" (W. H. Russell, *My Diary North and South* [Boston, 1863], 396, as quoted by Wiley, 367, note 47). Concerning target practice, Bell Wiley writes, "One of the most grevious [*sic*] deficiencies of early training – and it persisted to an amazing extent throughout the war – was the lack of target practice. A few regiments did have systematic instruction in musketry . . . but references to marksmanship exercises are notable chiefly for their absence" (26-27).

24. Fritz Haskell, ed., "Diary of Col. William Camm," [Illinois State Historical Society] *Journal* 28 (1926): 813, as quoted by Wiley, 50-51. It should be noted that the Illinois soldiers were firing old smoothbore muskets, but for whatever reason, the early Union infantryman was not an accomplished marksman.

25. A Pennsylvanian described a botched execution of a deserter. After the first volley the condemned man was still seated on his coffin:
Another platoon of the firing squad was hurried up and when they fired the poor fellow fell; his elbow struck the rough box; he recovered himself and sat up for the second time. The third squad was ordered up; they fired and he fell into his box dead (M.S. Schroyer, "Company G History," *Snyder County Historical Society Bulletin* 2 [1939]: 97, as quoted by Wiley, 207. For additional examples of these executions, see Wiley, 207).
In contrast, the condemned man facing a Berdan firing squad was assured of a quick and certain death.
After a short prayer by the chaplain attending him, his eyes were bandaged by the provost marshall, when he seated himself on the edge of the coffin which was by the side of the grave. Soon after 12 muskets poured forth their contents . . . and he fell dead into his coffin pierced by 11 bullets, one gun containing a blank cartridge (Stevens, *Sharpshooters*, 363).

26. "Colonel Berdan and His Sharpshooters," *Harper's Weekly* 5, no. 243 (24 August 1861): 540.

27. "Colonel Berdan," 540, and Stevens, *Sharpshooters*, 6.

28. Stevens, *Sharpshooters*, 451.

29. "The New Hampshire Sharpshooters," *Harper's Weekly* 5, no. 249 (5 October 1861): 625, 636.

30. Stevens, *Sharpshooters*, 9-11.

31. Abraham Lincoln to Edwin M. Stanton, letter, 20 September 1862; see *Abraham Lincoln*, 5:431.

32. Stevens, *Sharpshooters*, 5. Even the southern sharpshooters on the peninsula were a cut above the regular soldier in both character and dress. Private Alfred Bellard of the Fifth New Jersey Infantry described a dead rebel marksman he encountered at Yorktown:
He seemed to be of a diferent [sic] type from the rest as he was a fine looking man and well uniformed. He had on a fine pair of boots, but they did not stay there long, as one of our men thinking that he had no further use for them helped himself (Gone for a Soldier, 94).

33. General Porter to Colonel Berdan, letter, 6 April 1862, as quoted in Stevens, *Sharpshooters*, 42. See also 74-75.

34. *Petersburg Express*, as quoted by Stevens, *Sharpshooters*, 61. See full references to this incident with *cat.no.1*.

35. Captain Stevens in his history of the Berdan sharpshooters recounts how a New Hampshire marksman single-handedly captured an enemy cannon: "So successfully did he plant his bullets around the big gun, that it was not long before the firing ceased, and he virtually had the cannon captured. It was to all intents and purposes his gun – they couldn't load it" (Stevens, *Sharpshooters*, 62-63). For a variation on this tactic, see Bruce Catton, *Civil War* (New York: American Heritage, 1960), 272. During the war many unsuspecting officers lost their lives to the sharpshooter's bullet. Perhaps the most famous example was the death of Major General John Sedgwick. Just after he informed his men that snipers "couldn't hit an elephant at this distance," he was felled by one of their bullets. See Catton, *Civil War*, 455. For the death of General John Reynolds by sharpshooters at Gettysburg, see Catton, *Civil War*, 328-329. For the sharpshooter's role in covering attacking and retreating troops, see Stevens, *Sharpshooters*, 208-209.

36. Sharpshooters on both sides devised a variety of hiding places ranging from conventional positions, such as behind stone walls and houses, to the more unusual ones, including the inside of old chimneys and trees. For a representative sampling, see *Gone for a Soldier*, 56-57, 60, 93-94, 116; Stevens, *Sharpshooters*, 55-56; and *Gardner's Sketch Book*, pls. 40-41 and opp. texts.

37. Blake, 59. For more on the nocturnal methods and tactics of the sharpshooters, see *Gardner's Sketch Book*, pl. 15 and opp. text.

38. Stevens, *Sharpshooters*, 63.

39. Stevens, *Sharpshooters*, 64.

40. Stiles, 76.

41. See *Gardner's Sketch Book*, pl. 40 and opp. text.

42. After the peninsular campaign it was generally recognized that sharpshooters were entitled to military justice; however, as late as 1863 at Gettysburg some Confederate sharpshooters still believed that they faced immediate execution if captured. See Stevens, *Sharpshooters*, 340.

43. Henry Blake of the Massachusetts Volunteers described one such assault on Confederate forces with the capture of two treed sharpshooters: "Every object that looked like a rebel received a bullet: the pickets, leaving their rations and blankets, hastily fled; and two sharpshooters, perched in the tops of trees, were captured before they could escape" (Blake, 101).

44. "Our Army Before Yorktown," *Harper's Weekly* 6, no. 280 (10 May 1862): 289, 299.

45. "California Joe," *Harper's Weekly* 6, no. 292 (2 August 1862): 492. For more on the popular sharpshooter, see Stevens, *Sharpshooters*, 49-51.

46. Homer paid tribute to the colonel again in February 1864 when he exhibited his oil painting at the Brooklyn Fair and changed the painting's title from *Sharpshooter* to *Berdan Sharpshooter*. The new title is significant, for in January 1864, after three years of distinguished service, Colonel Berdan resigned his military commission and returned to civilian life in New York. Therefore, in changing the title Homer was paying tribute to Berdan while also exploiting his current popular appeal.

47. Blake, 133-134. The prince de Joinville, a French officer on McClellan's staff, also noted these striking contrasts between man and nature.
The woods breathed all the freshness of a fair spring morning. All around us lay a smiling landscape, decked with splendid flowers . . . but all this only deepened the mournful contrast of the battlefield, strewn with the dead and dying, with wrecks and ruins (Prince de Joinville, 55; see also 49; and Grossman, 93).

48. Confederate Major Robert Stiles describes the dangers of working in unprotected or uncovered areas of camp. "Only in regular and elaborate lines of 'siege', such as we had later about Petersburg, is seen the perfect protection of regularly covered galleries and ways for passing from one part of the line to another. . . ." Stiles, 290.

49. *Gone for a Soldier*, 55.

50. Blake, 58. See also *Gone for a Soldier*, 140, and Theodore Gerrish and John S. Hutchinson, *The Blue and the Gray* (Bangor, Me., 1884), 220:
It was almost certain death to show one's head above the works, and yet a sort of dare-devil fellow, belonging to one of the guns, mounted the works, and catching his red cap from his head, swung it defiantly at the enemy. Just then a bullet struck him squarely in the forehead, and he toppled over.

51. A Confederate lieutenant as quoted by Stevens, *Sharpshooters*, 462-463. The Union sharpshooters were renowned for the distance and accuracy of their fire:
From the top of a large pine tree was seen a puff of smoke, and the sentinel fell dead. The distance was so great that no danger had been apprehended, nor could the report of the rifle be heard. When the Federal line had been driven back, the distance from where the sentinel fell, to the top of the

tree, was taken, and proved to be nineteen hundred and sixty yards; or one mile, two hundred yards (Gerrish and Hutchinson, 221. For other examples, see Stevens, *Sharpshooters*, 49, 368, 417, 463).
The sharpshooter's large, conical bullet was a particularly deadly missile which not only silenced its victims but terrorized those who witnessed its destruction:
A brave handsome boy of our Company D, gay and smiling with the excitement of fighting, distaining [sic] to cover himself, was reloading his rifle when a ball traversed his head, leaving two ghastly orifices through which the blood and brains exuded, mingling with his auburn curls. He uttered strong, loud gaspings; it seemed possible, listening to them, that he might yet live; but his eyes were fast closed and his ruddy cheek paling; in a few minutes he was dead (John William DeForest, *A Volunteer's Adventures, A Union Captain's Record of the Civil War* [New Haven: Yale University Press, 1946], 117).

52. Civil War diaries and journals are filled with astonishing examples of lethal marksmanship. Union Captain John DeForest recalls one such example:
Several of our men were shot in the face through the portholes as they were taking aim. One of these unfortunates, I remember, drew his rifle back, set the butt on the ground, leaned the muzzle against the parapet, turned around, and fell lifeless. He had fired at the moment he was hit, and two or three eye-witnesses asserted that his bullet shivered the edge of the opposite porthole, so that in all probability he and his antagonist died together. It must be understood that these openings were but just large enough to protrude the barrel of a musket and take sight along it (DeForest, 118-119).

53. DeForest, 119.

54. Stiles, 77.
The [problem] of trench duty does not consist in the overwhelming amount of danger at any particular moment, but in the fact that danger is perpetually present. The spring is always bent; the nerves never have a chance to recuperate; the elasticity of courage is slowly worn out (DeForest, 116).

55. Wiley, 66. For representative descriptions of battle, see Blake, 134, and Frank Wilkeson, *Recollections of a Private Soldier in the Army of the Potomac* (New York: G. P. Putnam's Sons, 1886), 60.

56. Stevens, *Sharpshooters*, 427-428. DeForest, 105. At Fredericksburg, a Union soldier noted these same qualities in Confederate sharpshooters, "while from [behind] the stone wall, the enemy's riflemen picked off the leading officers as coolly as if at a turkey-shoot" (Francis A. Walker, *History of the Second Army Corps in the Army of the Potomac* [New York: Scribner, 1886], 165).

57. "Universally appreciated" are President Lincoln's words describing Berdan's sharpshooters in a directive to Edwin M. Stanton. See note 31 above.

58. For the sharpshooters' decisive role at Gettysburg, see Stevens, *Sharpshooters*, 304-307.

59. DeForest, 144.

60. Stevens, *Sharpshooters*, 368.

61. Conyngham, 128.

62. *Gone for a Soldier*, 56.

63. Stiles, 290. Bruce Catton quotes a Union soldier who captured this anti-sharpshooting sentiment when he said, "[I] hated sharpshooters, both Confederate and Union. . . . I was always glad to see them killed" (Catton, *Civil War*, 468).

64. Winslow Homer to George G. Briggs, letter, 19 February 1896, Archives of American Art, Smithsonian Institution, Misc. Homer MSS. Lucretia Giese cites this letter as an example of Homer's aversion to war but does not relate it to Homer's picture of the sharpshooter. See Lucretia Hoover Giese, "Winslow Homer's Civil War Painting *The Initials*," *The American Art Journal* 18, no. 3 (1986): 19, note 35. Homer's sketch appears as *fig.1.2*.

65. William H. Brearley to his father, letter, 26 September 1862, Detroit Public Library, as quoted by Wiley, 77; and the New Orleans *Daily Crescent*, 8 August 1861, as quoted by Wiley, *The Life of Johnny Reb, The Common Soldier of the Confederacy* (Indianapolis: Bobbs-Merrill, 1943), 362, note 22.

66. A. N. Erskine to his wife, letter, 28 June 1862, as quoted by Wiley, *Johnny Reb*, 32.

67. Conyngham, 157.

68. Stiles, 290, 292.

69. Stiles, 292-293. For another example of canteens and sharpshooting, see 291-292.

70. Captain DeForest of the Twelfth Connecticut Volunteers describes in his journal (2 September 1862) the picket line warning system:
About nine o'clock scattering musket shots broke out on the picket line, running along the front from the river to the cypress swamp. Then, before I could buckle on sword and revolver, there was a yell from the sergeants of "Fall in!" followed by the long roll of all the regiments roaring suddenly through the damp night (DeForest, 40).

71. Prince de Joinville, 81. Most soldiers would agree with Private Bellard of the Fifth New Jersey Infantry that picket duty relieved the boredom and routine of camp life and "taking it altogether, [we had] a very good time [on picket duty]" (*Gone for a Soldier*, 42).

72. *Deeds of Daring or History of the Eighth New York Volunteer Cavalry*, ed. Henry Norton (Norwich, N.Y.: Chenango Telegraph Printing House, 1889), 52. For a less favorable view of picket duty, see Conyngham, 170-171. Although Conyngham criticized picket duty, he did qualify his views later by stating, "Things continued in this [stalemate] for some time, the *ennui* being enlivened by an occasional skirmish and . . . picket duty" (174).

73. Felix Brannigan to his sister, undated letter written shortly after Gettysburg. Quoted by Wiley, *Billy Yank*, 350-351.

74. *Gone for a Soldier*, 89. See also "The Pleasures of Picketing," *Frank Leslie's Illustrated Newspaper* 14, no. 344 (24 May 1862): 94.

75. Herman Melville, "A Utilitarian View of the Monitor's Fight," from *Battle-Pieces and Aspects of the War* (New York: Harper & Brothers, 1866), 61-62.

76. *Times* [London], 5 August 1862, as quoted by Catton, *Sword*, 383.

77. Henry Graves to his father, letter, 16 June 1862, typescript, Georgia Archives, as quoted by Wiley, *Johnny Reb*, 35. This detachment is evident even within the literary structure of the diaries. For example, after describing brutal scenes of suffering and death during summer 1862, a Union private calmly turns his attention to the picturesque scenery.
The ball struck him in the back and after penetrating his body staid [sic] there. He was alive when we arrived on the ground, groaning and begging us to shoot him and put him out of his misery. . . . After lingering in agony for some time, death put an end to his misery.

From our position on the hill we had a splendid view of the country (Gone for a Soldier, 115).

78. John T. Sibley to E. P. Ellis, letter, 10 March 1863, Louisiana State University, as quoted by Wiley, *Johnny Reb*, 35. For related examples see Wiley, *Billy Yank*, 71, 72, 79.

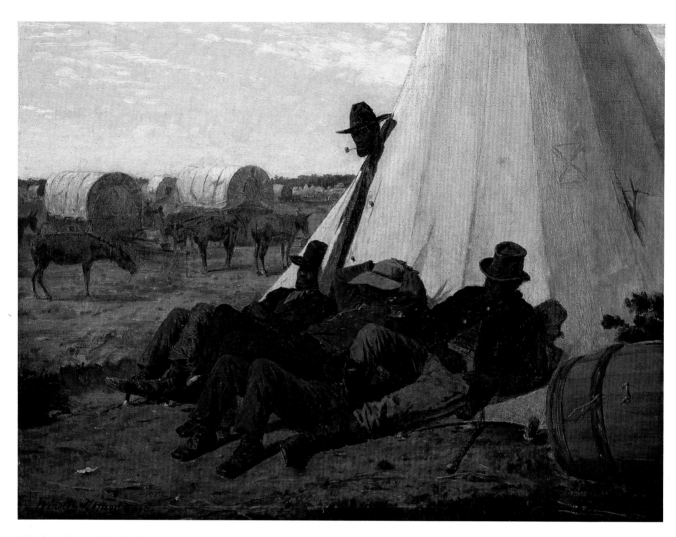

Winslow Homer. *The Bright Side*, 1865. Oil on
canvas, 13¼ × 17½ in. The Fine Arts Museums of
San Francisco. Gift of Mr. and Mrs. John D.
Rockefeller 3rd. 1979.7.56. *Cat.no.13*

The Bright Side:
"Humorously Conceived and Truthfully Executed"

Marc Simpson

The Bright Side (cat.no.13), Winslow Homer's painting of army teamsters lounging on the sunny side of their tent, was the first signal success in his career as a painter. Upon its exhibition it not only sold immediately but garnered for the young artist substantial critical acclaim, including the epithet, "the best chronicler of the war."[1] Because of a combination of factors, however, including its size, subject matter, and relative isolation in private collections for over a century after its creation, the painting has not received scholarly or popular attention comparable to that accorded its closest companions within Homer's oeuvre in quality and aspiration, *The Veteran in a New Field (cat.no.15)* and *Prisoners from the Front (cat.no.20)*.

Homer first showed *The Bright Side* in the Brooklyn Art Association's Spring Exhibition at the Academy of Music in March 1865 although it had been previewed in the New York press as early as the preceding January. He had begun developing the painting some time in 1864, leading up to the work with a more ambitious campaign of varied studies for the whole composition – including a fully worked graphite-and-wash drawing and an oil sketch *(cat.nos.13a,13b)* – than is now known for any other of his early paintings. Sold while at Brooklyn, it was one of three paintings that Homer showed in April at the National Academy of Design Fortieth Annual Exhibition, and was certainly the one of these that received the most favorable comments and far more attention in the press than any of the artist's works to that date. This favorable critical and popular response, and the quality of the work itself, was doubtless partially responsible for the vote of the

Academy on 10 May 1865 to advance Homer to full Academician status.[2] In 1866 Homer painted a near-replica of the painting *(cat.no.13f)*, probably commissioned by Lawson Valentine, his brother's business colleague.

In May 1867 *The Bright Side*, along with *Prisoners from the Front*, represented Homer at the Exposition Universelle in Paris. Perhaps, as a critic of 1866 had written, Homer agreed that "the two would make a comprehensive epitome of the leading facts of our war."[3] In December 1867 both were again exhibited at the National Academy, this time in that society's first annual winter exhibition. A decade later, when Homer exhibited five paintings in Paris at the Exposition Universelle of 1878, *The Bright Side* was again among the selections, along with four works from the 1870s.[4] The small scale of the painting must not, then, deceive one concerning either its ambition or its accomplishment.

Critics responding to *The Bright Side* in 1865, seeing it either in Homer's studio or on public exhibition, primarily identified two traits. Most important, they wrote of its truthfulness. In one way or another nearly every printed notice included acknowledgment of "the loyalty to nature and the faithful study that marks this little square of canvas."[5] But an effective counterpoint to this perception was the repeated mention of the painting's humor:
Good drawing and a broad sense of humour characterize this production.

There is in this work a dry, latent humor.

. . . nearly all his works contain a grotesque ele-

ment; witness particularly the comic old darkey with the pipe, poking his head through the tent-opening.[6]

Two years later, when the painting was noted by European writers in their criticism of the American paintings in the Exposition Universelle, a shift occurred. Both French and English writers praise the work for its truthfulness (as "firm, precise painting, in the manner of Gérôme, but with less dryness"; and, "the artist paints what he has seen and known"[7]). The European critics, however, do not even mention the notion of humor. Similarly, most modern commentators on the painting have not dwelt upon the work's humorous element.[8] This shift suggests that the critics in New York in the mid-1860s, and presumably the artist, perceived a distinct and impressive humor that translates neither geographically nor chronologically. Interpreting this perception presents an interesting problem. What did the critics of 1865 New York see that we do not and the European critics did not? How does our different point of view affect our response to *The Bright Side*?

Notions of humor are difficult to define — nothing kills a humorous story as effectively as earnest attempts to explain why, precisely, such-and-such a thing is funny. The key most frequently present in nearly all of the global theories regarding humor and laughter is the attribution of ignoble motives to the individual in quest of humor. Most philosophers seem to believe that we most often laugh at rather than laugh with someone.[9]

Professional humorists in nineteenth-century America appear to concur that humor possesses a bitter or acidic element:

Amerikans love caustic things; they would prefer turpentine to colone water, if they had to drink either. So with the relish of humor; they must hav it on the half-shell with cayenne. An Englishman wants his fun smothered deep in mint sauce, and he iz willing tew wait till next day before he tastes it. . . . I guess the English have more wit, and the Amerikans more humor. We havn't time yet to bile down our humor and get the wit out ov it. The English are better punsters, but i konsider punning a sort of literary sakriphise of spellink, about which i am pertickler.[10]

Josh Billings (a pseudonym of humorist Henry Wheeler Shaw, 1818-1885) might be pulling our collective leg when he protests against puns with their "sakriphise of spellink," but about the American preference for an aggressive humor over a playful wit this professional comic is perfectly sincere. As one contemporary noted,

the peculiarities of American humor, as distinguished from that of "the rest of mankind," lie in its extreme breadth and strength of absurdity, and its powerful presentation of ludicrous images to the mind's eye. . . . There is no attempt at subtlety, at playing upon words, or any other refinements of polished wit; but it is a plain, square exaggeration carried to the utmost confines, and generally calling up some irresistably laughable figure.

As may naturally be imagined, the gravest features of this quality of humor are coarseness and a tendency to make light of those sentiments which most people hold sacred.[11]

Where, then, is the humor so often noted in *The Bright Side* by Homer's New York critics? At whom were they laughing, and why?

Before exploring the answer to that question, it might be useful to consider the unfamiliar conjunction of Homer and humor. The paradigmatic Homer is, for most of us, an aloof, silent, all but misanthropic figure locked away in the stony fastness of Prout's Neck, Maine. The great, late paintings of the sea that rightly count among the most important and profound of American paintings, and the well-known icons of isolation and violence such as *The Fox Hunt* (1893, The Pennsylvania Academy of the Fine Arts) or *Right and Left* (*fig. 10.1*), confirm in their powerful and foreboding loneliness the recorded facts of the artist's reclusive retreat to the family compound there in 1883.[12] The artist's life and his works join to present a unified image of splendid solitude. And this is certainly as the artist wished it. In 1908 he wrote as much to the Boston critic William Howe Downes, who had proposed working on a biography of the artist:

It may seem ungrateful to you that after your twenty-five years of hard work in booming my pictures that I should not agree with you in regard to that proposed sketch of my life.

But I think it would probably kill me to have such a thing appear – and as the most interesting part of my life is of no concern to the public I must decline to give you any particulars in regard to it.[13] But the Homer of the 1860s and 1870s is a significantly different individual. By all reports he was affable, played an active role in several New York social and artistic organizations, and welcomed critics into his studio, where he would show his paintings and chat (he not only listened to but on occasion appears to have acted upon the critics' comments).[14] He talks and, most important, he laughs aloud for the world to hear. Thus one can find in the art columns of the time journalists' reports of what was underway during their latest visit to the studio, along with humorous stories about the progress on certain compositions.

Moreover, if for most of us Homer is preeminently a landscapist (a painter of scenes where man, if present at all, is an accessory to or a victim of nature's laws), when these journalists of the 1860s and 1870s categorize Homer, either in their chatty paragraphs of studio news or in specific exhibition reviews, it is as a genre painter (a portrayer of human incident in which man and his concerns are the center and the measure of all things) – a crucial distinction. And while different varieties of genre paintings exist – sentimental, nostalgic, moralizing, and comic among others – and while Homer tried several of these varieties, in his earliest works a still-recognizable comic mode dominates. The discomfiture portrayed in *In Front of the Guard-House* (cat.no.7), the shamming of *Playing Old Soldier* (cat.no.5), and the sly envy of *The Sutler's Tent* (cat.no.6), all convey a humorous delight at the expense of the men depicted. This seems especially clear when the paintings are seen in conjunction with the overtly satirical *Life in Camp* lithographs of 1864 that are related to them – *The Guard House, Surgeons Call,* and *Hard Tack* (cat.nos.7a,5a, and fig.1). One critic responded to *The Last Goose at Yorktown* (cat.no.3) with the exclamation "A neat bit of humor, Mr. Homer" – the same could be said for many works from the decade.[15] So pronounced was this tendency that in 1866 the critic of *The New-York Daily Tribune*, reviewing *Pris-*

fig.1 Winslow Homer. *Hard Tack*, 1864. Lithograph from *Life in Camp* (part 1), 4⅛ × 2½ in. The Metropolitan Museum of Art, New York

oners from the Front, wrote of the artist that "we were not quite prepared for so clever a study of character. We had feared, indeed, that he might degenerate into a mere caricaturist."[16]

Homer did not lose his sense of humor in later life, but it became considerably more private. Certain books of his library, apparently those he kept with him for their personal significance, included such comic masterpieces as Washington Irving's *The Sketch Book of Geoffrey Crayon, Gent*, Richard Sheridan's *The School for Scandal*, Laurence Sterne's *Works*, James Russell Lowell's *The Courtship* (with Homer's illustrations), as well as novels by George du Maurier and William Thackeray, and the second *Album Caran d'Ache*.[17] We can see humor peeking out in some of the caricatures of his family, such as *Little Charlie's Innocent Amusements* (ca. 1885, private collection), *Little Arthur – In fear of Harming a Worm* (ca. 1885, Lois Homer Graham), and a series based on Homer's father dating from 1897 and 1898, especially ones involving the family's black servant Lewis Wright: *Lewis, put your finger wet with cold water in the small of my back – That will complete my "full bath."* and *Lewis, plant those*

fig. 2 Winslow Homer. *Lewis, plant those English split peas in hills*. Ink on paper, 9 × 5¾ in. Bowdoin College Museum of Art, Brunswick, Maine. Gift of the Homer Family

English split peas in hills (*fig. 2*)[18]. The jokes are private ones for family members and we are not privileged to understand fully the humor of the punch lines. But the mode of the drawing makes it clear that, for those in the know, this was a form of appreciated family satire.

Eventually the humor "biles down" to wit (as Billings would have it), and Homer shares with his dealers the acid of his dry, acerbic self. Marginalia of *W. H. "hiding his light under a bushel"* after he has proclaimed *The Fox Hunt* to be a *"very beautiful* picture" (*fig. 3*) and other signs of an endearing self-awareness alternate with a withering irony, as in his comments on *Hound and Hunter* (1892, National Gallery of Art, Washington, D.C.):

The critics may think that that Deer is alive but he is not – otherwise the boat & man would by knocked high & dry. I can shut the deers [sic] eyes, & put pennies on them, if that will make it better understood.[19]

As Downes noted in the biography that he did eventually write, in spite of the artist's reticence:

To his other personal characteristics Homer added a very marked sense of humor. He had a quaint, solemn way of saying the most whimsical and delightful things, and he could utter stinging sarcasms without a smile. . . .

. . . The one thing that saved him from becoming downright misanthropic at times was the Yankee

fig. 3 Winslow Homer. *W.H. "hiding his light under a bushel,"* 17 March 1893. Ink on paper, 2 × 4 in. From *Art in America* 24, no. 4 (April 1936): 85. Photograph courtesy of the New York Public Library

sense of humor which enabled him to see the comical side of humanity's unbounded capacity for rambling and earnest vapidity.[20]

So Homer and humor are bound by more than an approximate homophony. For all of his isolation and grappling with the elemental forces of man and nature, Homer maintained a wry, satiric perspective on the world and his art. With that understood, we can return to the question of *The Bright Side*: where in that painting does the humor reside that was perceived by nineteenth-century New York critics, if not by their European colleagues?

The critic of *Watson's Weekly Art Journal* catalogued what, for him at least, created the humor of *The Bright Side*: "The lazy sunlight, the lazy, nodding donkeys, the lazy, lolling negroes, make a humorously conceived and truthfully executed picture."[21] Let us look at these elements in order. The "lazy sunlight" is clearly rhetorical, referring favorably to Homer's evocation of the pleasant well-being that often accompanies a sunny day. Later in the review the critic pronounced the painting's "sense of free open-air ness" to be "one of its greatest charms."

The "lazy, nodding donkeys," however, are another matter entirely. In the first place, the animals depicted in *The Bright Side* are mules (sterile hybrids of male asses and female horses), which Homer seems to have captured in an atypical moment of laziness.

When off duty in camp, they [the mules] were usually hitched to the pole of their wagon, three on either side, and here, between meals, they were often as antic as kittens or puppies at play, leaping from one side of the pole to the other, lying down, tumbling over, and biting each other, until perhaps all six would be an apparently confused heap of mule.[22]

The mule provided the locomotion for most of the army's supplies; quartermasters requisitioned nearly a half-million of them over the four years of the struggle. Unlike horses they were "better able to stand hard usage, bad feed, or no feed, and neglect generally," all of which they found in abundance.[23] They were most often hitched together into six-mule teams, forming with their wagons miles-long caravans that lumbered behind the troops.[24] Knowing the intimate connection between an army's fighting ability and its line of supplies, some writers attributed to the mule a crucial role in the war effort:

He bore hard usage and the scoffs and sneers at "thet ar meul" with uncomplaining heroism and was found dead on all the battlefields of the war. He was of inestimable value to the army, and it is doubtful if its varied operations could have been conducted without him.

Is it too much to say that to him, above some other claimants, should be given the credit of having saved the Union?[25]

During Homer's trips to the army camps, he must have been often among the army teamsters, for among his pencil sketches are many of mules and wagons (see, for example, *cat.nos.8a,13c,13d,13g,* and *fig.13.1*).

Perhaps the artist realized the hero's honor that would eventually come to the mules that "saved the Union." But Homer saw more than the utility of the beast. He was also apparently familiar with its rampaging character. In *An Unwelcome Visit*, a lithograph from his *Life in Camp* series of 1864, Homer shows a slyly smiling mule getting the better of a just-awakened Zouave (*fig.4*). We cannot tell what mischief the mule is up to—eating blankets, stomping about, or merely braying—but it is clearly a dismaying prospect for the men involved, and meant to be amusing for those of us looking on.[26] It was, however, the temper of the mule, its cussed-individual-orneriness ("half horse, half devil, half donkey. . . . [with] an inherited capacity to stand indefinitely on one foot and kick vehemently with all the others"),[27] that moved most Civil War memorialists to flights of hyperbole:

Josh Billings says somewhere that if he had a mule who would neither kick nor bite he would watch him dreadful "cluss" till he found out where his malice did lay. . . .

. . . I recently conversed with an old soldier who remembered having once seen, on the march, the four hoofs of a mule—those and nothing more; and the conclusion that he arrived at was that the mule, in a fit of temper, had kicked off his heels and gone up.[28]

fig.4 Winslow Homer. *An Unwelcome Visit*, 1864. Lithograph from *Life in Camp* (part 1), 4⅛ × 2½ in. The Metropolitan Museum of Art, New York

Homer's mules may appear placid by comparison to these many narratives, but both he and his audience must have known the animals' reputation for "malice" and felt the humorous potential even in the most pastoral of his camp scenes.

If beasts of this temper (even allowing for some exaggeration) were to be of use to the Union army, they had to be driven by men of singular strength and temperament. Army teamsters (a.k.a. mule-drivers or M.D.s) were apparently more than a match for most mules. Many of their number were black contrabands who were recruited into the quartermasters' service in order to allow enlisted men to rejoin their regiments in active service (*fig.5*).[29]

As the well-stocked Union wagon trains were attractive targets for Confederate raiders, the

work was dangerous, particularly for contrabands who, if captured, would be sent back to slavery or massacred:

It is reported from the battle-field near Murfrees-boro' that "all contrabands captured by the rebels on Union wagon trains are immediately shot. Twenty, thus killed, are lying on the Murfreesboro' pike."[30]

But for many the anecdotal character of the muleteer grew to match that of the beasts he had in his charge:

The mule driver of the army abolishes the step between the sublime and the ridiculous by making the ridiculous sublime. . . . There is a majestic repose in his features, and a placid confidence in his own powers . . . which stamps him the master of the situation. In that moment, grim and dingy though he be, the M.D. is sublime; he rises to the classic grandeur of the calm heroic. . . .

. . . The hero becomes a fury. His placid eye flashes with a fierce and wrathful fire. From the statuesque calm of his severe but dirty visage bursts a terrific storm of stunning curses.[31]

The ironic overstatement is thick and pungent, and the intent is clear. The muleteer may be necessary for the army, may be by his position both at risk and dangerous, but when he moves from the real world to the world of narration or art, he becomes a comic figure. In many cases, physical violence, given and received, becomes an element of his legend, and he (no less than the mule) is transformed into the subject of a prose slapstick (*fig.6*).

A veteran relates how, after the battle of Antietam, he saw a colored mule-driver approach his mules that were standing unhitched from the wagons, when, presto! one of them knocked him to the ground in a twinkling with one of those unexpected, instantaeous kicks, for which the mule is peerless. Slowly picking himself up, the negro walked delib-erately to his wagon, took out a long stake the size of his arm, returned with the same moderate pace to his muleship, dealt him a stunning blow to the head with the stake, which felled him to the ground. The stake was returned with the same quiet deter-mination. The mule lay quiet for a moment, then arose, shook his head, a truce declared, and driver

fig.5 Unidentified photographer. *A Group of Contrabands*, ca. 1865. Stereograph, mounted on card. International Museum of Photography at George Eastman House, Rochester, New York

fig.6 John R. Chapin (1823-1904). *The Army Mule*, reproduced from Warren Lee Goss, *Recollections of a Private: A Story of the Army of the Potomac* (New York: Thomas Y. Crowell, 1890), 167. Collection of the Library, University of California at Berkeley

and mule were at peace and understood each other.[32]

Homer's location of his wartime scene in a teamsters' camp, on a bright and sunny day, with many mules about, naturally predisposed his New York viewers to a humorous response.

But for a significant portion of Homer's audience, the humor of *The Bright Side* was more basic than mere setting or occupational circumstance. The principal figures in Homer's comedy are five black men. For many Americans of the 1860s, the mere presence of blacks in a work of art would prompt the thought that it was "humorously conceived":

Of all the ethnic groups in American culture, only the Afro-American was intimately linked to the broad field of humor. Not only were Afro-Americans perceived as the purveyors of laughter but they also served as the butt of comedy. Concomitantly they were initiator and receiver of humor. Other ethnics have found themselves in similar circumstances, but only for relatively short historical durations. The Irish were roundly regarded as a laughable people and as excellent stage performers;

and the Poles have been recipients of countless "stupid" jokes. But the Afro-American has had the unique distinction among American minorities of being on both ends of the humor continuum for over three centuries.[33]

From Uncle Tom and Little Topsy to "Amos 'n Andy," comic black stereotypes intimately entwined with humor have populated American culture. In spite of the Emancipation Proclamation (and the adoption of abolitionism as an official justification for the war), during the years of the Civil War black stereotypes, dialect, and falsely attributed physiological peculiarites[34] continued to be the subject of jokes and caricatures. "The convention was that a negro, as such, was funny."[35]

Evidence of this attitude abounds. Vicious cartoons, such as "Dark Artillery; or, How to Make the Contrabands Useful," which shows grinning blacks being used as artillery limbers, filled New York's illustrated periodicals during the early 1860s.[36] Perhaps this can be most clearly demonstrated by observing the transformation that the characters in John Tenniel's *One Good Turn Deserves Another* (*fig.7*) undergo when they move from London's *Punch* to New York's *Harper's Weekly*. Tenniel's work, which was published 9 August 1862, shows a sly and wily Abe Lincoln attempting to induce a nobly delineated free black to bear arms for the Union cause. Both figures are coarsened when they reappear in the 18 October 1862 issue of *Harper's Weekly* in *Who Are the Nigger Worshipers?* (*fig.8*). The white man sheds his "Uncle Sam" garb and becomes a Rebel Planter eager to risk his son at the front in order to spare his expensive slave. The white man's affiliation switches from Union to Rebel, but his role as a wrong-headed trickster remains constant in both cartoons. The black man, however — stripped of his clothing, his exaggerated features making a mockery of the human pride portrayed by Tenniel — in the hands of the *Harper's Weekly* draftsman becomes but a prop to level ridicule at the Rebel Planter. Instead of being the moral center of the image, he prompts laughter or ridicule. As late as 1880 one critic found

the magazines of the United States overrun with

pitiable caricatures of negroes, which do not contain the most evident characteristics of the race. . . . Almost as poor as the negro of the draughtsmen for the monthlies are the usual attempts at painting the much abused darky in oils.[37]

Writers in the popular press during these years often wrote of blacks as necessarily humorous. In a news article in *The New-York Times* on the Army of the Potomac, the correspondent observed:

But it is their domestic scenes (so to speak) that makes the colored soldiers objects of more especial interest. Whether drilling, digging, or enjoying themselves, they are always comical. Even when most seriously inclined the negro is amusing. . . .[38]

Many of Homer's earliest depictions of blacks seem to subscribe to the view of black as entertainer. Thus while the dancing black man at the center of the wood engraving *A Bivouac Fire on the Potomac* (*fig.2.4*) leaps about the campfire, a clownish, caricatured black plays the accompanying fiddle.[39] Another dancing figure appears, his humor more broadly and blatantly sketched, in *Our Jolly Cook* of 1863, one of the *Campaign Sketches* lithographs (*fig.8.2*). The banjo-playing slave portrayed in *Inviting a Shot before Petersburg, Virginia* (*cat.no.10*) is another in this series of almost cartoonlike depictions.[40]

In *The Bright Side* Homer draws not upon the musical abilities but upon the laziness stereotypically ascribed to blacks ("the lazy, lolling negroes" according to *Watson's*). A passage from *The New-York Times* article on the Army of the Potomac could almost serve as a text for the painting:

The darkies love the fire and its cheerful heat, and no matter how mild the day, heaps of smouldering logs can be seen throughout the camps. Round these can be seen at all times a lazy group, cosily toasting their shins, and placidly dozing or smoking, as their tastes suggest.[41]

This is simply a specific characterization that, under the guise of factual reporting, *Harper's Weekly* had earlier ascribed to the black race in general:

Travelers describe the natives of Congo as being small of stature, cheerful, good-humored, unreflecting, and possessed of little energy either of mind or body. Negro indolence is carried with them to the utmost excess.[42]

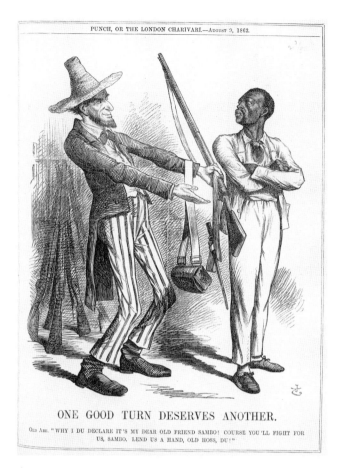

ONE GOOD TURN DESERVES ANOTHER.

OLD ABE. "WHY I DU DECLARE IT'S MY DEAR OLD FRIEND SAMBO! COURSE YOU'LL FIGHT FOR US, SAMBO. LEND US A HAND, OLD HOSS, DU!"

fig.7 Sir John Tenniel (1820-1904). *One Good Turn Deserves Another.* Wood engraving, 9³⁄₄ × 7 in. *Punch, or the London Charivari* 43, no. 1100 (9 August 1862): 55. Collection of the Library of Congress

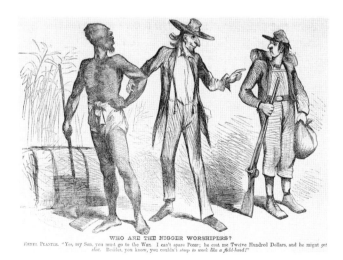

WHO ARE THE NIGGER WORSHIPERS?

REBEL PLANTER. "Yes, my Son, you must go to the War. I can't spare Pomp; he cost me Twelve Hundred Dollars, and he might *get shot.* Besides, you know, you couldn't *stoop to work like a field-hand!"*

fig.8 Unidentified artist. *Who Are the Nigger Worshipers?* Wood engraving, 5¹⁄₈ × 7 in. *Harper's Weekly* 6, no. 304 (18 October 1862): 672. Collection of the Stanford University Library

A comic illustrated paper such as *Vanity Fair*, relying on an audience sympathetic with this stereotype of black laziness, could use that stereotype for pointed attacks on serious journals (*fig.9*):

OUR LATEST SCARE

We find in the Tribune *the following dreadful statement, one which has curdled a good deal of our blood, and made most of our hair stand on end:*

"Very much has been said by the press and the public in reference to the assertion . . . that there exists among the Southern blacks a secret and wide-spread organization which has able leaders, and whose ultimate object is FREE-DOM. . . ."

Determined to learn for ourselves the particulars of this mysterious organization of Black Vehmge-richt, *we visited the Southern negroes personally, and found that their "able leaders" were mostly editorial ones from the* Tribune. *The mysterious society, however, was engaged, when we called, in* HOLDING A MEETING.

The drawing of the meeting in progress shows three blacks recumbent, apparently asleep. These "budding TOUSSAINTS" obviously pose no threat to anyone, and, Q.E.D. (according to the editor of *Vanity Fair*), the "latest scare" is a sham.[43]

In his choice of subject of the four dozing muleteers, Homer apparently sought to elicit a communal chuckle from his audience comparable to that provoked by *Vanity Fair*. For as a fellow artist/correspondent from *Harper's* had earlier asserted when drawing and writing about black muleteers:

No band of nigger minstrels could hope to equal in comic effect a party of these fellows, with their wonderfully held together rags, their comic heads of wool, often encased in a turban, their black-snakes (technical for whips), and great variety of expression.[44]

Certainly Homer's New York critics accorded him a complicitous smile of appreciation, perceiving in the painting both humor (as noted above) and truth:

[The muleteers'] faces are strikingly varied in character and expression, but they are evidently

*choke-full of those two blessings – inseparable from
the darkey idea of what we call freedom – warmth
and idleness. . . .*

*. . . It is simply a strikingly truthful delineation
of Ethiopean comfort of the most characteristic,
and therefore the most purely physical sort.*

*It expresses, however, an accurate knowledge of
African habits and peculiarities.*[45]

But if a seemingly racist humor can be found in
Homer's painting of the teamsters, complicating
elements are also there that require more than a
chuckle in response. One of these elements is the
ambiguity of Homer's characterizations of the
muleteers, who are not caricatures or types but
appear to be based on closely observed
individuals.

Perhaps the most important complicating
factor, however, is contributed by the head of the
teamster poking through the tent's door. This is
the dominant figure in the small work, despite
most of his form being hidden (parallel, in a way,
to the figure of the mule in *An Unwelcome Visit*
[*fig.4*]).[46] The strong diagonal of the side of
the Sibley tent and the dark strip of its opening

lead directly up to his head. Pipe and broad-
brimmed hat contribute to the crisp outlines that
set him off from the light sky, reinforcing his
prominence.

But Homer augments these formal devices by
having the man simply stare out at us from
beneath the shadow of his hat, and it is that stare –
level, appraising – that fixes attention. Unlike the
prominent foreground figures in Renaissance
works who catch the viewer's attention with their
glance and then aim that attention in toward
the central event of the painting, Homer's mule-
teer is the defiantly aware center of the canvas.
He challenges the viewer to respond, but provides
no clues as to what the nature of that response
should be. Several critics wrote specifically of the
figure:

*. . . through the opening another shows a grinning
countenance.*

*. . . nearly all his works contain a grotesque ele-
ment; witness particularly the comic old darkey
with the pipe, poking his head through the tent
opening. . . .*

*. . . another teamster's black head, broad hat, and
pipe are thrust out from between the tent folds. . . .*[47]
Although the critics reported him as "grinning"
or "comic," he in fact stares very coolly out of the
painting. As all of us tend to do, the critics saw
what they expected to find.[48]

Homer reportedly asserted that the presence of
that basilisk-stare in the work was an accident:
*Yes he said laughing I painted them from life just as
you see them and the funny part of it is just as I
had finished that darky poked his head out of the
tent door and looked at me and I painted him just
as he was –*[49]
When Homer did, in 1866, "copy" the painting
for reproduction as a wood engraving in *Our
Young Folks* (*cat.no.13e*), he omitted the man
entirely, including only the four recumbent team-
sters. The magazine's commentator wrote of the
scene:
*Contrabands, loving the sunshine as bees love
honey, have stretched themselves out on the warm
side of a tent, and, with their ragged hats slouched*

over their brows, are taking "solid comfort." Something to eat, nothing to do, and plenty of sunshine constitute a Contraband's Paradise.[50]
The engraving truly does show only "lolling negroes." Here, rather than with the painting, Homer depicts the stereotype that *The Bright Side* so significantly challenges.

The Bright Side contains not only humor (simple and complex), but also (*pace* Josh Billings) wit. This is the result of the painting's title. As a phrase, "The Bright Side" unlocks several complementary but distinct interpretations of Homer's painting (unlike the title *Near Andersonville, cat.no.19,* which locates and adds poignance to the image, but does little more than intensify its obvious meaning). Functioning on a strictly literal level (the men sit on the bright or sunny side of their tent),[51] the painting also holds out the possibility of metaphoric interpretation. Savoring their moments of peace and ease, have the muleteers drawn the bright side of Army duty (remembering that Gettysburg, Petersburg, Cold Harbor, and other sapping battles are only recently concluded or are still going on)? Or, as part of the Northern effort, are they placed on the bright (or right) side? Is the title an oxymoron that refers to the darkness of the men's skin?[52]

One of the most poignant and telling juxtapositions concerning blacks in 1860s America appears in the *Harper's Weekly* of 17 January 1863. On page 34 the magazine reproduces the text of the Emancipation Proclamation, with President Lincoln's carefully worded, official prose giving form to his dramatic pronouncement:

That on the first day of January, in the year of our Lord one thousand eight hundred and sixty-three, all persons held as slaves within any states or designated part of a state, the people whereof shall then be in rebellion against the United States, shall be then, thenceforward, and forever free. . . .

And upon this act, sincerely believed to be an act of justice, warranted by the Constitution upon military necessity, I invoke the considerate judgment of mankind, and the gracious favor of Almighty God.

Directly above Lincoln's text is the editor's discussion of the three wood engravings included in

that week's issue (all, including Homer's *Shell in the Rebel Trenches,* dealing with the subject of the war). One of these, *The Teamsters' Duel* (*fig.10*),

from a sketch by Mr. Waud, on page 33, is one of the humorous scenes in which our camps abound. When a quarrel arises between two colored teamsters a challenge passes, and the combatants lash each other with their long whips until one of them confesses that he can endure no more, and "throws up the sponge." The other is pronounced the victor, and very frequently admonishes his vanquished foe of the necessity of better behavior in future, amidst the roars and laughter of the white spectators.

The idea of black men lashing the flesh from one another to the amusement of onlooking whites is terrifying. That the bizarre juxtaposition of the two texts – the Emancipation Proclamation and *The Teamsters' Duel* – could occur without editorial comment, signals the complicated and vexed melange of attitudes toward blacks prevailing at *Harper's* and, by extension, with many citizens of the North.[53]

Homer, as a man of his time, shares elements of each side of this coupling of ennoblement and debasement. But perhaps in part because he was an artist of the particular concerned with the truth of individual situations, from his earliest paintings of blacks he looked hard at specific people rather than depicted stock characters. Four teamsters might doze on the bright side of a tent, but each of them is individualized and a fifth, alert and critical, watches us. It is in part this balance between generality and specificity in *The Bright Side*, this tension that results from Homer's portrayal of expected and stereotypical behavior in contrast to his detailing of each teamsters' handsome individuality, that energizes the painting and sparks its continuing fascination and greatness.[54]

Homer tempered the culture's simplifications with his real observations. That is why, when the painting was seen in Europe, within a social context that did not share New York's views of blacks, *The Bright Side* could be viewed and appreciated as truthful painting. That is why, as

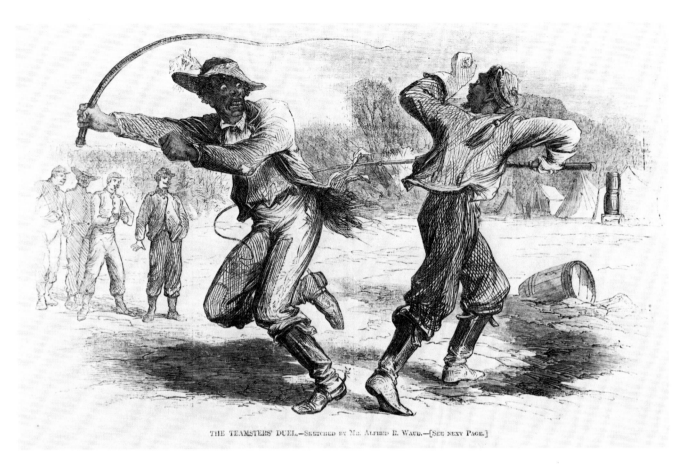

THE TEAMSTERS' DUEL.—Sketched by Mr. Alfred R. Waud.—[See Next Page.]

fig.10 Alfred R. Waud (1828-1891). *The Teamsters'
Duel*. Wood engraving, 6 × 9 ⅛ in. *Harper's Weekly*
7, no. 316 (17 January 1863): 33. Collection of
the Stanford University Library

our own society and its views of the races changed
over the decades, the perceived humor has
drained from the work and has been replenished
by admiration for its powers of observation and
formal strengths. That, finally, is why, when
Homer repeatedly turned to black subjects over
the next thirteen years, he was able to build from
serious works like *Near Andersonville (cat.no.19)*
to create paintings such as *The Cotton Pickers*
(1876, Los Angeles County Museum of Art) and
Dressing for the Carnival (1877, The Metropolitan
Museum of Art, New York) that are among the
noblest and most monumental images of blacks in
American art.[55]

1. "National Academy of Design," *The New-York Daily Tribune*, 3 July 1865.

2. Homer, along with Elihu Vedder and Seymour Guy, was elected Academician on 10 May 1865. The certificate validating the election to the National Academy (Chronology, *fig. 5*) was signed and dated on 9 May 1866, two days after the Council meeting at which Homer's diploma painting (*Croquet Player*, 1865, National Academy of Design, New York) was presented and accepted. Abigail Booth Gerdts to author, letter, 28 January 1988.

3. "National Academy of Design. Forty-first Annual Exhibition. First Article," *The Evening Post*, 28 April 1866. Lucretia Giese has correctly written: " 'The leading facts' of the Civil War — slavery and the attendant problem of racism, and a fratricidal war — do seem encapsulated in Homer's *The Bright Side* and *Prisoners from the Front*" (*Winslow Homer, Painter of the Civil War*, Ann Arbor: University Microfilms, 1985, 116).

4. The other paintings were *The Country School* (1871, The St. Louis Art Museum), *Snap the Whip* (1872, Butler Institute of American Art, Youngstown, Ohio), *A Visit from the Old Mistress* (1876, National Museum of American Art, Washington, D.C.), and *Sunday Morning in Virginia* (1877, Cincinnati Art Museum). Amid generally favorable reviews, some sour notes appeared:
Another of those "buds of promise" (occupying "line"), fallen like autumn leaves with the first frost, is Winslow Homer. What excuse can the painter offer for sending, and our "judge and jury" for accepting, under the head of Fine Arts, such nondescripts as those which bear Mr. Homer's name? He seems to have painted from his models (Outremer [pseud.], "Art Talks from Abroad," *The Aldine* 9, no. 6 [1878]: 198).

5. "National Academy of Design," *The New-York Daily Tribune*, 3 July 1865. This has become the dominant note of all Homer criticism. John W. Beatty wrote nearly fifty years later, "The basis of his art, I think, was simple truth" ("Introductory Note," in William Howe Downes, *The Life and Works of Winslow Homer* [Boston: Houghton Mifflin, 1911], xxv).

6. "Fine Arts. The National Academy of Design. Third Notice," *The Albion* 43, no. 21 (27 May 1865): 249. "National Academy of Design. Fortieth Annual Exhibition. Concluding Article," *The Evening Post*, 31 May 1865. George Arnold, "Art Matters," *The New York Leader* 11, no. 22 (3 June 1865): 1.

7. Paul Mantz, "Les Beaux-Arts à l'Exposition Universelle," *Gazette des Beaux-Arts* 23 (1867):230; author's translation. "Paris International Exhibition. No. VI — National Schools of Painting," *The Art-Journal* [London] 19 (1867): 248.

8. One exception is H. B. W. [Henry B. Wehle] who described the painting in 1923 in terms laden with racial stereotypes:
Four negro army teamsters are resting in the sun, lying against a tent in the incomparably lazy attitudes that southern darkies naturally assume. The head of a fifth negro pokes out from the tent opening, somehow foreshadowing the "hairy scary" commisariat camel of Kipling's verse. Further off are mules at their noon rest. The composition is piquant and the rendering of light finer probably than in any other of his early paintings ("Early Paintings by Homer," *Bulletin of The Metropolitan Museum of Art* 18, no. 2 [February 1923]: 40).

The ever-perceptive Lloyd Goodrich is another exception, writing of the Civil War works, "Humor was always present, though less obvious than in his illustrations," and, of *The Bright Side* and "*Army Boots*" in particular, he noted that "[Homer's] attitude reflected some of the typical Northern idea that the negro was primarily a humorous object" (*Winslow Homer* [New York: published for the Whitney Museum of American Art by Macmillan, 1944], 19-20).

9. Useful surveys of philosophical explorations of humor include both *The Philosophy of Laughter and Humor*, ed. John Morreall (Albany: State University of New York Press, 1987), which reprints key portions of classic texts from Plato to Bergson (11-126); and Anthony J. Chapman and Noel P. Sheehy, "Humour," *The Oxford Companion to the Mind*, ed. Richard L. Gregory (Oxford: Oxford University Press, 1987).

10. Quoted in Nick Beilenson, ed., *Wit and Wisdom of the Civil War* (White Plains, N.Y.: Peter Pauper Press, 1987), 7. The British critic and essayist William Hazlitt had earlier written on the distinction between humor and wit, and although he did not rely upon nationalistic lines, his characterization agrees in the main with Billings's:
Humor is the describing the ludicrous as it is in itself; wit is the exposing it, by comparing or contrasting with something else. Humor is, as it were, the growth of nature and accident; wit is the product of art and fancy (quoted in Morreall, 74).

11. "American Humor and Humorists," *The Round Table*, n.s. 1, no. 1 (9 September 1865): 2. Modern scholars in the field have tended to agree, writing, "authentic American humor is as we shall find it: caustic, wild, savage. All our comic expression may be placed along a continuum from irreverence to outright shock." Jesse Bier, *The Rise and Fall of American Humor* (New York: Holt, Rinehart and Winston, 1968), 1. Again, another scholar has noticed that if "there is in the very nature of

comedy a general connection between laughter and cruelty, it must also be said that nowhere is that connection more evident than in American humor" (Kenneth S. Lynn, *The Comic Tradition in America* [Garden City, N.Y.: Doubleday Anchor Books, 1958], 104).

12. Of the nine works by Homer included in the exhibition and catalogue *A New World: Masterpieces of American Paintings*, exh. cat. (Boston: Museum of Fine Arts, 1983), for example, seven date from 1885 or after and have as their principal subjects the sea or death.

13. Homer to William Howe Downes, letter, August 1908, in Downes, opp. 224.

14. Homer participated in the Artists' Fund Society sales and exhibitions and belonged to the Century Club from 1865 and to the more informal Tile Club from 1877 (where his nickname was "The Obtuse Bard"). He was elected an Associate member of The National Academy of Design in 1864 (an Academician the next year), and a member of the American Society of Painters in Water Colors in 1876. Criticism of works still in his studio through the mid-1860s demonstrates his relative accessibility (see Collected References Prior to 1876 in catalogue entries below), as does the lengthy interview with T. B. Aldrich in *Our Young Folks* (July 1866), noted in text accompanying *The Bright Side, cat.no.13*. For his response to critics, see the text for *The Veteran in a New Field, cat.no.15*.

15. [T. B. Aldrich], "The National Academy of Design. II," *The New-York Illustrated News* 8, no. 184 (16 May 1863): 34.

16. "The National Academy of Design. Forty-first Annual Exhibition," *The New-York Daily Tribune*, 4 July 1866.

17. David Tatham, "Winslow Homer's Library," *The American Art Journal* 9, no. 1 (May 1977): 97-98.

18. Illustrated in Gordon Hendricks, *The Life and Work of Winslow Homer* (New York: Abrams, 1979), 194, 236, 237.

19. Homer to Thomas B. Clarke, letter, 11 December 1892, Archives of American Art, Thomas B. Clarke papers, roll 2814, frames 598-601.

20. Downes, 20, 237.

21. "National Academy of Design. Seventh Article," *Watson's Weekly Art Journal* 3, no. 10 (1 July 1865): 148-149.

22. John D. Billings, *Hardtack and Coffee, or The Unwritten Story of Army Life* (1887; Williamstown, Mass.: Corner House, 1984), 284-285.

23. Billings, 282.

24. *In organizing a six-mule team, a large pair of heavy animals were selected for the pole, a smaller size for the swing, and a still smaller pair for leaders. There were advantages in this arrangement; in the first place, in going through a miry spot the small leaders soon place themselves, by their quick movements, on firm footing, where they can take hold and pull the pole mules out of the wallow. Again, with a good heavy steady pair of wheel mules, the driver can restrain the smaller ones that are apt to be frisky and reckless at times* (Billings, 282).

25. Warren Lee Goss, *Recollections of a Private. A Story of the Army of the Potomac* (New York: Thomas Y. Crowell & Co., 1890), 171. See also Billings, 279, 294.

26. In fact, from the cry of its mouth to the kick of its hoof, in retrospect or from a safe distance, the army mule often prompted "a plain, square exaggeration carried to the utmost confines":
His voice was of unusual compass and pitched mostly in the minor key, harmonizing with nature in a remarkable degree. It had in it the rush of waters, the sighing of winds, the filing of saws, the grating of slate pencils, and as a whole resembled a clap of thunder drawn through a coarse sieve (Goss, 166).

27. Henry A. Castle, *The Army Mule: And Other War Sketches* (Indianapolis: Bowen-Merrill, 1898), 6, 20-21.

28. Billings, 288, 294.

29. Lucretia Giese cites General Order, No. 6, of Major General William S. Rosecrans, published in early 1863, to signal the official purposes of the induction of blacks into the quartermasters' corps (*Painter of the Civil War*, 77-78). The order reads in part:
General Orders No. 6 – The General Commanding, desiring to increase as far as possible the effective force of this army, by returning to their regiments able-bodied men, now on detached service as teamsters, laborers and hospital attendants, direct that their places be supplied, as far as possible, by the substitution of men hired for the purpose.

· ·

Negroes may be employed and paid, in conformity with the Act of Congress, as follows.

1. As teamsters on Quartermasters' trains, provided a sufficient number of white teamsters and wagonmasters are retained to provide order. . . .

Commanders of corps, divisions, brigades and independent posts, are authorized to procure and employ negroes as above:

1. From those found free and roaming at large.

2. From those belonging to masters serving in the rebel army, or who have been employed, in any manner, in the rebel service.

3. From those belonging to persons who, though not now serving in the rebel cause, are disloyal, or have children or other near relatives in the rebel army, who are benefited or maintained by the labor of such slaves.

Lastly, when it becomes an absolute necessity, from among those belonging to loyal men. In this case, a copy of the order directing their employment, and a descriptive list of persons so employed, shall be given to the owner, duly authenticated by the commanding officer of the troops in whose service they are employed. . . .

III. All persons so employed in each regiment, except

those employed as officers' servants, will be entered on Quartermasters' rolls as laborers or teamsters. . . . They will be provided with clothing to be deducted from their pay, the balance to be paid to the person employed, unless he belong to a loyal master, in which case payment will be made to the master.

Every negro thus employed will receive a certificate from his employer, setting forth the fact and nature of his employment, and no male or female negro will remain in camp or subsist therein, without such certificate.

("Affairs in the Southwest," *The New-York Times*, 15 February 1863)
So many of the teamsters were black, in fact, that one black soldier, wounded near Petersburg, refused to abandon his gear on the way to the hospital for *"I don't want de fellows at de hospital to mistake me for a teamster"* (cited in Bruce Catton, *A Stillness at Appomattox* [1953], in *Bruce Catton's Civil War: Three Volumes in One* [New York: The Fairfax Press, 1984], 595-596).

30. "Shooting Negro Teamsters," *The Evening Post*, 5 January 1863. This episode was later featured as a vignette in a double page illustration by Thomas Nast, with an accompanying text (outlining this and other barbarities) entitled "Southern Chivalry" (*Harper's Weekly* 7, no. 319 [7 February 1863]: 87-89). The same event, along with other cruelties perpetrated upon blacks in the Union service, was the subject of another article in *Harper's* over a year later ("Rebel Atrocities," *Harper's Weekly* 8, no. 386 [21 May 1864]: 334).

Depredations could be caused by the teamsters as well as visited upon them. Numerous accounts speak of the lack of discipline among those who followed and supplied the army. Perhaps the most interesting of these, given Homer's acqaintance with Francis Channing Barlow, is the testimony of Colonel Theodore Lyman, who wrote to his family on 23 May 1864:
The waggoners and train rabble and stragglers have committed great outrages in the rear of this army. Some of the generals, particularly Birney and Barlow, have punished pillagers in a way they will not forget; and they will be shot if they do not stop outrages on the inhabitants (Theodore Lyman, *Meade's Headquarters 1863-1865* [Boston: The Atlantic Monthly Press, 1922], 117).

31. Unattributed anecdote from the *St. Paul Press*, quoted in Frank Moore, ed., *Anecdotes, Poetry, and Incidents of the War: North and South. 1860-1865* (1865; New York: The Arundel Print, 1882), 392-393.

32. Billings, 286-287. Even the men who were involved with the supply trains, who intellectually and experientially understood the difficulties and accomplishments of the drivers, had a tendency to assign stereotypical characteristics to the teamsters:
The drivers were usually expert and understood well the wayward, sportive natures of the creatures over whose

destinies they presided. . . . While I was guarding our pontoon trains after leaving Big Bethel, the teams stopped all along the line. Hurrying to the front, I found one of the leading teams badly mired, but not enough to justify the stopping of the whole train. The lazy colored driver was comfortably asleep in the saddle.

"Get that team out of the mud!" I yelled, bringing him to his senses. . . .

Cocking and capping my unloaded musket, I brought it to the shoulder, and again commanded the driver, "Get that team out of the mud!"

The negro rolled his eyes wildly and woke up all over. He first patted his saddled mule, spoke to each one, and then, flourishing his long whip with a crack like a pistol, shouted, "Go 'long dar! what I feed yo' fo'!" and the mule team left the slough in a very expeditious manner (Goss, 34-35).

33. Joseph Boskin, "The Complicity of Humor," in Morreall, 253.

34. In London in February 1864, Professor T. J. Huxley delivered a series of lectures on comparative anatomy that included discussions of whether one race of man was of a different species than another, and whether any of the races could be regarded as transitional or midway between animals and man. Huxley gave a resounding "no" to both questions, demonstrating that various assertions then published in New York concerning blacks – that the skeleton could not be forced fully upright, that the composition of the blood was different between blacks and whites, and that the brains of blacks were shaped more like lower primates than like whites – were patently false. The lecture was reported at length as remarks of "great importance to us in the United States" (*The New-York Daily Tribune*, 19 March 1864).

35. Robert F. Lucid, "Civil War Humor: Anecdotes & Recollections," *Civil War History* 2, no. 3 (September 1956): 44-46. Even as objective and neutral a work as Homer's *Dressing for the Carnival* (1877, The Metropolitan Museum of Art, New York) was called "a humorous negro sketch" when it was reviewed in the New York *Art Journal* in 1878 (see Natalie Spassky, *American Paintings in the Metropolitan Museum of Art* 2 [New York: The Metropolitan Museum of Art, 1985], 461). This work almost certainly is the painting that was exhibited at the Century Association in June 1877 as *Sketch – 4th July in Virginia* (as Homer later wrote that the Metropolitan painting was shown "at the club" [Spassky, 462]); whatever humor the nineteenth century saw in *Dressing for the Carnival* has now drained away.

36. *Frank Leslie's Illustrated Newspaper* 12, no. 309 (26 October 1861): 368.

37. *The New-York Times*, 9 April 1880. Quoted in Mary Ann Calo's excellent article, "Winslow Homer's Visits to Virginia During Reconstruction," *The American Art Journal* 12, no. 1 (Winter 1980): 5.

38. "The Army of the Potomac. What it has Done and What it is Doing," *The New-York Times*, 30 October 1864. Even in horrific circumstances, the response could be the same. After the capture of the bark *Wildfire* and its illegal cargo of slaves, a reporter for *Harper's Weekly* toured the ship:
We saw on board about six or seven boys and men greatly emaciated, and diseased past recovery, and about a hundred that showed decided evidences of suffering from inanition, exhaustion, and disease. Dysentery was the principal disease. But notwithstanding their sufferings, we could not be otherwise than interested and amused at their strange looks, motions, and actions
("The Africans of the Slave Bark 'Wildfire,'" *Harper's Weekly* 4, no. 179 [June 2, 1860]: 344).

39. Published in *Harper's Weekly* 5, no. 260 (21 December 1861): 808-809. The drawing for the figure *Soldier Dancing* is in the Cooper-Hewitt Museum, the Smithsonian Institution's National Museum of Design, New York, 1912-12-134. The figure reappears at the far left of *Thanksgiving in Camp* (cat.no.6b).

40. Others would include the outraged black in the background of *Foraging* (*fig.3.1*), another of the *Campaign Sketches* lithographs, and, perhaps, the "skedaddle" of the blacks shown in *A Shell in the Rebel Trenches* (*Harper's Weekly* 7, no. 316 [17 January 1863]: 36). More neutral renderings among Homer's earliest works can be found in *Expulsion of Negroes and Abolitionists from Tremont Temple, Boston, Massachusetts, on December 3, 1860* (*Harper's Weekly* 4, no. 207 [15 December 1860]), *The Songs of the War* (*fig.4.1*), and the lithographs *The Baggage Train* (1863), *In the Trenches* (1864), and *Teamster* (1864).

41. "The Army of the Potomac. What it has Done and What it is Doing," *The New-York Times*, 30 October 1864. Another New York reporter had earlier discussed the contrabands in Alexandria: *The contrabands have also adopted the 'scatteration' policy, and can be found in all quarters at all hours. Their morals are not as good as they ought to be, and they are chiefly notable for variety of shade, indolence and impudence* (D. Connelly, "News from Virginia," *The New-York Leader* 10, no. 2 [28 May 1864]: 2).

42. "The Africans of the Slave Bark," 345.

43. *Vanity Fair* 6, no. 136 (2 August 1862): 58.

44. Alfred R. Waud, "Paying the Teamsters," *Harper's Weekly* 7, no. 323 (7 March 1863): 150, illus. 148. Waud's text is illuminating of the level of casual bigotry acceptable in the largest of America's periodicals, and merits quotation at length:
In the Army of the Potomac there are probably from 8000 to 10,000 negroes employed as teamsters. This is a business they are well suited for, and of course it relieves an equal number of white men for other duties. A teamster's life is a very hard one, particularly at this season of the year. It does not matter how much it storms, or how deep the mud, subsistence must be hauled to the camps. . . .
. . . It is amusing to watch the effect of a handful of bills on the countenances of the colored ones as they receive their dues. Captain Howard, who is fond of a joke, would sometimes hand a particularly unsophisticated-looking darkey his money in large bills, tendering the next one a like amount in ones and half-dollar bills, thereby producing temporary but complete mystification in their souls. . . .
. . . Many of them are very wild, and need strict management to keep them in order. They appear, however, in most cases to realize the advantages of their new position, and do as well as can be expected.

45. George Arnold, "Art Matters," *The New York Leader* 11, no. 10 (11 March 1865): 5. "National Academy of Design, North Room," *The New-York Times*, 29 May 1865.

46. Associating blacks and animals together was not uncommon in the illustrated press of the early 1860s. The manner varied from simple juxtaposition, as when two mules loom over two dancing black boys (*The War in Louisiana – Scene at Tarleton's Plantation, Bayou Teche, Frank Leslie's Illustrated Newspaper* 18, no. 467 [10 September 1864]: 385), to overt statement, as in a cartoon of a black man strutting in front of assembled farm animals that bears the caption: CUTTING HIS OLD ASSOCIATES. "Man of color. 'Ugh! Get out! I ain't one ob you no more. *I'se a Man, I is!*'" (*Harper's Weekly* 7, no. 316 [17 January 1863]: 48).

47. *The Albion* 43, no. 21 (27 May 1865): 249. *The New York Leader* 11, no. 22 (3 June 1865): 1. *The Nation* 1, no. 2 (13 July 1865): 59.

48. Relatively few of Homer's figures gaze out from the picture to confront the viewer, and none so boldly or with such effect as this muleteer in *The Bright Side*. Of all the Civil War works, only the right-hand figure in "*Army Boots*" (*cat.no.16*) is comparable in the directness with which he apprehends the viewer.

49. James E. Kelly papers, box 9, The New-York Historical Society, MS, 4.

50. T. B. Aldrich, "Among the Studios. III." *Our Young Folks* 2, no. 6 (July 1866): 396-397.

51. And it is at this level that the alternate titles sometimes used for the painting (*Light and Shade* and *The Sunny Side*) function. The traditional title of the 1866 copy, *Army Muleteers*, works with an even simpler literalness, merely to identify rather than to enrich.

52. But if, as Hazlitt opines, "wit is the salt of conversation, not the food," so it is with *The Bright Side*. Serious aspects of the painting include the day-to-day relations of the races, the position of blacks in the industrial North, and the "all but universal" racism that prevailed throughout the country. Lucretia Giese has carefully explored these issues in relation to Homer's work. Especially interesting is her discussion of the National Acad-

emy of Design's rules barring blacks admission to the annual exhibitions (*Painter of the Civil War*, 64-87).

Interestingly, a writer for *Frank Leslie's Illustrated Newspaper* could write:

The darkey has not the slightest idea of wit; he would let the most beautiful double entendre or the finest turned pun pass him without so much as an agitation of countenance, but when it comes to humor he is all at home. The simplest sayings of the negro are oftentimes the very epitome of fun ("Negro Humor," 19, no. 473 [22 October 1864]: 67).

53. The editorial stance toward blacks in *Harper's Weekly* is a constantly shifting one. In 1860 it could run a cartoon of a black mother and child with the caption, "Now den Julius! If yer ain't a good litte nigger, mudder'l call de big ole Bobolitionist and let um runaway wid yer" ("At the South," 4, no. 161 [28 January 1860]: 64). And yet, as early as 21 June 1862, the editors would write:

There is a lively piece of twaddle afloat. It is the ineffably and silly assertion that this is a nation of white men, or a white man's government. Of course it is only one of the mean appeals to the hate that people always feel for those they have injured. Its intention is to quench any sympathy for black men. . . . The glory of this Government is not in the color of the skins of the citizens, but in the justice with which its laws are made and the fidelity with which they are executed. If the laws be unjust, the Government is mean and inglorious and the nation disgraced, although the face of every citizen were as white as snow. "Truth *Versus* Twaddle," 6, no. 286 [21 June 1862]: 387).

By the time of the Emancipation Proclamation, the principal prose of *Harper's Weekly* is primarily liberal. The war itself was in part responsible for the shift, as the editors themselves realized:

Even at the present time a mortal antipathy for the negro is entertained by a large class of persons at the North. . . . At the same time, the war has produced a remarkable change in the opinions of educated and liberal men at the North. Such leading men as General Wallace of Illinois, Daniel S. Dickinson of New York, General Butler of Massachusetts, and nine-tenths of the generals in the field – who, a year ago, really believed that slavery was the true station for the negro – have lately freely expressed what used to be called "abolition views." How long it will take for these liberal views to permeate society, and stamp themselves on the mind of the working-class, remains to be seen. We do not, for our part, apprehend any serious opposition at the North to the President's [Emancipation] policy, except in circles whose loyalty to the country may well be questioned ("Slavery Practically Abolished," 6, no. 301 [4 October 1862]: 626).

Over the course of the next year or so, particularly after the draft riots of July 1863, the illustrated portions of the periodical gradually grew to conform to this stance. The trend culminated in the closing cartoon of the 22 April 1865 issue, which shows a black and a white man, each with a leg amputated, shaking hands. The caption reads: "Give me your hand, Comrade! We have each lost a LEG for the good cause; but, thank GOD, we never lost HEART" ("A Man Knows A Man," 9, no. 434 [22 April 1865]: 256).

54. A similar balance operates in *Prisoners from the Front* (cat.no.20). We know that the Northern officer is the hero of the scene, the man on the literal and metaphoric right side. And yet many viewers cannot help but assign the greater interest to the central figure, the young captured officer who, though his cause be wrong and defeated, yet generates (like Milton's Satan in *Paradise Lost*) sympathy for his romantic and doomed beliefs, and admiration for his defiance.

55. The "Image of the Black in Western Art" research project of the Menil Foundation in Houston, Texas, has long studied Homer's attitudes toward blacks. The fruits of this research are scheduled to become public in the fall of 1988 with an exhibition and catalogue devoted to Homer's paintings of blacks in the 1870s.

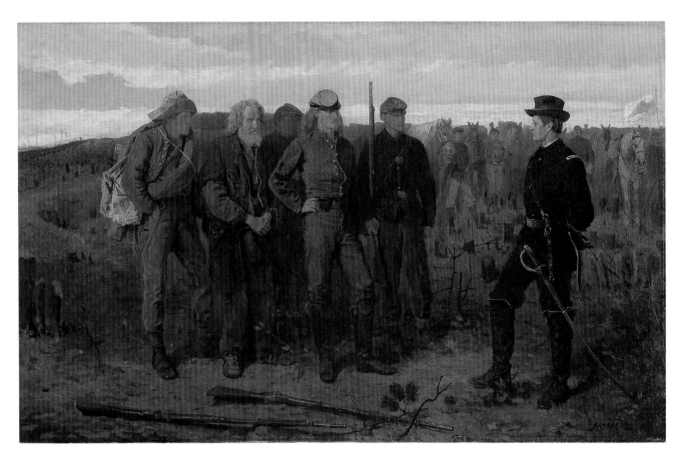

Winslow Homer. *Prisoners from the Front*, 1866. Oil
on canvas, 24×38 in. Signed and dated lower
right: HOMER 1866. The Metropolitan Museum of
Art, New York. Gift of Mrs. Frank B. Porter, 1922.
22.207. *Cat.no.20*

Prisoners from the Front:
An American History Painting?

Lucretia H. Giese

In April 1866 Winslow Homer exhibited two paintings at the National Academy of Design Forty-first Annual Exhibition that show him still occupied with Civil War subject matter. *The Brush Harrow* is a genre scene of civilian life, specifically of conditions at home altered by the hostilities (*fig.1*). Two boys prepare the ground for planting with a horse-drawn harrow. Children attempt to carry out ordinary domestic tasks that were the responsibility of older brothers or fathers before the war. This reading is supported by the comment in a review of the time that the horse's rump had been branded "U.S. [Army]."[1] Wartime allusions in *Prisoners from the Front* are unambiguous (*cat.no.20*). Three Confederate prisoners await their disposition by a Union general, whose escort to the left bears a division flag. The countryside wasted by war stretches behind the prisoners to the left, whose surrendered rifles lie across the foreground. What is less certain is whether *Prisoners from the Front* too is a genre painting. Is it a simple narrative or a work of substantive and contemporary implication?

Homer presumably began work on *Prisoners from the Front* in 1865. It seems to have been well under way when seen in his studio in February 1866.[2] Completion was possibly slowed by several changes in the composition. Whether to sharpen the painting's relevance or to strengthen the painting pictorially, the changes reflect Homer's deliberation and care with its production. Homer made changes to other Civil War paintings; alterations are by no means unique to *Prisoners from the Front*. Nevertheless, in the case of that painting, the consideration of other factors raises the possibility of Homer's essay into new territory.

One change is known only from a drawing (*fig.20.1*). Homer reconsidered the configuration of the Union general's hat, giving it the angular shape it has in the final painting. The same drawing indicates what is confirmed by *pentimenti* on the canvas itself, that Homer originally conceived the general's right hand as thrust into his jacket. In addition, Homer seems to have lowered its collar line, changed the young Confederate officer's broad-brimmed hat to a forage cap, and the flag's forked outline to that of a rectangle.[3]

Meaning seems unaffected by most of these changes. Labeled photographs of the period suggest that even when of the same rank Union officers wore a variety of headgear. The same was true for officers' jackets or frock coats. The modification of the Confederate officer's hat may be linked to the insignia on his sleeve, although its meaning has not been determined.[4] In the case of the flag, however, shape did govern function. If forked, with a red trefoil or club insignia, the flag signified the headquarters of the Second Corps, 1864-1865; if rectangular, it served only a division of the Second Corps.[5] This change is consistent with facts known about the northern officer, identified as General Francis Channing Barlow.[6] Barlow as brigadier general assumed command of the First Division of the Second Corps of the Army of the Potomac on 1 April 1864; not until after the war was Barlow appointed brevet major general.[7] Homer's drawing of Barlow shows the requisite two stars of a major general on his shoulder, which, however, do not appear in the painting. (Homer could have studied Barlow from life or have been aided by a Mathew Brady

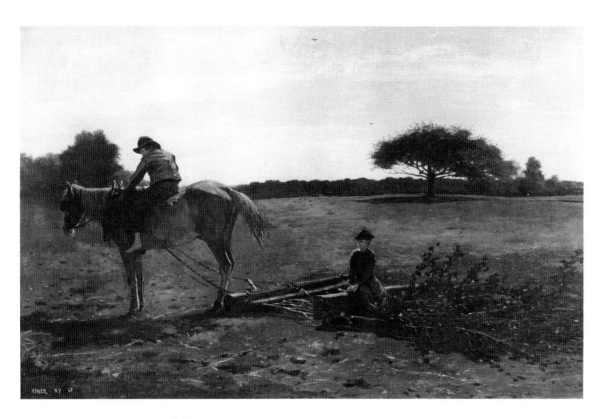

fig. 1 Winslow Homer. *The Brush Harrow*, 1865.
Oil on canvas, 23 × 37 ¼ in. Harvard University Art
Museums (Fogg Art Museum). Anonymous gift

photograph published as a wood engraving in *Harper's Weekly* on 21 October 1865 that included Barlow's two stars [*fig. 2*]).[8] Perhaps, in the end, Homer considered the indication of Barlow's post-war rank inappropriate for a painting suggesting the war itself. By November 1865 Barlow was secretary of state for New York; his career both during and after the war was public knowledge.

Other changes seem to have been more pictorially motivated. The reformulation of the Confederate officer's hat may have served some pictorial purpose. Certainly the shift in the position of the northern general's arm accentuates his overall columnar form and reinforces a sense of the figure's resolve. The lowered collar line on Barlow's coat emphasizes his head but also corresponds to the photograph mentioned above. The change may also support Barlow's son's contention that Homer later inserted Barlow's head on the figure for which another general posed,

Nelson A. Miles.[9] If so, Homer could only have studied Miles in the field for Miles was continuously in the war zone and immediately afterwards appointed commander of Fortress Monroe in which Jefferson Davis was incarcerated. Homer would have had easier access to Barlow. Yet a comparison of Barlow photographed slouched against a tree near the imposingly upright Second Corps commander General Winfield Scott Hancock is instructive (*fig. 3*).[10] As Barlow's son admitted, "Miles was a very fine figure of a man, and my father was nothing special in this respect."[11] Hancock could have been another possible substitute.

On completion, *Prisoners from the Front* impressed everyone with its appropriateness and seriousness.[12] It was soon acquired by the railroad magnate and collector John Taylor Johnston of New York.[13] Critics, however, seemed uncertain how to characterize the painting. Some considered it a figure or genre painting, another called

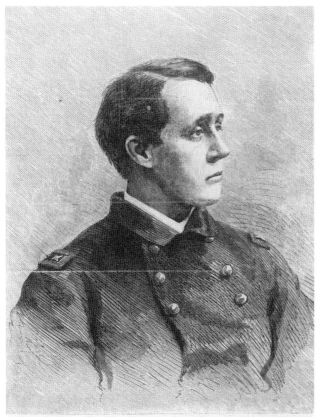

MAJOR-GENERAL FRANCIS BARLOW.—PHOTOGRAPHED BY BRADY. - [SEE NO. 458, PAGE 628.]

fig.2 Unidentified artist. *Major General Francis Barlow. – Photographed by Brady*. Wood engraving after a photograph by Mathew Brady. *Harper's Weekly* 9, no. 460 (21 October 1865): 669. Collection of Harvard College Library, Harvard University

it "historical art."[14] The first designations are easily understood; the third is more problematic. As a figure painting, large-scale figures do dominate the painting, and at least two critics recognized the northern officer as General Barlow.[15] As a genre painting, an ordinary event is shown in the sense that the taking of prisoners occurred throughout the war, even though there is nothing anecdotal or episodic in Homer's image of a northern general and three captured Confederates.

But as a history painting, *Prisoners from the Front* is decidedly unconventional. It makes no lofty point. No past event is presented with heroic ideality. It certainly does not promote, in traditional fashion, "permanent values and eternal ideals centered around the nexus of heroic antiquity."[16] Even taking into consideration the acceptance of more recent events and personages into history paintings by the late eighteenth century, *Prisoners from the Front* does not conform. No particular victory or precise moment of capitulation is celebrated, no military hero aggrandized.[17] The painting also eludes classification as "historical genre,"[18] the transmutation of history painting into a form of genre in the nineteenth century. No specific incident is recreated with verisimilitude. Although *Prisoners from the Front* incorporates pieces of observation (*cat.nos. 10a, 20a, 20c, fig. 20.1*), the painting is not a factual record or period reconstruction.

One contemporary seems to have understood this. He considered *Prisoners from the Front* the most "comprehensive art work that has been painted to express some of the most vital facts of our war."[19] The critical word used here is *express*, rather than *record*. That is, according to one definition, the painting expressed the Civil War through symbolic representation. *Prisoners from the Front* is indeed a grand pictorial conception, without trivial or incidental detail. Homer's Civil War scenes painted during the war years were for the most part somewhat anecdotal and informally, though by no means thoughtlessly, constructed. With *Prisoners from the Front*, Homer may have hoped to establish himself after the war as a serious artist capable of working in elevated style with important subject matter. The

fig.3 Attributed to Mathew
Brady (1822/23-1896). *Army of
the Potomac – General Hancock
and Staff* (detail), 1864. Silver
print. Collection of the Library
of Congress

example of nineteenth-century American history
painting may have contributed to the successful
pursuit of this plan.

Of the more than fifty paintings by Homer
dating from 1863 to 1866, camp scenes and
depictions of uncomplicated wartime activities
predominate. Homer had been to the war zone.[20]
There he witnessed camp life, skirmishes, and
raids, but actual warfare was another matter.
Except by chance, nonmilitary personnel had no
place in pitched battles. Homer had taken on
subjects having serious wartime resonance,[21] but
scenes of war's essential raw ingredient, combat,
are the exception. Only in three paintings is
fighting depicted, and they are of limited engage-
ments: *Sharpshooter* (*cat.no.1*); *Inviting a Shot
before Petersburg, Virginia* (*cat.no.10*); *Skirmish in
the Wilderness* (*cat.no.9*).

Sharpshooter of 1862/63 shows a single soldier taking aim at an unseen enemy. He is partially hidden by dense pine foliage. It is unclear what the effect of his action will be or whether he himself is the target of another sharpshooter. Some period clues locate the situation and individual, but the result is a haunting, inconclusive narrative. The painting makes no point in pictorial terms about the specific horrors or positive achievements of the Civil War. The painting falls into the category of genre.

No definite evidence exists that Homer exhibited this painting before 1864, when it was shown twice.[22] An engraved version had appeared, however, in the 15 November 1862 issue of *Harper's Weekly* (cat.no.1a).[23] An earlier pair of scenes of frontline combat engraved for *Harper's Weekly*, *The War for the Union, 1862 – A Cavalry Charge* (5 July 1862; *fig.6*) and *The War for the Union, 1862 – A Bayonet Charge* (12 July 1862; Wilson, this volume, *fig.2*), are, in contrast to the restraint in *Sharpshooter*, exaggerated fabrications. As with propagandistic war posters, the dual images rally but do not convince. Although Homer did convey the unheroic danger of warfare with a later work, *A Shell in the Rebel Trenches* (*Harper's Weekly*, 17 January 1863), this work is also colored by melodrama.

Homer did not try again to paint a martial scene until 1864, a year in which he submitted only three illustrations to *Harper's Weekly*. With *Inviting a Shot before Petersburg, Virginia*, Homer created a powerful and somber portrayal of war. The moment of potential danger and death on the battlefield is fully realized, although fighting has temporarily halted. The principal figure, a soldier, is silhouetted against the sky. He straddles an earth rampart, clenching his fists against the threat of a bullet as he turns toward the enemy-held desolate and scarred landscape. Another work, *Skirmish in the Wilderness*, potently depicts unorganized combat. Fighting takes place in a dense and tangled wood as an isolated group of soldiers engage the enemy by firing from the protection of a large tree. But again, these paintings are generic episodes, even with their inclusion of a few contemporary references, rather than pointed comments on the Civil War. They are closer to genre painting than any other category.

Skirmish in the Wilderness was shown at the Artists' Fund Society exhibition in November 1864; no painting matching the titles *Inviting a Shot* or *Defiance* appears on exhibition lists known to me, although a picture entitled *Watching the Shot* was included in an auction held after the war.[24] In any case, Homer submitted neither painting to the National Academy of Design. Apart from these two oils, no others were made that can be classified in any way as scenes of soldiers in war rather than of soldiers in camp.

Prisoners from the Front of 1866 represents a significant and different effort by Homer. In the first place, the painting shows surrender and confrontation, the consequences of fighting rather than combat itself. The attitude of North and South at the end of the war and the future of the nation are the issues at hand. The painting's concerns are intangible and fundamental to the times rather than to story-telling. Second, the painting is dignified in formal terms. The protagonists are prominent in relation to the canvas size and placed in static array across the foreground. They are given particular features, but the supporting figures are generalized. And like them, the setting is defined but essentially unspecified. Landscape and figures reinforce each other with new clarity in the composition. There are no superfluous, trivializing details. Reducing *Prisoners from the Front* to the level of narrative or figural work ignores the painting's considered presentation and the subject's solemn contemporary implications.

Is *Prisoners from the Front*, then, an example of historical art? At least one reviewer, probably Eugene Benson, thought so. He used those words to describe the painting in 1866 and repeated them in reference to the same painting a few years later in a lengthy article on "Historical Art in the United States."[25] As a colleague of Homer and an art critic, Benson may have articulated views held by others and even Homer's own. With that possibility in mind, Benson's comments on American history painting and *Prisoners from the*

fig.4 John Trumbull (1756-1843). *The Surrender of General Burgoyne at Saratoga, October 16, 1777*, ca. 1822. Oil on canvas, 144×216 in. Architect of the Capitol, United States Capitol Art Collection, Washington, D.C.

Front are worth examining closely. According to Benson,

American historical art is still mortifying to us, save in the example by Mr. Winslow Homer, the "Prisoners from the Front," which . . . fixed itself in the memory of so many of us as an actual and representative group out of our recent struggle, . . . a true bit of history.[26]

Of history painting as commonly understood, the depiction of "past historical events, which is to say, the representation of the destructive and aggrandizing action in war of great nations," Benson believed it did not exist in the United States. What passed for history painting in America, specifically that installed in the Capitol Rotunda, consisted of "the invented, the false, the conventional." Paintings such as Robert Weir's *Embarkation of the Pilgrims at Delft Haven,*

fig.5 Emanuel Leutze (1816-1868). *Washington Crossing the Delaware*, 1851. Oil on canvas, 149×256 in. The Metropolitan Museum of Art, New York. Gift of John S. Kennedy, 1897

Holland, July 22nd, 1620 (1843) or John Gadsby Chapman's *Baptism of Pocahontas at Jamestown, Virginia, 1613* (1840), fell by Benson's standards into these negative categories. They dealt with episodes occurring before the painters' lifetimes. Consistent with this attitude, Benson declared John Trumbull's *Declaration of Independence*, also in the Rotunda, impressive though "historical art not on a level with its subject." The first version was begun ca. 1787; Trumbull and the American Revolution were contemporaneous.

Striving to define history painting as work imbued with the vitality of the moment, Benson urged painters instead to "give us art that shall become historical; not art that is intended to be so." Understanding the scarcity of subjects with "majesty" and "dignity" available to American painters, he argued that American historical

art had to derive from an artist's personal experience. The past could only be fabrication on various levels. Additional problems Benson saw facing American painters were inadequate training and support for historical painting.

American painters from the time of Trumbull had attempted to transplant the European concept of history painting to America. History painting had traditionally been the category held in highest regard, requiring the imaginative, figural, and compositional skill of a painter, and expressing an ideal or lofty message. American painters had little success with history painting, for reasons Benson acknowledged. Nevertheless, Trumbull had procured a government commission for four mural-sized paintings of episodes from the American Revolution, which were installed in the Capitol Rotunda, Washington,

D.C., in November 1826. Although the Rotunda housed troops during the Civil War, it cannot have been closed to civilians.[27] When in Washington, D.C., early in the war, Homer could have seen Trumbull's paintings.[28] They could have offered Homer pictorial precedents for compositions with serious military and historical connotation.[29] In fact, it is not difficult to see resemblance in form and subject between Trumbull's *The Surrender of General Burgoyne at Saratoga, October 16, 1777* (*fig.4*), and Homer's *Prisoners from the Front*. The surrender of three principal officers to one general representing the opposition is depicted in a ceremoniously structured composition.

Other American painters besides Trumbull had their attempts in history painting on public display during the 1850s and 1860s. Homer, for instance, could have seen work by two Boston-born painters in that category before he moved to New York. John Singleton Copley's *King Charles the First Demanding in the House of Commons the Five Impeached Members* (1785) was exhibited at Williams & Everett's Art Gallery in July 1859, the year Homer left Boston.[30] George Healy's *Webster's Reply to Hayne* (1830) was displayed in Faneuil Hall as early as 1851.[31] Once Homer had settled in New York, more current work could have come to his attention. Emanuel Leutze's paintings, such as *Washington at the Battle of Princeton* (1859, location unknown) and *Madame Lafayette, with Her Daughters, Joining Her Husband in the Prison at Olmütz, 1795* (ca. 1861, location unknown), Daniel Huntington's *Republican Court in the Time of Washington* (1861, The Brooklyn Museum), William Powell's *Perry Transferring His Flag* (1864, location unknown), were discussed and shown in private galleries.[32] So too was Louis Lang's *Return of the New York Sixty-ninth* (1862, The New-York Historical Society), credited as the "first really important historic picture of the war."[33] Francis Bicknell Carpenter's *First Reading of the Emancipation Proclamation of President Lincoln* (1864, United States Capitol) toured several cities, New York included.[34] The National Academy of Design exhibitions furnished other types of history paint-

ing, ranging from pictures of biblical or literary scenes to military episodes drawn from the American Revolution and the present war. For example, Leutze's *Washington at the Battle of Monongahela (Washington at Braddock's Defeat)* (1858, General Braddock School District, Braddock, Pennsylvania) was exhibited at the National Academy of Design in 1860.[35]

However, Leutze's *Washington Crossing the Delaware* of 1851 could have been most cogent (*fig.5*). Although first exhibited in New York before Homer's move, the painting was widely known from engravings issued by Goupil & Company, and the original reappeared at the Metropolitan Fair in New York of 1864.[36] It is unthinkable that Homer would have missed the opportunity to see some of the most talked-about paintings of his time collected for exhibition at the fair, among them Frederic E. Church's *The Heart of the Andes* (1859, The Metropolitan Museum of Art, New York) and Albert Bierstadt's *The Rocky Mountains, Lander's Peak* (1863, The Metropolitan Museum of Art, New York). Homer himself included a "Study from Nature," possibly *The Initials*.[37] Leutze's own work, no. 1 in the fair's catalogue, all but filled an entire wall of the art exhibition hall.

Several levels of correspondence seem to exist between Homer's *Prisoners from the Front* and Leutze's *Washington Crossing the Delaware* on examination of pictorial means, subject, and intent. The paintings share similar though somewhat conventional compositional devices—the horizontal banding of sky, land, or water, against which large-scale figures are positioned across the foreground; a sub-group of less distinct figures in the middle distance at the right; and an opening into the far distance at the left. Intriguingly, the two principals gaze ahead to the left, head and torso in contained profile, sword at their side, weight resolutely distributed between straightened left and bent right leg.[38] Their placement within the composition differs, but there is no mistaking the figures' central importance. All this suggests more than a passing familiarity on Homer's part with Leutze's historical painting. The pictorial structure of *Prisoners from the Front*

is unlike that used by Homer earlier, as "*Home, Sweet Home*" (cat.no.4), *The Brierwood Pipe* (cat.no.8), and *The Bright Side* (cat.no.13), for example, attest.

A further point of correspondence lies in the paintings' treatment of the figures of George Washington and the Union officer, which are simultaneously actual and symbolic. Although no contemporaneous pictorial record of the crossing of the Delaware existed, portraits of Washington of that time did. Nevertheless, Leutze chose to render the Father of His Country in the iconoclastic guise of elder statesman. As such, Washington is not the soldier in the winter of 1776 orchestrating the surprise attack on Trenton, but "our ideal of Washington,"[39] the symbol of the Revolution and American independence. Similarly, Homer's northern general bears Barlow's features, but they were not widely recognized as his nor was much significance given to that fact, and his figure may not even have been modeled on Barlow's own, as discussed earlier.[40] Barlow instead represents the northern forces and position of the North during the country's struggle to preserve the Union. Such figural usage by Homer also uniquely occurs in *Prisoners from the Front*.

It is pertinent here to realize that at the time of the Civil War parallels were drawn between it and the American Revolution. That war provided general ideological and political justification for the country's traumatic second fight for nationhood and offered an endurable framework for the Civil War. Abraham Lincoln made the connection clear in his Gettysburg Address of 1863. His opening phrase, "Fourscore and seven years ago our fathers brought forth a nation," links events of 1776 with the Civil War that Lincoln believed would grant "this nation under God . . . a new birth of freedom."[41] Less eloquently and more obliquely than Lincoln's address, the entry on Leutze's painting in the Metropolitan Fair catalogue of 1864 also engendered the notion of linkage between the American Revolution and the Civil War. *Washington Crossing the Delaware* was given the "most conspicuous place" not only in the exhibition hall but in the catalogue as well.[42] A two-page description of the painting

contained phrases that resonated with feelings of the day. Washington's unflinching leadership and courage during "one of the severest of those trials, which marked the struggle of our forefathers for Independence" enabled his men to understand

that the deepest night does indeed foretell the coming day, for the dawn of their liberty – dim, rayless, almost chilling, but still dawn – soon struggled through the gloom upon their aching sight.[43]

Other paintings reflect a similar perspective. Frederic E. Church's *Our Banner in the Sky* (1861, New York State Office of Parks, Recreation, and Historic Preservation, Olana State Historic Site, Taconic Region) is one example. In Church's painting, God's sky, clouds, and stars form the tattered, war-rent national flag. The flag's ignominious treatment by southern forces after the surrender of Fort Sumter at the start of the Civil War generated patriotic memories of its first unfurling at the surrender of Burgoyne at the Battle of Saratoga during the Revolutionary War (note Trumbull's painting). This connection was meant to be perceived by those purchasing the print after Church's painting, as reference to it in a contemporary notice proves.[44] Leutze's *Angels upon the Battlefield* (1864, Ira Spanierman, Inc., New York) provides another example.[45] Soldiers in what appear to be Revolutionary War uniforms lie dead or wounded on the battleground, watched over by a heavenly guardian who records their deeds. Pictorial reference to the Revolution, a war considered to have moral purpose, cushions the particular horrors of America's fratricidal conflict.

Leutze had painted *Washington Crossing the Delaware* in part to support uprisings in Germany in the late 1840s.[46] It does not matter whether or not Homer was aware of this fact. After all, commentators in American journals about *Washington Crossing the Delaware* naturally assumed its national character.[47] What is of interest is that Leutze and Homer both were responding pictorially to a pressing current political situation.[48] Germany's struggle for freedom from oppression, the American Revolution, and the Civil War inspired more than simple anecdote. Although

fig.6 Winslow Homer. *The War for the Union,*
1862 – A Cavalry Charge. Wood engraving,
13¾×20⅝ in. *Harper's Weekly* 6, no. 288 (5 July
1862): 424-425. The Fine Arts Museums of
San Francisco, Achenbach Foundation for Graphic
Arts. Gift of Dr. and Mrs. Robert A. Johnson

Leutze's gigantic work, in contrast to Homer's
much smaller *Prisoners from the Front*[49] imagina-
tively reconstructs and heroicizes an event, both
are grave and elevated in content and presenta-
tion. These are ingredients of history painting.

What did history painting or "historical art," to
use Eugene Benson's phrase, mean in nineteenth-
century America? Probably the most definitive
statement was made by Daniel Fanshaw in his
review of the National Academy of Design Annual
of 1827.[50] Fanshaw placed "Epic," "Dramatic,"
and "Historic" first in his "departments of art."
This triad ranked highest as it involved more than
manual dexterity; it required "the greatest exer-

cise of the mind." Fanshaw cited Jacques Louis
David's *The Coronation of Josephine* and John
Singleton Copley's *The Death of Chatham* as past
examples in this category,[51] but no paintings in
the 1827 Annual met Fanshaw's criteria. He
defined historic painting as that which
portrays a fact, *an* event; *its characters may be*
ideal, provided truth is observed in time, place, and
custom, and that it records an event which has
happened; the event, *not the* persons, *are*
principal.[52]
This category of painting required a certain
"lofty character of mind" or concept in its
production.

fig.7 Emanuel Leutze (1816–1868). *Washington Rallying the Troops at Monmouth*, 1854. Oil on canvas, 156 × 261 in. University Art Museum, University of California at Berkeley. Gift of Mrs. Mark Hopkins, San Francisco

These ideas persisted a quarter-century later. The position of the painter-academician Daniel Huntington is representative; Huntington for the most part agreed with Fanshaw's definition of history painting.[53] Leutze's, reported in 1851, differed somewhat. He contended that
the artist as poet should first form the clear thought as the groundwork, and then adopt or create some anecdote from history or life, since painting can seldom or never be narrative but contemplative.[54]
That is, for Leutze, concept came first and then its historical envelope. Although following the idea, the historical reference was, however, not of secondary importance. Early in the 1860s, one

the historical *genre* we rank first among the nations of the earth, young as we are in history," citing, however, only past examples by Trumbull, John Vanderlyn, and others, omitting Leutze's name.

Few artists took up the practice; the public, he noted, preferred landscapes. Although paintings of American exploration and discovery were not exceptional by mid-century, as William Truettner has pointed out,[56] another commentator of the 1850s claimed that "a historical picture very writer on "American Art" offered a more straight-forward interpretation.[55] "Historic art" was a "nation's record." He went on to claim that "in

rarely makes its appearance here. Now and then, however, one comes up to remind us, as it were, that this class of art is not yet entirely extinct."[57] Leutze's work provided at least one example. Leutze was called "our great American history painter" on the basis of *Washington Crossing the Delaware*, and Thomas P. Rossiter's work *The Early Navigators and Discoverers of this Continent* (location unknown) was credited as "a good one in connection with our national historical art-productions, and one deserving of further encouragement."[58] The last phrase is telling in its repetition of an old concern. In an article of 1859 on "Hints to American Artists," a writer for *The Crayon* urged painters to take up "pieces of [American] history and civilization."[59]

The critic James Jackson Jarves's comments of 1864 also indicate concern about much the same matter. Jarves observed that

the lofty character and vast issues of our civil war have thus far had but slight influence on our art. . . . [Although] imperialism in France will not permit art to become the language of social and political hopes and aspiration . . . there is no reason why the art of democratic America shall not.[60]

That same year, 1864, a writer for *The Round Table* repeated what had been earlier noted in the same journal, that painters generally preferred an art of pleasantries and sentimentality. It was to younger artists "shaped and molded by the tumults and passions of the present" that one must look for art of "dramatic power in conception, and impassioned feeling." While these comments do not touch directly on historical art, painting with "little or no sympathy with the tragic or grand elements of life and nature" could only lie outside the highest "department" or category.[61] One does not know how much Homer read of such publications, but ideas relating to historical art in one form or another were aired and could have stimulated the still-experimenting painter.

By 1866 Homer had been painting for only three years.[62] The national conflict was over. Homer was ready to contemplate an ambitious painting that would climax his concentration on war imagery. He had gained technical experience.

What could be more fitting at the war's conclusion than a painting suggesting the serious political and moral issues of the war and its aftermath – the past horrors of fratricide and slavery, the difficulties ahead with reunion and restoration? Such a complex, awkward, "historic" subject would indeed require the "greatest exercise of the mind" for successful execution. What but Leutze's *Washington Crossing the Delaware* could have offered a more accessible and pertinent incitement?[63] Could the image have stimulated an attempt at "modernization?" Perhaps it is relevant here to recall Jarves's assertion of 1864 that Leutze's work "stands the highest in popular esteem."[64]

Benson's conclusion about the sort of "historical art" possible in America is applicable: *Historical art is the best* contemporary *art; it is portrait-painting at its highest level; it is* genre *painting; it is landscape painting; . . . Any other historical art in our country must be historical fiction and conventional misrepresentation, . . . at best, no more than a composed, a studied, and lifeless piece of pictorial art.*[65] To Benson, only "the concerns and activities of an artist's contemporaries" ("*genre* painting" in that sense) contained the building material for historical art. It is significant for our purposes that this thought was expressed more than a decade earlier, once again in connection with Leutze's *Washington Crossing the Delaware*: *Art has nobler work to do than to invoke the ghosts of dead ideas. She must ally herself to the realities of daily life. She must link herself with the great thoughts that are stirring the hearts of living men and women.*[66] The applicability of these statements to *Prisoners from the Front* is unmistakable.

In conclusion, then, is *Prisoners from the Front* a genre or a history painting? According to Fanshaw's traditional definition, Homer's painting falls short of the higher category. A specific fact or event is not of paramount importance. The painting does, however, seem to comply with Leutze's view that history painting expresses ideas through an "anecdote from history or life." That is, a history painting offers a framework of greater

substance and meaning than a simple narrative, a framework that instead involves a historical episode or life's concerns. But it is Benson's demands for history painting that are most clearly met. As the "best" painting of an artist's time, "that which the contemporary genius leaves as its personal record of its personal experience," the sincere, undazzling rendering of "current achievements,"[67] *Prisoners from the Front* is historical art. It is more than mere genre.

If indeed a form of history painting, *Prisoners from the Front* represents a singular, perhaps conscious experiment by Homer. The trauma of the war, the urging of critics throughout the war years to painters to use war imagery,[68] and Homer's striving for critical acclaim may all have contributed. Leutze's work could have provided a useful precedent, not for emulation assuredly, but for measurement. Although the reputation of Leutze by the 1860s had fallen from its high point in the early 1850s (Benson did not even mention him, for instance, and Homer too probably would not have admired the rigid theatricality of Leutze's productions), Homer would have at least known Leutze's history paintings. *Washington Crossing the Delaware* had been conspicuously displayed during the war; others were also exhibited, as noted earlier. Perhaps another picture by Leutze is relevant here. The compositional structure of Homer's "fabricated" 5 July 1862 engraving for *Harper's Weekly*, *The War for the Union, 1862 – A Cavalry Charge* (*fig.6*), appears to be the reverse of Leutze's *Washington Rallying the Troops at Monmouth* (*fig.7*). The correspondence may only be generic. Despite a showing in 1854 in New York and later in Great Barrington, Massachusetts, and a replica made in 1857, the painting is not known to have been engraved.[69] There is no way of determining whether Homer saw Leutze's *Washington at Monmouth*, but the visual connection tantalizingly hints at Homer's consideration of the work by the dominant living American history painter (a narrow field, admittedly). Certainly the atypical character of *Prisoners from the Front*, painted as Homer was shifting his focus from illustration to serious painting, raises the question of stimuli.

Whatever the case, after the Civil War, the impetus for similar historically grounded work did not come again. Homer sailed to Europe in December 1866 and after his return only sporadically took up Civil War material.[70] But, in a larger sense, Homer's search for a present-day subject matter reflecting "the concerns . . . of an artist's contemporaries" capable of "stirring the hearts of living men and women" and thus appropriate as contemporaneous historical art, began with *Prisoners from the Front*.[71] Specifically, the theme of confrontation there explored continued to be a major concern for Homer as it evolved to encompass both man and nature.

1. *The New York Leader* 12, no. 16 (21 April 1866): 1. Despite the statement, no brand marking was revealed through x-ray and infrared examination undertaken by the Painting Conservation Laboratory at the Fogg Art Museum, Cambridge, Massachusetts, in 1985.

2. *The New York Commercial Advertiser*, 20 February 1866, 2; *The Evening Post*, 21 February 1866.

3. I thank Natalie Spassky and Nicolai Cikovsky, Jr., for permitting me to see the infrared photographs.

4. Natalie Spassky, *American Paintings in the Metropolitan Museum of Art* (New York: The Metropolitan Museum of Art in association with Princeton University Press, 1985), 444, and Nicolai Cikovsky, Jr., "Winslow Homer's Prisoners from the Front," *The Metropolitan Museum Journal* 12 (1977): 169.

5. Spassky, 439-440.

6. Spassky, 440, and Cikovsky, 160. Barlow was named in at least two contemporary accounts; see *The Evening Post*, 17 April 1866; *Harper's New Monthly Magazine* 180 (June 1866): 117.

7. *Dictionary of American Biography*, ed. Allen Johnson (New York: Scribner, 1928), 1:209. On 18 August 1864, because of wounds sustained at Antietam and Gettysburg, Barlow was "compelled to relinquish command of his division . . . [and was] succeeded . . . by General [Nelson A.] Miles." (Francis A. Walker, *History of the Second Army Corps in the Army of the Potomac* [New York: Scribner, 1891] 578). Barlow assumed command of the Second Division of the Second Corps early in April 1865 and by 30 April was a brevet major general (678, 691).

8. A biographical statement and engraving after an earlier photograph of Barlow (wearing forage cap, facing front) appeared on 7 October 1865 in *Harper's Weekly*. A copy of the 21 October photograph by Brady was among Homer family material and is inscribed in two different hands on the verso: "Maj Genl Barlow/ Mrs Homer/ with regards/ of/ R.[ichard] D. Barlow." Archives of American Art, Winslow Homer Papers, Bowdoin College, roll 2933. I am grateful to John W. Coffey, curator, for checking the inscription for me. The photograph is illustrated in this volume as *fig. 20.3*. However, no insignia of rank is visible in that vignetted copy of the photograph.

Another contemporary photograph of a provost escort bears an uncanny resemblance to the right-hand grouping of men and horses in *Prisoners from the Front* (Library of Congress, Washington, D.C.); it is not known whether Homer had access to this photograph.

Homer traveled with Richard Barlow to the Yorktown area during the Peninsular Campaign of 1862 where Barlow's brother, Francis, was a regimental commander; Richard returned to be with his brother in 1864, but there is no evidence in letters to prove that Homer again accompanied Richard (Francis Channing Barlow letters, Massachusetts Historical Society, Boston). Francis Barlow and Homer knew each other, as Barlow also had grown up in Belmont and was graduated with Homer's brother Charles from Harvard University (Class of 1855).

9. See Spassky, 437-438, for Barlow's son's contention. Barlow would have been available to Homer after the end of the war after the Second Corps was formally disbanded 23 June 1865; Miles was sent directly to Fortress Monroe as its commander and was not relieved from duty there until 29 August 1866. Both officers at the end of the war held the rank of brevet major general (Walker, 693, 690-691).

10. Barlow wrote his brother Edward on 24 July 1864, "Is not the proposed picture in Harpers disgusting [*Army of the Potomac – General Hancock and Staff. – [Photographed by Brady]*," *Harper's Weekly* 8, no. 398 (13 August 1864): 517]. Have you seen the one that Brady took of Hancock myself [illegible word]?" Barlow, letters, Massachusetts Historical Society, Boston. For another photograph evidently of the same time, see *fig. 20.2*.

11. Spassky, 438. I thank Cikovsky for sharing with me his thoughts about the possible connection between the modified collar line and the substitution asserted by Barlow's son.

12. For a discussion and citation of portions of period critical commentary on the painting, see Cikovsky, 155ff. For a complete examination, see Spassky, 441ff.

13. In the National Academy of Design catalogue (no. 490), the painting is neither listed as for sale nor in Homer's or Johnston's possession. Homer did ask, however, that *Prisoners from the Front* be delivered from the Academy exhibition to Samuel P. Avery, dealer and agent for the American art representation at the Paris Exposition of 1867; see letter of Homer to T. A. Richards, 11 June 1866, original once with Mary Bartlett Cowdrey (Archives of American Art, New York Public Library Manuscript Division, N2). In the Paris Exposition catalogue the painting is listed as lent by Johnston.

14. For example, see *Harper's New Monthly Magazine* 180 (June 1866): 117; E[ugene?] B[enson?], *The Round Table* 3 (12 May 1866): 295; "Sordello," *The Evening Post*, 28 April 1866.

15. See note 6.

16. Linda Nochlin, *Realism* (New York: Penguin, 1971), 23.

17. See Spassky, 437, 445, for a different opinion.

18. Nochlin, 24.

19. *The Evening Post*, 28 April 1866.

20. Homer's proven excursions to the front occurred in 1861 (pass dated 15 October, illustrated in Chronology, this volume) and in 1862 (pass dated 1 April, illustrated in Chronology, this volume).

21. For an interpretation stressing the unusual relation of *Prisoners from the Front* and *The Bright Side* to the core issues of the Civil War, see Lucretia Giese, "Winslow Homer, 'best chronicler of the war,'" forthcoming article for the Center for Advanced Study in the Visual Arts, Washington, D.C.

22. The painting was exhibited at the Athenaeum Club, New York City (*The Round Table* 1, no. 7 [30 January 1864]: 107) and at the Brooklyn and Long Island Fair in aid of the United States Sanitary Commission (Clark S. Marlor, *A History of the Brooklyn Art Association, with an Index of Exhibitions* [New York: J. F. Carr, 1970], 230). The Sanitary Commission can be seen as a precursor to the Red Cross; see Charles Janeway Stille, *History of the United States Sanitary Commission, being the general report of its work during the war of the rebellion* (New York: Hurd and Houghton, 1868). Fairs organized to raise funds in support of the commission's activities began in 1863 and soon became enormously popular and effective.

23. *The Army of the Potomac – A Sharpshooter on Picket-Duty – From a Painting by W. Homer, Esq.* "Homer" was inscribed on the block.

24. The auction was held on 19 April 1866 at Miner & Somerville, New York. Another intriguing title as yet

unattached to a work by Homer is *On the Picket Line*.

25. "Sordello," *The Evening Post*, 28 April 1866. Nicolai Cikovsky, Jr., has identified Eugene Benson as "Sordello." On the other hand, Henry L. Tuckerman (*Book of the Artists* [New York: G. P. Putnam's Sons, 1867], 336) persisted in classifying *Prisoners from the Front* as a genre painting.

26. Eugene Benson, "Historical Art in the United States," *Appleton's Journal of Popular Literature, Science, and Art* 1 (10 April 1869): 46.

27. Nathaniel Hawthorne, for instance, described watching Emanuel Leutze paint his mural *Westward the Course of Empire Takes Its Way* for the Capitol's west staircase ("Chiefly about War-Matters, by a Peaceable Man," *The Atlantic Monthly* 10, no. 58 [July 1862]: 46).

28. A letter from Homer's mother to his brother Arthur on 28 October 1861 describes Homer as being in Washington (private collection, quoted in Chronology, this volume). Homer was in Washington again at least by the early part of the following year. He sailed from Alexandria, Virginia, on 2 April 1862, judging from the message "I am off tomorrow" on the back of a drawing which Homer also inscribed "Soldiers leaving Alexandria for Fortress Monroe/April 1st" (private collection).

29. For differing opinions on the matter of possible pictorial sources for *Prisoners from the Front*, see Ellwood C. Parry, *The Image of the Indian and the Black Man in American Art 1590-1900* (New York: Braziller, 1974), 140, Cikovsky, cited above, and Christopher Kent Wilson, "A Contemporary Source for Winslow Homer's *Prisoners from the Front*," *Source: Notes in the History of Art* 4, no. 4 (Summer 1985): 37-40. Parry suggests a European prototype and Cikovsky believes Homer used none. At the very least, Homer was aware of illustrations of military exploits in the popular press, as Wilson also notes, but they themselves reflected traditional prototypes.

30. The painting had been acquired by a group of citizens who presented it to the Boston Public Library. "Domestic Art Gossip," *The Crayon* 6, no. 8 (August 1859): 256.

31. See *Bulletin of the American Art-Union* 4 (November 1851): 132, for a review of the painting when exhibited in New York City.

32. Leutze's *Washington at the Battle of Princeton* was discussed in *The Crayon* 6, no. 10 (November 1859): 349, and 7, no. 2 (February 1860): 56, on the occasion of the painting's exhibition in the Studio Building, New York. His painting of Madame Lafayette was shown at the Derby Gallery, New York, 1863 (*The National Museum of American Art's Index to American Art Exhibition Catalogues from the Beginning through the 1876 Centennial Year*, compiled by James L. Yarnall and William H. Gerdts [Boston: G. K. Hall & Co., 1986], 3: 2199). Huntington's "great historical picture of Mrs. Washington's Reception" was commented upon in *The Crayon* 8, no. 7

(July 1861): 151, and later reviewed at length in *The New Path* 2, no. 11 (November 1865): 176-178. A review of Powell's *Perry Transferring His Flag* appeared in the *New York Times*, 14 October 1864.

33. *The New York Leader* 8, no. 42 (18 October 1862): 1.

34. "His success is unquestionable," pronounced a reviewer of Carpenter's painting shown at the Crayon Gallery (*The New-York Times*, 21 October 1864).

35. For example, in the National Academy of Design exhibition of 1860 – no. 573, *Washington at Braddock's Defeat* by Leutze; 1861 – no. 446, *Madame Lafayette, with Her Daughters, joining Her Husband in the Prison at Olmütz, 1795* by Leutze; 1862 – no. 151, *Mercy's Dream* by D. M. Carter, accompanied by a passage quoted from *Pilgrim's Progress*; 1863 – no. 83, *An Episode of the War; the Cavalry Charge of Lt. Harry B. Hidden*, accompanied by a descriptive piece about the incident, by V. Nehlig; 1864 – no. 154, *Intended Assassination of Queen Elizabeth by a Scotch Lady in Male Attire*, again with explanatory piece, by Louis Lang; 1865 – no. 394, *The Two Marys at the Sepulchre*, with scriptural verses, by Robert Weir.

36. The fair was held to aid the United States Sanitary Commission.

37. Although the phrase "a study from nature" was often applied to paintings at the time, one critic referred to *The Initials* in that way when the painting was shown a year later under its present title; see *The New York Leader* 9, no. 24 (17 June 1865): 5. For its relation to the Civil War, see Giese, "Winslow Homer's Civil War Painting *The Initials*: A Little-Known Drawing and Related Works," *The American Art Journal* 8, no. 3 (1986): 4-19.

38. It may be significant that Homer compacted Barlow's form in the painting. It conforms more closely in fact to that of Washington in Leutze's famous canvas.

39. *Bulletin of the American Art-Union* 4 (November 1851): 131.

40. Leutze also compiled his image of Washington; he relied upon the bust-length portrait of Washington originally sculpted in 1785 by Jean Antoine Houdon and the body of an American painter in Düsseldorf, Worthington Whittredge, who modeled for Leutze; see "The Autobiography of Worthington Whittredge, 1820-1910," ed. John I. H. Baur, *Brooklyn Museum Journal* (1942): 22-23.

41. Garry Wills discusses Lincoln's association of the Civil War period with 1776 in *Inventing America: Jefferson's Declaration of Independence* (Garden City, N.Y.: Doubleday, 1978), xiii-xx.

42. The reception of Leutze's painting, the Metropolitan Fair catalogue notwithstanding, was mixed by the 1860s. Clarence Cook (*The New-York Daily Tribune*, 9 April 1864, quoted in Raymond L. Stehle, *The Life and Works of Emanuel Leutze* [privately printed, 1972], 157) railed against the "spirit in which the subject is treated." He considered the painting "commonplace, not

to say vulgar." George William Curtis, another influential critic of the day (*Harper's Weekly* 8, no. 384 [7 May 1864]: 290), defused Cook's harsh pronouncements (paraphrased by Curtis as "unnatural in conception and extravagant in execution") by attributing them to Cook's pre-Raphaelite bias. Yet another critic (*The New-York Times*, 12 April 1864), while acknowledging the painting's fame, considered Leutze's Düsseldorf training responsible for the "dreadful failure" of Washington's image in *Washington Crossing the Delaware*. In 1867 Tuckerman (1867, 343) praised it as "an effective and impressive work."

43. *Catalogue of the Exhibition at the Metropolitan Fair in Aid of the Sanitary Commission* (New York, 1864), 3. The entry itself is earlier than 1864, as it repeats verbatim one in the Stuyvesant Institute catalogue, *Exhibition of Leutze's Great National Picture of Washington Crossing the Delaware* (New York). Though undated, an advertisement on the inside back cover mentioning an engraving in process of George Caleb Bingham's *Daniel Boone Emigrating to the West* (issued in 1852) suggests that the catalogue dates from the early 1850s.

44. "The publishers print a short descriptive account to accompany the engraving. They remind the public that the most interesting incident connected with the Battle of Saratoga, was the unfurling for the first time the Stars and Stripes, at the surrender of Burgoyne." (*The New-York Illustrated News* 4, no. 93 [12 August 1861]: 238). For a further discussion of the painting, see Doreen Bolger Burke, "Frederic Edwin Church and 'The Banner of Dawn,'" *The American Art Journal* 14, no. 2 (Spring 1982): 39-46.

45. Leutze's *Angel Upon the Battlefield* is illustrated in Barbara Groseclose, *Emanuel Leutze, 1816-1868: Freedom is the Only King*, National Collection of Fine Arts (Washington, D.C.: Smithsonian Institution Press, 1975), 99, no. 110, and in Brucia Witthoft, *American Artists in Düsseldorf: 1840-1865*, exh. cat. (Framingham, Mass.: Danforth Museum, 1982), no. 26.

46. Groseclose, 38, does not really answer her own question as to whether *Washington Crossing the Delaware* was intended for a German or an American audience, possibly because, as she points out, the opportunity to paint a second version for exhibition in America almost immediately presented itself. See Raymond L. Stehle, "Washington Crossing the Delaware," *Pennsylvania History* 31 (July 1964): 269-294, for a discussion of the history of the various versions of that painting.

47. For example, see *Bulletin of the American Art-Union*, 1 November 1851, 131-132, and 1 December 1851, 149.

48. Not under discussion here is the effect of Leutze's training in Düsseldorf, Germany.

49. *Prisoners from the Front*, 24 × 38 in., is the largest of Homer's Civil War paintings, apart from *Pitching Quoits*, 1865 (*cat.no.14*), which measures 26¾ × 53¾ in. At the very least, *Pitching Quoits* is a monumental summation of Homer's paintings of Civil War camp life. None followed it in 1866. Thus, *Pitching Quoits* may be Homer's first attempt at a more "substantive piece," though probably only in formal terms.

50. Daniel Fanshaw, "The Exhibition of the National Academy of Design, 1827: The Second," *The United States Review and Literary Gazette* 2, no. 4 (July 1827): 241ff.

51. The remaining departments in order of importance were "Historical or Poetic Portrait," "Historical Landscape," "Landscapes and Marine Pieces, Compositions," etc., ending with the tenth, "Copies."

52. Fanshaw, 245.

53. Daniel Huntington, *General View of the Fine Arts, Critical and Historical* (New York: G. P. Putnam's Sons, 1851), 42-43.

54. *Bulletin of the American Art-Union*, 1 December 1851, 95; Leutze's statement also appears in Tuckerman 1867, 339, with, however, a slight modification of the last phrase.

55. *The Knickerbocker* (July 1861): 48.

56. William H. Truettner, "The Art of History: American Exploration and Discovery Scenes, 1840-1860," *The American Art Journal* 14, no. 1 (Winter 1982): 4-31.

57. *The Crayon* 5, no. 10 (October 1858): 291.

58. *The Knickerbocker* (October 1852): 475; *The Crayon* 6, no. 1 (January 1859): 25 (actually Rossiter's "design in color" for the painting).

59. *The Crayon* 6, no. 5 (May 1859): 145-146.

60. Jarves, *The Art Idea* (1864; Cambridge: Belknap Press, 1960), 170, 207. Jarves (178) held Leutze's *Washington Crossing the Delaware* to be an example of "his epic style. Bad taste in composition overpowers much that is meritorious in design and execution."

61. *The Round Table* 1, no. 4 (9 January 1864): 53, and no. 2 (26 December 1863): 21.

62. According to tradition and evidence, Homer began to paint in oil late in 1862; see Lloyd Goodrich, *Winslow Homer* (New York: published for the Whitney Museum of American Art by Macmillan, 1944), 17-18.

63. That Homer felt some closeness to Leutze is suggested by Homer's contribution of two drawings to a sale to raise money for Leutze's widow in 1869. See "Executor's Sale of the Effects of the late Mr. E. Leutze . . . [and] Contributions for the Benefit of the Family of the late

Mr. E. Leutze," nos. 70, 71, each listed as "Drawing of a Soldier. Study. Winslow Homer. *passe partout.*"

64. Jarves, 177.

65. Benson, 46. Benson's view of history painting expressed here is noticably similar to that of one expressed more than a decade earlier by the French nineteenth-century painter Gustave Courbet: "Historical art is by nature contemporary. Each epoch must have its artists who express it and reproduce it for the future." (quoted in Nochlin, 28; and *Edouard Manet and the Execution of Maximilian*, exh. cat. (Providence: Department of Art, Brown University [1981], 113, note 64). That such ideas were common currency in America by the 1860s is attested to by the fact that Francis Bicknell Carpenter, a self-taught painter, published in 1866 statements such as "That Art should aim to embody and express the spirit and best thought of its own age seems self-evident." See Carpenter, *Six Months at the White House with Abraham Lincoln: The Story of a Picture* (New York, 1866), 9, quoted in Harold Holzer, Gabor S. Boritt, Hark E. Neely, Jr., "Francis Bicknell Carpenter (1830-1900): Painter of Abraham Lincoln and His Circle," *The American Art Journal* 16, no. 2 (Spring 1984): 69.

66. *Bulletin of the American Art-Union*, 1 December 1851, 149.

67. Benson, 46.

68. For further information on critical expectations for the arts and painters in particular during the Civil War, see Giese, "Winslow Homer: Painter of the Civil War," Ph.D. diss., Harvard University, 1985, ch. 3.

69. See Groseclose, 85, no. 62. Leutze originally intended *Washington at Monmouth* to be the companion piece for *Washington Crossing the Delaware* and had hoped for governmental funds; instead, a private citizen commissioned the work. See also Stehle, "Washington Crossing the Delaware," *Pennsylvania History* 31 (July 1964): 294.

70. These reversions to Civil War imagery post-date 1867: *Rainy Day in Camp* (1871, The Metropolitan Museum of Art, New York); *Foraging* (cited in the catalogue for the National Academy of Design in 1876); *Officers at Camp Benton* (1881, unconfirmed date provided by owner; Boston Public Library, Massachusetts); and adaptations of earlier drawings for *The Century* magazine and its publication on *Battles and Leaders of the Civil War* (1887).

71. I want here to thank Eric Rosenberg for our discussions about Homer and Patricia Burnham and Sara Junkin for their help.

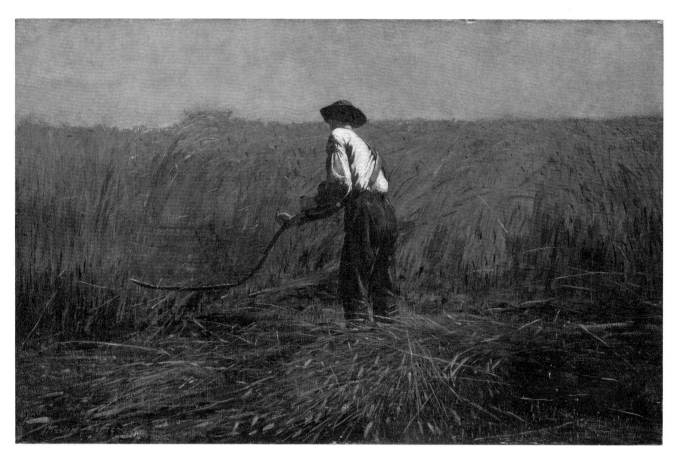

Winslow Homer. *The Veteran in a New Field*, 1865.
Oil on canvas, 24⅛ × 38⅛ in. Signed and dated
lower left: *Winslow Homer 65*. The Metropolitan
Museum of Art, New York. Bequest of Miss
Adelaide Milton de Groot, 1967. 67.187.131.
Cat.no.15

A Harvest of Death:
The Veteran in a New Field

Nicolai Cikovsky, Jr.

Winslow Homer's *The Veteran in a New Field* (*cat.no.15*) was painted and first exhibited in 1865. It is one of his major paintings, a work of enormous expressive and formal power. Yet only recently has its quality and the range and depth of its meaning been properly recognized.[1] What is more, few of Homer's paintings, early or late, display as much of, or display as clearly, Homer's artistic resources – his methods, motives, and mentality – about which we otherwise know very little.

Although *The Veteran in a New Field* hangs in The Metropolitan Museum of Art, New York, and has been frequently reproduced, it does not belong to the canon of Homer's celebrated works.[2] It did not, when it was painted or later, contribute notably to Homer's fame. It is not a large painting, measuring somewhat more than two by three feet.[3] Neither is it a work of his full artistic maturity, although it is one of the first, perhaps *the* first, in which the elements of that maturity are clearly apparent and in full operation. It is not even, although it greatly deserves to be, one of Homer's most acclaimed Civil War paintings, eclipsed in this respect by his *Prisoners from the Front* of 1866 (*cat.no.20*). Nevertheless, *The Veteran in a New Field* is one of Homer's greatest and most moving works. Despite its utter simplicity and extraordinary economy, it is also one of his most richly meaningful ones.

The Veteran in a New Field has only three parts: the veteran himself, seen from the rear and placed, without any attempt at compositional subtlety, unequivocally at the center of the painting; the earth and field of wheat, filling about three-quarters of the canvas; and the band of sky at the top. But despite its succinctness, no painting – not even Homer's *Prisoners from the Front*, which is verbose by comparison – spoke of the issues, events, and feelings at the end of the Civil War as fully, as memorably, and as articulately as this one.

This achievement is all the more remarkable because the *Veteran* was painted in the four or five months following the surrender at Appomattox on 9 April 1865. Homer allowed himself little time to consider the complex consequences of the war's end and to develop his artistic response to them. Yet he seems to have grasped with intuitive suddenness clear and compelling modes of pictorial address. What is more, he did so well before any other American artist managed to do the same. As a result, there is in the *Veteran* forceful, immediate feeling lacking in the later *Prisoners from the Front*. That work offers a more analytical consideration, almost an explanation, of the causes of the war and the characteristics of its belligerents.

The Veteran in a New Field is the more remarkable because Homer made it when he was not only a fledgling painter, but had little or no formal artistic training, so far as is known. Born in Boston in 1836, Homer began his artistic life there as an apprentice lithographer in 1855. Only in his early twenties, after moving to New York in 1859, did he have some slight and occasional instruction in painting.[4] Yet by 1863 he began exhibiting paintings at the National Academy of Design that immediately attracted attention and praise. It is astonishing, really, that *The Veteran in a New Field* was made by someone who had painted for no more than five years and had

exhibited professionally for only two. Not only is the work painted with assurance, it is conceived with maturely developed emotion and understanding. Only three years separate *The Veteran in a New Field* from an illustration by Homer for *Harper's Weekly* like *The War for the Union, 1862 – A Cavalry Charge* (see Giese, this volume, *fig. 6*). Yet in that short time Homer managed to replace conventional military posturings with the most restrained simplicity of form, and with a content that thoughtfully and feelingly expressed the realities of war.

The Veteran in a New Field was not exhibited prominently at the time it was painted. Homer did not show it at the year's major exhibition, at the National Academy of Design, which opened in April, but instead in the annual Artists' Fund Society exhibition in November.[5] This was not because he regarded it less highly than his other paintings of that year, but for the simple reason that it was not finished in time for the Academy exhibition. In fact, it was not even begun. Homer surely thought well of the picture, however, because in 1867, two years after it was painted, he allowed it to be published as a wood engraving in *Frank Leslie's Illustrated Newspaper* (*cat. no. 15 b*).[6] Because the *Veteran* was not prominently exhibited, it generated little of the critical commentary that Homer's works in Academy exhibitions had already begun to do. It was mentioned only twice when it was exhibited, in *The Evening Post* (New York) and *The Nation*,[7] although later its reproduction in *Leslie's* was accompanied by a text that mixed editorial and critical observations.

The texts in *The Nation* and *Leslie's* are the most important. (*The Evening Post* review raises issues of style and stylistic affiliations that require extensive separate discussion.) Both texts mention what nearly all of Homer's critics admired in his art: its truthfulness. Although the writer in *The Nation* objected to the "slap-dash execution" of the picture, he said that "the spirit of the single figure takes the eye from the consideration of faults and foibles" because of the "real human action [of] this one man mowing." The writer in *Leslie's* said, "Mr. Homer is to be warmly com-mended for [his] simple and truthful way" of expressing himself.

However truthful, the painting must surely strike one as more than faithfully descriptive. It is unmistakably symbolic. Its relentless simplicity – the complete absence from it of the incident and anecdote that are, for example, part of Homer's other important paintings of 1865, his Academy entries *Pitching Quoits* (*cat. no. 14*) and *The Bright Side* (*cat. no. 13*) drive one to ponder what the painting stands for, not only what it depicts.

Although the picture must have been this economical in its conception, Homer made it even more so by repainting parts of it to remove not only anything that might be merely pleasing or ingratiating, but even anything that was merely accurate. The critic of *The Nation* found two things wrong with the picture. To slightly repeat him, he called it

a very insufficient and headlong piece of work, slap-dash execution enough in cornfield and suggested trees; . . . Moreover, we are inclined to quarrel with the veteran for having forgotten, in his four years or less of campaigning, that it is with a cradle and not with a scythe alone, that he should attack standing grain.[8]

His use of the word *attack* is entirely although probably unintentionally appropriate. We can now see what was invisible to *The Nation*'s critic: the remains of a cradled scythe that Homer painted out before the painting was exhibited (*fig. 1*). In Homer's painting as we now know it no trees are visible. He painted them out. But their branches are clearly visible in the *Leslie's* engraving (*cat. no. 15 b*). The engraving crops the painting at the right, so that some of the trunk of the tree and not only its branches may have been present in the painting. Homer must have considered the trees to be a detail that detracted from and softened the starkness and austerity he wanted his painting to have, or gave it, however faintly, the narrative implications of a painting like William Sidney Mount's *Farmers Nooning* (*fig. 2*), which, if its trees remained, Homer's *Veteran* would in a general way resemble. Quite as well as his critic, Homer also knew that by the 1860s the cradled scythe was used to cut large fields of grain. Having

fig.1 Unidentified photographer. *Mowing Grain with a Cradle, and Binding by Hand*, reproduced from Fred A. Shannon, *The Farmer's Last Frontier: Agriculture 1860-1897* (New York: Farrar & Rinehart, 1945), 135. Collection of the Library of Congress

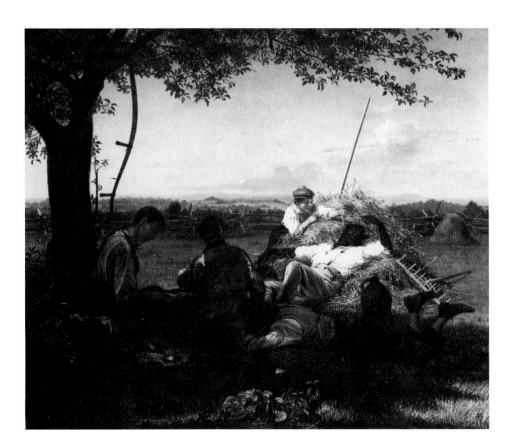

fig.2 William Sidney Mount (1807-1868). *Farmers Nooning*, 1836. Oil on canvas, 20 ⅛ × 24 ⁵⁄₁₆ in. The Museums at Stony Brook, Stony Brook, New York. Gift of Frederick Sturges, Jr., 1954

at first been precise about that technicality, he evidently found that it interfered with the creation of the painting's ruling symbol.

The painting makes two other important symbolic references that we may consider first. They are still accessible today, but they would have been inescapable to the nineteenth century. One is to the legendary Cincinnatus, who left his farm to assume the dictatorship of Rome and defend it against its enemies, then later relinquished power and office to return to his farm and the occupations of peace. Cincinnatus was obviously a model of republican virtue and thus a special hero to Americans. Because of the veteran's heroic anonymity and, in the painting's lower right-hand corner, a military jacket and canteen that identify the figure as a veteran and tell how recently he had been a soldier, it would have been nearly impossible not to think of Homer's figure as an American Cincinnatus and a modern exemplar of the ideal of civic responsibility that Cincinnatus represented. This was an ideal especially pertinent to the Union cause, for its huge army was composed not of professional soldiers but almost entirely of volunteers.

Homer's painting makes another reference more inescapable than that to Cincinnatus, the famous passage in Isaiah 2:4:
And they shall beat their swords into plowshares, and their spears into pruning hooks; nations shall not lift up sword against nation, neither shall they learn war any more.
Nineteenth-century Americans, steeped in the language and imagery of the Bible, could not fail to detect in Homer's painting its invocation of that unforgettable Old Testament passage. Nor could they fail to see, too, in the months following the internecine slaughter of the American Civil war, the special pertinence of its appeal to healing and its summons to the pastoral pursuits of peace. This reference was underscored by Lincoln's memorable call, in his second inaugural address delivered little more than a month before the war's end, to, "with malice toward none; with charity for all, . . . bind up the nation's wounds."[9] That Homer understood its pertinence is indicated not only by the *Veteran* but by another

painting of 1865, *The Brush Harrow* (see Giese, this volume, *fig. 1*), that similarly, though less obviously, refers to Isaiah. When that work was exhibited in 1866 a critic saw that the horse was branded with the initials "U.S.,"[10] identifying it as a former military horse, another kind of veteran now returned to peaceful undertakings, one who had perhaps pulled the cannons that ravaged the earth and now pulls an agricultural instrument that smooths and heals it.

Readings like these were current at the time Homer made his picture. For instance, an editorial in *The New-York Weekly Tribune* in summer 1865, speaking of the disbandment of the Union army, invoked both Cincinnatus and Isaiah: *Rome took her great man from the plow, and made him a dictator – we must now take our soldiers from the camp and make them farmers. . . . We know that thousands upon thousands of our brave soldiers will return gladly to the pruninghooks and plowshares.*[11]

The painting's allusions to Cincinnatus and Isaiah are essentially didactic or persuasive, addressing as they do issues of republican virtue and pacification posed by the end of the war. But Homer's painting also marks the end of the war in a more celebratory way, as it was marked by other American artists and writers, by a scene of harvest. To a largely agricultural nation, a bountiful harvest was a certain manifestation that peace and plenty had succeeded the trials and denials of war. *Peace and Plenty* (*fig. 3*) is precisely the title of the great painting of harvest by which George Inness proclaimed the end of the war in 1865. The writer in *The Nation* criticized Homer for the size of his wheat – "Such grain!" he exclaimed, "Six feet high at its shortest stalks" – but he mistook here, just as he did when criticizing the absence of the cradled scythe, Homer's symbolic intentions.

Homer exaggerated to produce an emblem of peaceful plenty. But he may also have done so to refer to the actual abundance of the harvest of 1865. An editorial in the *The New-York Times* marvelled, "Here we are in the middle of August, and the earth blooms and grows with all the vigor of June. A harvest of hay absolutely immense

fig. 3 George Inness (1825-1894). *Peace and Plenty*, 1865. Oil on canvas, 77 5/8 × 112 5/8 in. The Metropolitan Museum of Art, New York. Gift of George A. Hearn, 1894

has been gathered; the yield of wheat has been generous and even ample, . . . the earth brings forth abundantly."[12] Yet this, too, was emblematic, as the *Times* editorial went on at considerable but helpful length to make clear:

We rejoice in the great and undeserved blessings showered upon our land by an ever kind and merciful Providence . . . [and] this year it would seem that a kind Providence has taken us under special protection. . . . If ever a nation has especial provocation to gratefulness, we are that nation. Precipitated into a civil war of unequaled difficulties, suddenly forced upon circumstances that might have tried and broken the power of the oldest nation on earth, we have had the kind and constant favor of Heaven to an extent so remarkable that it would almost seem like a direct interposition on our behalf. . . . And if we are unable to appreciate causes for thankfulness, let us imagine the result had it happened that the crops of 1862 or 1863 had failed. With a million and a half of men in the army to feed, to say nothing of the people at large, where would we have been but for the inestimable blessing of a liberal harvest? The complete failure of a single harvest would have been the complete failure of a great nation. . . . The good Providence is not yet withdrawn, but, as if to mark with distinguished favor the course of our loyal people, this year crowns the whole with increased abundance.

Nothing less than America's survival as a nation, in other words, rested on abundant harvests; and nothing less than Providential interposition and Divine sanction of the Northern cause was read into them. Harvests were not ordinary events. They were invested with solemn and sacred meanings and were regarded in their abundance as tokens of Providential favor and support. The bountiful harvest that followed the war was a crowning sign of Divine approval and sanctification of purpose. That is why, of course, harvests were used to celebrate the conclusion of the war in images in art and literature. That is why Homer's veteran is harvesting, rather than performing some other act. And that is why, taxing the credulity of *The Nation*'s critic, Homer made

his grain so tall. For he was invoking supernatural significance, not depicting mere natural growth.

It is remarkable that an image so minimally simple, by such a slightly trained and still-young artist, contains so many levels of significance and points in so many directions of meaning. But the work is yet more remarkable. Those of its meanings and messages that have been considered so far, however artfully and subtly they are put, tend ultimately to a mode of public patriotic utterance. There is, however, another side to the painting, a more private and perhaps a darker side; not one that delivers messages but evokes and expresses feeling. In this aspect the understanding, insight, and irony that are the major ingredients of Homer's mature artistic achievement are apparent, wholly formed, for the first time in his art.

If the immense simplicity of the painting was designed to make it emblematic and symbolic, that simplicity also makes the work expressive by giving it a cast of seriousness, gravity, and even the sinister. Its formality causes the veteran to seem engaged less in an ordinary, normal event of life than in some solemn ritual, enacted under a blue sky that is in its intensity less cheerful than ominous.

But Homer not only created an expressive mood and a climate of feeling. He deliberately made an image of solemn and disturbing meaning. The writer in *The Nation* criticized Homer for what he believed to be the oversight of equipping the veteran with a single-bladed rather than a cradled scythe. But, as we are now able to see, Homer had originally depicted a cradled scythe and then changed it to a single-bladed one. Why this knowing anachronism, at a time not only when cradled scythes were in common use, but when, moreover, because of the shortage of manpower during the war, manual reaping was being replaced by the mechanical reaper?[13] The answer can only be, I think, that the attribute of the single-bladed scythe transformed the mowing veteran into the familiar and unmistakable symbol of Death as a reaper.

With this transformation Homer no longer summons us to think of republican virtue, or pacification and reconciliation, or Providential guidance and support. He no longer supplies such consoling abstractions. He recalls us instead to grim reality. He reminds us that the veteran harvesting bountiful golden wheat — facelessly dispassionate, terrifyingly anonymous — was once the harvester of men. Homer reminds us of "the blank horror and reality of war," as Alexander Gardner's text accompanying Timothy O'Sullivan's photograph of the battlefield at Gettysburg (*fig.4*) put it; reminds us of the *Harvest of Death*, as Gardner entitled O'Sullivan's photograph,[14] in which the veteran once participated as he does now in the harvest of grain. O'Sullivan's photographic image did not, so far as one can tell, influence Homer's painting in any usual way, although it was published by Gardner in 1865 and was thus available to Homer.[15] But an engraving related to it (*fig.5*) appeared in *Harper's Weekly* — to which Homer was a major contributor — in July 1865, precisely at the time when it could contribute to the conception of an essential meaning of the *Veteran*. It might also be helpful to know, as Homer could have known, that two of the bloodiest episodes of the battles of Gettysburg and Antietam took place in wheat fields.

Homer's painting is not as gruesome as O'Sullivan's photograph. But it is not less compelling. Death's grim presence in a setting of peaceful harvest, the moving and disturbing juxtapositions of the pleasures of harvest and the horrors of war, of fruitfulness and death, make the terror of war just as unforgettable and inescapable — more so, perhaps, because of the irony of the intimacy, in the same confined context, of highly charged symbols of life and death.

By virtue of its irony, Homer's is not a conventional and commonplace image of joyful harvest. He was not alone in perceiving the sinister meanings of the harvest and the symbolic dimension of the reaper. In 1871 a critic saw these meanings in Constant Mayer's *The Mower*:
A strong man, muscular and full of life, cuts swaths with a suggestiveness and force which make us forget the farmer, and think of him as some symbolical figure, like Old Father Time. He cuts so firm and clean, you pity the blades of grass beneath his

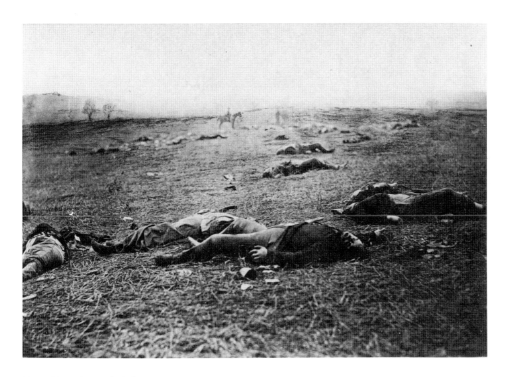

fig.4 Timothy H. O'Sullivan (1840-1882).
Harvest of Death, Gettysburg, July 1863. Silver
print (collodion negative). *Gardner's Photographic
Sketch Book of the War* (Washington, D.C.: Phil[i]p
& Solomons, Publishers, 1866), pl. 36. Collection
of the Library of Congress

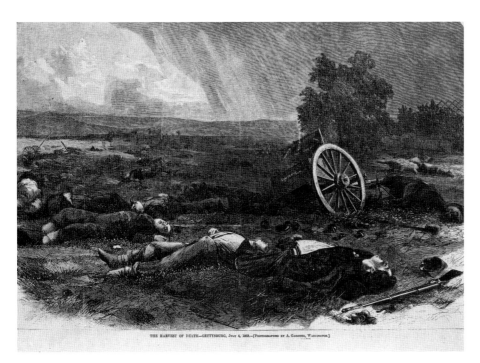

fig.5 Unidentified artist. *The Harvest of Death—
Gettysburg, July 4, 1863.—[Photographed by A.
Gardner, Washington].* Wood engraving after
Alexander Gardner, 9 × 13⅝ in. *Harper's Weekly* 9,
no. 447 (22 July 1865): 452. Collection of the
Library of Congress

fig.6 Winslow Homer. *1860-1870*. Wood engraving, 13 × 21¾ in. *Harper's Weekly* 14, no. 680 (8 January 1870): 24-25. Bowdoin College Museum of Art, Brunswick, Maine. Museum purchase

fig.7 Winslow Homer. *Our Watering-Places – The Empty Sleeve at Newport*. Wood engraving, 9¼ × 13¾ in. *Harper's Weekly* 9, no. 452 (26 August 1865): 532. National Gallery of Art, Washington, D.C.

scythe, and involuntarily think of a Fate, or the "Reaper whose name is Death," or some other inexorable force. . . .[16]

In 1879, another critic saw them in E. L. Henry's *Children at Play*:

Children have stopped on a path near some ancient tombstones, and are playing so earnestly that they do not notice the gray-haired sexton, who, unlike in his dress to Time in the primer, but like him in occupation, is using his scythe on the rank grass about the tombstones under the shadow of the church.[17]

Most memorably, but much later, Vincent van Gogh sensed similarly sinister meanings in his warm and sunny painting of *The Reaper*: "I see in this reaper," he wrote his brother Theo, "the image of death, in the sense that humanity might be the wheat he is reaping."[18]

In 1870, five years after painting the *Veteran*, Homer made an illustration for *Harper's Weekly* that, although it is of no comparable artistic importance, assures us that the meanings just proposed are not mistaken. Entitled *1860-1870* (*fig.6*), it summarizes the momentous events of the decade of the 1860s by an openly symbolic use of images, so that there can be no question here at least that Homer was capable of symbolic speech. Two parts of the illustration are particularly informative. One is the figure of Time at the bottom. Time, as Death's agent, is commonly synonymous with it; here Time is virtually synonymous with Homer's veteran. The other is the group of mowers still wearing their uniform caps and placed immediately below a field of battle where a surrender takes place. These connections link the fields of harvest and battle almost seamlessly, so that their sinister intimacy cannot be missed.

In this connection one ought not neglect the title that Homer gave his painting: *The Veteran in a New Field*. Like the painting itself it is deceptively simple. It seems to be merely descriptive, but, like the painting, it is not. To what does the "new field" refer? Not to the field of grain. It is not new but mature, ready for harvest. The reference is to the veteran's new field of activity, his new occupation, made by an almost punning play

on words. (Homer was fond of punning titles in his early works. For instance, the title of another painting of 1865, *"Army Boots"* (*cat.no.16*), refers both to the two orderlies – "boots" – and to the footwear they are polishing.) In recognizing the veteran's new field one cannot avoid thinking of the older one, particularly as the military jacket and canteen tell how very recently one has replaced the other.

The association that Homer makes between harvesting and warfare, one must hasten to say, is not one that he alone perceived during the Civil War. It often occurs in poetry. For example, there is this stanza in Bret Harte's *The Reveille* (1861):

"Let me of my heart take counsel –
War is not of life the sum;
Who shall stay and reap the harvest
When the autumn days shall come?"
But the drum
Echoed, "Come!"
Death shall reap the braver harvest!"
Said the solemn sounding drum.[19]

Or this is the anonymous *The Modern Gilpin. A Ballad of Bull Run*:

Past fields where just the day before
The harvest-scythe was sweeping,
They rushed where soon its human sheaves
Death's sickle would be reaping![20]

In John Piatt's poem, *The Mower in Ohio*, a father at home has a vision of his sons, all soldiers at the front, as mowers.[21] There is a great deal more.[22]

While quoting verse, there are these lines in a poem entitled *The Empty Sleeve*:

It [the empty sleeve] tells of a battle-field of gore –
Of the sabre's clash – of the cannon's roar –
Of the deadly charge – of the bugle's note –
Of the gurgling sound in the foeman's throat –
Of the whizzing grape – of the fiery shell –
Of a scene that mimics the scenes of hell.[23]

One of Homer's illustrations for *Harper's Weekly* was entitled *Our Watering-Places – The Empty Sleeve at Newport* (*fig.7*).[24] It appeared just at the time that Homer was at work on, or was conceiving, *The Veteran in a New Field*. The illustration's meaning – the presence of war and death, which for the poet the empty sleeve so forcefully evoked,

in a setting of peace, pleasure, and youthful beauty – is precisely the same as the meaning of the painting, though without its resonance.[25]

Another aspect of meaning can still be found in this uncommonly rich picture.

It is fairly certain when Homer painted it. He did not, as we know, submit it to the National Academy of Design exhibition in April 1865. Visitors to Homer's studio in New York earlier that year described his other Academy entries, but not the *Veteran*, indicating that it was not yet begun.[26] Its subject alone tells that it could not have been painted before 9 April 1865. It is not a war or camp scene, as were both *The Bright Side* (cat.no.13) and *Pitching Quoits* (cat.no.14), which he sent to the Academy. As we need no reminding, it is a scene of the war's aftermath. It can thus only postdate the surrender at Appomattox. The painting was completed by November in time to be included in the Artists' Fund Society exhibition. *The Veteran in a New Field* was, in other words, painted in the five or six months between the surrender in April and the Artists' Fund exhibition that fall, and, given the scene of harvest that it depicts, possibly as late as August or September.[27] It is interesting to know that. What is more interesting is why Homer exhibited the painting in the less important Artists' Fund exhibition in the fall instead of reserving it for the Academy exhibition the following year, where it would receive the kind of public and critical attention seldom given to works in Artists' Fund exhibitions. We do not know why. It is plausible that he felt he could not wait, that he needed to address urgent circumstances with equal urgency, that postponement might diminish meanings, that time might discharge his own and his audience's feelings.

Nothing, not even Union victory, touched Northern Americans so profoundly in summer 1865 as the death by assassination of Abraham Lincoln on 15 April. They were plunged into national mourning and moved to universal expressions of grief. As the editorial in *The Evening Post* on the day of Lincoln's death said, "The tears and lamentations of twenty millions of people, who are stricken as they never were before by the death of a single man, follow him to his bier."[28] It was that event, that profound national tragedy, that Homer memorialized in the *Veteran*.

In addition to everything else that the painting is about, it is Homer's expression of grief, his elegy upon the death of Lincoln. That is why he could not wait to show the painting, compelled to do so by the climate of feeling in and for which it was made, and by the very ardor of his own feelings. For about the next fifteen years Homer would receive criticism such as that by the critic of *The Nation*, which objected to violations of conventional standards of finish. The brief time in which Homer could have made the picture suggests that it was painted quickly, perhaps even in a state of aroused emotion. No matter how cautious one must be in imposing recent formal understandings on nineteenth-century paintings, it is difficult not to feel that the bold, impulsive handling of the wheat field, which fills so much of the picture, announces powerful, expressive need, or not to see the feeling recorded by the brushwork.

Yet as directly as the work might in this way embody Homer's feelings, the painting's function as an elegiac image is established by other formal means, chiefly by a rigorous pictorial economy that endows the work with monumental solemnity. But its memorial character is also established, as other aspects of the painting's meaning have been, by symbolic reference, particularly to the figure of Death as a reaper. Biblical passages evoked by that figure carry funerary associations, such as Isaiah's "flesh is grass" (40:6), and Job's "man that is born of woman is of few days, and full of trouble. He cometh forth like a flower, and is cut down" (14:1-2) – the latter a passage that inspired images for, and was used as an epigraph on, American funerary monuments. Related to this figure was the use, on such monuments, of sheaves of wheat as symbolic devices (*figs.8, 9*), and the use, too, of actual sheaves of wheat to decorate coffins before interment. All this, joined to the solemnity of its form and its central symbol of death, conspires to make *The Veteran in a New Field* into a kind of mourning image, Homer's

fig.8 Gravestone of Charles J. F. Sherman at Mount Auburn Cemetery, Cambridge, Massachusetts. Reproduced from Edmund V. Gillon, Jr., *Victorian Cemetery Art* (New York: Dover, 1972)

fig.9 Detail of gravestone at Quabbin Reservoir, Massachusetts. Reproduced from Edmund V. Gillon, *Victorian Cemetery Art* (New York: Dover, 1972)

pictorial lamentation on the death of Lincoln, cut down by an assassin.

The Veteran in a New Field is a consciously and deliberately symbolic painting. Homer can have changed the cradled scythe to a single-bladed scythe for only one reason: not to make his painting more beautiful and certainly not to make it more accurate (just the opposite), but to make a symbol, the symbol of Death. No painting by Homer tells us with as much certainty that Homer made a symbol – and, because of the changes wrought by time, almost shows him making it.

At virtually the beginning of his artistic career, therefore, Homer possessed both the intention and the intelligence to create symbolic meaning. Not every picture that followed the *Veteran* was as clearly and richly symbolic, or even symbolic at all; few, after all, were made in such momentous circumstances. But Homer's ability to invent symbols and manipulate symbolic references becomes a potential of his pictorial practice that any interpretation of his later art must take into account.

There is something else about the *Veteran* that may in another way illuminate Homer's artistic purposes and practices. When the painting was reproduced as a wood engraving in *Frank Leslie's Illustrated Newspaper* in 1867, two years after it was painted, it was accompanied by a text that read, in part, as follows:

One of the most conclusive evidences of the strength of a republican form of government is the way in which our army has disbanded, each man seeking again the sphere of usefulness which he left only temporarily, to aid the government in its need. The taunts of our enemies in Europe, and the predictions they kept constantly uttering, that even if we escaped the danger of drifting into a military despotism, we would find, when the army was disbanded, that the country would be filled with men who had been demoralized by years spent in its service, shook the faith of even many thoughtful persons who believed in the republican system. Now, however, that the war is over, and all such fears are shown to be groundless, we can well congratulate ourselves on the manner in which the

veterans returned to the old fields, or sought new ones, since in this we find one of the surest proofs of our political system.[29]

This text was written two years after Homer painted *The Veteran in a New Field*. Image and text are not contemporary and for this reason, therefore, we are not obliged to assume that the text describes what the picture was about. Yet surely it does. Whether the huge Union army would disband peacefully and conscripted soldiers demoralized and brutalized by war would return to civilian life, as they had not done after European wars, was a source of deep apprehension for Americans in the months following the end of the war in 1865. As an editorial in the *New York Herald* said at that time, "the thought of this disbandment and of the return of soldiers to their Northern homes filled many persons with alarm."[30] Expression of concern was so frequent, and the concern itself was so real, that no alert and intelligent person — of the kind that other aspects of *The Veteran in a New Field* show Homer to have been — could have escaped them. The title of Homer's painting, the one it always bore and that Homer himself certainly gave it, tells, of course, that this is what his painting was about, as do, within the painting itself, the jacket and canteen that identify the figure as a recent soldier just returned to peaceful occupations, and which provide the measurement of his changed state. In other words, the painting's reference to disbandment was manifestly clear, and it was no less manifestly intended by Homer.

But was Homer memorializing disbandment as a historical occurrence? If so, should *The Veteran in a New Field*, in addition to everything else, be understood as a type of history painting? Perhaps. Americans were certainly aware that the dispersal of the volunteer army following the Civil War was an unprecedented historical phenomenon, of the sort that might deserve a memorial.

But disbandment was regarded as considerably more than an episode of history. The *Leslie's* writer, as we have heard, said it was "evidence"

and "proof" of the strength of republican government. And Walt Whitman put the matter more eloquently and gave it a finer point: "The peaceful and harmonious disbanding of the armies in the summer of 1865," Whitman wrote, was one of the "immortal proofs of democracy, unequall'd in all the history of the past."[31]

The Veteran in a New Field, then, is an image of an "immortal proof of democracy." Homer had to know that his subject, or the event to which it so inescapably referred, carried this particular and essentially political meaning. If so, then Homer's painting can be taken as evidence of awareness and belief. It provides evidence that Homer — who seemed so cool and detached, so much the uninvolved observer, almost the Baudelairean dandy (*fig. 10*) — did believe, and was engaged.[32] And the painting offers evidence of what he believed, what his painting's subject was an "immortal proof" of: democracy. Homer's *Veteran*, representing the peacefully disbanded army, symbolizes democracy understood as Whitman understood it, the central ideal and distinguishing principle of America, from which it was inseparable. ("The words America and democracy," said Whitman, "are convertible terms.")[33]

Homer was not a prophet and theoretician of democracy like Whitman. But if it is possible to regard *The Veteran in a New Field* as a democratic picture, its subject knowingly a proof of democratic ideals and in that way evidence of Homer's belief in them, it may, perhaps, give substance to the possibility that Homer somehow shared a democratic faith like Whitman's, and what is more, an ambition like Whitman's to make a democratic art.

The most apparent way in which such an ambition may be visible during roughly the first fifteen years of Homer's artistic practice, until his art changed dramatically in the early 1880s, is through subject matter. In general, of course, by depicting ordinary people in commonplace acts and settings, all of Homer's subjects are democratic. But the democratic character of some

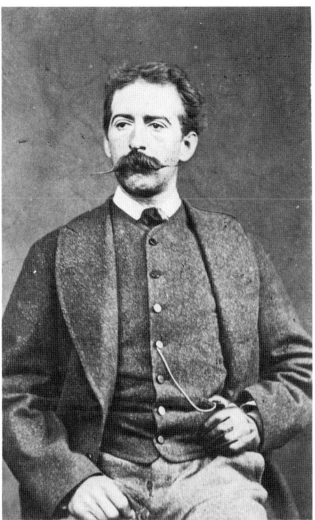

fig.10 Bautain. *Winslow Homer in Paris*, 1867.
Carte de visite photograph. Bowdoin College
Museum of Art, Brunswick, Maine. Gift of the
Homer Family

subjects seems to have an almost ideological edge, almost the quality of a pedagogical demonstration.

For example, the principal figure in *Prisoners from the Front* (*cat.no.20*), the Union officer at the right, is General Francis Channing Barlow. Barlow was not a professional soldier, but enlisted as a private at the beginning of the war and rapidly rose to general rank. For this reason, as well as for his exemplary uprightness and exceptional heroism, he was an ideal representative of an officer in the army of a democratic republic. Homer surely understood this, for that is clearly the role in which Barlow is cast in his painting, made explicit by the emphatic contrast with the aristocratic Confederate officer.[34]

Almost all of Homer's Civil War paintings, as the naturalist John Burroughs said in 1866 in speaking of his friend Whitman's Civil War poetry, are "in obedience to the true democratic spirit." Although he might as well be describing Homer's art (*cat.nos.7, 14*), Burroughs went on to say of Whitman that "attention . . . is not drawn to the army as a unit — as a tremendous power wielded by a single will, but to the private soldier, the man in the ranks, . . . still a citizen engaged in the sacred warfare of peace. Always and always the individual."[35] So much did Homer avoid the glorification of the heroic personality, it seems, that he more than once depicted its complete opposite (*cat.no.7*).

Such a postwar subject as *Croquet Scene* (*fig.11*) reflected the popularity of a new sport.[36] Croquet was healthful and provided opportunities for dalliance. But one of its features was a special equality of the sexes; it was a game that, in competition with men, women could win. Perhaps that is why in Homer's croquet paintings where both men and women appear the women are the larger and dominant figures.

Whitman spoke of women in democracy as the "robust equals" of men[37] and described the traits of their equality almost as they appear in Homer's art:

fig.11 Winslow Homer. *Croquet Scene*, 1866. Oil on canvas, 15 ⅞ × 26 ⅛ in. Collection of The Art Institute of Chicago. Friends of the American Art Collection

They are tann'd in the face by shining suns and
 blowing winds,

. .

They know how to swim, row, ride, wrestle,
 shoot, run . . .
They are ultimate in their own right – they are
 calm,
clear, well possess'd of themselves.[38]

Homer depicted Long Branch, New Jersey, several times beginning in 1869 (*fig.12*) because it was just then a newly popular summer resort, but also because it had a distinctly, for many a vulgarly, democratic character: "Long Branch . . . is perhaps better in accord with the spirit of American institutions than any other of our watering-places. It is more republican . . . because within its bounds the extremes of our life meet more freely."[39]

Through railroads, steamships, and by other means, postwar Americans attained after the Civil War a democratic access to nature that was frequently Homer's subject, an access fundamentally different from the essentially private and privileged communion with nature that pre-war Americans enjoyed.[40]

Schools (*fig.13*), which Homer depicted prominently in the early 1870s, were the cornerstones of American democratic civilization, "as vital to our political system," said *The New-York Weekly Tribune* in 1870, "as air to the human frame."[41]

At the same time that he painted democratic subjects like these, Homer may also have attempted as part of the same project to fashion a democratic style. To suppose so, at any rate, can offer one explanation for the most visible, novel, and for many of his contemporaries most troublesome, stylistic aspect of the art of his early maturity.

fig.12 Winslow Homer. *Long Branch, New Jersey,*
1869. Oil on canvas, 15 × 21 ½ in. Museum of Fine
Arts, Boston. Charles Henry Hayden Fund

Homer's critics in the 1860s and 1870s were
"perplexed" by the incompleteness of both his
style and his pictorial propositions.[42] His style was
called "coarse" and "careless."[43] Of his appar-
ently incomplete pictorial ideas a critic wrote in
1876, "he should concentrate all his talent on a
single picture, and finish that satisfactorily"[44] – in
other words, carry his idea to customarily intelli-
gible completeness. Homer was criticized again
and again for lack of refinement and resolution.
But it did not make him change, for he evidently
regarded favorably, as we do, what his critics
regarded as faults. That these attributes were
deliberately rather than by default part of Homer's
art, intentional and not accidental, is suggested
also by their resemblance to the stylistic openness
of Whitman's consciously and carefully fashioned
democratic literature.

There is no sanction for Whitman as a direct
influence on Homer, even though in 1883, shortly
after the period of Homer's work that here con-
cerns us, a critic noted "the same rude virility and
independence, with the same disregard for con-
ventional forms" in both artists.[45] Still earlier,
what one might call Whitmanism entered
Homer's circle through his friend, the artist and
critic Eugene Benson, who, in 1868, was linked to
Whitman as one of those who "crave a literature
that shall be truly American."[46] But just as Whit-
man's especially articulate expression of the
aspects and ideals of American democracy sup-
plies texts in poetry and prose that elucidate
Homer's subject matter, Whitman's literary style
can serve as a model of Homer's.[47]

The two most apparent and to his contempo-
raries most puzzling and objectionable traits
of Homer's art were the "rude" and "coarse"
suggestiveness of its style and the seemingly

fig.13 Winslow Homer. *Snap the Whip*, 1872. Oil
on canvas, 24 ¼ × 36 ½ in. The Butler Institute of
American Art, Youngstown, Ohio

incomplete, even fragmentary, form of its pictorial propositions. These traits were visible in all his art of the later 1860s and 1870s in both oils and watercolors, but they were epitomized in exhibitions of the American Water-Color Society. In 1875 Homer showed as many as thirty-four watercolors and drawings and in 1879 his twenty-nine works apparently comprised an entire portfolio of watercolors and drawings, ones of such brevity that they were referred to as "art stenography."[48] One is reminded by this of the features that most clearly marked much of Whitman's literary art, his deliberately suggestive incompleteness of form and his enumerative profusion of imagery. The features of Homer's style and artistic practice epitomized in these exhibitions of the 1870s may have been Homer's way, as they were Whitman's, of making an American language of style that captured and conveyed in its artistic form, as a style of more conventional

means and methods was incapable of doing, the unprecedented and always shifting formations, the unresolved and perhaps never resolvable multiplicity of American democratic life.

1. This article was first presented as a paper at Arizona State University in 1981 and later in enlarged form at a colloquium at the Center for Advanced Study in the Visual Arts, National Gallery of Art, Washington, D.C. Christopher Kent Wilson, "Winslow Homer's *The Veteran in a New Field*: A Study of the Harvest Metaphor and Popular Culture," *American Art Journal* 17 (Autumn 1985): 3-27, discusses the painting from "an agrarian and religious point of view," and examines "the popular metaphors and images" that shaped the consciousness by which it was understood. We inevitably cover some of the same ground, rely on the same sources, and come to some similar conclusions and interpretations. But it is perfect evidence of the extraordinary subtlety and richness of the painting itself that it can nourish two differing but complementary considerations.

2. It is prominently reproduced in: Albert Ten Eyck Gardner, *Winslow Homer, American Artist: His World and His Work* (New York: Clarkson N. Potter, [1961]), 55; John Wilmerding, *Winslow Homer* (New York: Praeger, 1972), fig. 2-22; Julian Grossman, *Echo of a Distant Drum* (New York: Abrams, 1974), pl. 197; John Wilmerding, "Winslow Homer's Creative Process," *Antiques* 107 (November 1975): 965; and Natalie Spassky, *Winslow Homer* (New York: The Metropolitan Museum of Art, 1981), pl. 1.

The painting is thoroughly discussed in Natalie Spassky, *American Paintings in the Metropolitan Museum of Art* (New York: The Metropolitan Museum of Art in association with Princeton University Press, 1985), 2:433-437.

The Veteran in a New Field came to The Metropolitan Museum of Art in 1967 as the bequest of Miss Adelaide Milton de Groot. It does not appear in two important early Homer monographs – William Howe Downes, *The Life and Work of Winslow Homer* (New York: Houghton Mifflin, 1911), and Lloyd Goodrich, *Winslow Homer* (New York: Whitney Museum of American Art, 1944) – that predated that gift. Its absence from Gordon Hendricks, *Life and Work of Winslow Homer* (New York: Abrams, 1979), like so much else about the book, must be merely capricious.

3. None of Homer's paintings of this period are large, probably because of the smallness of his studio. Thomas Bailey Aldrich, "Among the Studios. III," *Our Young Folks* 2 (July 1866): 395.

4. See Hendricks, 41-42. National Academy of Design records show, however, that Homer registered in the 1863-1864 life class.

5. The exhibition opened 7 November in the National Academy of Design building.

6. 24 (13 July 1867): 268.

7. "American and French Art. Pictures in the Artists' Fund Society Exhibition," *The Evening Post*, 23 November 1865; "Fine Arts. The Sixth Annual Exhibition of the Artists' Fund Society of New York," *The Nation* 1 (3 November 1865): 663-664.

8. *The Nation*'s critic was Russell Sturgis, a founding member of the American pre-Raphaelite group, the Society for the Advancement of Truth in Art. That accounts for the character of his criticism – its admiration of Homer's truthfulness, but also its compulsive alertness to errors of fact.

9. 4 March 1865, in *The Collected Works of Abraham Lincoln*, ed. Roy L. Basler (New Brunswick: Rutgers University Press, 1953), 8:333.

10. "The horse is used up, or was never meant to be used, although marked U.S." ("National Academy of Design: Forty-first Annual Exhibition," *The New York Leader* (12, no. 16 [21 April 1866]). The *U.S.* is not now visible.

11. 30 September 1865.

At the beginning of the war, however, there was a considerable amount of reversed Isaiahianism, such as the following stanza from C. H. Webb's *The Two Furrows* (*Harper's Weekly* 15 [3 August 1861]: 482):

> The blacksmith's arms were bare and brown
> And loud the bellows roared:
> The Farmer flung his plow-share down –
> Now forge me out a sword!

12. "The Blessed Harvest – Provocation to General Thanksgiving," *The New-York Times*, 12 August 1865.

13. See "Trial of the Mowing Machines," *Harper's Weekly* 9 (12 August 1865): 500: "It conclusively proved the superiority of machine over hand labor."

More harvesting machines were produced in the few years of the Civil War than had been turned out during the entire period which elapsed from . . . 1833 to the outbreak of the struggle (Leo Rogin, *The Introduction of Farm Machinery in Its Relation to the Productivity of Labor in the Agriculture of the United States During the Nineteenth Century* [Berkeley: University of California Press, 1931], 93).

14. *Gardner's Photographic Sketch Book of the War* (Washington, D.C.: Philp [*sic*] & Solomons, [1865-1866]), no. 36.

15. See *Catalogue of Photographic Incidents of the War, from the Gallery of Alexander Gardner . . .* (Washington, D.C.: H. Polkinhorn, 1863), in which it is listed as available as a folio, stereo, or album photograph.

16. Susan Nichols Carter, "The Exhibition at the National Academy of Design," *Appleton's Journal* 5, no. 113 (27 May 1871): 619.

17. "Brooklyn Art Exhibition," *The New-York Times*, 27 April 1879. Homer's friend Enoch Wood Perry's *Sharpening the Scythe* (1865), depicting two children watching an old man honing a scythe, expresses in a similar way the same intimation of mortality. See *American Art Selections* 5, Chapellier Galleries [New York, 1975], 37.

18. Letter, September 1889, *The Complete Letters of Vincent van Gogh* (London: Thames and Hudson, [1958]), 3: letter 604.

19. In *Poetical Pen-Pictures of the War: Selected from Our Union Poets*, ed. John Henry Haywood (New York, 1863).

20. In *Personal and Political Ballads*, ed. Frank Moore (New York: G. P. Putnam's Sons, 1864).

21. *Harper's Weekly* 8 (6 August 1864): 497.

22. The image did not only occur in poetry. In Albion W. Tourgee's novel *A Fool's Errand* (Cambridge, Mass.: Harvard University Press, [1879]), 31, a character says, the war is "all over now. I want my parole, so I can go home, and go to killin' grass!" Neither was it confined to literature; Stephen W. Sears, *Landscape Turned Red: The Battle of Antietam* (New Haven: Ticknor & Fields, 1983) gives several examples from both sides: " 'The enemy fell like grass before the mower,' reported Major Orrin Crane of the 7th Ohio" (252); "Colonel F. M. Parker of the 30th North Carolina had warned his men that he would not give the order to fire until the Yankees crossed the ridge and they could see the belts of their cartridge boxes and 'to aim at these.' They obeyed his order so precisely, he added, that their first volley 'brought down the enemy as grain falls before the reaper' " (238).

23. T. Wilmot, "The Empty Sleeve. After the Battle of Mariatown, Mo., September 17th, '61," in Haywood 1863.

24. 36 (26 August 1865): 532. The engraving was accompanied by a sentimental story entitled, "The Empty Sleeve at Newport; or, Why Edna Aukland Learned to Drive."

25. Homer expressed the same thought, at the same time, by the one-legged veteran in *Thanksgiving Day – The Church Porch*, *Frank Leslie's Illustrated Newspaper* 21, no. 534 (23 December 1865): 217.

26. "A Visit to the Studios. What the Artists are Doing," *The Evening Post*, 16 February 1865; George Arnold, "Art Matters," *The New York Leader*, 11 March 1865.

27. If the notice "Winslow Homer has been dividing his summer between labor and recreation at Newport and Saratoga" (*The Round Table* 2 [9 September 1865]: 7) was prompted by his recent return to New York, perhaps he did not begin it until early in September.

28. "The Death of the President," *The Evening Post*, 15 April 1865.

29. *Frank Leslie's Illustrated Newspaper* 24 (13 July 1867): 268.

30. "Coming Home from the Wars – the Orderly Conduct of the Soldiers," *New York Herald* (14 June 1865). See, too, "The Future of the American Soldier," Boston *Evening Transcript*, 14 February 1865, "The Fall of the Curtain," *The Evening Post*, 24 May 1865, and articles like "Work for Soldiers" (10 June 1865) and "Our Returning Soldiery" (24 June 1865) in the *The New-York Weekly Tribune*.

The extraordinary complexity and remarkable success of the return of volunteer soldiers to civilian life is described in Ida M. Tarbell, "Disbanding the Union Army," *McClure's Magazine* 16, no. 5 (March 1901): 400-412.

31. "National Uprising and Volunteering," *Specimen Days* (1881), in *The Portable Walt Whitman*, ed. Mark Van Doren (New York: Penguin, 1977), 406.

32. There is, in this connection, another aspect of the painting's political meaning, or message. One reaction to Lincoln's assassination was a call for revenge and retribution. By memorializing Lincoln's death in an image derived from Isaiah, Homer makes an appeal to reasoned forgiveness.

33. *Democratic Vistas* (1871), in *The Portable Walt Whitman*, 318.

34. See Nicolai Cikovsky, Jr., "Winslow Homer's *Prisoners from the Front*," *Metropolitan Museum Journal* 12 (1978): 168-169.

35. "Walt Whitman and His 'Drum Taps,' " *The Galaxy* 2 (1 December 1866): 611.

36. See David Park Curry, *Winslow Homer, the Croquet Game*, exh. cat. (New Haven: Yale University Art Gallery, 1984).

37. "Democracy," *The Galaxy* 4 (December 1867): 931.

38. "A Woman Waits for Me" [1856], *Leaves of Grass*, in *The Portable Walt Whitman*, 168. Homer depicted these activities in the paintings *High Tide*, *The Bathers* (1870, The Metropolitan Museum of Art) and *The Bridle Path*, *White Mountains* (1868, Sterling and Francine Clark Art Institute, Williamstown, Mass.).

39. Olive Logan, "Life at Long Branch," *Harper's New Monthly Magazine* 53, no. 316 (September 1876): 482. *There is an absence of formality which is absolutely refreshing. You dress as you please, talk with whom you please, and select your own society. . . . Representatives of all classes are to be met, heavy merchants, railroad magnates, distinguished soldiers, editors, musicians, politicians and divines, and all are on an easy level of temporary equality.* ("The Watering Places. Long Branch," *The Evening Post* [28 July 1868]).

[T]*he society at Long Branch, on the whole, is deficient in refinement, cultivation, and high intelligence. . . . The atmosphere of the place is sensuous, crass, and earthy.* ("Long Branch: The American Boulogne," *Every Saturday* 5 [26 August 1871], 218).

40. Perhaps the most famous image of this communion is Asher B. Durand's *Kindred Spirits* (1849, New York Public Library, Astor, Lenox, and Tilden Foundations).

41. "The School Question," *The New-York Weekly Tribune* (6 April 1870). For a discussion of Homer's school subjects, see Nicolai Cikovsky, Jr., "Winslow Homer's *School Time*: 'A Picture Thoroughly National,' " *Essays in Honor of Paul Mellon, Collector and Benefactor* (Washington, D.C.: National Gallery of Art, 1986), 47-69.

42. "Mr. Homer is always perplexing" ("The National Academy of Design. [Second Notice]," *The Art Journal* 2 [1876]: 190).

43. "The fault we are constrained to find with his pictures in general is the coarseness of their execution." ("Fine Arts: National Academy of Design – Fifty-first Annual Exhibition," *The New-York Daily Tribune* [1 April 1876]). "Mr. Homer was never more careless and capricious and trying" (*The Nation* 24, no. 607 [15 February 1877]: 108).

44. Erastus South, "The Water-color Exhibition: A Glance at the Work of Our Prominent Artists," *New York Daily Graphic* (3 February 1876); "it is impossible for Mr. Homer to finish anything" ("Fine Arts. Exhibition of Water Color Drawings to be Opened this Evening," *Brooklyn Daily Eagle* [8 March 1875]); ". . . we do not like to think how long it is since Mr. Homer showed us a finished picture" ("Fine Arts. The American Society of Painters in Water-Colors – Eighth Annual Exhibition," *New York Tribune* [22 February 1875]).

45. "The Water-Color Exhibition. Second Notice," *The New-York Daily Tribune* (19 February 1883).

46. "Literature Truly American," *The Nation* 6, no. 131 (2 January 1868), 7.

47. Whitman's theory and critique of democracy was most fully expressed in *Democratic Vistas*, published it 1871. But part of it was published earlier in *The Galaxy*, to which Homer was also a contributor: "Democracy," *The Galaxy* 4 (December 1867): 919-933, and "Personalism," *The Galaxy* 5 (May 1868): 540-547.

48. "Fine Arts. The Growing School of American Water-Color Art," *The Nation* 28 no. 714 (6 March 1879): 171.

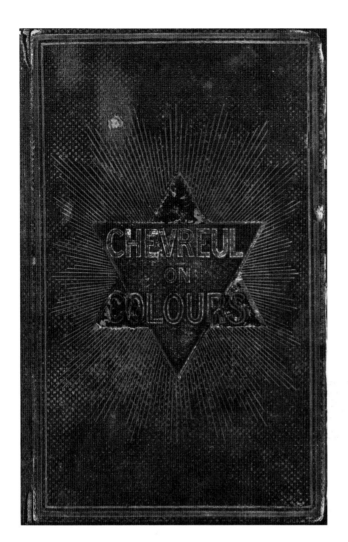
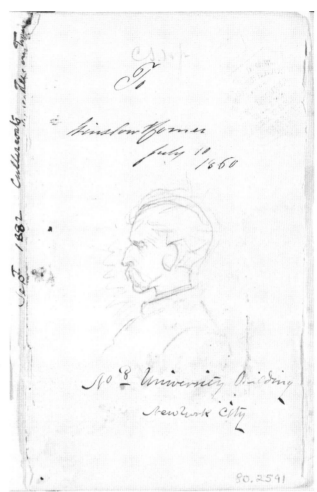

fig. 1 Front cover and front endpaper of Winslow Homer's personal copy of Michel Eugène Chevreul, *The laws of contrast of colour*, translated and edited by John Spanton (London: Routledge, Warnes, and Routledge, 1859). Endpaper shows Homer's pencil portrait of his brother Charles Savage Homer, Jr., ca. 1860. Photographs courtesy of The Margaret Woodbury Strong Museum, Rochester, New York

"A Hand Formed to Use the Brush"

Kristin Hoermann

The examination of an artist's technique can reveal new dimensions of the creative process. By tracing the separate steps and techniques of the painting process, the artist's approach, guiding principles, and desired ends can be discovered. Certain characteristics come to be seen as products of that artist's particular training, others as either instinctual inclinations or conscious efforts to develop and change. After a descent into the underlying layers and subtle details of a painting, one can emerge with a deeper appreciation for the genius of the artist and the power of the work itself.[1]

Winslow Homer was not one to expound on the theory and practice of his art. "He was not much inclined to 'talk shop'. . . . I found him a rather pleasant man to talk with, but he avoided as much as possible talking about himself, or his work, or about pictures," wrote the painter William J. Bixbee, who knew him in the 1890s.[2] Accounts by Homer's contemporaries do occasionally mention his painting practice and thoughts on art. Of these, the three most important sources are discussions with the artist John W. Beatty in 1903,[3] the undated recollections of James E. Kelly, who received a brief painting lesson from Homer,[4] and an interview with George W. Sheldon in 1878.[5] From this interview Sheldon wrote several articles, which include a brief history of Homer's artistic training.

Sheldon describes Homer as virtually a self-taught painter:
In 1861 [he] determined to paint. For a month, in the old Dodworth Building near Grace Church, he took lessons in paint of Rondel, an artist from Boston, who, once a week, on Saturdays, taught him how to handle his brush, set his palette, etc. The next summer he bought a tin box, containing pigments, oils, and various equipments, and started out into the country to paint from Nature.[6]

"His very first picture in oils," according to his friend Russell Shurtleff, who watched Homer paint it, was *Sharpshooter (cat.no.1)*,[7] a very accomplished painting already exhibiting the subtle understanding and careful control of color and space characteristic of Homer's work throughout the Civil War period. To suggest that Homer decided to paint, took four or five rudimentary lessons, spent roughly four months or a year painting studies from nature, and then sat down and painted a masterpiece is perhaps an exaggeration. Nonetheless, Homer came to painting with an innate understanding of what he wanted to do and how to do it. In these first pictures there is no sense of tentative explorations in search of a direction nor of a gradual blossoming of painterly abilities. As expressed by a critic in 1864, "Few if any of our young painters have displayed in their first works so much that belongs to the *painter* as Mr. Homer. His pictures indicate a hand formed to use the brush."[8] Together with the confident, direct brushwork, it is the sensitive perceptions of his eye and mind, and his deliberate control of the elements of painting — color and value, light and space, form and composition — which are most striking in these early works.

The power of *Sharpshooter* derives from its simplicity and concentrated focus. The simplified format was perhaps chosen by Homer, in part, to limit the difficulties of producing this first image in paint. Homer was already an experienced draftsman, having begun his artistic career in the

Boston lithography shop of J. H. Bufford in 1855. However, color brings more varied capabilities and complications to composition and modeling of form, to the creation of space and use of light, than are encountered in black-and-white engraving. In *Sharpshooter* Homer dealt with the problem of color itself by limiting the intensity of larger areas and using bright colors only in small spots. Most noticeable is the bright scarlet indication of an insignia on the soldier's cap, but barely visible are touches such as brilliant blue edges to the tree trunk, salmon pink on the edges of sleeve highlights, as well as dashes of varied bright color in the foliage. This unleashing of bold color in the smallest spots, while the general color scheme is kept carefully under control, is characteristic of Homer's technique throughout these early pictures.

Because Homer has limited the masses of flat color to the center of the picture, he avoids complication of the compositional balance by color. In some measure Homer had difficulty with his incorporation of light and dark value differentiations into the color. In some areas forms melt together because hue and value are too close: the form of the rifle is partially lost in the trees, as is the form of the cocked arm against the jacket.[9] On the other hand, the melding of the hand onto the face, with the ill-defined features, enhances the sense of the man as the extension of the rifle and an instrument of death. The face and hands are silhouetted light against dark, and the body, dark against light. This interaction of values ties the figure into its environment, making the pictorial space more fully realized. The silhouetting of branches against sky spikes the picture with a charged energy, found again in the horizon lines of other paintings. Homer was later to tell Beatty: *I have never tried to do anything but get the true relationship of values; that is, the values of dark and light and the values of color. It is wonderful how much depends upon the relationship of black and white. Why, do you know, a black and white, if properly balanced, suggests color. The construction, the balancing of parts is everything.*[10]

Although Homer has limited the spatial dimension in *Sharpshooter* to a shallow foreground, the space is subtly manipulated. Because the tree trunk and branch are cut off by the edges of the painting, the tree tends to read at the front plane of the picture surface. Because the sharpshooter's leg dangles in front of this plane, it protrudes into the viewer's space, thus connecting us more intimately with the picture. Focused-in, as we are, on this treetop taken out of its normal earthbound context, we seem to be sitting up in the neighboring treetop, or observing the sharpshooter through our own telescopic sight. The device of engaging the viewer through forms severed at the picture edge is used repeatedly in the paintings and is already evident in Homer's engravings. Another technique, providing depth within the picture, is the highlighting with bright sunlight of the dead branches and pine needles above the soldier's hand. Being lighter, they project forward and are separated from the mass of the pine tree. Other branches are pushed back in space by being covered with a thin, translucent, scumbled layer of sky. Because they are thus rendered indistinct, they appear to be at a greater atmospheric distance.

Homer is generally perceived as a truly independent artist who eschewed all outside influence. J. Eastman Chase, the dealer, who knew him well from the early 1880s, wrote that "Homer was less influenced by others and by what others had done than any artist — any man, I may as well say — I have ever known."[11] Homer proclaimed to J. Foxcroft Cole, during their apprenticeship at Bufford's during the 1850s, "If a man wants to be an artist, he should never look at pictures."[12] His own pictures show that he came to painting with a fresh eye, unimpressed by traditional and current practices, but highly sensitized to his own perceptions of color, light, space, and form, as we have seen in *Sharpshooter*. This sensitivity to perceptual phenomena, although perhaps instinctual, was fostered by his familiarity with the color theory of M. E. Chevreul. Indeed, Homer's debt to Chevreul in his use of color and light and in his method of modeling form has never been adequately discussed, although Chevreul is probably the most important outside influence to be found in Homer's painting practice.

Homer was given a copy of Chevreul's *The laws of the contrast of colour*[13] in 1860 by his older brother Charles, with whom he was very close throughout his life and who, like Chevreul, was a chemist by profession.[14] John Beatty records several comments by Homer that reveal the importance of Chevreul. "One day I picked up from his table a copy of Chevreul's well-known book on the laws of color, and without revealing my surprise, asked if he found it of value. He replied simply, 'It is my bible.' "[15] On another occasion Homer remarked to Beatty, "You can't get along without a knowledge of the principles and rules governing the influence of one color upon another. A mechanic might as well try to get along without tools."[16]

Goodrich had dated Homer's possession of Chevreul to "1873 or earlier,"[17] and it was only recently that Homer's personal copy of the book was uncovered with an inscription on the front endpaper, "To Winslow Homer, July 10, 1860," a profile drawing of Charles, and Winslow's University Building address (*fig. 1*).[18] Homer thus owned and probably read Chevreul prior to beginning his first oil painting in 1862. Homer obviously studied the book carefully for he marked pages and sections of particular interest.[19] On the back endpaper are notations that have been described as color triads, but which actually seem to be color perception tests that Homer had performed for himself. The tests demonstrate how color perception changes, depending on what color the eye has previously perceived.[20] Homer signed and dated the test results in 1873. Over the pages immediately preceding this, he pasted a sheet of paper on which he listed the results on repeating the test, this time signed and dated 1884. This suggests that Homer referred back to the book at various points in his life. Indeed, as David Tatham describes, "The volume seems to have served as a memory-book of sorts, as well as a guide to color,"[21] for it includes the pasted insertions of a photograph of a fishing boat, labeled "Cullercoats, Sept. 1882" (a memento of his second trip to Europe), and a photo of Chevreul at age 102 taken the year before his death in 1889. Homer also pasted in two sheets of paper

with mathematical equations,[22] and on the last page sketched very faintly two clothed female figures.

M. E. Chevreul was appointed to the position of Director of Dyes for the Royal Manufactures at the Gobelins tapestry works in 1824, where his interest in color theory and the nature of color perception began. He carried out extensive experiments and in 1839 published his monumental treatise, *De la loi du contraste simultané des couleurs*.[23] It soon caught the attention of French artists and was much discussed. Delacroix expressed great interest and Pissarro was an ardent proselytizer. Later, Seurat made direct use of Chevreul's theories, as did Delaunay. Thomas Couture, in whose studio Manet as well as many American artists studied, incorporated Chevreul's ideas into his teachings and paintings. John La Farge (the only artist with whom Homer enjoyed discussing art, according to his nephew)[24] was also familiar with Chevreul in the 1860s and deeply involved with color theory, often applying it to extreme ends in his paintings. In his tribute at the time of Homer's death, La Farge wrote: *In painting I had less to do with Homer, though my advice probably came in at certain moments to direct and encourage some side of his efforts. I was just beginning to study in the direction of the future the question of colored light and the relations of the complementaries. Of course a great deal had been done that way, but not as yet as far as we proposed to carry it. Homer was too great a man to be tied by the knowledges of art. He could use them, but from instinct and from reason he knew that art has something else to do than to carry out principles of study.*[25]

The text of Chevreul's treatise is roughly divided into three sections. Presented first are the theoretical premises, based on the scientific concept of simultaneous contrast in colors. Stated simply, this concept contends that two different colors when placed next to each other will interact, altering our visual perception of each color. The second section is a lengthy and detailed account of Chevreul's experimental findings. In the third section he relates the principles to all sorts of aesthetic problems, from painting to wardrobe

selection, from stained glass design to garden planting. The significance of the work rests not only on the importance of the principles, the admirably thorough experimental investigation, and the comprehensive cataloguing of effects in painting and the various arts, but also, particularly for nineteenth-century artists, on Chevreul's phenomenological and perceptual approach. Chevreul focuses not on innate color properties, but on the active process of color perception, whereby color is defined as a dynamic, changing phenomenon.[26] The basic premise is expanded into hundreds of interrelated effects involving light as well as color, value, form, and distribution in space, among others. The effect that this book can have upon the interested reader (though weighty and repetitious in parts) is also a dynamic one. Objects are no longer perceived as things unto themselves, but as affected by the color, direction, and intensity of light, as well as by other objects in the field of vision (in terms of their color, value, shape, size, and proximity). In the same way, elements in a painting are seen as dynamically interrelated.

Chevreul defines two species of color harmony that the artist may use, the harmony of analogy and the harmony of contrast.[27] The dominance of shades of brown, a common practice at that time, is an example of the use of analogous hues, but Chevreul clearly favors harmony of contrast. "Whenever the artist would attract the eye by colours, doubtless the principle of harmony of contrast must be his guide."[28] He is of the opinion that the eye relishes the excitement of exaggerated color, which "is essentially analogous to the inclination we have for food and drink of a flavour and odour more or less pungent."[29] He advocates that colors be vivid and strongly contrasted, and lights and shadows be extreme.[30] Nevertheless, because of the complex interrelationships, it behooves the artist to limit his palette to only a few of these strong colors:

Although harmony of contrast most favourably causes two colours to impart value to each other, yet, when we desire to derive the greatest advantage from a union of numerous brilliant colours in any work – a picture, for instance – this diversity pre-sents some difficulties in the general harmony, which a smaller number of colours, and especially of brilliant colours, would not present.[31]

Large sections of *The laws of contrast of colour* are devoted to listing which colors, when placed next to each other, are agreeable, indifferent, or unpleasant. The color combination that is most highly recommended by Chevreul is that of complementary colors.

Combination of Complementary Colours: This is the only association where the colours mutually improve, strengthen, and purify each other without leaving their respective scales. This case is so advantageous to the associated colours, that the combination is also satisfactory when the colours are not absolutely complementary, also when they are made dull with grey. I therefore prescribe the complementary association when we have recourse to the harmonies of contrast in painting, in tapestry, . . .[32]

The dominant tonality of most of Homer's Civil War paintings is based on the complementary colors orange and blue. This combination is seen in early works, such as *Playing Old Soldier* (*cat.no.5*), but becomes more frequent in the later works, such as *Prisoners from the Front*, where it is dulled with gray (*cat.no.20*), *The Veteran in a New Field* (*cat.no.15*), and *A Rainy Day in Camp* (*cat.no.22*). Where not dependent on the complementary orange and blue, Homer simply added green or red to the orange/blue, or used a combination of green and orange (*In Front of Yorktown* [*cat.no.2*] and *Skirmish in the Wilderness* [*cat.no.9*]). For Chevreul these latter combinations, in diverging from simple complementary schemes, can be fraught with difficulties injurious to the harmony:

Red and orange do not accord well. . . . Red and blue accord passably, especially if the red incline rather to scarlet than to crimson. . . . Orange and green do not accord well. . . . Blue and green produce an indifferent affect, but better when the colours are deep. . . .[33]

Therefore secondary rules govern these more or less inharmonious combinations: The effect is better if the colors are not given equal prominence. In the case of one primary and one secondary

color, the primary should be more luminous. The combination is more effective if there is a great difference in values. It can improve if the colors are dulled with brown or gray or by adding an adjacent area of white, black, or gray, but here again it depends on the specific color combination. Surprisingly, Homer marked these sections of complicated dictums and seemed to follow much of the advice. For example, in *Pitching Quoits* (*cat.no.14*), which has a strong red component added to the blue/orange, the gray and black of the campfire have a mitigating effect. It is no wonder that Homer only let loose with an uncontrolled spattering of varied bright color in small areas.

Chevreul was ahead of his time in recommending the combination of bold contrasting colors over analogous hues. He was relatively free of the confines of accepted practice because he was not closely involved with the fashions of the contemporary art world but was dealing with varied forms of applied art and design, such as stained glass, mosaics, wallpapers, gardens, tapestries, and carpets, in addition to painting.[34] Neither was Homer deeply concerned with traditional and current painting practice. His use of color was bold for his time, and frequently not accepted by the critics:

The figures are full of character, but a trifle fresh in color, as is also the landscape.

They are not pleasing in color, but in many respects very creditable and promising.

They are crude in color, and not altogether correct in drawing; but they show great originality. . . .

The color is a trifle crude. . . .[35]

In reference to *The Bright Side* (*cat.no.13*), in which the colors are toned down slightly with browns, a critic noted that "neither the coloring nor the drawing are so hard as we usually find in Mr. Homer's pictures."[36] "*Army Boots*" (*cat.no.16*), which is painted in analogous hues rather than bright contrasting colors, was called "very fine in color, being clear and rich."[37]

In his writings Chevreul discussed two

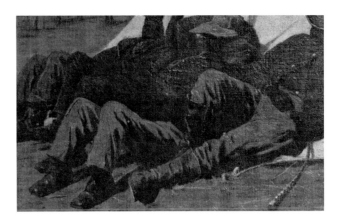

fig.2　Trousers, detail of *Army Teamsters* (*cat.no.13f*)

approaches to the modeling of form: painting by chiaroscuro (forms enveloped by subtle gradations of shadow) and painting in flat tones (separate, unmodulated areas of color).

In painting in flat tints, the colours are neither shaded, blended together, nor modified by the coloured rays coming from objects near that which the painter has imitated. . . . If the choice of contiguous colours has been made conformably to the law of simultaneous contrast, the effect of the colour will be greater than if it had been painted on the system of chiaro-'scuro.[38]

In his advocacy of painting in flat tones, Chevreul was a harbinger of future practice, but he remained somewhat apologetic, realizing that this technique was far afield from current practice.

To apply painting in flat tints to historical, portrait, and landscape painting – in a word, to the imita-

tion of any object of which we can produce a faithful representation, would be going back to the infancy of art; but to abandon it to practise exclusively the system of painting where all modifications of light are reproduced according to the rules of chiaro-'scuro, would be an error which can be demonstrated beyond question.[39]

One of the distinctive aspects of Homer's technique is his use of flat tones – unmodulated areas of color juxtaposed to flat dark shadows, without blending them together into a smoothly modeled form (*fig. 2*).[40] In accordance with the accepted practice at that time, the artist would lay in the darks and lights in this manner during the initial sketch or *ébauche* stage, but would then go back and blend the dark shadow into the lighter area, creating a smooth transition and subtle nuances through halftones. This smoothing and refining is referred to as "finish," and it was the lack of finish that disturbed many of Homer's critics, from the 1860s onward.

It seems to us that Mr. Homer must aim for completeness and refinement. At present his work is deficient in both these particulars. But we recognize with gladness the uncommon strength of his work. . . .[41]

If Mr. Homer learns to finish some of his pictures, so much will be a gain from his studies abroad.[42]

Mr. Winslow Homer, who rarely carries his works beyond the finish of sketches, sent several subjects broad enough in treatment, being mere indications of objects and effects, to please his most enthusiastic admirer. . . . Mr. Homer's style is wonderfully vigorous and original; with a few dashes of the brush, he suggests a picture, but a mere suggestion only, and it is a mistaken eccentricity which prevents its finish.[43]

As these comments suggest, while refinement may be forfeited, vigor and freshness result.

Included in the critics' objections is Homer's use of broad masses of flat color. Henry James in his perceptive review of 1875 wrote (with dispar-

agement couched within his praise):

Mr. Homer has the great merit, moreover, that he naturally sees everything at one with its envelope of light and air. He sees not in lines, but in masses, in gross, broad masses. Things come already modelled to his eye. If his masses were only sometimes a trifle more broken, and his brush a good deal richer – if it had a good many more secrets and mysteries and coquetries, he would be, with his vigorous way of looking and seeing . . . an almost distinguished painter.[44]

Another aspect of Chevreul's research that Homer incorporated in his paintings concerns the special effects produced by colored light.

A painter may also choose a dominant colour which produces, on every object in his composition, the same effect as if they were illuminated by a light of the same colour, or as if they were seen through a coloured glass.[45]

In Front of Yorktown (cat. no. 2) presents an interesting study in colored light. The yellow-and-orange light of the campfire has modified the blue gray uniforms of the soldiers just as Chevreul prescribes. Indeed, in his copy of Chevreul, under the heading "Modifications produced by Yellow light," Homer has marked the lines "Yellow rays falling on Light Blue make it appear Yellow-green," and "Yellow rays falling on Dark Blue make it appear Green-slate."[46] Also relevant but unmarked is the passage, "Orange rays falling on Light Blue make it appear Orange-gray."[47] Homer has painted the uniforms orange gray with green highlights. The face and hands of the center man were first laid in with bright yellow, then modeled in orange, then highlighted on cheeks and chin with yellow. The eyes too are yellow, modeled with orange, and even a subdued orange highlights the moustache. The bright white highlights on the belt (as well as on the metal parts of muskets and canteens) seem out of keeping with the yellow orange illumination from the fire. Perhaps Homer was putting to use another of Chevreul's principles: the more highly polished a surface is, the more light it will reflect,

to the point where it loses its own color in the area of highest reflection, appearing white.[48]

Chevreul discussed not only the modifications produced by colored light, but also distinguished between direct, diffuse, and reflected light. In *Sounding Reveille* (*cat.no.18*), Homer depicted four different lights: the cool, diffuse light of predawn, the rosy glow of dawn just beginning to penetrate, the first rays of direct, yellow sunlight, and the orange light of a campfire. After painting the myriad effects produced by these lights, he returned to the picture and painted out the delicate nuances and subdued the variety of color by covering them with swatches of muddy brown and gray. Bits of the original layers can still be discerned under magnification, but we can only imagine the appearance of the previous state: a deep blue mountain ridge (since painted out) rising behind the camp with the cool, early dawn lingering in its shadow, casting blue-and-green tones on a gray ground; the sky filled with more intense pink clouds, tinged with scarlet and orange, breaking apart to reveal patches of bright turquoise sky; the pink diffuse dawn light illuminating the figures' blue gray coats with shades of lilac; the yellow sunlight breaking across their shoulders, creating light green highlights on the coats and emblazoning the bugle a more brassy yellow; and canvas tent sides glowing warmly from sunlight filtering through or from firelight penetrating the interiors. These effects have all been painted out, though the direct sunlight still breaks across the bugler's neck and strikes a few tents in the left distance with yellow and orange. Homer changed this painting from one of the most highly developed coloristically to one of his most subdued. Perhaps he was uncomfortable with the complexity of color this naturalism produced, and preferred a more simplified and controlled arrangement.[49]

Homer's interest in the natural effects of light is illustrated by the following comment made to Sheldon:

I prefer every time a picture composed and painted out-doors. The thing is done without your knowing it. Very much of the work now done in studios should be done in the open air. This making studies and then taking them home to use them is only half right. You get composition, but you lose freshness; you miss the subtile and, to the artist, the finer characteristics of the scene itself. I tell you it is impossible to paint an outdoor figure in studiolight with any degree of certainty. Out-doors you have the sky overhead giving one light; then the reflected light from whatever reflects; then the direct light of the sun: so that, in the blending and suffusing of these several luminations, there is no such thing as a line to be seen anywhere. I can tell in a second if an outdoor picture with figures has been painted in a studio. When there is any sunlight in it, the shadows are not sharp enough; and when it is an overcast day, the shadows are too positive. Yet you see these faults constantly in pictures in the exhibitions, and you know that they are bad.[50]

From 1861 until 1872 Homer had a studio in the New York University Building (*fig.3*). The

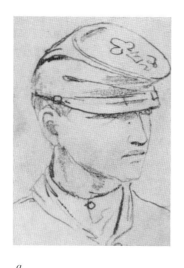
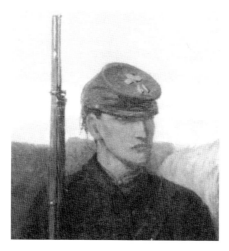
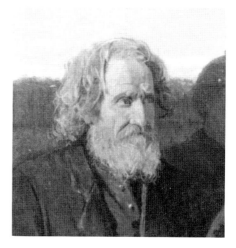

a. b.

fig.5 Detail of *Prisoners from the Front* (*cat.no.20*)

fig.4 Guard's head: *a.* Detail of *Six Studies of
Soldiers' Heads*, pencil (*cat.no.20c*) *b.* Detail
of *Prisoners from the Front* (*cat.no.20*)

studio was a tower room that seems "altogether
too small for a man to have a large idea in,"[51] but
it had access to the roof, which was flat and pro-
tected by a parapet. Here Homer was able to pose
his models under the direct light of the sun.
That much of his work was done on this roof is
suggested by the comment of a critic in 1864:
*Mr. Homer studies his figures from realities, in the
sunshine. If you wish to see him work you must
go out upon the roof, and find him painting what
he sees . . . real things, instinct with life and warm
with the glory of God's sunshine.*[52]

Homer used live models and lay figures (mani-
kins), as well as sketches made during his sojourns
to the front. He seems to have assembled a variety
of military props in his studio, including a musket
and Union, Confederate, and Zouave uniforms.[53]
While Homer was painting Prisoners from the
Front *and the rest of the army subjects of that
period, he had a lay figure, which was alternately
dressed up in the blue uniform of the Union soldier
and the butternut gray of the Confederate soldier,
serving with soulless impartiality, now as a Nor-
therner and now as a Southerner. One day, while
he was at work on the roof of the University Build-
ing, where he had posed his effigy in order to get
the effect of the full sunlight on his figure, a sudden
gust of wind came up and was like to have carried*

*the lay figure off the roof before the artist could
catch it and secure it.*[54]

The difference in handling between a figure
painted from a quick field sketch and one painted
directly from a model is readily apparent. Even
within the same picture, constancy to source was
more important than consistency in handling.
The resulting variety in level of realization gives a
dynamic life to the pictures that more polished
works often lack. In *Prisoners from the Front* the
guard's face is painted from a line drawing
(*figs.4a,b*). The form is flat, the paint pastily
opaque, and the features merely linear indications
on the surface. On the other hand, a live model
surely served for the old Southerner (*fig.5*). The
face is built up almost sculpturally out of many
shades of color worked together, wet-into-wet
with a fine brush. The left eye is highly detailed,
capturing the inner light of the pupil. The light
plays across the furrowed brow, and dissolves
lines into planes. In no other face from this series
of paintings did Homer achieve quite the same
degree of naturalism.

Homer advised Kelly on the importance of
using a model for even such minor elements as
hats and shoes.
*'Did you ever practise drawing high hats? You
should'; and taking out his own, he placed it on a*

table, saying, 'There is a great deal of drawing in a high hat, to get not only its curves, but its delicate variations in the outline which give it style.' He placed it on its side, showing part of the inside, and 'pointed out the beauty and grace of the complicated lines, and the precision required to give the proper effect.' He added, 'They are generally badly drawn; if you can draw a high hat correctly, you can draw anything.' He also put some old shoes on the table, and said, 'You should practise drawing old shoes and getting their character,' pointing out the different character and expressions in well-worn shoes.[55]

This attitude may explain why, although the study sketch for *Prisoners from the Front* shows Barlow in a top hat, Homer did not use an underdrawing for the hat in the painting. The x-radiograph reveals that he left no space for Barlow's hat when painting the sky, though he did for the other hats (*figs.6,7a,b*). Perhaps Homer chose to paint the top hat directly, using his own as a model. The attitude expressed to Kelly may also explain why the boots and shoes in the Civil War paintings are often modeled with a high degree of naturalism and with a freedom of wet-into-wet brushwork that is unmatched in other parts of the same pictures (*figs.8,9*).

It is interesting to note that most of the preparatory sketches that have been found were used by Homer for middle-distance figures and groups. These are most often quick pencil sketches, made in the field and saved as source material, used, and often reused, in both paintings and prints. Existing studies for foreground figures are fewer and, aside from the bugler in *Sounding Reveille* (*cat.no.18*) and the guard's head in *Prisoners from the Front*, are more highly resolved. It is tempting to suppose that many of the foreground figures may have been painted more directly with the aid of lay figures and live models.

The spatial construction in Homer's paintings is very carefully controlled. Separate compositional units are placed in separate planes stepped back into space. Most typically, the Civil War paintings consist of a foreground frieze of figures, a middle-ground unit of figures and tents or mules and wagons, and a background grouping

of tents and figures near the horizon. Some of the pictures consist of foreground friezes only.[56] Although *Trooper Meditating beside a Grave* (*cat.no.17*) and *The Sharpshooters* (*cat.no.21*) concentrate on the foreground figures, the middle and far-distance planes have each been indicated summarily – by grave markers in the former painting and by bands of men in the latter. A few of the pictures have only two realized planes or are enacted in the middle ground alone. *Pitching Quoits* and *A Rainy Day in Camp* could be categorized as foreground friezes with middle grounds expanded, through perspective, into the distance. Another separate compositional element often included (primarily in the foreground) is a still life of sorts – objects such as army boots, rifles, barrels, and campfires (*figs.8-10*).

Homer was very skillful at creating the illusion of depth in his painting.[57] A decrease in size is the simplest technique. He used a tiered diminution in size for background elements, rather than a truly consistent reduction with distance, and this exaggerates the sense of space considerably. He rarely employed the convincing though artificial system of linear perspective. The two exceptions mentioned above are both unusually wide pictures, and the perspective helps to unify the compositions. Homer made frequent use of the perceptually more natural principle of aerial perspective, whereby objects in the distance appear closer in value to each other than objects in the foreground, and do not exhibit the same extremes of dark and light.[58] The decrease in value differences in the middle-distance elements of *The Brierwood Pipe* (*cat.no.8*) clearly illustrates this.

The steps in Homer's painting process remained fairly constant throughout these pictures. He used a medium-fine preprimed canvas, except in *Portrait of Albert Post* (*cat.no.11*) and *Inviting a Shot before Petersburg, Virginia* (*cat.no.10*). These two were painted on thin wood panels with no ground, so that the warm orange color of the wood affects the overall tonality.[59] Homer drew the separate design elements onto the canvas or wood support with pencil and sometimes chalk.[60] He included in the underdrawing

fig.6 Confederate prisoners' heads, detail of x-radiograph of *Prisoners from the Front* (*cat.no.20*)

foreground, middle ground, and distant compositional units, as well as the horizon line and major landscape elements such as trees, arbors, and embankments. No traces of underdrawing are found for many of the foreground still-life elements. The boots in *"Army Boots"* (*fig.8*), for example, show no drawing, though surely they were initially planned. Perhaps, as presumed for Barlow's top hat, Homer painted the boots directly from a model.

In the underdrawings, Homer drew his forms with light contour lines; when taken from a study drawing the forms are carefully transcribed, including even the small undulations of line, as well as details such as the uniform buttons and facial features. In *Study for "The Bright Side"* (*cat.no.13b*), he traced the two central figures directly from the pencil-and-wash sketch to the oil study. The sizes correspond exactly, and indentations can be seen on the sketch where it was traced. In *The Brierwood Pipe* registration marks were drawn in both top corners, visible with infrared reflectography, as if a drawing had been placed for tracing onto the canvas. Several of Homer's sketches from the field, unrelated to these paintings, have heavy black pencil rubbed onto the reverse, so that when the drawing was

traced, the design would be transferred.[61]

After drawing the design elements onto the white ground, the next step in Homer's procedure was to lay down thin washes of underpaint. With a warm brown he covered the foreground area, working around the contours of the figures. The brushwork of the wash is vigorous and free, often very fluid and translucent as if extra oil medium was added to the paint. In the earlier works this was a deep reddish brown. In later works it was often a lighter orange. This underpainting often shows through the top layers, and together with the blue of the sky helps to establish the complementary orange/blue tonality. The undertone was sometimes extended up through the middle and far distance and sometimes under the sky, as well. Occasionally it was used separately to establish the ground area of each compositional unit. In *Pitching Quoits* there are separate reddish brown washes in the area around the central arbor, the left group of Zouaves, and the campfire, while the rest of the ground is underpainted in a lighter orange tone. In many of the paintings, the foreground is underpainted in an orange brown wash and the middle ground is underpainted in a lighter yellow tan, which helps to establish the aerial perspective. This can be clearly seen in *The*

a.

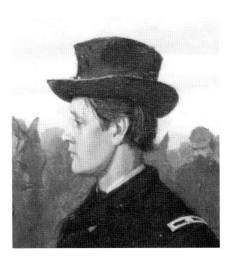

b.

fig.7　Barlow's head in *Prisoners from the Front* (*cat. no.20*): *a.* Detail of x-radiograph, revealing underlying paint layers *b.* Detail of finished painting

Bright Side as the top layers are thin and intermittent.

When Homer began painting *Halt of a Wagon Train* (*cat.no.12*) it was about three-quarters inch wider on the right edge. After painting the initial washes he decided to eliminate this section, probably because the blanket hanging from the pole looked awkward. He therefore restretched the canvas, turning this narrow section over the edge of the stretcher where it would not be seen. This unfinished edge affords the opportunity to study the wash underpainting. It shows a reddish brown foreground wash and a yellow tan above it, extending up to the horizon. Homer also blocked in the sky with a pale blue wash. The skies in other pictures could be similarly underpainted, masked by the thick paint on top.

After the ground and perhaps the sky had been set, the white space for the figures would stand out in contrast. Homer's next step in these paintings was to establish the form of the figures by blocking in the shadows with dark brown washes (e.g., the creases in the clothing and shadows on

the ground). Sometimes he also applied a thin, uniform undertone to select areas in the figures, such as a light brown for flesh areas. This initial working-up of the painting in flat, broad washes is reminiscent of the manner in which he prepared the woodblock for the engraver. Onto the warm tone of the boxwood block "he clearly defined areas of local color and shadows, painting them in broad, flat monochromatic washes of india ink in two or three tones."[62]

With the composition thus defined, Homer began the actual painting. He seems to have completed areas in a piecemeal fashion. One of the first areas he painted was the sky, perhaps because it gave him an overall sense of the light that would illuminate the picture. "I have learned two or three things in my years of experience," Homer told Beatty in 1903. "One is, never paint a blue sky." When asked why, he replied, "Why, because it looks like the devil, that's all. Another thing; a horizon is horrible – that straight line!"[63] Most of Homer's skies are heavily clouded and frequently painted in several layers. By this layer-

ing he avoided the dead, flat blue sky to which he had such an aversion. The unfinished section in *Halt of a Wagon Train* shows that over the blue wash he applied a white layer of highly textured brushstrokes. When this was dry he painted a blue wash on top that would pool more thickly in the troughs of the brushstrokes and be wiped thin on the high points. A greater sense of vibrancy results from this variation. The horizon lines of the Civil War pictures are varied by silhouetted trees, pine branches, stumps, horses or tents, and often by a jumping, rhythmically angular band that energizes the painting (*fig.11*).

Homer sometimes redrew figures on top of the paint layers. The defiant rebel silhouetted against the sky in *Inviting a Shot before Petersburg* and the veteran silhouetted against the wheat in *The Veteran in a New Field* were drawn on top of the sky and field, respectively. Most likely, Homer did not want to interrupt the vigorous, impastoed brushwork of these areas to conform to the intricacies of the figures' contours.

One of the last areas to be painted in each of the pictures was the ground lying behind the foreground. This is just a flat filling-in of empty space with a single color, thinly applied, as seen in the green hillside of *The Sutler's Tent* (*cat.no.6*). This provides a nebulous, inactive atmospheric area that the eye can glide over without distraction. The order in which the other elements in each picture were painted is difficult to determine. It can only be judged when the edges of one form overlap another area. For instance, it can be seen that Homer invariably painted the uniforms before faces and hands.

Homer's method of paint application is direct, choosing one color for an area and applying it broadly without many variations, superimposed layers or "coquetries" of the brush. This is most evident in the technique he used for the uniforms. After the thin brown shadows had been applied in the underpainting, he then filled in the local color around them, adding highlights only sparingly and leaving the shadows from the underpainting exposed. This perfunctory method was habitual with Homer. Because he uses the same dark brown shadows, no matter whether the

uniform is dark or light, a much higher value contrast shows in the light trousers, for instance, than in the darker jackets. In *Army Teamsters* (*cat.no.13f*) the two pairs of light trousers take on a strange quadrupedal life of their own, because their higher contrast causes them to stand out from the rest of the figural group (*fig.2*).

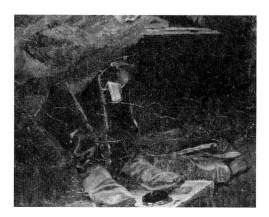

fig.8 Detail of *"Army Boots"* (*cat.no.16*)

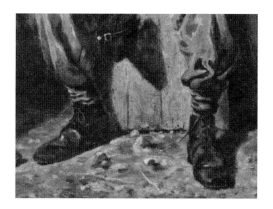

fig.9 Detail of *Playing Old Soldier* (*cat.no.5*)

Being ever cognizant of where elements are situated in space, Homer often toned back areas that were bright and tended to pull forward. The trousers of both figures in *The Sutler's Tent* have been toned back with a very thin brown glaze. This same brown glaze was used to tone back large areas of *A Rainy Day in Camp* and frequently small areas, like the white highlight on the tongue in *Playing Old Soldier* (*cat.no.5*). In *"Army Boots"* (*cat.no.16*) the brown glaze over the bright white section of tent on the right has been

removed in a previous restoration, upsetting the space and atmosphere of the picture.

The foregrounds of these pictures are very dynamic and eye-catching. Homer dashes off streaks of color that energize the foreground and invite the eye into the picture. In *The Veteran in a New Field* the shafts of wheat lying on the ground are like sparks spewing from a sparkler. As a last step in *A Rainy Day in Camp* Homer flicked bright colors – greens, blues, oranges, and yellows – and electric strands of hay across the foreground. In *Skirmish in the Wilderness* he scattered blue, yellow, orange, red, and bright green over the foreground like confetti. By contrast it is not splashes of color that lend an immediate reality to the foreground of *Playing Old Soldier*, but naturalistic objects rendered in high relief – bunches of pine needles, pine cones, rocks, and twigs.

Occasionally Homer played with texture to achieve an unusual effect. The blanket hanging at the left side of the lean-to in *Playing Old Soldier* has a wonderful wooly, tactile quality. This is achieved by first applying the paint in a raised, nubby impasto. Over this Homer laid and then wiped off a thin brown glaze, so that it remains only in the depressions of the impasto, accentuating the play of light over the texture. The blanket, severed at the picture edge, functions almost as a trompe l'œil curtain, pulled aside to reveal the picture to the viewer. In *The Sutler's Tent* Homer has carefully simulated wood-graining on one of the boxes inside the tent by scraping a pattern into the wet paint. He scratched through the paint of the foreground to create strands of straw in *Halt of a Wagon Train*. Similarly, he created scratched textural interest in otherwise flat areas of *Trooper Meditating beside a Grave*.[64]

Homer delighted in the inclusion of small naturalistic details. His method of building up tiny brass buttons through multiple layers of paint makes them stand out in shining relief. The buttons on the rebel boy's jacket in *Prisoners from the Front* are painted with layers of yellow ochre, reddish brown modeling, brown shadows, black delineations, pale blue reflected light, and tiny bright orange highlights. We find realistic details

fig.10 Still life, detail of *In Front of the Guard-House (cat.no.7)*

throughout the Civil War paintings, most obviously in the attention to military dress, muskets, bayonets, sabres, spurs, and insignia, but also in less obvious naturalistic touches such as inner trouser seams and carefully tied shoes (*The Sutler's Tent*), braided whip and tent pegs whittled to a point (*The Bright Side*), dust rising from the thud of the thrown horseshoe and a kindling stick charred almost to the point of breaking into sections (*Pitching Quoits*), and ashes, glowing embers, and curling smoke inside the pipe bowl (*The Brierwood Pipe*). Although Homer sought to simplify his broader masses, he often gave inordinate attention to these small details.[65] This effort is parallel to his careful control of color in larger areas, while flashing the rainbow in small details and brushstrokes.

A Rainy Day in Camp (cat.no.22) is a tour de force in which Homer portrays countless realistic details, as well as broader naturalistic effects, resulting from the rain, wind, and stormy light. Rain clouds are passing over the scene but the sun has broken through, so it is both rainy and sunny at the same time. The rain beating down on the left half of the picture while only a few stray drops are falling on the right is painted by Homer with great delicacy as thin, parallel, intermittent streaks of white, pale blue, and yellow. He took the trouble to change some white and dark blue rain streaks to pale blue, carefully repainting each thin stroke. The raindrops

fig.11 Horizon line, detail of *Halt of a Wagon
Train (cat.no.12)*

splashing into the barrel tops are pink, yellow,
white, and blue, although the color differences
are barely distinguishable. The eye actually reads
the rain as it would in reality, as indistinct parallel
flashes picked out only at intervals, especially
against dark areas (the barrels), where they splash
(in the barrel tops), or where highlighted by the
sun (the bright area behind the barrels). The
effect is subtle. Across the sky Homer has sug-
gested the rain by dragging a dry brush through
the wet paint so that the brush bristles create
textural streaks.

Curiously, it is difficult to determine the direc-
tion of the wind. On the one hand, the campfire
smoke and right overcoat are blown from right to
left. Similarly, the mule seems to be braced with
the wind to his back, and the storm seems to be
passing toward the left, where it is dark and
raining heavily in the distance. On the other
hand, the streaks of rain run diagonally from left
to right, as though being driven by the wind in
that direction. However this can be explained if
Homer used a straight edge to paint the rain, for
in this direction it is considerably less difficult
to hold the guide with the left hand and paint the
parallel lines with the right, assuming Homer
was right-handed.

In many of his paintings, Homer demonstrates
an interest in terrain. Although primarily serving
as a stage for the figures and compositional

groups, it is never flat and empty but shows subtle
dips and rises as well as surface enlivenment. In
A Rainy Day in Camp, these subtle variations are
particularly interesting. In the foreground and
leading back toward the horses, the ground is
pocked by deep mudholes made in the wet ground
by feet and hooves. Puddles have formed in many
of the indentations. The surrounding ground
seems to slope gently down to this low, muddy
area, and a slight trough with puddles of water
runs from behind the mule, curving toward
Homer's signature. The mule himself is standing
on a slight rise above this trough, his form
reflected in the puddles at his feet. On the left
side of the picture, the covered wagon is tipped to
one side, as if the wheels are sinking in the mud.
In other areas the ground is slick with rain. Both
the covered wagon and large sibley tent cast
reflections on the wet ground below. The ground
in front of the tent glistens as the sunlight hits the
shallow layer of water. This yellow area of ground
was toned back with a thin dark brown glaze
that helps to create the illusion of water on the
ground. Because the glaze is translucent it gives
the sense of light penetrating through a shallow
layer and being reflected by the ground under-
neath, while the opaque blue reflections establish
the top surface of the water.

The sky of *A Rainy Day in Camp* is unlike those
of the other Civil War pictures. It seems to reflect

a familiarity with European art, acquired perhaps during Homer's ten-month stay in France in 1867. The bold patches of cloud, often created by a single brushstroke, the form defined more by the action of the wrist and brush than by any preconceived shape, painted wet-into-wet, but not blended systematically; the large cloud masses surcharged with rain, accompanied by small patches scudding by, signifying a sky in flux; and the wide-angle funneling of the clouds to a single vanishing point remind one of the skies of the Dutch painters, Constable, and the Barbizon school. The practice of painting the sky thinly over a reddish ground, common since the seventeenth century, gives a warm undertone to the cloud bellies. Homer produced this same effect in *A Rainy Day in Camp*, although he achieved it here by adding a red tone to the paint, rather than allowing a red ground to show through from below.

In this last painting of the Civil War period Homer shows a greater vigor and freedom in the brushwork, varying from full and sweeping to choppy and jagged strokes. There is more delight in the action of painting, which in this picture is quick and sure. Aside from the technique of the sky that points to the direction of his later oils, the method and approach is the same as in the earlier paintings, but now there is an even greater sense of confidence and bravura. The complementary color scheme of orange and blue has never been bolder. With this picture we have the sense that Homer has taken the concept and approach that he developed in the Civil War paintings to their natural conclusion.

Homer developed his own highly effective system and technique for creating these works. He came to painting with a fresh eye, relatively unencumbered by previous painting traditions or the influence of a teacher's direction. It was Chevreul's principles of color perception that helped to formulate his concerns.[66] Homer's early painting process demonstrates that he was deeply concerned with both the naturalism observed in reality and the interrelationships perceived within the pictures. His careful control of color, light, space, form, composition, and the active engage-

ment of the viewer reveal a deep understanding of perception, "his vigorous way of looking and seeing," as Henry James described it.[67]

The changes Homer made during the painting process will be enumerated in the catalogue entries of this volume. Such changes earmark problems with which the artist was consciously concerned. Many of the changes Homer made involve compositional relationships and the development of space, others are in the interest of greater naturalism or greater presence through simplification, while some affect the underlying emotional appeal or the narrative implications.

The most important means to understanding Homer's paintings is the contemplation of each picture, gaining an appreciation for, in Homer's words, "the subtile and, to the artist, the finer characteristics of the scene."[68] For this pursuit, the relatively fine state of preservation of most of these pictures helps immeasurably. While many have suffered to some degree through insensitive lining, thereby losing some of the vibrancy of the brushwork, the paint layers are, overall, still intact and have not been compromised in previous cleanings. The good condition of these works must be attributed in part to Homer's painting technique – his broad, direct manner and the materials he used.[69] A painting in good state is the most direct communication between the artist and viewer. As John La Farge said, describing Homer's taciturn nature, "Homer had manners of telling you things without words."[70] These pictures speak to us with great clarity.

1. The basis for this study of Homer's painting technique was the visual examination of the paintings together with Marc Simpson, the Ednah Root Curator of American Paintings of The Fine Arts Museums of San Francisco. X-radiographs, ultraviolet light, infrared reflectography, and the microscope were used when available. We are most appreciative of this opportunity provided by the various museums and owners, and wish to thank the conservators, curators, and directors who assisted us.

2. Lloyd Goodrich, *Winslow Homer* (New York: Whitney Museum of American Art by Macmillan, 1944), 35.

3. John W. Beatty, "Recollections of an Intimate Friendship," written in 1923-1924 from notes of 1903. In Goodrich, 207-226.

4. James E. Kelly papers, box 9, The New-York Historical Society (MS, n.d.).

5. George W. Sheldon, "American Painters – Winslow Homer and F. A. Bridgman," *The Art Journal* 4 (August 1878); *American Painters* (enlarged ed., 1881; New York: Benjamin Blom, 1972); and *Hours with Art and Artists* (1882; New York: Garland Publishing, 1978).

6. Sheldon, *American Painters*, 28.

7. Russell Shurtleff, "Correspondence: Shurtleff Recalls Homer," *American Art News* 9, no. 3 (29 October 1910): 4.

8. "National Academy of Design," *The Round Table* 1, no. 21 (7 May 1864): 326.

9. To some extent, these losses of form may be due to changes with time and past restoration. As dark colors age they tend to lose some definition of form through darkening and increased transparency. Lining has somewhat flattened the brushwork that originally could have helped define the form.

10. Beatty, in Goodrich, 220.

11. J. Eastman Chase, "Some Recollections of Winslow Homer," *Harper's Weekly* 54, no. 2809 (22 October 1910): 13.

12. Goodrich, 6. This is indicative of Homer's attitude, but should not be taken at face value, for other references show that he did attend galleries and exhibitions.

13. Michel Eugène Chevreul, *The laws of contrast of colour: and their application to the arts of painting, decoration of buildings, mosaic work, tapestry and carpet weaving, calico printing, dress, paper staining, printing, illumination, landscape and flower gardening, &c.*, trans. and ed. John Spanton (London: Routledge, Warnes and Routledge, 1859). All page references to Chevreul are from this edition.

14. Charles Homer joined the Valentine Company, manufacturers of paint and varnish, in the mid-1860s, so in a sense both brothers' livelihoods depended on the same raw materials.

15. Beatty, in Goodrich, 223.

16. Beatty, in Goodrich, 222.

17. Goodrich, 180.

18. In 1974 the staff of the Margaret Woodbury Strong Museum, Rochester, New York, discovered a previously unknown holding of twenty-four books from Homer's personal library in the home of Mrs. Strong (1897-1969), which she had acquired in the 1930s. See David Tatham, "Winslow Homer's Library," *American Art Journal* 9, no. 1 (May 1977): 92-98.

19. I am indebted to Elaine Shallacombe and Carol Sandler of the Strong Museum Library for transcribing the annotations that Homer made in his copy onto my copy of Spanton's version of Chevreul.

20. The test is described in Chevreul, 30-31, and demonstrates the principle of "mixed contrast" due to after-images.

21. Tatham, 93.

22. These mathematical equations and expressions are incomplete segments, possibly from an algebra lesson (Sherman Stein, Mathematics Department, University of California, Davis) and perhaps are a memento of some sort.

23. M. E. Chevreul, *La loi du contraste simultané des couleurs* (Paris: Pitois-Levrault, 1839). The first English translation of Chevreul's treatise was the Martel translation that appeared in 1854. The Spanton version (which Homer owned) is somewhat condensed by comparison.

24. Philip Beam, *Winslow Homer at Prout's Neck* (Boston: Little, Brown, 1966), 162.

25. Gustave Kobbé, "John La Farge and Winslow Homer," *New York Herald*, 4 December 1910, magazine section, quoted in Goodrich, 36.

26. This idea is discussed by Mark Leonard, "The Concept of Simultaneity in the Works of Michel Eugène Chevreul and Robert Delaunay," thesis, Institute of Fine Arts, New York University, 1978.

27. Chevreul, *The laws of contrast of colour*, 81.

28. Chevreul, 96.

29. Chevreul, 84.

30. Chevreul, 112. This section was marked by Homer.

31. Chevreul, 215. This section was marked by Homer.

32. Chevreul, 210.

33. Chevreul, 51-52. This section was marked by Homer.

34. In his copy Homer marked many pages in these sections. His far-reaching involvement with Chevreul is shown in the following incident: "A young neighbor working in his flower garden was once accosted by the painter with the query, 'Who taught you about color?' and on his next visit to the studio, Chevreul was produced to show that he had arranged his flowers exactly right." Goodrich, 180.

35. T. B. Aldrich, "Among the Studios. III," *Our Young Folks* 2, no. 6, (July 1866): 394-398, in reference to *The Last Goose at Yorktown* and *"Home, Sweet Home"*; *The New-York Times*, 21 November 1863, in reference to *Playing Old Soldier*; *The Evening Post*, 14 December 1863, in reference to *The Sutler's Tent* and *Playing Old Soldier*; and *The New York Leader* 10, no. 18 (30 April 1864): 1, in reference to *The Brierwood Pipe*.

36. "American and Foreign Art," *The Evening Post*, 23 November 1865.

37. *The New-York Times*, 29 May 1865.

38. Chevreul, 81.

39. Chevreul, 217.

40. This schematic use of light and dark has been attributed to his training in engraving where halftones are not possible (see James Thomas Flexner, *The World of Winslow Homer* [New York: Time-Life, 1966], 33, 71). However, his early engravings show that a more sophisticated modeling was often achieved when he so chose.

41. *The Round Table* 1, no. 21 (May 1864): 326.

42. *The Nation* 3, no. 73 (22 November 1866): 72.

43. *Art Journal* (March 1875): 2, quoted in Goodrich, 51.

44. Henry James, Jr., "On Some Pictures Lately Exhibited," *The Galaxy* (July 1875): 90, quoted in Goodrich, 53.

45. Chevreul, 95.

46. Chevreul, 71.

47. Chevreul, 70.

48. Chevreul, 76. If indeed used, the principle has been slightly misunderstood, as the colored light would still have an effect on the white highlights.

49. For specific details see the catalogue entry for *Sounding Reveille (cat.no.18)*.

50. Sheldon, *Hours*, 138.

51. Aldrich, 395.

52. *The New York Leader* 10, no. 18 (30 April 1864): 1.

53. James E. Kelly papers, NYHS, and T. B. Aldrich, "Among the Studios. IV," *Our Young Folks* 2, no. 9 (September 1866): 574.

54. William H. Downes, *The Life and Works of Winslow Homer* (1911; New York: Lenox Hill Co., Burt Franklin Reprints, 1974), 55-56.

55. James E. Kelly, quoted in Goodrich, 48.

56. Homer's use of figural friezes has been attributed to his previous experience in engravings, where space is more difficult to realize (see James Thomas Flexner, *That Wider Image* [New York: Dover Publications, 1970], 275-276). However, Homer's early engravings show that he could depict a plenary recession into space quite successfully when he wished.

57. A. Ames, Jr., "Depth in Pictorial Art," *Art Bulletin* 8 (September 1925): 4-24. Mr. Ames, using optical lenses, studied the illusion of depth in various paintings. The artists who achieve the greatest success by subtle perceptual manipulations are, in his judgment, Turner, Corot, and Homer.

58. A second aspect of aerial perspective is that in the distance dark objects appear bluer and light objects warmer.

59. No wood analysis or grain comparison has been done, but it is possible that the panels for *Inviting a Shot before Petersburg* and *Portrait of Albert Post* both came from the same board, as the thickness and height are very close.

60. By the precise quality of the line, those underdrawings not in graphite pencil appear to be chalk rather than charcoal, but no technical analysis was done.

61. For example, Cooper Hewitt drawings: 1912.12.159, 1912.12.136, and 1912.12.166.

62. Helen A. Cooper, *Winslow Homer Watercolors* (New Haven: Yale University Press, 1986), 17, 19; see also Hereward Lester Cooke, "The Development of Winslow Homer's Watercolor Technique," *The Art Quarterly* 24 (Summer 1961): 169-193.

63. Beatty, quoted in Goodrich, 224.

64. For an excellent article on Homer's watercolor technique, see Judith C. Walsh, "Observations on the Watercolor Techniques of Homer and Sargent," *American Traditions in Watercolor*, ed. Susan E. Strickler (New York: published for the Worcester Art Museum by Abbeville Press, 1986), 45-64.

65. The painter Fairfield Porter disparagingly describes this aspect of Homer's technique: "He fills the artistic gap with a humorless attention to boring detail. He paints as if he were Abraham Lincoln walking miles to return three cents change" ("Homer. American vs. Artist: A Problem in Identities," *Art News* 57, no. 8 [December 1958]: 26).

66. Likewise, when Homer later took up etching, he relied heavily on instruction from books. "Homer said he had never received a lesson in etching. He read books describing the process, made inquiry among friends who knew the art and then worked his own way out" (Beatty, quoted in Goodrich, 212).

67. James, quoted in Goodrich, 53.

68. Sheldon, *Hours*, 138.

69. Technical analysis of Homer's pigments and medium would be of interest. His brother, Charles, was a paint and varnish chemist who developed a particularly hardy coach varnish. He may have influenced Homer's choice of materials. Perhaps Homer used an unusually tough medium. Some of the paintings give the appearance of having been "oiled out," i.e., thin layers of oil or varnish had been applied between paint layers. Cross-sections of the paint layers would help determine if this were the case. Pigment analysis would be of interest in judging whether Homer extended Chevreul's principles to color mixing. There is also Kelly's account (Kelly papers, NYHS) that Homer instructed him not to crush the minute granulations of pigment when mixing colors, which would bear investigation. A preliminary analysis of pigments in *The Brierwood Pipe* was undertaken by Bruce Miller, Paintings Conservator at the Cleveland Museum of Art, using x-ray fluorescence. It suggests that Homer may have used certain pigments not long after they became available. Further pigment analysis might show that Homer was experimental in his choice of paints, which would not be unexpected with a brother in the paint and varnish industry.

70. Downes, 36.

Abbreviated References

Bardeen, *Little Fifer's War Diary*
Bardeen, C[harles] W. *A Little Fifer's War Diary.*
Syracuse, N.Y.: C. W. Bardeen, 1910.

Billings, *Hardtack and Coffee*
Billings, John D. *Hardtack and Coffee, or, The Unwritten Story of Army Life. . . .* 1887. Reprint. Williamstown, Mass.: Corner House Publishers, 1973.

Catton's Civil War
Catton, Bruce. *Bruce Catton's Civil War: Three Volumes in One (Mr. Lincoln's Army* [1951], *Glory Road* [1952], *A Stillness at Appomattox* [1953]). New York: The Fairfax Press, 1984.

Downes, *Life and Works*
Downes, William Howe. *The Life and Works of Winslow Homer.* Boston: Houghton Mifflin, 1911.

Giese, *Painter of the Civil War*
Giese, Lucretia Hoover. *Winslow Homer: Painter of the Civil War.* Ann Arbor: University Microfilms, 1986.

Goodrich, *Winslow Homer*
Goodrich, Lloyd. *Winslow Homer.* New York: published for the Whitney Museum of American Art by Macmillan, 1944.

Hendricks, *Life and Work*
Hendricks, Gordon. *The Life and Work of Winslow Homer.* New York: Abrams, 1979.

Ketchum, *American Heritage Picture History*
Ketchum, Richard M., ed. *American Heritage Picture History of the Civil War.* New York: American Heritage, 1960.

Linderman, *Embattled Courage*
Linderman, Gerald F. *Embattled Courage: The Experience of Combat in the American Civil War.* New York: The Free Press, 1987.

Lyman, *Meade's Headquarters*
Lyman, Theodore. *Meade's Headquarters, 1863-1865: Letters of Colonel Theodore Lyman from the Wilderness to Appomattox.* Ed. George F. Agassiz. Boston: The Atlantic Monthly Press, 1922.

Moore, *Anecdotes, Poetry, and Incidents*
Moore, Frank, ed. *Anecdotes, Poetry, and Incidents of the War: North and South, 1860-1865.* 1865. Reprint. New York: Arundel Press, 1882.

Whitman, *Complete Poetry and Collected Prose*
Whitman, Walt. *Complete Poetry and Collected Prose.* New York: Library of America, 1982.

Wiley, *Life of Billy Yank*
Wiley, Bell Irvin. *The Life of Billy Yank: The Common Soldier of the Union.* Indianapolis: Bobbs-Merrill, 1952.

Williams, *The Artists' Record*
Williams, Hermann Warner, Jr. *The Civil War: The Artists' Record*, exh. cat. Washington, D.C.: Corcoran Gallery of Art, 1961.

Catalogue

Note to the Reader

Height precedes width, all measurements are in inches.
Unless otherwise noted, all works are by Winslow Homer.
Principal titles are the earliest public ones we were able to
locate; alternate titles are included, with the years they
were used in square brackets if they appeared before
1900. In some instances where an early published title
could not be documented to a work now known, we have
noted when a painting might "possibly" be associated
with it.

The provenance section has evolved from lender's
records, our own researches, and The Lloyd and Edith
Havens Goodrich/Whitney Museum of American Art
Record of Works by Winslow Homer, now on deposit at
the City University of New York. In instances where
we could not reconcile these sources, we have opted for
the likeliest sequence of owners, but these summaries
must be viewed as provisional.

In quoting nineteenth-century sources, original spell-
ing and punctuation have been maintained.

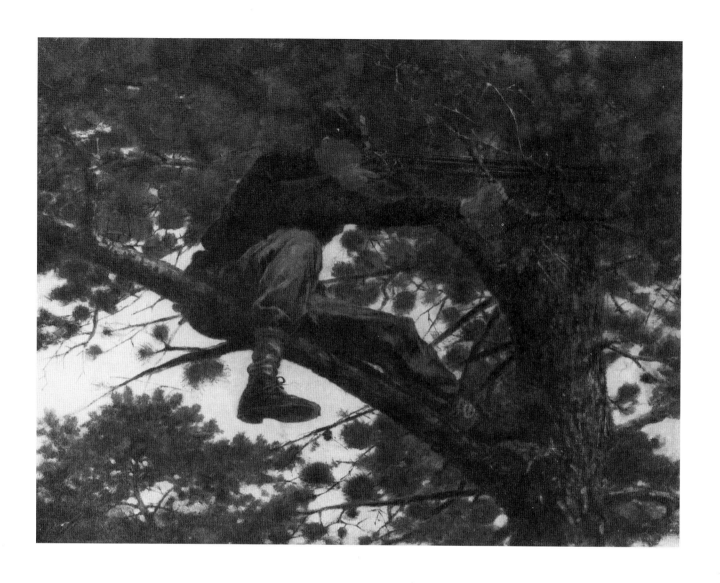

1. Sharpshooter, 1862/63

(Also called *Berdan Sharp-Shooter* [1864], *Yankee Sharpshooter,*
Sharpshooter on Picket Duty)
Oil on canvas, 12 1/4 × 16 1/2 inches
Signed and dated lower left: W. HomeR 63
Private collection

Sharpshooter is one of the icons of the Civil War. A lone Union sharpshooter, his face obscured, is perched in the fork of a tree. He aims his rifle with its telescopic sight, prepared to fire. It is an image of stark power, testimony to the brutal elegance with which this sharpshooter and his technologically advanced equipment could deal death to his foes. The remorseless fascination with death that came to preoccupy the artist's later works begins here.[1]

The work is reputed to be Homer's earliest oil painting. Writing in 1910, the artist's friend and colleague R. M. Shurtleff recalled:

His very first picture in oils was painted in his studio in the old University Building in Washington Square. It represented a "Sharpshooter" seated in a brig top, aiming at a distant "Reb," a canvas about 16 by 20. I sat with him many days while he worked on it, and remember discussing with him how much he could ask for it. He decided not less than sixty dollars, as that was what Harper paid him for a full page drawing on the wood.

I wonder where the picture is now, and whether its owner would put as modest a price on it?[2]
The public would have first seen the image (with slight but significant variations)[3] as a wood engraving in the *Harper's Weekly* of 15 November 1862 (*cat.no.1a*), where it bore the caption *The Army of the Potomac – A Sharp-Shooter on Picket Duty. – (From a painting by W. Homer, Esq.).* In spite of the wood engraving's caption, Homer continued to work on the painting after the print was made, signing and dating the work in 1863. By March 1864 he had exhibited the oil at least twice.

Family tradition tells how Homer placed the painting, with *In Front of the Guard-House* (*cat.no.7*), for sale in a now-unspecified location, telling his brother Charles that if they did not sell he would accept a permanent position as illustrator for Harper's Brothers. Charles secretly purchased them both, it is said, and Homer declined the berth at Harper's. When the artist some years later discovered that his brother had made the acquisitions, and that his supposed patronage was not disinterested, he reportedly grew very angry and refused to speak to his brother for weeks.[4]

Sharpshooter, pared down to the essentials of man, tree, and gun, is an image of concentration. The strength of Homer's synthesis of these elements is perhaps most clear when it is juxtaposed to a flaccid image of the same theme by the amateur draftsman, Alfred Bellard, *Sharpshooter firing at the gunners (fig.1.1)*. In both these works, the unusual point of view is from treetop level, as if the artist (and the viewer) shared the marksman's lofty perch.[5]

The object of the sharpshooter's intent gaze, his patient watching, is the death of an enemy soldier:

[T]he sharpshooter would take up his position, and, cat-like, patiently watch for his victim, whose appearance, although but momentary, was the signal of his death. . . .

The endurance of the sharpshooter is remarkable. Seated on a bough of a tree, in a ruined chimney, or in any other position where they could see without being seen, they have been known to remain in the same position for hours, without food, with their eye fixed on one particular object – the spot where the expected victim was to make his appearance.[6]

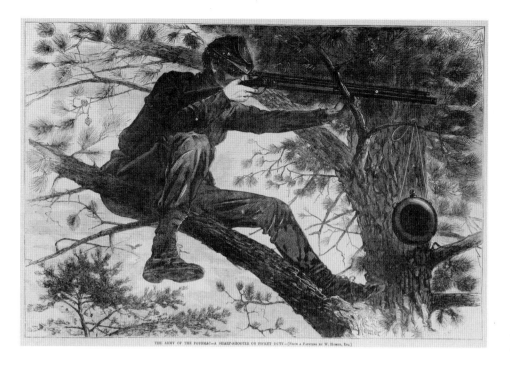

1a. *The Army of the Potomac –*
A Sharp-Shooter on Picket Duty.
Wood engraving, 9 ⅛ × 13 ¾ in.
Harper's Weekly 6, no. 307 (15
November 1862): 724. Signed
lower right (in block): Homer;
full caption reads: FROM A
PAINTING BY W. HOMER ESQ.
Peggy and Harold Osher
Collection. Courtesy of the
Portland Museum of Art,
Portland, Maine

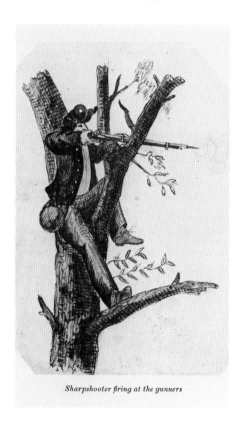

Sharpshooter firing at the gunners

fig.1.1 Alfred Bellard (ca. 1843-1891). *Sharp-*
shooter firing at the gunners, reproduced from *Gone*
for a Soldier: The Civil War Memoirs of Private
Alfred Bellard (Boston: Little, Brown, 1975), 60.
Used by permission of the Julian Bach Literary
Agency, Inc., New York

Death often came to the sharpshooter's victim as a surprise. Without warning, without a chance of return fire, sometimes without even so much as the sound of the shot (the distance being too great), the sharpshooter could snuff out the life of the man who appeared in his sights. The marksman's cold deliberation, coupled with his impressive feats of shooting, led opposing soldiers to despise the professional sharpshooter. A Southern journal reported:

A gentleman informs of the death of one of McClellan's sharpshooters, on the Peninsula. . . . Several of our men, it seems, were killed while going to a spring near by, but by whom no one could imagine. It was at last determined to stop this inhuman game, if possible, even at the cost of killing the hireling himself, who was thus in cold blood butchering our men. . . .

A trap is set once the Confederates are able to see the tell-tale puff of smoke from the rifleman's gun. Digging a new rifle pit under cover of darkness, a Confederate from Kentucky ambushes the sharpshooter the next morning.

Upon repairing to the spot, which the Kentuckian did immediately, he discovered [the Northerner's] riflepit, and a sturdy Yankee in it, in the last agonies

of expiring nature. The pit was provided with a cushioned chair, pipes and tobacco, liquors and provisions. . . . [B]ut for a sharp lookout for the smoke of his gun, there is no saying how long this Yankee vandal would have enjoyed the luxury of killing Southern men, without even a chance of losing his own worthless life.[7]

The language of the article, using words like "butchering" and "in cold blood" although in the midst of war, apparently reflected widespread sentiments. It was perhaps the one-sidedness of the exchange that was so infuriating and that made retribution seem just:

[Sharpshooters] are not likely often to be taken prisoners, as death is considered their just penalty; for as they very seldom are in a position to show mercy, so, in like manner, is mercy rarely shown to them.[8]

As one Northern officer wrote, "a sharpshooter shot at me, which I hate – it is so personal."[9]

Even among other soldiers of their own side, sharpshooters gained negative reputations as somehow less human than normal men.[10] Homer, the hunter and sportsman, who at least once himself looked down the scope of one of their rifles, apparently felt them to be so:

I was not a soldier – but a camp follower & artist, the above impression (fig. 1.2) struck me as being as near murder as anything I ever could think of in connection with the army & I always had a horror of that branch of the service.[11]

So the relative impersonality of Homer's sharpshooter, with regular, stylized features showing no emotion, was in accord with the cool, merciless deliberation perceived to be typical within the army's sharpshooter regiments.

Among Northern civilians, however, who did not have to experience directly their "so personal" attacks, the two regiments of the Army of the Potomac's sharpshooters were a source of much pride. Organized by Hiram Berdan in the summer and fall of 1861, and only open to skilled rifleman who could meet rigorous field tests, Berdan's Sharpshooters early in the conflict became an elite corps with special equipment, green rather than blue uniforms, and a remarkable reputation.[12] Conundrums were published in their honor:

fig. 1.2 Homer to George G. Briggs, sketch in letter, 19 February 1896. Misc. MSS, Winslow Homer Papers, Archives of American Art, Smithsonian Institution

A "Burden" the Rebels will find "more than they can bear."
Colonel Berdan, with his sharpshooters.[13]

A Fatal Oversight.
Colonel Berdan's sight over a Minié rifle.[14]
Cartoons featuring them appeared by such gifted caricaturists as Elihu Vedder (*fig. 1.3*). Thus it is not too surprising that, even though his sharpshooter does not wear the camouflage green of the regiment, when Homer exhibited the painting in February 1864 it bore the significant title *Berdan Sharp-Shooter.*[15]

No matter its title, no matter its size, the painting has a monumental power. At least in part this stems from Homer's depiction of the death-giver's relentless patience. As with *The Fox Hunt* of three decades later (1893, Pennsylvania Academy of the Fine Arts, Philadelphia), the artist energizes the canvas by encapsulating imminent violence within an elegant and simple form.

M.S.

THE PATENT CHRONOMETER TELESCOPE RIFLE.

fig.1.3 Elihu Vedder (1836-1923). *Camp Sketches – The Patent Chronometer Telescope Rifle*. Wood engraving, 3×2 in. *Vanity Fair* 4, no. 99 (16 November 1861): 222. Collection of the Library, University of California at Berkeley

1. See Henry Adams, "Mortal Themes: Winslow Homer," *Art in America* 71, no. 2 (February 1983): 112-126.

2. "Correspondence. Shurtleff Recalls Homer," *American Art News* 9, no. 3 (29 October 1910): 4.

3. In the wood engraving there is a closer focus on the soldier. This greater immediacy is accentuated by the clearer delineation of the sharpshooter's face, the clearly legible "A Company" insignia on his cap, and the addition of his canteen hung within easy reach. There is less greenery to shelter him from sight. The hand with which he will pull the trigger is the most startling part of the wood engraving. It is the only portion of the soldier's body that, rather than being fully modelled, is instead almost pure outline. Its relatively unbroken form, set amidst the dark lines of the figure, draws attention (by contrast) to itself and its potency. For a discussion of the contrast between Homer's paintings and wood engravings throughout his early career, see Courtney Ann Damkroger, "Winslow Homer: Image and Audience, A Comparison of Paintings and Related Engravings," M.A. thesis, University of California, Berkeley, 1986.

4. Downes does not give the name of the purchaser, but states that seven years elapsed before Homer learned the purchaser's name (*Life and Works*, 47). Goodrich, although less specific about the passage of time – noting only that it was "several years" – wrote that the discovery occurred when Homer went to visit his brother in Massachusetts and "saw one of the pictures" (*Winslow Homer*, 1944, 19). Recent scholars, such as Giese (*Painter of the Civil War*, 278-280) have cast doubt on the family tradition.

5. In fact, because the artist/reporters were hard-pressed to find convenient spots to view the smoke-filled battles, by war's end "practically every sketch artist considered himself an expert tree scaler." W. Fletcher Thompson, Jr., *The Image of War: The Pictorial Reporting of the American Civil War* (New York: Thomas Yoseloff, 1959), 82.

6. "Colonel Berdan," *The Portrait Monthly* 2, no. 18 (December 1864): 85.

7. Moore, *Anecdotes, Poetry, and Incidents*, 222-223. Captain C. A. Stevens recounted the same incident from the Northern perspective, citing the heroism of the Yankee sharpshooter (Joseph Durkee), and calling the reported luxuries a spinning out of a yarn (*Berdan's United States Sharpshooters in the Army of the Potomac, 1861-1865* [St. Paul, Minn.: The Price-McGill Co., 1892], 61) – see Wilson, this volume. Alexander Gardner makes the anecdotes real with his poignant photographs *A Sharpshooter's Last Sleep* and *The Home of a Rebel Sharpshooter, Gettysburg*, in *Gardner's Photographic Sketch Book of the Civil War* (1866; New York: Dover Publications, 1959), pls. 40, 41.

8. "Colonel Berdan," 85.

9. Lyman, *Meade's Headquarters*, 109.

10. Thus Frank Wilkeson later wrote: "Our sharpshooters were as bad as the Confederates, and neither of them were of any account as far as decisive results were obtained. . . . I hated sharpshooters, both Confederate and Union, in those days, and I was always glad to see them killed." *Recollections of a Private Soldier in the Army of the Potomac* (New York: G. P. Putnam's Sons, 1887), 120-121.

11. Homer to George G. Briggs, letter, 19 February 1896. Quoted in Giese, *Painter of the Civil War*, 238.

12. Cases were reported that had the Federal sharpshooters killing men from a distance of 1,960 yards — over a mile away (Theodore Gerrish and John S. Hutchinson, quoted in Williams, *The Artists' Record*, 104). Other often recounted incidents included "Old Seth's" "capture" of a cannon by picking-off anyone who approached it (Moore, *Anecdotes, Poetry, and Incidents*, 339-340), and the remarkable aim of "California Joe" who was said to have killed men at two miles distance (Ronald H. Bailey, *Forward to Richmond: McClellan's Peninsular Campaign* [Alexandria, Va.: Time-Life Books, 1983], 100). For a thorough review of these troops and their history, see Stevens, *Berdan's Sharpshooters*.

13. *Vanity Fair* 4, no. 85 (10 August 1861): 72.

14. *Vanity Fair* 4, no. 86 (17 August 1861): 76.

15. The red lozenge on the top of the soldier's cap identifies him as a member of the Third Corps, First Division of the Army of the Potomac, which as of April 1862 included the First U.S. Sharpshooters. See Philip R. N. Katcher, *Army of the Potomac* (Reading, Berkshire: Osprey Publishing Ltd., 1975), 29, 33. The fifth military group produced by John Rogers, in May 1862, was based on Berdan's Sharpshooters. See David H. Wallace, *John Rogers: The People's Sculptor* (Middletown, Conn.: Wesleyan University Press, 1967), 204.

PROVENANCE Charles S. Homer; Samuel Barlow, Lawrence, Mass.; his daughter, Josephine Barlow (Mrs. Victor) Reed (1892-at least 1941); her daughter, Mrs. J. Alexander McWilliams (by 1948-1982); [Sotheby's, New York, 22 October 1982]; [Schweitzer Gallery, New York]; private collection.

EXHIBITIONS PRIOR TO 1876 January 1864, New York, Atheneum Club; February 1864, Brooklyn and Long Island Fair in Aid of the United States Sanitary Commission (no. 85 as *Berdan Sharp-Shooter*; artist-owned).

CHANGES IN THE COMPOSITION Painting was examined using infrared reflectography; x-radiographs were available. Examination reveals that the painting originally resembled the print more closely. Contour changes include the sharpshooter's extended leg, which was thinner. The painting was less densely foliated. The artist painted over a sky that was originally pink and orange toward the bottom edge.

COLLECTED REFERENCES PRIOR TO 1876
Mr. Homer was represented by a "Sharpshooter," a very characteristic picture.
"Atheneum Club and our Artists," *The Round Table* 1, no. 7 (30 January 1864): 107.

W. Homer's "Sharpshooter" is a striking, truthful picture, the most interesting, on the whole, that we have seen of this artist's very individual work.
"Artists' Reception for the Benefit of the Brooklyn and Long Island Fair," *The New-York Daily Tribune*, 19 February 1864.

2. In Front of Yorktown, 1862/63

(Also called *Camp Near Yorktown* [1871], *A Camp Scene* [1874];
possibly also called *On the Picket Line* [1866])
Oil on canvas, 13 1/4 × 19 1/2 inches
Signed twice, lower right: HOMER/HOMER
Yale University Art Gallery
Gift of Samuel Rossiter Betts, B.A., 1875 (1930.15)

In the darkness of the Virginia night, five Yankee pickets cluster around their bivouac fire. Two of the men slumber beneath a rude shelter of pine boughs (Homer would use their recumbent forms in a *Harper's Weekly* wood engraving – *Winter-Quarters in Camp – The Inside of a Hut* – in January 1863 [*cat.no.2a*]), while another two at the left stare dully into the roaring campfire (a large pencil drawing for the right-hand one of these shows Homer's most schematic figural style [*cat.no.2b*]). At the center one man sits alert, his face raised, watchful.

The men are part of McClellan's Army of the Potomac, embarked on the long-planned Peninsular Campaign, the first major Union offensive of the war. After the Union debacle of the First Battle of Bull Run on 21 July 1861, General George B. McClellan was named commander of the troops in the Washington area, and spent nine months turning his tens of thousands of raw recruits into a well-organized and efficient army. This accomplishment was a significant one, especially given that McClellan was under constant political pressure to mount a major offensive and claim a speedy military victory for the shaken North. Instead of yielding to that pressure, he drilled and trained his men and formulated a plan that, when the time was ripe, he hoped would end the war with one swift campaign. Rather than attempting the direct overland route to Richmond, which was crossed by a series of defensible rivers, McClellan decided to transfer his army by water to Fortress Monroe, seventy miles southeast of the Confederate capital on the peninsula between the York and the James rivers.

Unfortunately, because a portion of his force was withheld for the defense of Washington (Stonewall Jackson, embarked on his campaign in the Valley of Virginia, loomed as a threat), the inflated estimates that were made of Confederate troop strength, and his natural caution that has damned him in hindsight, McClellan delayed before the physically substantial but undermanned fortifications of Yorktown for over a month. Battling against torrential rains his troops labored to establish the groundwork of an intensive siege operation.[1] On 4 May, without the siege having begun, without any shots being fired from the one hundred fifty mortars that McClellan had caused to be placed for a bombardment, the Confederates under General Joseph E. Johnston withdrew. The delay before Yorktown was to prove fatal for the campaign, allowing Confederate forces to concentrate in defense of the capital. Although McClellan was to advance to within sight of Richmond, he was thrown back by Robert E. Lee in the series of bloody encounters known as the Seven Days, 25 June to 1 July 1862. The Federals retreated to Harrison's Landing on the James River and the Peninsular Campaign was at an end.[2]

Homer witnessed the Peninsular Campaign from its beginnings. As early as February he apparently explored the possibility of visiting the front as a special reporter.[3] Among his drawings are spirited sketches of the troops embarking at Alexandria on 2 April, and works done on board ship when he followed soon thereafter.[4] Once in Virginia, Homer made a series of small, quick studies of soldiers in a rough camp (*figs. 2.1-3*), which eventually he combined to form a large, composite drawing of great vigor and strength

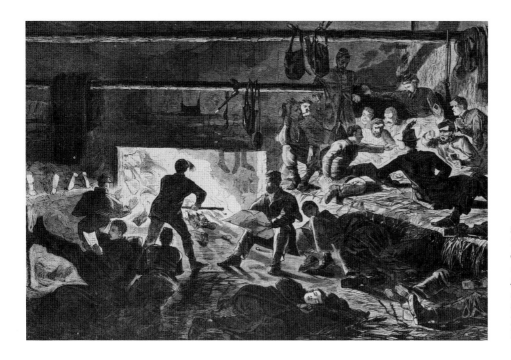

2a. *Winter-Quarters in Camp –
The Inside of a Hut.* Wood
engraving, 9 ⅛ × 13 ⅞ in.
Harper's Weekly 7, no. 307 (24
January 1863): 52. Peggy
and Harold Osher Collection.
Courtesy of the Portland
Museum of Art, Portland,
Maine

2b. *Sketches of a Seated Soldier and Three
Sketches of Soldiers' Heads.* Pencil with touches of
watercolor, 9 ¾ × 6 ½ in. Inscribed center left:
Bot/Space; binerra (crossed out); *canteen* (crossed
out). Cooper-Hewitt Museum, the Smithsonian
Institution's National Museum of Design, New
York. Gift of Charles Savage Homer (1912-12-271v)

(*cat.no.2c*). Homer would later use portions of this
drawing for *In Front of Yorktown.*

During the nearly two months that Homer
stayed with the army on the peninsula, he must
often have seen scenes like the bivouac fire.[5] A
larger, more convivial group outside Washington
had earlier attracted his attention for a December
1861 *Harper's Weekly* illustration (*fig.2.4*).
Another wood engraving that appeared in *Har-
per's* in May 1862, *Rebels Outside Their Works at
Yorktown Reconnoitering with Dark Lanterns,*
establishes Homer's specific interest at the time of
his Yorktown sojourn in nocturnal scenes.[6]

Homer's use of night imagery varies from his
wood engravings to his paintings. In the wood
engravings he takes full advantage of the drama
and grotesqueries of nighttime illumination –
distortions of shadow and form, for example –
while maintaining a full range of gray tones so
that nearly all the objects depicted can be easily
read. The darkness creates a mood but does
not threaten the legibility of any portion of the

2c. *An Army Encampment*, 1862. Pencil,
11⅝×24¾ in. Cooper-Hewitt Museum, the
Smithsonian Institution's National Museum of
Design, New York. Gift of Charles Savage Homer
(1912-12-158)

image. He creates a symbol of night rather than renders a veristic impression of it. His approach in the painting, on the other hand, is startlingly real. The only source of light for *In Front of York-town* is the flaming and sparking campfires. Objects loom from the darkness in accord with their placement in the firelight, the heavily shadowed areas fading to dark illegibility. Homer's palette, as well, apparently reflects his observation of night; his soldiers presumably wear standard blue uniforms, but they appear green under the orange glow of the firelight (see Hoermann, this volume).

That a novice painter — *In Front of Yorktown* is his second or third work — would choose the challenge of a nocturnal scene so early in his career demonstrates considerable ambition. Certainly other genre and landscape artists active at the mid-century (such as J. M. Culverhouse, George Caleb Bingham, Eastman Johnson, Robert Salmon, and Albert Bierstadt) attempted nocturnes.[7] Compared to these Homer's effort

seems strikingly observed and unconventional. Not until his own *Camp Fire* eighteen years later (1880, The Metropolitan Museum of Art, New York) would so realistic a campfire appear in American art, an extraordinary accomplishment since, as Kenneth Clark has observed, "Night is not a subject for naturalistic painting."[8]

In Front of Yorktown is a carefully and patiently evolved picture. Homer has selected a composition of unusual daring for the work — a dark screen of trees reaching beyond the top of the picture separates the viewer and the central motif.[9] Moreover, as the work progressed he changed and manipulated its design to great effect. The principal modification is the artist's thickening of the left-most foreground tree. By blocking more of the fire's brightness, Homer centered further attention on the alert man, on whose face and kepi he lavished considerable (almost microscopic) detail. Throughout the scene, in fact, Homer uses the bright yellows and oranges that glint from the cut edges of logs or broken twigs

fig.2.1 Soldier Seated, Seen from the Rear. Pencil on pasteboard, 3⅝ × 4⅞ in. Cooper-Hewitt Museum, the Smithsonian Institution's National Museum of Design, New York. Gift of Charles Savage Homer (1912-12-161)

fig.2.2 Two Sketches of Campfires, with Soldiers Seated Around. Pencil on pasteboard, 4¾ × 3⅜ in. Cooper-Hewitt Museum, the Smithsonian Institution's National Museum of Design, New York. Gift of Charles Savage Homer (1912-12-173)

fig.2.3 Slight Sketch Showing Soldiers Eating near a Field Kitchen. Pencil on pasteboard, 3½ × 4¾ in. Cooper-Hewitt Museum, the Smithsonian Institution's National Museum of Design, New York. Gift of Charles Savage Homer (1912-12-177)

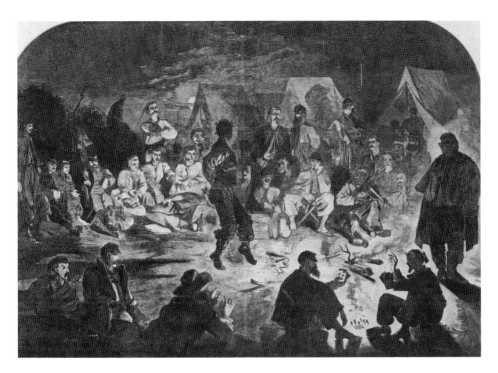

fig.2.4 *A Bivouac Fire on the Potomac.* Wood engraving, 15¾ × 20¾ in. *Harper's Weekly* 5, no. 260 (21 December 1861): 808–809. Sterling and Francine Clark Art Institute, Williamstown, Massachusetts

scattered across the clearing sparingly, so as to keep attention focused on the men who, like the trees for the fire, are the fuel for the war.[10]

The men portrayed are bivouacked on picket duty. They have been sent some distance from the main Union camp, sometimes as far forward toward the opposing force as two or three miles, to patrol the front and raise the alert at any enemy advance. Through the course of the night one of the soldiers (the sentinel or vedette) will move further forward while his comrades (as in *fig.2.5*) remain around the fire.[11] Soldiers in the field for the first time often found "the long and lonely vigils on the picket line" terrifying:

[N]ever in my life have I passed such a horrible night. The fate of the army might hang on me. . . . I had often been frightened in my life, but never like that, for it was torture.[12]

But most soon came to view it as "the pleasantest part of soldiering:"[13]

Picket was the soldier's romance. The camp was a noisy place with always the feeling of a multitude.

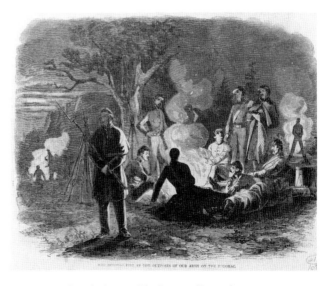

fig.2.5 Unidentified artist. *The Bivouac Fire at the Outposts of Our Army on the Potomac.* Wood engraving, 7⅛ × 9¼ in. *Harper's Weekly* 5, no. 249 (5 October 1861): 632. Collection of the Library of Congress

On picket we were far from the madding crowd, in the country by ourselves as it were, always in little groups and much of the time individually alone. . . .

Then it was about the only place where we felt individual responsibility. . . .

. . . The picket was the soldier's picnic.[14]

It was, as well, while on picket duty that the discipline of warfare most frequently broke down, and that the men of the two opposing armies would meet as friends to exchange newspapers, food, and tobacco. In battle, these men who traded and joked with one another would fight to the death. But during the many days when the armies hung fire, opposing pickets often declared unofficial truces with one another and gave warning if an officer were about to force a resumption of hostilities. "To 'wing' [or shoot] a picket in mere wantonness would disgrace a soldier."[15]

The scene in *In Front of Yorktown*, with the huddled, rather miserable-looking fellow at the left and the tense, unsmiling soldier at the center, has little of the air of a picnic. Walt Whitman, who went on picket duty with Union men near Falmouth in December 1862, conjured a comparably solemn poetic response that echoes Homer's image:

By the bivouac's fitful flame,
A procession winding around me, solemn and
* sweet and slow – but first I note,*
The tents of the sleeping army, the fields' and
* woods' dim outline.*
The darkness lit by spots of kindled fire, the
* silence,*
Like a phantom far or near an occasional figure
* moving,*
The shrubs and trees, (as I lift my eyes they seem
* to be stealthily watching me,)*
While wind in procession thoughts, O tender and
* wondrous thoughts,*
Of life and death, of home and the past and
* loved, and of those that are far away;*
A solemn and slow procesion there as I sit on the
* ground,*
By the bivouac's fitful flame.[16]

<div align="right">M.S.</div>

1. Alfred Davenport, *Camp and Field Life of the Fifth New York Volunteer Infantry (Duryee Zouaves)* (New York: Dick and Fitzgerald, 1879), 154-179, especially 155, 162, 167, 168.

2. *Catton's Civil War*, 64-86.

3. Letter dated 18 February from Francis Channing Barlow telling his mother, "I should be glad to see Homer here." See Chronology for full citation.

4. See, for example, *6th Penn Cavalr[y] Embarking at Alexandria . . .*, Cooper-Hewitt (1912-12-137), and soldiers on board a sidewheeler, Cooper-Hewitt (1912-12-144).

5. Staying during at least early April with Francis Channing Barlow, whose portrait would later stand for the image of the Northern officer in *Prisoners from the Front*, the artist remained at the front "about two months," according to a letter written on 7 June by Homer's mother. See Chronology for full citation.

6. Other reporters turned to the same effects for their works – see "The Eleventh Indiana Volunteer Regiment," *Frank Leslie's Illustrated Newspaper* 12, no. 294 (6 July 1861): 125. Reproductions of other night picket scenes are conveniently gathered together in Bardeen, *Little Fifer's War Diary*, 50, 54, 56, 58.

7. The master of these all, of course, was James McNeill Whistler, whose earliest night scenes in oil date from 1866, and whose *Nocturnes* would prove so important to the history of late-nineteenth-century art.

8. Kenneth Clark, *Landscape into Art* (1949; New York: Harper & Row, 1986), 103.

9. The central, largest tree is stripped of its bark. This might be used as kindling for the fire. More likely, however, it is an elm tree. According to Alfred Davenport, describing his camp near Yorktown on 21 April 1862: "On the banks above the ravine there was a thick wood of pine, with its ever-green foliage; elm-trees, which were soon robbed of their bark to satisfy the chewing propensities of the men; sassafras bushes, the roots of which are pleasant to eat, and are therefore pulled up without regard to quantity; but the wood is now getting thinner every day." *Camp and Field Life of the Fifth New York Volunteer Infantry (Duryee Zouaves)* (New York: Dick and Fitzgerald, 1879), 162.

10. A writer for *Vanity Fair* drew a comparison between the men of the Army of the Potomac and wood as early as 1861: "There is a wooden stake used to fasten cavalry horses, which is called a Picket, but must not be confounded with the Picket we are describing, although many of the latter are mere sticks to be sure, and are being driven in at that." "Campaigning – The Pickets," *Vanity Fair* 4, no. 90 (14 September 1861): 131.

Through use of natural empathy taken in conjunction with small formal details, such as touches of bright red at cuff or neck, Homer emphasizes the men rather than the atmosphere or the setting as the subject of the work.

11. For a full report of the soldier's point of view, see Captain Robert Goldthwaite Carter, *Four Brothers in Blue, or, Sunshine and Shadows of the War of the Rebellion: A Story of the Great War from Bull Run to Appomattox* (1913; Austin: University of Texas Press, 1978), 229.

12. James M. Dalzell, *Private Dalzell: His Autobiography, Poems and Comic Wars Papers* (Cincinnati: Robert Clarke & Co., 1888), 77; William A. Stone, "An Emetic for a Picket," quoted in B[enjamin] A. Botkin, ed., *A Civil War Treasury of Tales, Legends, and Folklore* (New York: Random House, 1960), 439.

13. George Grenville Benedict, *Army Life in Virginia. Letters from the Twelfth Vermont Regiment. . . .* (Burlington, Vt.: Free Press Association, 1895), 50.

14. Bardeen, *Little Fifer's War Diary*, 49-50, 63.

15. Bardeen, *Little Fifer's War Diary*, 49-63, especially 62.

16. "By the Bivouac's Fitful Flame," *Drum-Taps*, in Whitman, *Complete Poetry and Collected Prose*, 436.

PROVENANCE [Possibly Miner & Somerville, New York, 19 April 1866, as "On the Picket Line," no. 85]; George F. Betts (d. 1898); his son, Samuel R. Betts (to 1930); Yale University Art Gallery, New Haven, Conn.

EXHIBITIONS PRIOR TO 1876 February 1871, New York, Century Association (as *Camp Near Yorktown*); March 1874, New York, "Artists' Association 'Palette,'" held at the Kurtz Art Building (as *A Camp Scene*).*

*Two exhibition references in the mid-1870s might refer to this work, although both were listed under the "Watercolor Cabinet": New York, Century Association, March 1875 [as *Picket Guard*]; Chicago, Industrial Exposition Building. Spring Exhibition of Fine Works of Art, From John Snedecor . . . and The Haseltine Galleries, Spring 1876 [as *Picket Line – Front of Yorktown*].

CHANGES IN THE COMPOSITION Painting was examined without using infrared reflectography; x-radiographs were not available. Left foreground tree almost doubled in width and made straighter; brightness of fire's color toned back.

SELECTED REFERENCES PRIOR TO 1876
There are a large number of pleasantly-treated works by New York artists, among which are "A Camp Scene" – soldiers grouped around a watch fire – by Winslow Homer.
"Artists' Association 'Palette,' Third Annual Exhibition – The Paintings," *The Evening Post*, 18 March 1874.

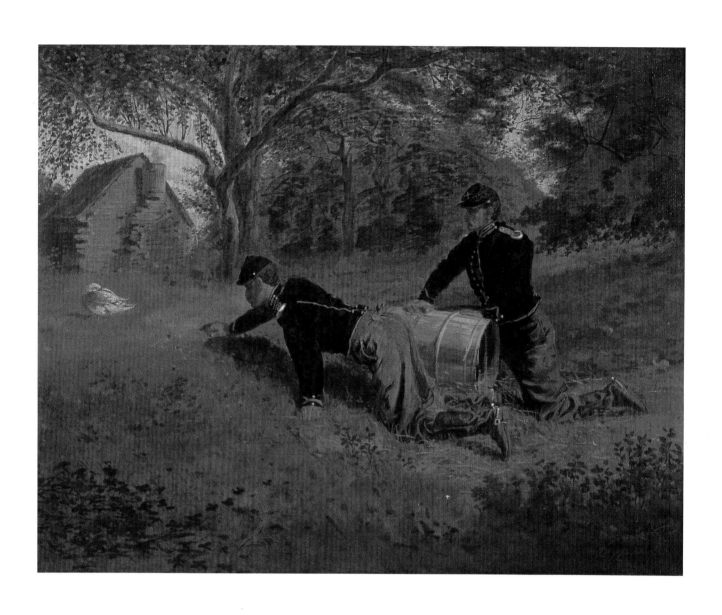

3. The Last Goose at Yorktown, ca. 1863

Oil on canvas, 14¼ × 17⅞ inches
Signed lower right: W. Homer
Private collection
NOT IN EXHIBITION

One of the two paintings by Homer that first appeared in an Annual Exhibition of the National Academy of Design, and consequently one of the first works to bring Homer's name to the attention of New York's major public and critical audience, was *The Last Goose at Yorktown*. In a grassy and wooded field, far from any sign of camp, two Union cavalrymen attempt to sneak up behind a sleeping goose. One kneels, holding steady the barrel that will serve as a cage for their intended victim, while the other stealthily crawls forward on his hands and knees. A small farmhouse or outbuilding sits in the left distance, empty of, perhaps even deserted by, occupants who might witness or halt the soldiers' incipient theft.

Homer's painting pays homage to a well-known, if not entirely sanctioned, practice of soldier life—foraging. Standard army rations were frequently meager and invariably monotonous, and while a soldier in camp might improve his diet by a visit to the sutler's tent, he might also find the sutler's prices too high and his goods of uneven quality (see *cat.no.6*). On the march conditions often became worse, since sutlers were not in the vicinity and rations might not last through any extensions or delays in a planned march. Raids on the outlying countryside soon became routine, although at first such behavior was severely discouraged on both moral and philosophical grounds:
[E]arly in the war many of the prominent government and military officers thought that a display of force with consideration shown the enemy's property would win the South back to her allegiance to the Union; but that if, on the other hand, they devastated property and appropriated personal
effects, it would only embitter the enemy, unite them more solidly, and greatly prolong the war. . . .[1]

Both Union and Confederate generals in the early years of the conflict were inclined to uphold a code of honor among their armies, believing it wrong for individual soldiers to punish enemy civilians. George McClellan forbade his soldiers to burn enemy fence rails for fuel, and before his invasion of Pennsylvania in June 1863 Robert E. Lee reminded his army that "The duties exacted of us by civilization and Christianity are not less obligatory in the country of the enemy than in our own."[2] The army might still expect civilians in enemy territory to provide certain items necessary for its men and their animals, but early in the war, foraging was a job assigned to specially authorized groups, who actually provided receipts for confiscated goods. Soldiers on march might be subject to frequent roll calls as well as fines for any missing cartridges or killed animals.[3] But as the war wore on, soldiers and officers alike grew indifferent to the restraints of orders and ethics. Soldiers might claim that they killed only those beasts that "refused to take an oath of allegiance";[4] others made no such pretense, bragging about the extent of their booty and idealizing the exploits of those particularly adept at going "out on a French."[5] Officers, too, soon relaxed their vigils, as reported by a Union soldier from North Carolina:
Whenever we neared a town where we were to halt, our approach was marked by a spattering fussilade [sic], amid which the last dying squeaks of the unfortunate pigs far and near were heard. . . . When we first started the colonel tried to prevent

our foraging but he quickly found out that all that was nonsense & before we got back we were as expert at it as any of the old hands.[6]

Most officers in fact found themselves the beneficiaries of offerings delivered to their tents as atonements. The captain of James Dalzell's regiment, "as big a rake as any of us," had a hard time punishing one forager, "because every time the fellow came in he had a leg of mutton, a full canteen, or a bunch of honey, to appease the captain's wrath and conciliate his good will."[7] The Confederate general Joseph Shelby, upon hearing one of his men answer that a suspicious bundle in front of his saddle was only laundry, told the soldier "You had better fix to get your laundry to camp before it bleeds to death," and ordered the man to the guardhouse for pillaging. That night, however, a roast pig was delivered to the General's tent, and after taking a bite, Shelby remarked, "Release that man from the guardhouse. It doesn't seem quite right to confine him for a little laundry."[8]

Ultimately, foraging assumed distressing and disastrous proportions when General William T. Sherman led his army through Georgia on his "march to the sea." What at first had been condoned as an immediate and short-term response to the needs of an army had now evolved into a strategic means to punish and terrify an entire Southern population. Arguing that "the crueler [war] is, the sooner it will be over," Sherman ordered his troops to "forage liberally on the country while on the march," and did little to suppress the looting, depradation, and wanton destruction that accompanied such activity. Sherman's army left behind them "a blackened swath seventy miles wide."[9]

Homer's cavalrymen sneaking up on a lone goose, painted after the artist's visits to the front at Yorktown during McClellan's Peninsular Campaign in spring 1862, depicts an earlier, more innocent chapter of the Civil War. Homer's two well-dressed cavalrymen might well be on an officially sanctioned forage trip; in appearance and demeanor they are far from the "bummers" who would characterize foraging efforts later in the war.[10] Homer chose to depict a moment *pre-*

ceding any actual crime; his soldiers are only *about* to commit their act of pillage and a chance remains that they will not succeed. Unlike so many other illustrations of foraging, including Homer's own lithograph of late 1863 (*fig.3.1*), no distraught or outraged civilians appear in this composition to comment upon or condemn the soldiers' activities.[11] What finally remains is a sleeping goose who has reduced two sturdy men to their knees; there is no guarantee that the goose will not awaken and escape from the fate so dearly wished upon him by the hungry soldiers. But whatever humor may be afforded by seeing dashing cavalrymen caught in somewhat compromising circumstances, Homer implies by his title a more solemn interpretation to these soldiers' activity. Could this solitary white bird, its head calmly tucked beneath its wing, really be the "last goose" in all of Yorktown? If so, the soldiers, weary already from two months of frustrating siege operations (see Wilson, this volume), are in more serious straits than their immediate circumstances admit. The humor of the situation, as well as the lushness of the wooded, pastoral setting, softens the harsh reality of hunger and the army's often desperate search for food.

s.m.

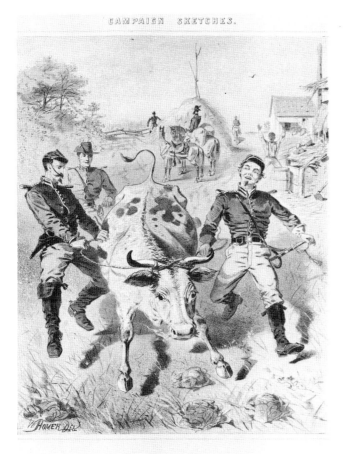

fig.3.1 Foraging, 1863. Lithograph from *Campaign Sketches*, 13⅞×11 in. Amon Carter Museum, Fort Worth, Texas (32.83)

1. Billings, *Hardtack and Coffee*, 231.

2. Linderman, *Embattled Courage*, 180-181.

3. Billings, *Hardtack and Coffee*, 231-232; Linderman, *Embattled Courage*, 182.

4. Jay Monaghan, "Civil War Slang and Humor," *Civil War History* 3, no. 2 (June 1957): 132.

5. See the chapter, "Dave Sheppard, The Forager," in James M. Dalzell, *Private Dalzell: His Autobiography, Poems and Comic War Papers . . . A Centennial Souvenir* (Cincinnati: Robert Clarke & Co., 1888), 65-77. Foraging also went by the names of "japaning," "cabbaging," and no doubt many others invented by soldiers to avoid the term "stealing." See Monaghan, 132.

6. Samuel Storrow to his parents, letter, 19 November 1862, quoted in Wiley, *Billy Yank*, 234.

7. Dalzell, 65.

8. Quoted by Monaghan, 132.

9. Linderman, *Embattled Courage*, 212-215; Billings, *Hardtack and Coffee*, 239-241; Ketchum, *American Heritage Picture History*, 546-547.

10. When Homer's painting *In Front of the Guard-House (cat.no.7)* was exhibited at the National Academy in 1864, the year after *The Last Goose at Yorktown* was shown, one critic assumed that the painting depicted a soldier being punished for "foraging on a simple basis of direct theft."

11. Other examples include the "Treasure Seekers" and "The Bummer" illustrated in Bardeen, *Little Fifer's War Diary*, 248-249; or the "Union foragers in the Shenandoah," illustrated by Edgar H. Klemroth in "Shenandoah Sketchbook," *Civil War Times Illustrated* 14, no. 8 (December 1975): 16. Homer's painting of a *Cabbage Garden* (unlocated), exhibited in the 1864 Artists' Fund Exhibition, may have been a foraging scene very similar to his 1863 lithograph. In the print, cabbage heads feature prominently in the foreground; "cabbaging" was a slang term for foraging (see note 5). A reviewer for *The New-York Times* noted the painting by saying "In HOMER's cabbage garden you may see the romance of that institution" (26 December 1864). In 1876 Homer exhibited another painting of *Foraging* (unlocated) at the National Academy of Design; this is probably the painting of *Zouaves Foraging* noted in Homer's studio in the fall of 1875 and exhibited at the Century Club in November of that year. See "The Arts," *Appleton's Journal* 114, no. 346 (6 November 1875): 603; and "Art at the Century," *The Evening Post*, 9 November 1875.

PROVENANCE [Probably Samuel P. Avery, New York, (1863-no later than 1867)];* Joseph A. Dean, New York (before 1874-1902);† [Dean sale, New York, Fifth Avenue Art Galleries (James P. Silo, Auctioneer), 6 March 1903, no. 74]; Andrew C. Zabriskie, Barrytown Corners, New York (probably 1903-1916); his son, Christian A. Zabriskie, Annandale-on-Hudson, New York (1916-1970); Yale University Art Gallery, New Haven, Conn. (1970); [Kennedy Galleries, New York (1970)]; private collection (1970-1984); [Davis & Langdale Company, New York (1984)]; present collection.

*It has often been assumed that Joseph Dean purchased *The Last Goose at Yorktown* directly from the National Academy of Design's 1863 exhibition. However, Aldrich in 1866 related that both of Homer's entries to that exhibition had been bought "by a well-known connoisseur." Since it is known that Samuel P. Avery owned "*Home, Sweet Home*," it is reasonable to deduce that Avery also purchased *The Last Goose* and sold it to Dean sometime between 1863 and 1867, the date that Avery left for Europe and liquidated his stock. *The Last Goose* was not among the paintings that Avery sold at auction in 1867.

†Dean certainly owned *The Last Goose* by 1874, the year he first exhibited it at the Yale School of the Fine Arts; he may well have known of Homer much earlier, for Dean's home at 17 Waverly Place was very close to Homer's studio in the University Building. Homer's colleague Eugene Benson seems to have known Dean quite well; before leaving New England to join Homer in Europe, Benson wrote to William Conant Church, editor of *The Galaxy*, asking him to "Please address me at 17 Waverly Place." Benson to Church, letter, 21 May 1867, in The New York Public Library, Manuscripts Division, William Conant Church Collection/The Galaxy Correspondence; roll N-5, frames 1210-11. Archives of American Art, Smithsonian Institution.

EXHIBITIONS PRIOR TO 1876 April 1863, New York, National Academy of Design, "Thirty-Eighth Annual Exhibition," no. 255; 1874, New Haven, Ct., Yale School of the Fine Arts, Yale College, "Fifth Annual Exhibition," no. 26; 1875, New Haven, Conn., Yale School of the Fine Arts, Yale College, "Sixth Annual Exhibition," no. 33.

CHANGES IN THE COMPOSITION Painting has not been examined.

COLLECTED REFERENCES PRIOR TO 1876
But meanwhile, we must mention . . . Mr. Winslow Homer's Nos. 255 [*The Last Goose at Yorktown*], and 371 ["*Home, Sweet Home*"]. The two last are incidents of the camp, treated with perfect spirit and freshness.
"The Lounger: The National Academy of Design," *Harper's Weekly* 7, no. 331 (2 May 1863): 274.

Two little war-scenes, (Nos. 255 and 371,) by Winslow Homer – his first appearance in any academy – have received and merited much notice. Mr. Homer calls his pictures *The Last Goose at Yorktown*, and *Home Sweet Home*. The first represents a couple of Union boys cautiously approaching on all fours an overturned barrel, out of the farther end of which the wary goose is observed making a Banks-like retreat. A neat bit of humor, Mr. Homer.
"The National Academy of Design. II," *The New-York Illustrated News*, 16 May 1863. Reappears with slight variances in phrasing and punctuation in T. B. Aldrich, "Among the Studios. III," *Our Young Folks* 2, no. 6 (July 1866): 398.

Winslow Homer is one of those few young artists who make a decided impression of their power with their very first contributions to the Academy. He . . . succeeds in virtue of having waited until he knew how to draw and paint, instead of having rushed into the arena impetuously upon the strength of mere taste or talent for his art. . . .
"The Last Goose at Yorktown" is a capital picture of that bird, and of the strategy of two soldiers creeping on his rear, the one with hands extended to grab him at the moment of close approach, the other holding a barrel for his imprisonment when caught. The attitude, both of bird and men, the expression on the faces of the latter, and the working out of the nice little bit of trees and meadow around the objects of interest, are done with a maturity creditable to any, and surprising in so young an artist.
"The National Academy of Design. Its Thirty-Eighth Annual Exhibition. Fifth Article," *The Evening Post*, 12 June 1863.

Winslow Homer is a new name on the catalogue, but his two pictures, Nos. 255 [*The Last Goose at Yorktown*] and 351 ["*Home, Sweet Home*"], which we omitted accidentally, to notice among the figure pieces, give evidence to a rare talent in *genre* subjects.
"Fine Arts. Thirty-Eighth Annual Exhibition of the National Academy of Design. No. III. Concluding Notice," *The Independent* 15, no. 760 (26 June 1863): 6.

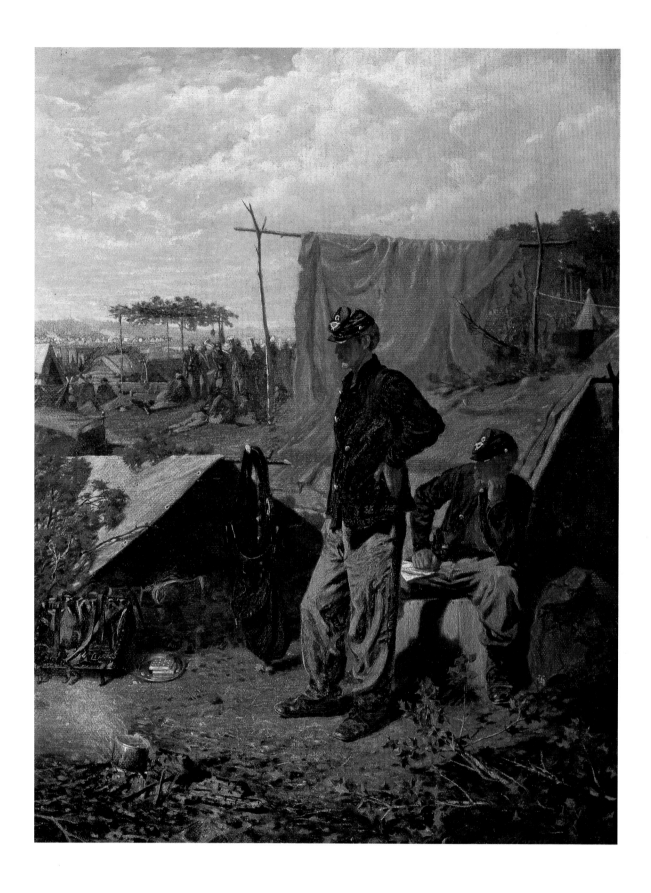

4. "Home, Sweet Home," ca.1863

Oil on canvas, 21 ½ × 16 ½ inches
Signed lower right: W Homer
Private collection
NOT IN EXHIBITION

Of Homer's two works in the 1863 Annual Exhibition of the National Academy of Design marking his debut as a painter, one was an image that he must have known would resonate strongly with veterans and civilians alike – a painting of two soldiers outside their simple army encampment, one standing, the other seated with what appears to be a letter in his hand, both musing silently while in the distance a regimental band plays. The painting's title *"Home, Sweet Home"* not only suggests the content of the soldiers' thoughts, but comments ironically on the assembled comforts of their crude camp: the small fire upon which a pot boils, boughs of pine and holly that provide additional shade to the low shelter tents, posts and stakes upon which hang such possessions as fit into a haversack or pouch, and finally, the ever-present soldier's meal, two hardtack biscuits on a tin plate. The soldiers' circumstances, as well as their thoughts, could be readily imagined and personally interpreted by any viewer. Still familiar today, "the lyric that is perhaps more widely known than any other in the English language" carried special appeal to anyone whose family bonds were broken by the war:

'Mid pleasures and palaces though we may
roam,
Be it ever so humble, there's no place like Home!
. .
An exile from Home, splendour dazzles in vain! –
Oh, give me my lowly thatched cottage again! –
The birds singing gaily that came at my call. –
Give me them! – and the peace of mind dearer
than all!

Home, home! sweet, sweet Home!
There's no place like Home!
There's no place like Home![1]

Homer was well aware of the suggestive force of music – an aural power that could be translated into visual terms with the simple help of a title. Among the first illustrations Homer produced for *Harper's Weekly* after his initial visit to the front in October 1861 was *The Songs of the War*, which appeared in *Harper's* on 23 November 1861 (*fig.4.1*). At the beginning of the conflict, when both energy and enthusiasm were high among the Army of the Potomac, it was appropriate that Homer give the largest space of his illustration to "Glory Hallelujah" – the refrain of "John Brown's Body," that "rude chant to which a million of the soldiers of the Union kept time."[2] Other songs included "The Bold Soldier Boy," "Hail to the Chief," "We'll be Free and Easy Still," and the Confederate standard, "Dixie"; but at the center of these rousing, manly vignettes stands "The Girl I Left Behind Me." As the war wore on, the rallying songs were heard less and less while soldiers requested more of the softer tunes that might set their hearts at ease and remind them of the life, as well as the women, they had left behind. By mid-1863, a war nurse had noticed that soldiers were no longer singing "The Battle Hymn of the Republic" nearly as often as "When This Cruel War is Over," a song that has been described as "the war's supreme ditty of heartbreak," so moving that the Army of the Potomac banned its singing, claiming that it caused desertion.[3] "Just Before the Battle, Mother" and Walter Kittredge's "Tenting Tonight" rivaled "When

fig.4.1 The Songs of the War. Wood engraving,
14 × 20 in. *Harper's Weekly* 5, no. 256 (23 November
1861): 744-745. Sterling and Francine Clark Art
Institute, Williamstown, Massachusetts

This Cruel War is Over" as the soldiers' gloomy
favorites:

> *We're tenting to-night on the old camp ground.*
> *Give us a song to cheer*
> *Our weary hearts, a song of home,*
> *And friends we love so dear.*
> *Many are the hearts that are weary to-night,*
> *Wishing for the war to cease;*
> *Many are the hearts looking for the right,*
> *To see the dawn of peace.*[4]

Sentimental standards such as "Auld Lang Syne,"
"Rock Me to Sleep, Mother," and "Do They Miss
Me at Home?" could provoke moist eyes if not
audible sobs in soldier audiences;[5] "Home, Sweet
Home" was among the most potent of these.
During the long winter following the Battle of
Fredericksburg in late 1862-early 1863, when the

opposing armies were camped on opposite sides of the Rappahannock in full sight of one another, and rival pickets swapped coffee and newspapers for tobacco and gossip, the Union bands assembled one evening on the banks of the river to play a variety of familiar tunes. After a round of sentimental favorites, the bands played "John Brown's Body" and "The Battle Cry of Freedom"; the Southerners asked for some of their own songs, and the Northerners responded with "Dixie" and "The Bonnie Blue Flag."

And then at last the massed bands played "Home, Sweet Home," and 150,000 fighting men tried to sing it and choked up and just sat there, silent, staring off into the darkness; and at last the music died away and the bandsmen put up their instruments and both armies went to bed. A few weeks later they were tearing each other apart in the lonely thickets around Chancellorsville.[6]

Homer's painting appeared at the National Academy in mid-April 1863, just days before General Joseph Hooker moved his Army of the Potomac across the Rappahannock toward Chancellorsville and a bitter defeat. Poignant as the reminder of a "Home, Sweet Home" might be in spring 1863, those sentiments would gain increased sharpness toward the end of the year, when many volunteers faced the question of renewing the commitments they had made in 1861. Requiring soldiers to make a decision six months to a year prior to the expiration of their original three-year enlistments, the army command offered several incentives in the form of bonuses and appeals to pride, patriotism, and comradeship. But the most compelling of these inducements, as Gerald Linderman has argued, was the promise of an immediate furlough. To an increasingly fatalistic army, many of whom fully believed that they would not live to see the end of their enlistments, the promise of a month at home meant they would at least see their families once more. As a soldier of the Fifth Maine described it,

Many of the men had been away from home for two years and half. . . . Thirty-five days furlough! It seemed almost an age. . . . The news spread like lightning. Re-enlist? Yes. What tempted those men? Bounty? No. The opportunity to go home. . . . Oh, if they could only see home again, they were ready to risk anything and everything. The theme was up on all lips. It was reenlistment – furlough – home.[7]

A captain of the Sixty-fifth Ohio regiment phrased it bluntly when he reported that his soldiers had agreed to gamble "three years more of hell" in exchange for "thirty days of heaven – home."[8]

Homer's image alludes to such powerful sentiments, without specifically defining them or indulging in sentimentality. By posing his soldiers as if they were staring down into the campfire, Homer casts their faces in shadow and leaves their features indistinct. As if to insist upon the reality and presence of his scene, however, Homer has described the surrounding camp environment with delicacy and precision. Such description is convincing and appropriate, down to the berries on the holly boughs, the punched holes in the hardtack, and the insignia on the soldiers' kepis, the jager and "G" which designated the soldiers' branch of service (infantry) and individual company.[9] Critics who saw the painting in 1863 universally praised the truthfulness of Homer's representation, the simple honesty and lack of affectation in what might easily become a cloying scene. The critic for *The New Path* described the painting as one of the very few "truthful" depictions of the war, even if only of its "sentimental side – and yet, the 'Home, Sweet Home,' of the last Academy Exhibition [is] too manly-natural to be called sentimental."[10] Such was the appeal of this image, painted by an artist who was still unfamiliar to most of his audience, that it was sold by the second day of its exhibition.

S. M.

1. Gustave Kobbé, *Famous American Songs* (New York: Thomas Y. Crowell, 1906), 20-22. John Howard Payne's famous verse, written in Paris in 1822, first appeared in the opera *Clari, The Maid of Milan*, set to music by Sir Henry Bishop.

2. Brander Matthews, "The Songs of the War," *The Century Magazine* 34, no. 4 (August 1887): 619. Soon after Homer's illustration appeared in *Harper's*, "John

Brown's Body" was given new words by Julia Ward Howe and became "The Battle Hymn of the Republic." Howe's lyrics were first published in *Atlantic Monthly* in February 1862; Howe describes the circumstances of their origin in a "Note on the 'Battle Hymn of the Republic' that follows Matthews' "The Songs of the War," 629-630.

3. Linderman, *Embattled Courage*, 224; James Stone, "War Music and War Psychology in the Civil War," *The Journal of Abnormal and Social Psychology*, 36, no. 4 (October 1941): 555.

4. Reverend Louis Albert Banks, *Immortal Songs of Camp and Field* (Cleveland: The Burrows Brothers Company, 1899), 149.

5. Linderman, *Embattled Courage*, 244.

6. *Catton's Civil War*, 104-105. Elsewhere this episode is placed near Murfreesboro, Tennessee, on the night before the battle of Stones River in December 1862. See Bell Irvin Wiley and Hirst D. Milhollen, *They Who Fought Here* (New York: Macmillan, 1959), 146.

7. George Bicknell, quoted by Linderman, *Embattled Courage*, 262.

8. Captain Brewster, quoted in Linderman, *Embattled Courage*, 262-263.

9. See Philip R. N. Katcher, *Army of the Potomac* (Reading: Osprey Publishing Limited, 1975), 5-6, and Francis A. Lord, *Uniforms of the Civil War* (New York: Thomas Yoseloff, 1970), 43-44.

10. Lionel [pseud.], "The Artists' Fund Society, Fourth Annual Exhibition," *The New Path*, 1, no. 8 (December 1863): 95.

PROVENANCE [Samuel P. Avery (1863?-1867)]; [Avery sale, New York, Leeds Art Gallery (Leeds & Miner, Auctioneers), 5 February 1867, no. 59];* Mrs. Alex H. Shepherd; [Howard Young Galleries, New York]; [M. Knoedler & Co., New York]; George M. L. LaBranche, New York and New Rochelle (by 1944); Mr. and Mrs. Nathan Shaye, Detroit (by 1958-1984); [sale, New York, Sotheby's, 30 May 1984, no. 19]; [Hirschl & Adler Galleries, New York (1984)]; present collection.

*"Home, Sweet Home" was sold on the second night of the Avery sale, and appears in the "Catalogue of oil paintings, being the balance of the stock consigned to S. P. Avery. . . ." The previous night, Leeds & Miner had auctioned "the private collection of oil paintings by American artists, made by Samuel P. Avery, during the last fifteen years. . . ." Thus Avery seems to have owned "Home, Sweet Home" only in order to sell it; it was not part of his personal collection.

EXHIBITIONS PRIOR TO 1876 April 1863, New York, National Academy of Design, "Thirty-Eighth Annual Exhibition," no. 371.

CHANGES IN THE COMPOSITION Painting has not been examined.

COLLECTED REFERENCES PRIOR TO 1876
But meanwhile we must mention . . . Mr. Winslow Homer's Nos. 255 [*The Last Goose at Yorktown*], and 371. The two last are incidents of the camp, treated with perfect spirit and freshness. No. 371, *Home, Sweet Home*, was marked "for sale" in the catalogue on the first day. But on the second it was labeled "sold." It is a little work of real feeling; soldiers in camp listening to the evening band, and thinking of the wives and darlings far away. There is no strained effect in it, no sentimentality, but a hearty, homely actuality, broadly, freely, and simply worked out.
"The Lounger. The National Academy of Design," *Harper's Weekly* 7, no. 331 (2 May 1863): 274.

Again another unfamiliar name occurs, attached to no. 371, *Home, Sweet Home*, two lounging soldiers in camp, who appear heartily to wish they were out of it. The fore-ground is frittered away into too many minute parts; but if, as we are told, this is Mr. Winslow Homer's maiden effort, it is a good one, and he may well be encouraged to persevere.
"Fine Arts. National Academy of Design. Third and Concluding Notice," *The Albion* 41, no. 19 (9 May 1863): 225.

WINSLOW HOMER is a new name in the catalogue of the Academy pictures; but — if I may found a judgment on the works from his easel now in the exhibition — one that

must do honor to any collection. Mr. Winslow Homer, in the picture entitled "Home, Sweet Home," No. 372 [sic], shows a strength and boldness in execution truly admirable. We hail it as a promise; we accept it as a worthy achievement. The picture illustrates a fact of camp life; and the artist has left nothing out but the music. Great facility is shown in the disposition of material, and the general effect of color is agreeable. The *best* painting in the work, however, is the ground; the weakest that of the hands, which are not worked out with a skill and power equal to that shown in other parts of the picture. The picture, as a whole, is a fine piece of objective work, and shows a genuine and conscientious spirit. There is no clap-trap about it. Whatever of force is in the picture is not the result of trickery, and is not merely surface work, not admitting of examination, but painstaking labor directed by thought.
Atticus [pseud.], "Art Feuilleton," *The New York Leader* 9, no. 18 (9 May 1863): 1.

Two little war-scenes, (Nos. 255 and 371,) by Winslow Homer – his first appearance in any academy – have received and merited much notice. Mr. Homer calls his pictures *The Last Goose at Yorktown*, and *Home Sweet Home*. . . . The second picture shows a Federal camp at supper time. The band in the distance is playing "Home Sweet Home"; in the immediate foreground are two of the boys, one warming the coffee at the camp fire, and the other dreamily watching the operation, but his heart is far away, for the suggestive music of the band has filled his eyes with pictures of sweet, sweet home. The different sentiments of the two incidents are worked out with gracious skill. The pictures are a trifle fresh in color, otherwise unexceptionable.
"The National Academy of Design. II," *The New-York Illustrated News*, 16 May 1863. Reappears with slight variances in phrasing and punctuation in T. B. Aldrich, "Among the Studios. III," *Our Young Folks* 2, no. 6 (July 1866): 398.

Winslow Homer is one of those few young artists who make a decided impression of their power with their very first contributions to the Academy. . . . Another army piece, "Home, Sweet Home" (371), is of the pathetic order, and tender in its humanity to the last degree, representing as it does the bitter moment of home-sickness and love-longing which comes upon two brave men in camp on hearing the band play the air which recalls all priceless things from which they are separated. The delicacy and strength of emotion which reign throughout this little picture are not surpassed in the whole exhibition. Mr. Homer needs not our welcoming to the honorable rank which he took from the night of the private view.
"National Academy of Design. Its Thirty-Eighth Annual Exhibition. Fifth Article," *The Evening Post*, 12 June 1863.

Winslow Homer is a new name on the catalogue, but his two pictures, Nos. 255 [*The Last Goose at Yorktown*] and 351 [sic], which we omitted accidentally, to notice among the figure pieces, give evidence to a rare talent in *genre* subjects.
"Fine Arts. Thirty-Eighth Annual Exhibition of the National Academy of Design. No. III. Concluding Notice," *The Independent* 15, no. 760 (26 June 1863): 6.

Mr. Homer is the first of our artists – excepting Mr. [Jervis] McEntee, in his "Virginia" – who has endeavored to tell us any truth about the war. True, he has looked only on the laughing or the sentimental side – and yet, the "Home, Sweet Home," of the last Academy Exhibition, was too manly-natural to be called sentimental. . . .
Lionel [pseud.], "The Artists' Fund Society, Fourth Annual Exhibition," *The New Path* 1, no. 8 (December 1863): 95.

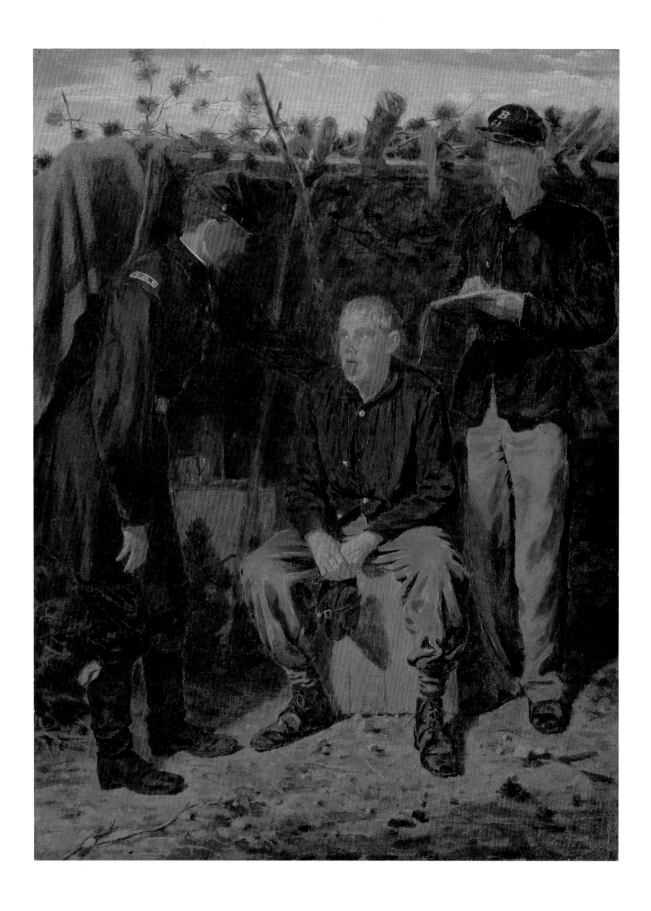

5. Playing Old Soldier, 1863

Oil on canvas, 16 × 12 inches
Signed lower right: Homer
Museum of Fine Arts, Boston
Ellen Kelleran Gardner Fund (43.129)

Outside the surgeon's quarters marked by a red flag, a soldier presents himself to the army medic. The surgeon leans over to examine his seated patient, who sticks out his tongue and stares straight ahead. An attendant makes notes. This scene might portray an actual case of discomfort or disease had not Homer appended a title to make it clear that this blonde soldier is only feigning illness, or "playing old soldier" in order to avoid dangerous or disagreeable service.[1]

Not surprisingly, suspicious pains and ailments appeared most frequently just before battle. Early in the conflict, an officer noted in his diary that upon hearing the "Long Roll" or summons to battle, his regiment

turned out to a man and were in line of Battle in 7 minutes, and ready for the enemy. Yet there was a number who were suddenly taken with a "pain in the stomach" and felt like going back to their tents. The trouble evidently was cowardice.[2]

No less than the officers who commanded them, soldiers who risked their lives in battle looked down upon cowards and offered no sympathy to shirkers who avoided responsibility. One man who was "believed by his comrades to have feigned sickness" found a chilly reception when his regiment returned from the battle he had missed. Apologizing for his absence but claiming that little was lost thereby, since he was not an especially good soldier, his reply came from a man "embittered by the havoc among his friends," who remarked "that if the apologist had been present he might have been shot in the place of a better man."[3]

To some shirkers, camp responsibilities could be every bit as onerous as combat duty. Again,

feigned illness was a convenient method for securing reprieve from drill or duty. Malingerers would present themselves at "sick-call," sounded by the buglers each morning after reveille and the breakfast call, along with those soldiers who had legitimate complaints of illness. As a surgeon described it,

The responsibility of deciding as to malingerers was thrown upon the medical officers and it was a trying condition many times. We always had a certain number of dead beats and the ingenuity displayed by them would have made them professionals in almost any calling of life. No species of lying was too subtle for them, although it might be difficult to detect the trick.[4]

Stories abound to describe such subterfuges. Some soldiers would affect the "will fits," by chewing soap to cause froth at the mouth and writhing in apparent agony; others would coat their tongues with mixtures bought from a druggist.[5] Still other soldiers resorted to yet more devious means. One disheartened soldier wrote to his wife that, in working "some plan to get my discharge," he had been

stuffing medicine in myself since I been out here. I have been taking Pulsotil, Bryvina, Beladona, Acoute, Nuy Pom . . . Mucurins And Arsnic Poison when you write I wish you would send me some Arsnic or some other kind of stuff so as to make me look pale . . . find out at the druggist what will make you look pale and sickly . . . and send a small quantity in every letter.[6]

Surgeons quickly caught on to most ruses, as did the medic who treated Private "George W. Peck," who had, upon the advice of an unscrupulous

chaplain, presented himself at surgeon's call in order to avoid a tiresome drill:

I got in line with about twenty other soldiers, and we marched over to the surgeon's quarters. . . . I was the last one to be served, and the interview was about as follows:
Doc. – What's the matter?"
Me – Bilious.
Doc. – Run out your tongue. Take a swallow out of the black bottle.
That seems very simple, indeed, but it nearly killed me. . . . The hospital steward handed me the bottle that a dozen other sick soldiers had drank out of . . . [and] told me to take a good big swallow, and I tried to do so. Talk about the suffering brought on by the war, it seems to me nobody ever suffered as I did, trying to drink a swallow of that castor oil out of a two quart bottle, that was dirty.[7]

Indeed, most attempts to fake an illness were obvious even to the casual onlooker. One soldier recalled that "the genuine cases went with a different air from the shams," and remembered those

"beats on the government" emerging from their tents at sick-call in the traditional army overcoat, with one hand tucked into the breast, the collar up, cap drawn down, . . . and a pace slow and measured, appearing to bear as many of the woes and ills of mankind as Landseer had depicted in his "Scapegoat."[8]

Homer's painting gives little evidence of such clever or affected schemes. The blonde soldier at the center, though caught in an ungainly position, is deftly and sensitively modeled; neither his features nor his expression is exaggerated for comic effect, as they would be in the 1863 lithograph *Surgeons Call* (cat. no. 5a). As usual, Homer's careful description of details such as the army shoes, the insignia on shoulders and caps, the still life in the surgeon's tent, or the blanket at the left corner, which has been painted with a roughened impasto, lends a convincing sense of presence and vitality to the scene. Yet other passages reveal Homer's status as a beginning artist. Unlike the central soldier, the two medics are more simply realized; their proportions are awkwardly drawn and their postures stiff. The light

source is inconsistent, falling mainly from the left, yet the patient receives full frontal light that gives his figure prominence and creates dramatic shadow patterns at the center. Homer attempts here a nearly friezelike arrangement of figures across the frontal plane of the composition, and blocks any recession into distant space by restricting access to the area inside and beyond the surgeon's tent. The single stripe of blue sky above the surgeon's tent does not entirely relieve the dark compression of the composition below. Even the beams at the top of the surgeon's lean-to, which jut so convincingly into space, form diagonals that lead the eye forward, not back. In no other Civil War painting did Homer cluster figures together so tightly without describing a larger setting for them or suggesting a world beyond.[9]

Critics who reviewed *Playing Old Soldier* at the time of its exhibition in 1863 generally acknowledged the humor afforded by Homer's title, but did not linger on the subject, finding more to discuss in Homer's technique and expression. If the humor in Homer's painting is subtle or ambiguous, it found full expression in the lithographic series *Life in Camp*. In *Surgeons Call* (cat. no. 5a) Homer's blonde soldier now appears older and grimmer, and is only one in a line of soldiers awaiting the surgeon's attention. The humor of this image seems to derive its strength not from the patient's ploys but from the surgeon's plight, the duties of the one noble figure who attends to the line of surly, gaunt, or diseased men. Homer's humorous approach to this situation masks the very real and haunting presence of disease in the army, and the critical (if often sadly ineffectual) role played by the army surgeon. Civil War casualties came not from bullets and mortar alone, but from the ravages of disease brought on by inadequate hygiene, poor nutrition and rancid food, deplorable sanitary conditions, and a medical science in its infancy that did not yet understand the relationship between germs and infection.[10] The army surgeon with his limited resources could offer only a minor check in the advance of diseases and conditions that

5a Surgeons Call, 1864. Lithograph from *Life in Camp* (part 1), 4⅛ × 2½ in. Museum of Fine Arts, Boston. Koehler Collection (K3382)

claimed, by all accounts, well over twice the number of casualties received in battle. Of the over 623,000 Americans who died in the Civil War, over 448,000 succumbed to disease.[11]

<div align="right">S. M.</div>

1. Bruce Catton asserts that an "old soldier," "in the traditional army meaning of the term" was one who pretended "to be sick or disabled so that [he] could avoid drill and take [his] ease in the hospital tents." *Catton's Civil War*, 476. Aside from the critic for *The Evening Post*, who used the term in describing Homer's painting, I have been unable to find any such usage of the term in my survey of contemporary Civil War literature. References to an "old soldier" more commonly indicate a veteran.

2. S. E. Thomason, 23 June, 1861, quoted in Wiley, *Billy Yank*, 86.

3. Edwin Clark Bennett, *Musket and Sword, or The Camp, March, and Firing Line in the Army of the Potomac* (Boston: Coburn Publishing Co., 1900), 105-106. Linderman, in *Embattled Courage*, has argued convincingly that courage was the central motivation of soldiers in the Civil War. He also points out several demoralizing factors peculiar to that war that eventually weakened the distinction between courage and cowardice. Sympathy, if not forgiveness, became possible, as with the one army surgeon who avowed that "no man ever faced bullets flying thick and fast, or heard the sounds of 'bombs bursting in air,' with unqualified feelings of pleasure. . . . I remember so well a delicate young fellow at the beginning of [the] battle of Cane River, who came to me saying, 'Doctor, please tell me what is the matter with my heart. It beats so it seems as if it would come through my chest wall.' He was pale and had evidently lost all strength. . . . He meant to do his duty but the flesh was too weak." Major and Surgeon Seth C. Gordon, "Reminiscences of the Civil War from a Surgeon's Point of View," in *War Papers Read Before the Commandery of the State of Maine, Military Order of the Loyal Legion of the United States* (Portland: The Thurston Print, 1898), 1:142–143. See also Wiley, *Billy Yank*, 87.

4. Gordon, 143.

5. Jay Monaghan, "Civil War Slang and Humor," *Civil War History* 3, no. 2 (June 1957): 130; *U. S. Army and Navy Journal* 1 (1863-1864): 314, as quoted in Williams, *The Artists' Record*, 55.

6. Quoted in Wiley, *Billy Yank*, 291.

7. George Washington Peck [pseud.], *How Private George W. Peck Put Down the Rebellion, or the Funny Experiences of a Raw Recruit* (Chicago: Belford, Clarke & Co., 1887), 40-41.

8. Billings, *Hardtack and Coffee*, 174.

9. In *The Sutler's Tent (cat.no.6)*, a work shown along with *Playing Old Soldier* at the Artists' Fund Society exhibition in 1863, Homer opened the composition by showing the distant background behind the central figures. Even in a work such as *"Army Boots" (cat.no.16)*, Homer suggests by the direct gaze of the boy on the right a connection to the viewer's world outside the canvas.

10. Army life tore open the protected environments of many young men from small towns and rural areas, exposing them to various communicable diseases they had never encountered and against which they had built no immunities. See Wiley, *Billy Yank*, 133-137; Linderman, *Embattled Courage*, 115. Linderman adds, "Those who think Margaret Mitchell intended the measles death of Scarlett O'Hara's husband in *Gone with the Wind* to show he was a milksop would be surprised to learn how many died that way."

11. Mortality figures for disease were higher on the Confederate side, although they lost fewer men in battle. While figures continue to be disputed and revised, best estimates indicate that of the 360,222 total Federal army deaths, 224,580 can be attributed to disease; in the Federal Navy, 3,000 deaths from disease are listed among 4,804 deaths. On the Confederate side, 164,000 of an estimated 258,000 deaths were due to disease. See E. B. Long, *The Civil War Day by Day: An Almanac, 1861-1865* (Garden City, New York: Doubleday, 1971), 710-711.

PROVENANCE [Sale, New York, Henry H. Leeds &
Miner, 15-16 February 1866, no. 98]; Murray P. Ryder,
Portland, Maine; his son, Murray Ryder; [Vose Galleries,
Boston, 1943]; Museum of Fine Arts, Boston.

EXHIBITIONS PRIOR TO 1876 November 1863, New
York, The Artists' Fund Society, "Fourth Annual Exhibi-
tion," no. 108; April 1864, Baltimore, Art Exhibition, The
Maryland State Fair (in aid of the United States Sanitary
Commission), no. 97; June 1864, Philadelphia, The
Great Central Fair (also called The Philadelphia Sanitary
Fair), no. 203.

CHANGES IN THE COMPOSITION Painting was examined
without using infrared reflectography; no x-radiographs
were available. No significant changes in the composition
or structure evident. Some pine fronds have been scum-
bled out, and the branch support to the left of the patient's
head has been toned back in the course of painting.

COLLECTED REFERENCES PRIOR TO 1876
Nos. 108 and 144, "Playing Old Soldier" and "The
Sutler's Tent" are two episodic scenes of military life, by
Mr. Homer, which show that Art has gained some good
even from "the struggle." The head of the pretended
invalid, in the first, is admirably painted, and the free,
natural, wholesome handling of both deserves the highest
praise.
"Artists' Fund Exhibition," *The New-York Daily Tribune*,
13 November 1863.

Mr. Winslow Homer is, we believe, very young in the
profession; but his *Playing Old Soldiers* [sic], no. 108,
should not be overlooked.
"Fine Arts. Exhibition of the Artists' Fund Society," *The
Albion* 41, no. 47 (21 November 1863): 561.

No. 108, "Playing Old Soldier," by W. HOMER, is one of
several pictures by this artist of soldier life, which manifest
great fidelity to certain aspects of nature. They are not
pleasing in color, but in many respects very creditable and
promising.
"The Artists' Fund," *The New-York Times*, 21 November
1863.

Then there are . . . Winslow Homer's "Playing Old
Soldier" and " The Sutler's Tent," both natural and
faithful to certain phases in nature, but unpleasing in
color. . . .
"Artists' Fund Society of New York," *Boston Evening
Transcript*, 5 December 1863.

Winslow Homer's "Sutler's Tent" and "Playing Old
Soldier," [are] two of the cleverest pictures, as regards a
faithful adherence to nature, which we have recently

seen. They are crude in color, and not altogether correct
in drawing; but they show great originality, and evince
appreciation of certain humorous phases of camp life. . . .
"Playing Old Soldier" represents one of our blue-coated
volunteers being examined by the surgeon; his tongue
is thrust out of his mouth, and his whole appearance
denotes an entire willingness to be considered ill; but the
surgeon is not to be imposed upon, and has evidently
detected the attempt in his patient to play "old soldier."
. . . Mr. Homer is, we presume, a young artist, and while
there is much room for improvement in his pictures,
they still are highly creditable performances and com-
mand our kindest consideration.
"The Artists' Fund Exhibition. Second Notice," *The
Evening Post*, 14 December 1863.

Mr. Homer's two pictures, Nos. 108 [*Playing Old Soldier*]
and 144 [*The Sutler's Tent*], hang near two of Mr. [Sey-
mour] Guy's, Nos. 102 and 143. Compare the drapery in
each; the boys' trowsers with the soldiers'. . . . Mr.
Homer's you will find signed all over with truth – truth in
conception, worked out with faithful striving after
truth. . . .
Lionel [pseud.], "The Artists' Fund Society, Fourth
Annual Exhibition," *The New Path* 1, no. 8 (December
1863): 96.

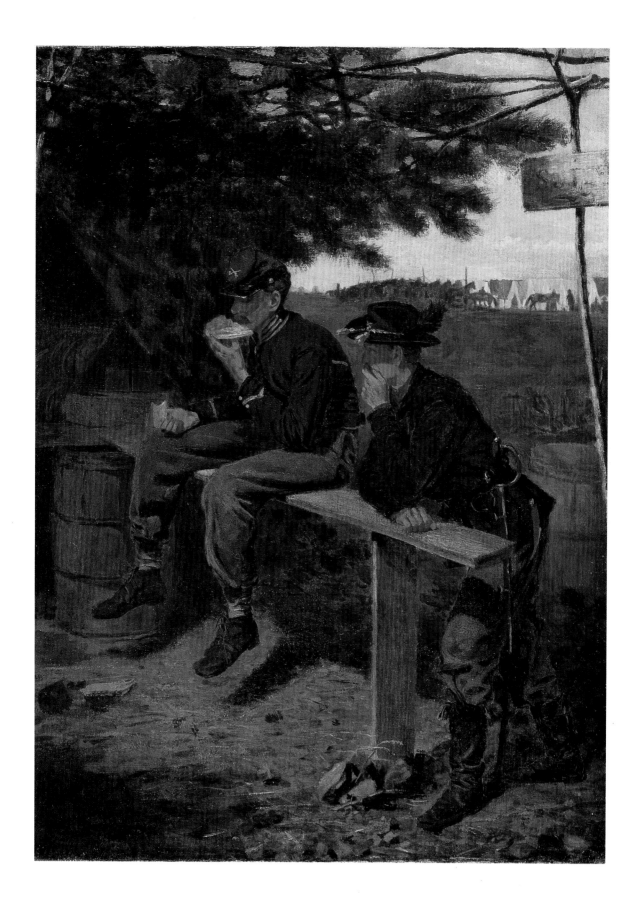

6. The Sutler's Tent, 1863

(Also called *Extra Rations* [1866], *Rations* [1899])
Oil on canvas, 16 ¼ × 12 inches
Signed and dated lower left: HOMER 1863
Collection of Jeannette Scott

Two cavalry soldiers relax beneath an awning of pine boughs outside the opening of a tent. Their company's mounts are tethered in a line far behind them; no other sign of activity is present in the camp. One soldier stands pensively resting his chin in his hand; at the center sits the other soldier, dangling his legs before him, holding a wedge of cheese while devouring a huge, flat pie.

Concerns for food, clothing, and shelter—as in rations, boots, and tents—run as constant thematic threads through nearly every Civil War soldier's memoirs or diary, but none so frequently as that for food. Even after General Joseph Hooker assumed command of the Army of the Potomac in January 1863 and took major steps to improve the conditions and morale of his beleaguered soldiers, the army suffered continually from insubstantial, monotonous, and poorly cooked rations, as one soldier described in a letter to his brother:

Sometimes we get nothing but coffee, sugar, salt meat, and hard bread, for two or three weeks at a time. Some days we get for each man two spoonfulls of sugar, three spoonfulls of ground coffee, a spoonful of salt, two spoonfulls of rice, or three of beans, three or four little potatoes, a little loaf of bread, a pound of fresh beef, and now and then a little pepper, and once in a long time about a quarter of a pint of molasses; vinegar whenever we want it, which is seldom, as we have nothing to eat with it. . . . We hardly ever get half of these things during a month, and never get them all at once.[1]
Wholescale deprivation was uncommon, but the Army of the Potomac frequently faced simple shortages, and soldiers became familiar with a standard fare of hardtack and coffee. Nor did

Homer's role as a "special artist" at the front render him immune to concerns for diet; in June of 1862, Homer's mother wrote to his brother Arthur that Winslow had gone
to the war front of Yorktown & camped out about two months. He suffered much, was without food 3 days at a time . . . plug tobacco & coffee was [sic] the staples.[2]

A common, if expensive, relief from standard army rations came with the arrival of the army sutler and his wagon. The sutler—a term no longer in general use, apparently derived from the Dutch *soetelen*, meaning "to undertake low offices"[3]—followed the troops with a variety of items for sale:
This personage played a very important part as quartermaster extraordinary *to the soldiers. He was not an enlisted man, only a civilian. . . . Each regiment was supplied with one of these traders, who pitched his hospital tent near camp and displayed his wares in a manner most enticing to the needs of the soldier. The sutler was of necessity both a dry-goods dealer and a grocer. . . . He made his chief reliance, however, a stock of goods that answered the demands of the stomach.*[4]
These goods included fruit, butter, cheese, milk, canned and dried meats, canned and fresh vegetables, pickles, sardines, and eggs, and such non-food items as liquor, tobacco, patent medicines, writing equipment, newspapers, toothbrushes, and razor straps.[5] Despite attempts by the Federal War Department to fix prices, sutlers generally charged whatever they could get away with, and though his services were much in demand throughout the war, in general the sutler became the object of resentment if not contempt:

6a *Army Encampment*, 1862. Pencil and
watercolor, 4⅜ × 9⅞ in. Cooper-Hewitt Museum,
the Smithsonian Institution's National Museum of
Design, New York. Gift of Charles Savage Homer
(1912-12-122)

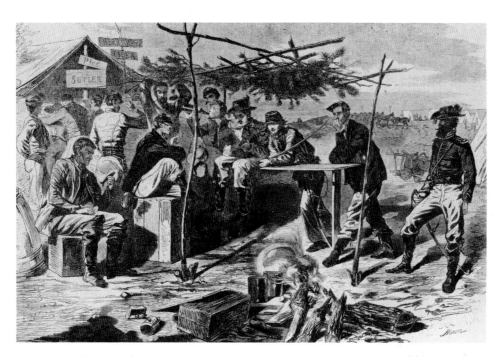

6b *Thanksgiving in Camp*. Wood engraving,
9⅛ × 13¼ in. *Harper's Weekly* 6, no. 309 (29
November 1862): 764. Signed lower right (in
block): HOMER. Peggy and Harold Osher Collec-
tion. Courtesy of the Portland Museum of Art,
Portland, Maine

Owing to the high prices which they asked the soldiers for their goods, the belief found ready currency that they were little better than extortioners; and I think that the name "sutler" to-day calls up in the minds of the old soldiers a man who would not enlist and shoulder his musket, but who was better satisfied to take his pack of goods and get his living out of the soldiers who were doing his fighting for him.[6]

Generous soldiers referred to sutlers as "a necessary evil"; others more bluntly called them "vampires" or "a wretched class of swindlers."[7] A soldier of the First Massachusetts recalled that "the only place where a sutler could find sympathy was in the dictionary."[8]

Although the sutler bore the brunt of many insults, pranks, and raids on his tent, "no soldier was compelled to patronize [him],"[9] and indeed payday became the occasion for mass rallies around his tent. Homer's illustration of such a scene appeared in *Harper's Weekly* on 28 February 1863 (*fig.6.1*); overwhelming the corollary events

of a "Pay Day in the Army of the Potomac" – soldiers lining up to receive pay, men sending money home, a family receiving their soldier's letter – is a massed hubbub of men, bills in hand, forming a "descent on the Sutler."[10] Despite efforts from the home front to persuade soldiers to send their pay to their families rather than spending it on gamblers and sutlers,[11] many soldiers continued to squander their meager earnings on such visits, racking up debts that were credited against their next pay. David Brett, writing home to his wife, told her that in the camp at Centreville, Virginia, "we have got a sutler so the boy[s] buy pies and cakes and waste their bread . . . the boys spend their money just as fast as they can with few exceptions"; a few months later from the Culpeper Court House he wrote, "we have just ben [*sic*] paid off so you will get $14 in a few days there are plenty of Sutlers here so the boys will spend their money pretty Quick[.]"[12]

In contrast to the 1863 engraving, Homer's painting of *The Sutler's Tent* is a quiet scene, one

fig.6.1 *Pay-Day in the Army of the Potomac.* Wood engraving, 13 5/8 × 20 1/2 in. *Harper's Weekly* 7, no. 322 (28 February 1863): 136-137. Sterling and Francine Clark Art Institute, Williamstown, Massachusetts

that eliminates from its narrative both the sutler, that character of dubious reputation, and all signs of the soldiers' clamor. In 1911 Downes reported that Homer finished *The Sutler's Tent* in 1863, "from studies made in 1862."[13] One of these studies is known today, that showing a line of horses tethered beside a row of tents (cat.no.6a). Homer returned to this drawing in 1871 when he painted *A Rainy Day in Camp* (cat.no.22), but it first appeared in the wood engraving *Thanksgiving in Camp*, published in *Harper's Weekly* on 29 November 1862 (cat.no.6b). The left half of this illustration shows a mass of soldiers "descending upon the sutler," but progressing to the right, the composition becomes calmer, concentrating on single soldiers and a view into the background. It is this more meditative section of the picture that Homer chose for his 1863 oil. The focus narrows to the perspective of the soldier enjoying – or wishing he could enjoy – the sutler's wares. Inside the tent can be seen some of the sutler's goods – including a row of the pies that one soldier remembered for their "taste resembling rancid lard and sour apples," "moist and indigestible below, tough and indestructible above, with untold horrors between."[14] Using many of the same elements of composition as *Playing Old Soldier* (cat.no.5), its companion at the Artists' Fund Society exhibition of 1863 – carefully modeled soldiers, a canopy of pine branches, a view to the inside of a tent structure – Homer activated the composition by turning the primary axis to a diagonal, creating a deep space by the extension of the plank support into the sutler's tent, and opening the view to show a distant camp scene at the right. If Homer's draftsmanship is occasionally awkward, such as in the dangling legs of the seated soldier that appear too long even for his hunched-over torso, his skills of observation and description are evident in details such as shoes, saber handles, insignia, and costume details.

If Homer's two figures today appear unconnected, each lost in his own thoughts, a humorous interpretation was understood by late nineteenth-century viewers:

It is hard times in camp. Rations are short and the sutler's shed, under its arbor of pine boughs in the foreground is the cynosure of many hungry eyes more blessed with appetite than the means of gratifying it. One campaigner, happy in the possession of funds, is seated on the rude plank table at the sutler's door. . . . Another trooper leans upon the shelf and watches his occupation with a melancholy born of an empty purse and a craving stomach. . . . The humor of the situation is accentuated by the side glance which the lucky enjoyer of extra rations – who is a private soldier – casts upon his neighbor, whose uniform shows him to be an officer a remove or two above him in grade.[15]

While the painting seems to support such interpretations, it does not preclude others. The still, bent postures of both figures suggest contemplation, and without assuming the object of their thoughts, one can view the painting as a meditation on food and/or the lack of it. Hunger was common to both officer and enlisted man, and each looked forward to assuaging it. Homer's painting represents the simple pleasures of a soldier's life intertwined with its basic hardships.

S.M.

1. "Incidents in the Life of a Soldier," *The Portrait Monthly* 1, no. 1 (May 1864): 171. For additional accounts of typical Civil War rations, see Bardeen, *Little Fifer's War Diary*, 196-201; and Palmer H. Boeger, "Hardtack and Burned Beans," *Civil War History* 4, no. 1 (March 1958): 73-92.
2. Quoted in Hendricks, *Life and Work*, 50.
3. Francis A. Lord, *Civil War Sutlers and Their Wares* (New York: Thomas Yoseloff, 1969), 17.
4. Billings, *Hardtack and Coffee*, 224.
5. See Lord, 38-63.
6. Billings, *Hardtack and Coffee*, 227.
7. D. G. Crotty, *Four Years Campaigning in the Army of the Potomac* (Grand Rapids, Mich.: Dygert Bros. & Co., 1874), 170; Lord, 57, 19.
8. Bardeen, *Little Fifer's War Diary*, 47.
9. Billings, *Hardtack and Coffee*, 226.
10. Homer's first depiction of a sutler's tent appeared in *Harper's Weekly* on 4 January 1862, in a scene nearly opposite to the February 1863 engraving. In the earlier print, the arrival of gifts from home in *Christmas Boxes in Camp – Christmas, 1861* creates a melee among the soldiers in the foreground, who delight in opening their packages and completely ignore the sutler in his tent behind them.

11. Theodore Roosevelt, Sr., lobbied a bill through Congress authorizing the appointment of "Allotment Commissioners" who worked to persuade soldiers to permit part of their pay to be sent directly to their families; Roosevelt himself became one of these Commissioners. Linderman, *Embattled Courage*, 90.

12. David Brett, *"My Dear Wife . . .": The Civil War Letters of David Brett, 9th Massachusetts Battery, Union Cannoneer*, ed. Frank Putnam Deane 2d (Little Rock, Ark.: Pioneer Press, 1964), 51, 82.

13. Downes, *Life and Works*, 47.

14. Bardeen, *Little Fifer's War Diary*, 47. Despite this gruesome description, Bardeen also recalled that "Chaplain Quint says the 2d Mass. bought 650 pies in one day, and it was an off day with them at that."

15. *Catalogue of the Thomas B. Clarke Collection of American Pictures*, exh. cat. (Philadelphia: Pennsylvania Academy of the Fine Arts, 1891), 61.

PROVENANCE [Sale, New York, Somerville Art Gallery (Miner & Somerville, Auctioneers), 19 April 1866, as *Extra Rations*, no. 23]; Thomas B. Clarke (by 1891-1899); [Clarke sale, New York, American Art Association, 14-18 February 1899, as *Rations*, no. 149]; Eli H. Bernheimer, New York (1899-1936); [John Levy Gallery, New York]; [William Macbeth, New York, 1936-1937]; Houghton P. Metcalf (1937-1958); his daughter, Eleanor Metcalf Scott; her daughter, Jeannette Scott.

EXHIBITIONS PRIOR TO 1876 November 1863, Artists' Fund Society, "Fourth Annual Exhibition," no. 144.

CHANGES IN THE COMPOSITION Painting was examined without using infrared reflectography; no x-radiographs were available. Certain shapes in the background to the right of the cavalry officer's cap, originally sketched in with dark brown, have been painted out with green. Sharper, more angular forms that originally appeared to the right of the seated soldier's head have been replaced by covered wagons. The word "SUTLER" on the sign at the upper right has been partially painted out, giving the effect of sunlight striking the sign.

COLLECTED REFERENCES PRIOR TO 1876
Nos. 108 and 144, "Playing Old Soldier" and "The Sutler's Tent" are two episodic scenes of military life, by Mr. Homer, which show that Art has gained some good even from "the struggle." . . . [T]he free, natural, wholesome handling of both deserves the highest praise.
"Artists' Fund Exhibition," *The New-York Daily Tribune*, 13 November 1863.

Then there are . . . Winslow Homer's "Playing Old Soldier" and "The Sutler's Tent," both natural and faithful to certain phases in nature, but unpleasing in color.
"Artists' Fund Society of New York," *Boston Evening Transcript*, 5 December 1863.

Winslow Homer's "Sutler's Tent" and "Playing Old Soldier," [are] two of the cleverest pictures, as regards a faithful adherence to nature, which we have recently seen. They are crude in color, and not altogether correct in drawing; but they show great originality, and evince appreciation of certain humorous phases of camp life. . . . The other picture depicts the exterior of a sutler's tent, and two of "our boys," one of whom is seated independently on the extempore counter, his feet swinging beneath it, and his hands and mouth filled with indigestible-looking pie. The other leans carelessly over the counter. Mr. Homer is, we presume, a young artist, and while there is much room for improvement in his pictures, they still are highly creditable performances and command our kindest consideration.
"The Artists' Fund Exhibition. Second Notice," *The Evening Post*, 14 December 1863.

Mr. Homer's two pictures, Nos. 108 [*Playing Old Soldier*] and 144 [*The Sutler's Tent*], hang near two of Mr. [Seymour] Guy's, Nos. 102 and 143. Compare the drapery in each; the boys' trowsers with the soldiers'. . . . Mr. Homer's you will find signed all over with truth – truth in conception, worked out with faithful striving after truth.
Lionel [pseud.], "The Artists' Fund Society, Fourth Annual Exhibition," *The New Path* 1, no. 8 (December 1863): 96.

7. In Front of the Guard-House, 1863

(Also called *Punishment for Intoxication*)
Oil on canvas, 17 × 13 inches
Signed and dated lower left: HOMER 1863
Canajoharie Library and Art Gallery (317108)

A soldier stands uncomfortably atop a wooden crate while a patrolling guard seen only from the back marches past him, his gleaming rifle and silver bayonet offering a sharp counterpoint to the stubby wooden log shouldered by his prisoner. Beyond the two figures lie the edges of a camp settlement, a single tent at the left that is probably the "guardhouse" itself, and a line of wagons to the right. But for these small indications of camp life, the scene is staged within an open landscape, beneath a cloud-filled sky against which the prisoner stands in powerful silhouette.

As in so many of his earliest paintings, such as *The Last Goose at Yorktown* (*cat.no.3*), *The Sutler's Tent* (*cat.no.6*), or even *The Brierwood Pipe* (*cat.no.8*), with which it was exhibited at the National Academy of Design in 1864, Homer reduced the dramatic incident of *In Front of the Guard-House* to its two centrally placed protagonists. Having restricted the narrative further by denying any physical interaction or even eye contact between these two figures, Homer directs his concerns toward modeling form and creating a convincing sense of space. The forms of the overturned barrel and the cracker-box platform are richly sculpted by strong sunlight; their contours gleam with shiny highlights, as do the long edges of the bayonet and wooden log. The figures, more thinly painted and in many ways flatter and less fully realized than the inanimate objects beside them, still serve as receptacles for light; Homer accentuates their forms by the highlights on each soldier's pant leg, as well as the warm light that crosses the toes and tops of the prisoner's boots and picks out the edge of his cracker-box pedestal.

Although no drawings are known for this composition, Homer must have observed several such scenes during his months in camp with the Army of the Potomac. Enforcing discipline in the army ranks was a frequent necessity in the Civil War, especially during those fallow periods between campaigns when the army lay in wait and few events other than interminable drills enlivened the daily routine between reveille and taps. Several imaginative – if occasionally cruel – treatments were devised as punishment for various infractions of rules.[1] While the gravity of the offense dictated the severity of its penalty, the particular method of punishment seems not to have been determined by any specific violation, but rather by the mood of the commanding officer. In his memoirs of 1887 John Billings made clear his disapproval of that "class of officers who felt that every violation of camp rules should be visited by the infliction of bodily pain in some form."[2]

Traditionally, Homer's painting has borne the title of *Punishment for Intoxication*. Drunkenness was among the most common infractions of army discipline; it frequently led to fighting and brawls, and drunkenness on guard was never tolerated.[3] Punishments varied from camp to camp, so it is not at all clear that Homer has in fact depicted a soldier being punished for intoxication.[4] Billings described solitary confinement in the guardhouse as a common penalty for drunkenness; a Pennsylvania soldier noted in his diary that "Desher being quite [drunk] as a punishment . . . was compelled to carry a musket and a carpet bag strapped to his [back] containing fifty pounds of stones"; a visitor to the guardhouse

of the Second Rhode Island regiment noticed "a man bucked and gagged":

Crime, drunkenness. The operation consists of putting a stick in the mouth, with a string passed from each end around the back of the head. The bucking process consists of tying the hands together securely, placing them over the knees, and running a stick through under the knees and over the arms.[5] Yet another Pennsylvania soldier related that "three men [were] sentenced to walk in barrels for six days for continuous drunkenness."[6] An engraving appearing in *Harper's Weekly* on 28 June 1862, entitled *Camp Punishments – Too Fond of Whisky* (*fig. 7.1*), shows such a sentence: a soldier encased in an enormous barrel (also known as a "wooden overcoat") parades before a tent (presumably the guard-tent), heckled by a group of soldiers who have gathered to taunt him.

Homer's painting shows none of these cited penalties for drunkenness, but actually describes a combination of two common punishments, carrying a log and standing on a barrel. These more generic punishments might have been prescribed for any number of infractions. For instance, Homer's painting comes closest to resembling the sentence received by a private of the Seventh Massachusetts Regiment for absence without leave: "Stand on a barrel in front of Guard house with stick of wood on his shoulder from Reveille to Retreat for 2 days."[7]

"Carrying the log" must have been an especially frequent punishment, for both written and drawn sketches of this curious and assuredly uncomfortable penalty abound in soldiers' sketchbooks and diaries. Frank Wilkeson was subjected to this penalty in 1864 and later decried "the utterly useless and shoulder-chafing punishment of carrying a stick of cord-wood," recalling that logs *had an unaccountable property of growing heavier and heavier as the sun rose higher and higher. One morning at ten o'clock I dropped a stick that did not weigh more than twelve pounds at sunrise. I sat down by it and turned it over and over. It had not grown, but I was then willing to swear that it had gained one hundred and eighty-eight pounds in weight during the time I had carried it.*[8] Homer's image must have struck a responsive

fig. 7.1 Attributed to Larkin Goldsmith Mead (1835-1910). *Camp Punishments – Too Fond of Whisky – Scene in the Army of the Mississippi.* Wood engraving, 6 7/8 × 9 1/8 in. *Harper's Weekly* 6, no. 287 (28 June 1862): 412. Collection of the Library of Congress

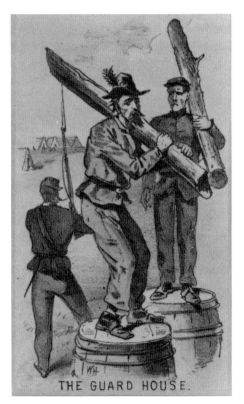

7a. *The Guard House*, 1864. Lithograph from *Life in Camp* (part 1), 4 1/8 × 2 1/2 in. Initialed lower left (on stone): WH. Museum of Fine Arts, Boston. Koehler Collection (K3382)

and humorous chord in many of his viewers. Homer returned to the image for the lithographic series *Life in Camp*, published by Louis Prang in 1864 (*cat.no.7a*). For this frankly illustrative and anecdotal format, Homer sharpened the humor of the incident by showing the charged soldier now stooped beneath the weight of his burden, a log at least twice as large as the one carried by the soldier in the painting. He bears a pained expression on his face, as does the companion who shares his punishment. The guard now takes a larger step on his patrol, his jaunty stride and upright bayonet accentuating the freedom denied to his charges. As did the illustration *Too Fond of Whisky*, the lithograph *The Guard House* emphasizes humor and humiliation in a way that Homer's 1863 painting only suggests.

Long owned by the artist's brother Charles, *In Front of the Guard-House* has traditionally been thought to be one of the two paintings placed by Homer in a shop window and purchased by Charles Homer to encourage his brother's career (see *cat.no.1*). Homer was later to say of the painting that it was "about as beautiful and interesting as the button on a barn door."[9] But at the time of its initial showing, it was praised as "a good, vigorous piece of painting," with figures who had "activity and life bulging out in all parts" – a promising work from a noteworthy artist.

S.M.

1. For descriptions, see Billings, *Hardtack and Coffee*, ch. 8; Frank Wilkeson, *Recollections of a Private Soldier in the Army of the Potomac* (New York: G. P. Putnam's Sons, 1887), 25-36; Wiley, *Billy Yank*, ch. 8.

2. Billings, *Hardtack and Coffee*, 146.

3. Wiley, *Billy Yank*, 198. In February 1862, General George B. McClellan declared that "Drunkenness is the cause of by far the greater part of the disorders which are examined by the courts-martial." Quoted in Bell Irvin Wiley and Hirst D. Milhollen, *They Who Fought Here* (New York: Macmillan, 1959), 170.

4. The first reference to this painting as "a soldier being punished for intoxication" seems to appear in Downes, *Life and Works*, 47. A reviewer for *The New-York Times* who saw the painting in 1864 assumed that the unfortunate soldier had been "foraging on a simple basis of direct theft." See Collected References Prior to 1876.

5. Billings, *Hardtack and Coffee*, 145; Wiley, *Billy Yank*, 197-198; Moore, *Anecdotes, Poetry, and Incidents*, 30. Desher's mode of punishment, carrying a heavily weighted bag, is illustrated in the engraving *Army Discipline – Method of Punishing Soldiers for Drunkenness at Three Island Lighthouse*, which appears in *Frank Leslie's Illustrated Newspaper (Supplement)* 14, no. 347 (21 May 1862): 144.

6. Wiley, *Billy Yank*, 198.

7. Wiley, *Billy Yank*, 197-198. Elsewhere, Wiley notes that "a peddler who bootlegged 'condensed corn' in another camp was forced to stand on a barrel, while his wife, likewise apprehended, was compelled to carry a log" (254).

8. Wilkeson, 35-36. For comparable artist's sketches, see Edwin Forbes, *Thirty Years After: An Artist's Story of the Great War* (New York: Fords, Howard, & Hulbert, 1890), 302; *Gone for a Soldier: The Civil War Memoirs of Private Alfred Bellard*, David Herbert Donald, ed. (Boston: Little, Brown, 1975), 25; Eugene B. Hovey, "A Soldier's Sketchbook," *Civil War Times Illustrated* 8, no. 5 (August 1969): 36-37; and Billings, *Hardtack and Coffee*, 144.

9. Goodrich, *Winslow Homer*, 18.

PROVENANCE Charles S. Homer (1864?-1917); his widow, Mrs. Charles S. Homer (d. 1937); [Macbeth Galleries, 1938-1941]; Canajoharie Library and Art Gallery, Canajoharie, New York.

EXHIBITIONS PRIOR TO 1876 January 1864, New York, "Artist's Reception," Dodworth Studio Building; April 1864, New York, National Academy of Design, "Thirty-Ninth Annual Exhibition," no. 73.

CHANGES IN THE COMPOSITION Painting was examined using infrared reflectography; no x-radiographs were available. No significant changes are evident.

COLLECTED REFERENCES PRIOR TO 1876
[At] the first "Artists' Reception" of the season last night at Dodworth's Studio Building in Fifth avenue . . . Hennessy, Gray, Huntington, Eastman Johnson, Winslow Homer . . . all had characteristic pieces. "Artists' Reception at Dodworth's Studios," *The New-York Daily Tribune*, 15 January 1864.

One of the most vigorous and promising works at the [Dodworth's] Artists' Reception was that by Mr. Winslow Homer, representing an incident before a guard-house. We take pleasure in writing of this picture, because it is the work of a comparatively new man in art, and though incomplete in parts, indicates rare force and reality. Mr. Homer's work shows the directness and

matter-of-fact perception and realization of a simple and strong manhood; it is full of energy of execution, and the promise of brilliancy, velocity, and great power in style, and the broad open-day effect is rendered with truth.
"Art. The Artists' Reception," *The Round Table* 1, no. 6 (23 January 1864): 92.

WINSLOW HOMER has two unfinished pictures, the subjects of which are drawn from camp-life. One is . . . "Before the Guard-House" – a soldier undergoing punishment by being placed upon a cracker-box and compelled to bear on his shoulder a log of wood, while another soldier stands guard over him.
"What Our Artists Are Doing. Second Notice. The University Building," *The Evening Post*, 28 January 1864.

I sincerely advise Mr. Hall [the artist George Henry Hall] to go every day and examine a little picture in the first gallery, numbered seventy-three, and entitled, "In front of the guardhouse." . . . by Mr. Winslow Homer. He is a young man, and almost a new beginner; but he did something that very few of our young artists do; learned to draw with the point before he attempted color. . . . Looking at [this picture] this morning, I said to a friend, "If this is the work of a new beginner, where on earth will he stop?"
"The Academy Exhibition. Second Article," *The New York Leader* 10, no. 18 (30 April 1864): 1.

One of the most successful exhibitors this year is Mr. Winslow Homer, who gives us a couple of camp pieces that are full of life and originality. No. 73 is called "In front of the Guard-House," and represents a soldier doing ignominious penance on the top of a wine box with a rail across his shoulder for a musket. He has evidently been foraging on a simple basis of direct theft, and this is his uncomfortable mode of punishment. The sentinel who keeps guard over the culprit is a lithesome fellow, who has activity and life bulging out in all parts of his body. He has his back to the spectator, but the drawing is so vigorous that you can almost hear his tread on the ground.
"National Academy of Design. Notices of Works on Exhibition," *The New-York Times*, 5 May 1864.

There are characteristics in Mr. Homer's work which serve as indications of progress. Picture No. 70 [sic] is a good, vigorous piece of painting. The sense of outdoor life is forcibly rendered, and we take pleasure in complimenting the artist on the force of effect of his picture. The faults of this work are such as must be overcome with practice. There is roughness of execution in the sky, and a want of delicate painting throughout which indicates a hand not yet sure of its touch. But the

two pictures, No. 70 and No. 140 [*The Brierwood Pipe*], are full of promise, and their merits are of no commonplace character.
"Exhibition of the National Academy of Design. III," *The Round Table* 1, no. 21 (7 May 1864): 326.

A little further on and we are told by Mr. Winslow Homer we stand in front of the Guard-house. I am informed the artist is not related at all to the Homer of Odyssey notoriety. He is no Greek, nor an alien, but a true American, as his pictures show. His idea of a guard-house is, however, singular. It is a barrel his soldiers stand before, conveying to the uninitiated mind the idea of a hencoop rather than a house.
The figures of the military gentlemen are exceedingly well drawn out – I do not think they would bear the least additional stretching. The picture is fine in point of length – breadth is, I regret to state, wanting. The idea seems to be a lesson in manoeuvring to a new recruit. Standing upon a box, the better to observe the movements of his well-instructed comrade, he imitates them with a log of wood placed in his hands instead of a musket, as a precaution against carelessness.
"The National Academy Exhibition. (Continued)," *The New-York Illustrated News* 10, no. 236 (7 May 1864): 444.

Nothing new from Mr. Hosmer [sic], whose pictures Nos. 73, 140, we have amply praised before. Characteristic, true, and painted with a good deal of skill, we always study them with interest, and we hope to record continual progress.
"National Academy of Design. The Thirty-Ninth Exhibition. (Seventh Article)," *The New-York Daily Tribune*, 11 June 1864.

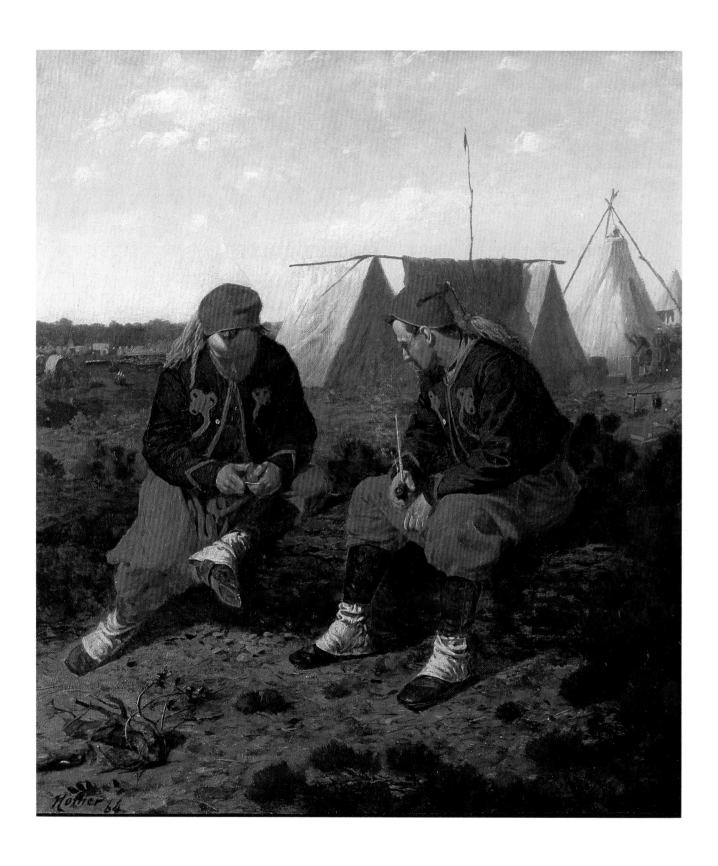

8. The Brierwood Pipe, 1864

(Also called *Making Brier-root Pipes* [1864], *Making Brierwood Pipes* [1864], *The Briarwood Pipe*, and other close variants)
Oil on canvas, 16⅞ × 14¾ inches
Signed and dated lower left: Homer 64
The Cleveland Museum of Art
Mr. and Mrs. William H. Marlatt Fund (44.524)

In *The Brierwood Pipe* Homer shows two men sitting on a log, one busily at work carving a pipe, the other (his own pipe already in action) watching his colleague's progress. The two figures, complexly posed and convincingly drawn, fill the canvas. The soldiers' bright costumes, the intensity of their concentration on the handicraft, and (more symbolically) the clear sky overhead, signal an idyllic interlude for these men in the midst of war.

As is the case in so many of his Civil War paintings, Homer has taken particular care to make the soldiers' shoes, spats, and leggings illusionistic. Other areas of fine detailing include the glowing pipe — touched with red, orange, and yellow, with twists of gray smoke rising from both the bowl and the stem — and the turquoise highlights that animate the color of the smoker's shirt. But Homer did not succumb to detail. Instead, he created a broadly atmospheric work. Even in the drawing of such critical portions of the composition as the ends of the log on which the soldiers sit, he dared to leave decidedly unresolved passages. The foreground is littered with bright green puffs of clustered pine needles. To the left lies a gnarled chunk of the brier root that gives the painting its title.

Smoking was "the proverbial soldier's pastime," according to one man's memoirs. "A pipe was [the soldiers'] omnipresent companion, and seemed to make up to them in sociability for whatsoever they lacked of entertainment in other directions."[1] "Now the pipes, of course. . . . Old Comrade, tell me, is not this real comfort?" wrote another.[2]

Carving, as well, helped to fill the empty hours in camp. Soldiers on both sides of the battle made rings, pipes, and trinkets of various sorts as keepsakes. One private later recalled:

A common occupation of a leisure hour, with the smokers, is the carving of pipes from the roots of the laurel, found in profusion in the woods here. It is a slow business, in most cases beginning with a chunk about half as large as one's head, which is reduced by slow degrees and patient whittling to the small size of a pipe bowl.[3]

Both occupations, smoking and whittling, were conducive to reflection. As a poem called "The Brier-wood Pipe," published in 1861, put it:

My pipe, it's only a knot from the root of the brier-wood tree,
But it turns my heart to the Northward. . . .[4]

The soldiers enjoying the quiet companionship of their pipes in both the poem and in Homer's later painting belong to Zouave regiments. The Zouave costume — full red britches cuffed at the calf and set off by dark leggings and white spats, blue short jacket with red trim, and gold-tasseled red fez or turban — were prominent among the wide diversity of Union outfits at the outset of the war.[5] Derived from the uniforms of (and named after) the Zouaves — Berber tribesmen of Algeria who fought alongside the French in the Crimean War, reportedly possessing unquenchable vigor and valor in battle — the uniforms quickly became the favorite of journalists and illustrators.

For the latter this was doubtless a response both to the eye-catching quality of the colors and to the more practical fact that the Zouave suit was a distinctive one even in black-and-white line drawings. Thus a Zouave early during the conflict

was synecdochically identifiable with the whole Northern cause.[6] A further factor predisposing New Yorkers to the Zouave uniforms could have been the popularity there of the North African works of Jean-Léon Gérôme.[7] Certainly in Homer's case, the small scale of *The Brierwood Pipe*, its exotic costumes, its absorptive subject of men smoking, and its jewel-like colors, associate it with Gérôme's oeuvre, in spite of the major difference in the notions of finish evident in the works of the American and French artists.[8]

In spite of their inspiriting design and color, many Zouave units found the costumes unwieldy and ill-suited for active soldiering:

The Turkish fez, with pendent tassel, was seen on the heads of some soldiers. Zouave regiments wore them. They did very well to lie around camp in, and in a degree marked their owner as a some-what conspicuous man among his fellows, but they were not tolerated on line; few of them ever survived the first three months' campaigning.[9]

Soon after entering the field most regiments exchanged the regalia for standard blue uniforms, a decision prompted by the difficulty of maintaining the splendid colors and excess yardage, and the fact that all that bright stuff made superb targets of its wearers.[10]

For the New York audience of 1864, however, the sparkling Zouave uniforms in Homer's painting would have had a special significance. Two of the most famous Zouave outfits in the Army of the Potomac were from New York, Duryee's and Hawkins's. Both regiments were mustered out of service in May 1863. On their return to New York, the city gave the men of these regiments parades and banquets honoring both the men who survived the war's "baptism of fire and sword," as well as their fallen comrades — half to three-quarters of the men in each regiment were lost.[11] So by the time *The Brierwood Pipe* was exhibited at the 1864 National Academy exhibition, the serenity of the scene and the uniforms themselves would have carried the viewer back several years, before optimism about a quick and tidy limited war was replaced by the realization of the long and absolute struggle that it was in fact to be.

The Brierwood Pipe is a studio painting, a composition devised by Homer in New York rather than a response to a specific scene witnessed in Virginia. Homer had purchased a Zouave costume from a soldier,[12] and at least one critic included in his discussion of this painting the fact that Homer painted his figures on the roof of his University Building studio:

Mr. Homer studies his figures from realities, in the sunshine. If you wish to see him work you must go out upon the roof, and find him painting what he sees . . . real things, instinct with life and warm with the glory of God's sunshine.[13]

Where the impetus for Homer's rooftop studio came from (so like Thomas Eakins in the next decade) is unknown. To judge by the critic's comments, few of his colleagues in New York were out on the roofs with him. Perhaps it was the urge for bold truth, parallel to that which (totally separately) animated Claude Monet in precisely these same years. Perhaps simply it was an aspect of the experimentation concerning perception and the act of painting that drove him to include the challenge of night and dawn scenes among his earliest works, as in *In Front of Yorktown* (*cat.no.2*) and *Sounding Reveille* (*cat.no.18*).

There are no drawings now known for the principal figures of *The Brierwood Pipe*, nor are there any compositional studies known. Since examination of the painting with infrared reflectography (*fig.8.1*) reveals that Homer initially considered a radically different background for the painting (perhaps a lean-to comparable to that in *Playing Old Soldier, cat. no.5*), but changed his mind very early on, it is likely that he designed the painting as he executed it. The pattern of the tents in the present background, configured in a largely arbitrary fashion with formal concerns of rhythm and pattern dominating rational structure, echoes a similar arrangement in his earlier lithograph *Our Jolly Cook* (*fig.8.2*). Only the distant grouping of mules and wagons at the far left apparently grew from an on-site sketch (*cat.no.8a*).

Which is not to say that Homer deviated from nature in the rendering of the two Zouaves. For one generally favorable critic, in fact, he remained too close to Nature:

*The color is a trifle crude in [*The Brierwood Pipe*].*
The drawing and character are exquisite, but
those Zouaves have dreadfully red trousers. The
color may have been actually crude; but it would
have been pleasanter to see, if the artist had selected
an older, more stained and subdued pair of trowsers
to work from.[14]

But this is an idyll for Homer, a nostalgic celebration of the easy romance of the war. The men he depicts are those who

hear the drum and the bugle, the tramp of the cow-
skin boots,
We are marching on our muscle, the Fire Zouave
recruits![15]

Stained trousers and the scars of the campaign were not yet part of his paintings' repertoire.

<div align="right">M. S.</div>

fig.8.1 Partial transcription of underdrawing of
The Brierwood Pipe, as seen with infrared
reflectography.

1. Billings, *Hardtack and Coffee*, 66-67. On occasion they could be entertaining indeed. Charles Fuller recounted one cold morning in December 1862:
At 6 a.m. the regiment formed on the color line, ready to move. While we were thus waiting, I was smoking my briarwood pipe, and, at what I supposed was the end of my smoke, I threw out the ashes and put the pipe in my breeches pocket. In a short time I was conscious of a change in temperature in that locality, and hastily brought to view the pocket and pipe. Doubtless some of the fire remained in the bowl, which got out and set fire to that part of my clothing. I had no trouble in extinguishing this ignition, but the pocket was gone and my leg had a raw spot.
(*Personal Recollections of the War of 1861. . . .* [Shelburne, N.Y.: News Job Printing House, 1906], 76).

2. Samuel H. Putnam, *The Story of Company A*, quoted in Williams, *The Artists' Record*, 66.

3. George G. Benedict, *Army Life in Virginia: Letters from the Twelfth Vermont Regiment. . . .* (Burlington, Vt.: Free Press Association, 1895), 67-68. Another reminisced:
I sent home by one of the men a pipe bowl made out of laurel root upon which was carved a heart and hand, meaning I suppose that he was heart and hand in the service of his country. It was made by a rebel soldier and was picked up at Yorktown by one of our men. Another pipe found there had the owner's name, co. and regt. carved on it, and it was very well done (Alfred Bellard, *Gone for a Soldier* [Boston: Little, Brown, 1975], 205-206).

4. "The Brier-Wood Pipe," by Charles Dawson Shanly, *Vanity Fair* 4, no. 80 (6 July 1861): 5. The poem continues, in part:
My thoughts are back in the city, I'm everything I've been;
I hear the bell from the tower, I run with the swift machine.
I see the red shirts crowding around the engine-house door,
The foreman's hail though the trumpet comes with a hollow roar.

. .

I hear the drum and the bugle, the tramp of the cow-skin boots,
We are marching on our muscle, the Fire Zouave recruits!
Lucretia H. Giese (*Painter of the Civil War*, 296) was the first, to my knowledge, to associate the poem and the painting.

5. Many of the early volunteer regiments' uniforms were based on those worn by local militia groups and could be considerably flamboyant. Standardization of the uniform came about only toward the end of 1861 when it became clear that the war was not a lark but an earnest endeavor that would extend for years. This did not occur before some serious confusions had arisen in battle concerning Yankees in gray militia suits being mistaken for enemies (Philip Haythornthwaite, *Uniforms of the*

OUR JOLLY COOK.

fig.8.2 Our Jolly Cook, 1863. Lithograph from *Campaign Sketches*, 13⅞ × 11 in. Amon Carter Museum, Fort Worth, Texas (56.83)

American Civil War, 1861-65 [Poole, Dorset: Blandford Press, 1975], 101-102; Philip R. N. Katcher, *Army of the Potomac* [Reading: Osprey Publishing, Ltd., 1975], 8-12.

Interestingly, Zouave-style garments had entered women's fashion just prior to the war. See "La Mode – The Zouave Jacket," *Harper's Weekly* 4, no. 174 (28 April 1860): 272.

6. As in a July 1861 cartoon in *Harper's Weekly* that bears the caption "It is understood that much land hitherto devoted to Cotton is now sown with Grain. By about August our Zouaves will be along there, *and will Reap it!*" *Harper's Weekly* 5, no. 236 (6 July 1861): 419. Entitled "One man sows and another reaps," the cartoon is illustrated in Christopher Kent Wilson, "The Veteran in a New Field," *The American Art Journal* 12, no. 4 (Autumn 1985): 12.

Compounding the visual appeal of the uniform, the symbolically charged death of the young Zouave leader, Colonel Ellsworth, early in the conflict, added an aura of noble heroism to any of the several New York and Pennsylvania regiments that started the war so attired. The "ideal figure of a fallen hero," Ellsworth's death was the first of the war to capture popular attention. See Margaret Leech, *Reveille in Washington* (1941; New York: Carroll & Graf, 1986), 81-82.

7. Works by Gérôme were well known in New York through public exhibitions and private collections. See, for example, "Personal," *The Evening Post*, 17 January 1863; "Art Notes," *The Round Table* 1, no. 1 (19 December 1863): 12; "Fine Arts," *The Albion* 43, no. 13 (1 April 1865): 153; "Pictures by Jean Léon Gérôme," *The New Path* 2, no. 5 (May 1865): 78; "The National Academy of Design," *The Independent* 17, no. 861 (1 June 1865): 4; and most interestingly, an article by Eugene Benson in *The Galaxy* for August 1866, excerpted in "The Galaxy," *The New York Commercial Advertiser*, 19 July 1866.

8. French critics, on seeing Homer's work in 1867, would make the association between the two artists. See *The Bright Side (cat.no.13)*, Collected References Prior to 1876.

9. Billings, *Hardtack and Coffee*, 277.

10. There were a few regiments, notably those of the Third Brigade, Second Division, Fifth Army Corps, that maintained the uniform throughout the war (Francis A. Lord, *Uniforms of the Civil War* [New York: Thomas Yoseloff, 1970], 72-73). Katcher reports that as late as 1864 some regiments of that Brigade, such as 140th New York, adopted the Zouave dress in favor of the standard uniform (*Army of the Potomac*, 9).

11. *The New-York Times*, 6 and 9 May 1863.

12. James E. Kelly papers, box 9, The New-York Historical Society.

13. *The New York Leader* 10, no. 18 (30 April 1864): 1.

14. *The New York Leader* 10, no. 18 (30 April 1864): 1.

15. Shanly, 5.

8a. *Army Encampment*, 1862 (also called *Wagon Train in Camp; Wagon Train with Mules Unhitched*). Pencil, 3¼×6¼ in. Cooper-Hewitt Museum, the Smithsonian Institution's National Museum of Design, New York. Gift of Charles Savage Homer (1912-12-124)

PROVENANCE James Thomas Fields (d. 1881); Mrs. James Thomas Fields (née Annie Adams, d. 1915); her nephew, Dr. Z. Boylston Adams; his wife, Mrs. Z. Boylston Adams (by 1944); The Cleveland Museum of Art.

EXHIBITIONS PRIOR TO 1876 24 March 1864, New York, "Artists' Reception," Dodworth's Studio Building; 1864, New York, National Academy of Design, "Thirty-ninth Annual Exhibition," no. 140.

CHANGES IN THE COMPOSITION Painting was examined using infrared reflectography; x-radiographs were not available. Homer had originally sketched in a different background to right – filling it in with an object (perhaps a lean-to) rather than the open sky; left side of sibley tent widened; horizon to left has been lowered and regularized; board or handle for tool or gun leaning against log to right has been covered over.

COLLECTED REFERENCES PRIOR TO 1876
WINSLOW HOMER . – Mr. Homer, our most promising young battle painter, is at present engaged upon a picture of camp-life, representing a couple of soldiers seated on an old pine log, making brier-wood pipes.
"Artists' Studios," *The Round Table* 1, no. 3 (2 January 1864): 44.

Winslow Homer has two unfinished pictures, the subjects of which are drawn from camp-life. One is "Making

Brier-root Pipes" – two Zouaves seated on a bank cutting out pipes from the brier-wood.
"What Our Artists Are Doing," *The Evening Post*, 28 January 1864.

[At the Artists' Reception at Dodworth's Studio Building] Homer had a strong and effective little work, incidental to the war, of two zouaves occupied in making brier-wood pipes.
"The Artists' Reception," *The Evening Post*, 25 March 1864.

Mr. Winslow Homer had two pictures, which were interesting, but no equal to previous works of his. The portrait of the lady. . . . The other picture – two Zouaves sitting on a tree trunk, one whittling, the other watching him, was naturally composed and had considerable truth of expression, but showed a sad falling off in the study and care that went to the execution of the last pictures by this artist, which we noticed.
"Fourth Artist's Reception," *The New-York Daily Tribune*, 26 March 1864.

THE private view of the thirty-ninth annual exhibition of the National Academy of Design takes place this evening. . . . Among the figure pictures will be . . . "Making Brierwood Pipes," by W. Homer.
"National Academy of Design," *The Round Table* 1, no. 18 (16 April 1864): 281.

I sincerely advise Mr. Hall [the artist George Henry Hall] to go every day and examine a little picture in the first gallery, numbered seventy-three, and entitled, "In front of the guardhouse." After that he may visit the second gallery and study number one hundred and forty – "The briar-wood pipe." These two are by Mr. Winslow Homer. He is a young man, and almost a new beginner; but he did something that very few of our young artists do; learned to draw with the point before he attempted color. I hope not to be thought flippant if I say that too few of our students "see the point." They want to feel the gracious weight of the palette upon their thumbs too early, and they bear animosity to the crayon. Another thing: Mr. Homer studies his figures from realities, in the sunshine. If you wish to see him work you must go out upon the roof, and find him painting what he sees. Not dusky, characterless, dreamy, impossible *muchachos*, but real things, instinct with life and warm with the glory of God's sunshine.

The color is a trifle crude in number one hundred and forty. The drawing and character are exquisite, but those Zouaves have dreadfully red trousers. The color may have been actually crude; but it would have been pleasanter to see, if the artist had selected an older, more stained and subdued pair of trowsers to work from. That he has a fine and generous feeling for harmony in this, is plainly shown by the sky in the same picture. It makes all the skies of the landscapes near it look painty, dull, opaque. . . .
. . . Feeling can not be learned; execution can. Mr. Homer is full of the former, and has made gigantic strides in the latter. Looking at these two pictures this morning, I said to a friend, "If this is the work of a new beginner, where on earth will he stop?" It astonishes me that neither of these works have been bought as yet.
"The Academy Exhibition. Second Article," *The New York Leader* 10, no. 18 (30 April 1864): 1.

One of the most successful exhibitors this year is Mr. Winslow Homer, who gives us a couple of camp pieces that are full of life and originality. [Discussion of *In Front of the Guard-House*.] Mr. Homer's other picture is in the adjoining room, numbered 140. A couple of Zouaves are engaged in the manufacture of briarwood pipes – not a very lofty topic, but sufficient to enable the artist to display an excellent knowledge of color and drawing.
"National Academy of Design," *The New-York Times*, 5 May 1864.

MR. WINSLOW HOMER – It is pleasant to record an advance however slight. There are characteristics in Mr. Homer's work which serve as indications of progress. . . . But the two pictures, No. 70 [sic] and No. 140 [*In Front of the Guard-House* and *The Brierwood Pipe*], are full of promise, and their merits are of no commonplace character. The *painting* of these pictures, and the genuineness which is characteristic of everything Mr. Homer has done thus far, prophesy a distinguished future. Few if any of our young painters have displayed in their first works so much that belongs to the *painter* as Mr. Homer. His pictures indicate a hand formed to use the brush. It seems to us that Mr. Homer must aim for completeness and refinement. At present, his work is deficient in both these particulars. But we recognize with gladness the uncommon strength of his work, a characteristic not often found in American pictures. Mr. Homer's picture, called "Making Brier-Wood Pipes," is well grouped and the general forms truly given. It is positive, and has a sky of much delicacy in execution and color, and which would do credit to our best landscapists.
"Exhibition of the National Academy of Design. III," *The Round Table* 1, no. 21 (7 May 1864): 326.

Mr. Homer makes some progress, as *Brierwood Pipe*, no. 140, pleasantly testifies.
"Fine Arts: The National Academy of Design," *The Albion* 42, no. 19 (7 May 1864): 225.

Nothing new from Mr. Hosmer [sic], whose pictures Nos. 73, 140, we have amply praised before. Characteristic, true, and painted with a good deal of skill, we always study them with interest, and we hope to record continual progress.
"National Academy of Design: The Thirty-ninth Exhibition. [Seventh Article.]," *The New-York Daily Tribune*, 11 June 1864.

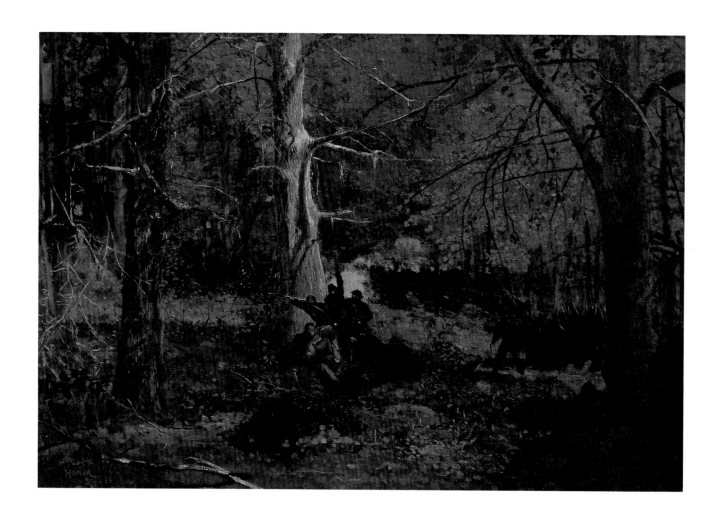

9. Skirmish in the Wilderness, 1864

Oil on canvas mounted on masonite panel, 18 × 26 inches
Signed lower left: HOMER / NY –
New Britain Museum of American Art
Harriet Russell Stanley Fund (1944.5)

But for a few wood engravings published early in the Civil War (for example, *The War for the Union, 1862 – A Cavalry Charge*, Giese, this volume, *fig. 6*), Homer avoided depicting scenes of actual battle or confrontation. One notable exception is *Skirmish in the Wilderness*, a "battle painting" as unusual for its time as were the battle tactics developed in the Civil War. At the center of the painting, several Union soldiers stand protected by a large tree trunk, loading their rifles or firing into the woods. One has fallen and lies slumped beside the tree trunk; another crawls forward on his hands and knees, beyond the range of fire. Behind them to the right a column of troops advances to reinforce the position established by these skirmishers; their leader bears on his cap a red dot that presumably indicates the red cloverleaf insignia of the First Division, Second Corps of the Army of the Potomac.[1] But these faceless soldiers, painted with swift, summary strokes, are small actors on a wilderness stage; dwarfed by trees and surrounded by dense foliage, their advance is blocked and their enemy invisible. No less clear, directed, or unheroic action painting ever purported to present a scene of battle.

However, Homer's painting well epitomizes the Battle of the Wilderness, fought between the armies of Ulysses S. Grant and Robert E. Lee on 5 and 6 May 1864, and described by one veteran as *the strangest and most indescribable battle in history. A battle which no man saw, and in which artillery was useless and hardly used at all. A battle fought in dense woods and tangled brake, where maneuvering was impossible, where the lines of battle were invisible to their commanders, and whose position could only be determined by the rattle and roll and flash of musketry, and where the enemy was also invisible.*[2]

This was Grant's first battle as lieutenant general in command of all the Union armies, marking his debut with General George Gordon Meade's Army of the Potomac.[3] In spring 1864, when Grant assumed his command, that Army was camped near Culpeper Court House along the north bank of the upper Rapidan River; Lee's Army of Northern Virginia lay beyond the river. In planning his assault on the Confederate capital of Richmond, Grant intended to move his army southward by crossing the river and cutting through a densely wooded section of land known as "The Wilderness," thus turning Lee's right flank and forcing a battle in the open country to the south. But Lee, with the audacity that distinguished him in so many fields, determined to attack before the Union army could pass out of those "dreary and dismal woods."[4]

The Army of the Potomac had fought in woods before, during the "Seven Days' Campaign" in June 1862 (*fig. 9.1*) and again at Chancellorsville in May 1863. But they had encountered no terrain quite like the Wilderness.

The woods of the Wilderness have not the ordinary features of a forest . . . for above a hundred years, extensive mining has here been carried on. To feed the mines the timber of the country for many miles had been cut down, and in its place there had arisen a dense undergrowth of low-limbed and scraggy pines, stiff and bristling chinkapins, scrub-oaks and hazel. It is a region of gloom and the shadow of death.[5]

Lee knew well the terrain of the Wilderness, and was also aware that Federal advantages in artil-

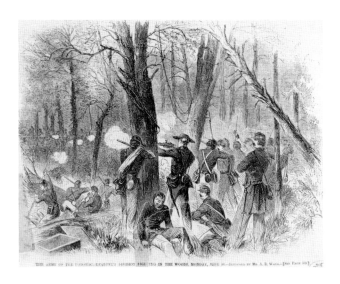

fig.9.1 Alfred R. Waud (1828-1891). *The Army of the Potomac – Kearney's Division Fighting in the Woods, Monday, June 30.* Wood engraving. *Harper's Weekly* 6, no. 293 (9 August 1862): 500. Collection of the Library of Congress

lery and manpower would mean little in an area where heavy guns would be virtually useless and the maneuvering of large bodies of troops would be difficult in the extreme. The battle that ensued was intense and vicious, and before long the rapid gunfire set areas of the dry underbrush of the Wilderness aflame. Wounded soldiers too badly hurt to move were burned before their comrades could rescue them. When the fighting died down, Grant's casualties numbered over 17,000.[6] But even in the face of such loss, Grant did not retreat, as did General Joseph Hooker under similar circumstances the year before. Moving by his left flank, Grant forced Lee to pull back and the two armies raced toward another calamitous struggle at Spotsylvania Courthouse. On 11 May Grant wrote to Washington, "I propose to fight it out on this line if it takes all summer."[7] Making one final, desperate frontal attack at Cold Harbor, Grant in a matter of minutes lost over 7,000 men in the only battle he ever regretted having fought. Abandoning hope for a breakthrough, he transferred his army south of the James River and invested Petersburg.

The Battle of the Wilderness thus introduced to the Army of the Potomac a style of leadership unlike the gallant but often tentative warfare it had experienced under generals such as George B. McClellan or Joseph Hooker. Grant, described by one soldier as a man who "habitually [wore] an expression as if he had determined to drive his head through a brick wall and was about to do it,"[8] had resolved to achieve his goal, no matter what lay in his path. If his troops met Lee in the woods instead of the open plain, they would fight there no matter what shape that fighting took or how unconventional its tactics might be. And unconventional it was; in the words of one veteran "this singular battle" of the Wilderness was in actuality "a disconnected series of bushwhacking encounters, illustrating the tactics of savages rather than the science of modern war."[9]

According to the records of the Union League Club, which owned the painting in the nineteenth century, Homer told Charles B. Curtis that he painted *Skirmish in the Wilderness* from sketches made on the spot at the time of battle.[10] Scholars have disputed Homer's claim, finding no hard evidence that Homer was at the front in 1864,[11] but sketches do exist for this painting (*cat.no.9a* and *fig.9.2*).[12] These drawings describe the soldiers' actions in the briefest of lines, as would be appropriate to the darting maneuvers of a skirmish, and Homer made little attempt to enlarge upon these small, sketchy figures when he painted them into his canvas. Rather, Homer took his vantage point from some distance, maintaining the reduced scale of his figures and allowing the landscape setting of tall trees and dense greenery to assume a large and significant role. Like the tense, summary drawing of his figures, Homer's description of this landscape is made with quick touches, daubs of green and red that suggest foliage, strokes of yellow and brown that indicate branches and tree trunks. The painting itself is a tangle: scumbles and spots of pigment read as foliage, patches of light, or the puffs of gunfire smoke, while at the center the dark form of a supporting line of infantrymen might as well be a row of tree trunks. Deciphering the action of this painting, one becomes as confused as the soldiers who fought that battle must have been.

Skirmish in the Wilderness is the only one of

fig.9.2 Sketches of Soldiers in Action, probably 1864 (verso of *fig.18.2*). Pencil, 11⅜ × 16¾ in. Cooper-Hewitt Museum, the Smithsonian Institution's National Museum of Design, New York. Gift of Charles Savage Homer (1912-12-108v)

Homer's Civil War paintings, and one of a very few early works, in which the natural landscape plays a predominant role. It relates closely to works such as *Waverly Oaks* (1864, Thyssen-Bornemisza Collection, Lugano), in which trees dwarf the figures next to them, and spiky, leafless forms, animated by dramatic contrasts of light, create an unsettling, almost gothic mood. Both *Waverly Oaks* and *Skirmish in the Wilderness* feature as their dramatic center an enormous tree. As early explorations in landscape painting, these works bear the distinct mark of Boston, where in the early 1860s William Morris Hunt was encouraging curious and progressive painters, such as Homer's friend John La Farge, to study works of the French Barbizon School. Unlike their counterparts in New York, Boston painters such as Hunt, La Farge, and Homer's former colleague at Bufford's, J. Foxcroft Cole, took a subjective approach to the art of landscape painting in the mid-1860s, studying Barbizon works and using landscape subjects to further investigations into color theory, tonal harmonies, and expressive mood.[13]

The uneasy relationship between man and nature seen in *Waverly Oaks* is in *Skirmish in the Wilderness* pushed to an expressive end especially appropriate to its subject matter. With its composition framed by dark branches and heavy foliage that admit no access to light or sky beyond, it serves as a disturbing inversion of the man/nature dichotomy in *Inviting a Shot before Petersburg, Virginia* (*cat.no.10*). In contrast to the single, defiant Confederate soldier who stands atop a rampart, challenging the war-scarred landscape before him, the Union soldiers who skirmish in the Wilderness are enveloped in, even consumed by the threatening landscape surrounding them. *Skirmish in the Wilderness* is Homer's first painting in which the landscape plays a decidedly adversarial role. It signals the direction Homer would take in the most powerful works of his maturity, paintings set in the Adirondack mountains or along the coasts of Cullercoats and Prout's Neck, in which the human figure, alternatively surmounting or overwhelmed by the landscape, either defies or is defeated by the larger forces of nature around it.[14]

S.M.

1. This division was commanded by Brigadier General Francis Channing Barlow, whose regiment Homer had accompanied during his visits to the Army of the Potomac in 1862. Having returned to service in April 1864, following his recovery from wounds sustained at Antietam and Gettysburg, Barlow was placed in charge of the First Division of General Winfield Scott Hancock's Second Corps. Nicolai Cikovsky has suggested that the figure leading a column of troops in *Skirmish in the Wilderness* might be Barlow (who liked to carry a long cavalry sword even though he was a commander of infantry), but admits that the figure is "too sketchily indicated to be sure." Cikovsky, "Winslow Homer's Prisoners From the Front," *Metropolitan Museum Journal* 12 (1977): 164n.

9a. Studies of Soldiers Taking Aim, 1862. Pencil on pasteboard, 4¾ × 3¼ in. Cooper-Hewitt Museum, the Smithsonian Institution's National Museum of Design, New York. Gift of Charles Savage Homer (1912-12-171)

2. Robert Stoddard Robertson, *From the Wilderness to Spottsylvania: A Paper Read Before the Ohio Commandery of the Military Order of the Loyal Legion of the United States . . . December 3, 1884* (Cincinnati: Robert Clarke & Co., 1888), 18-19.

3. Having replaced Major General Joseph Hooker, Major General Meade had been Commander of the Army of the Potomac since 27 June 1863. Following Grant's ascendance to overall commander of the Union armies in March 1864, the two generals met and Meade offered to retire quietly if it would suit the new general in chief. Grant firmly rejected the offer, and later "wrote that he was favorably impressed by the way it was made." *Catton's Civil War*, 482.

4. Robertson, 11.

5. William Swinton, *Campaigns of the Army of the Potomac: A Critical History of Operations in Virginia, Maryland and Pennsylvania from the Commencement to the Close of the War, 1861-1865* (1866; New York: Scribner's, 1882), 428-429.

6. Of the more than 100,000 Federal soldiers engaged in the Battle of the Wilderness, 2,246 were killed, 12,037 wounded, and 3,383 missing, for a total of 17,666. E. B. Long, *The Civil War Day by Day: An Almanac, 1861-1865* (Garden City, N.Y.: Doubleday, 1971), 494. Casualties in Lee's Army of Northern Virginia numbered about 7,600.

7. Robertson, 29.

8. Ketchum, *American Heritage Picture History*, 308.

9. Warren Lee Goss, *Recollections of a Private: A Story of the Army of the Potomac* (New York: Thomas Y. Crowell, 1890), 272.

10. Manuscript catalogue compiled by C. B. Curtis, Union League Club Library. See also "Barbizon & American Paintings, Old Masters, British Portraits from the Collections of the Late Mr. and Mrs. Percy A. Rockefeller and . . . Union League Club of New York . . ." Parke-Bernet Galleries, New York, 24 March 1938, 50.

11. See Hendricks, *Life and Work*, 54-55, 58; see also Chronology, this volume. Whether Homer was in the Wilderness or not in May 1864, his understanding of that battle may have been informed by communications with Francis Barlow or Barlow's family in Massachusetts, and by conversations with his colleague at *Harper's*, Alfred Waud, who did accompany the Army of the Potomac into the Wilderness. Several of Waud's illustrations of the Wilderness battles appeared in *Harper's Weekly* on 4 June 1864; curiously, Homer's painting of a *Skirmish in the Wilderness* bears a closer relation to Waud's 1862 illustration of *Kearney's Division Fighting in the Woods (fig. 9.1)*.

12. Although these works appear to be part of a group of more finished studio drawings from 1863-1864, they are in any case smaller and more rapidly sketched than those drawings. See Giese, *Painter of the Civil War*, 245-255.

Giese suggests that Homer may have drawn these sketches in preparation for a major battle painting.

13. The approach and ambitions of these Boston painters differed significantly from the two styles of landscape painting prevalent in New York in the 1860s – the expansive grandeur of the Hudson River School or the tight, minutely descriptive Ruskinian mode. See Peter Bermingham, *American Art in the Barbizon Mood*, exh. cat. (Washington, D.C.: The National Collection of Fine Arts, 1975), esp. ch. 2, "Hunt, Inness, and a Few Friends: The Early Years," and 52-54, 144-146. Henry Adams has made a convincing case that Homer's early knowledge of Barbizon painting and his contacts with artists such as John La Farge in the 1860s set the stage for later "impressionistic" tendencies in his art. See "Winslow Homer's 'Impressionism' and Its Relation to His Trip to France," forthcoming article for The Center for Advanced Study in the Visual Arts, Washington, D.C.

14. For example, *Inside the Bar, Tynemouth* (1883, watercolor, The Metropolitan Museum of Art, New York) or *The Woodcutter* (1891, watercolor, private collection), vs. *Winter Coast* (1890, oil on canvas, The Philadelphia Museum of Art) or *The Gulf Stream* (1899, The Metropolitan Museum of Art, New York).

CHANGES IN THE COMPOSITION Painting was examined without using infrared reflectography; no x-radiographs were available. No significant changes apparent. In the course of painting, the trunk of the tree at the right was brought down and extended over the dark green pigment in the corner. The large tree at the right was added at a later stage, after the sunlit patch of ground behind it was painted.

COLLECTED REFERENCES PRIOR TO 1876
Winslow Homer's "Skirmish in the Wilderness" is an effective work, depicting in a rapid and skilful manner the story of a skirmish in the woods.
"Fine Arts. The Artists' Fund Exhibition," *The Evening Post*, 30 November 1864.

The sale at auction, on Friday evening, of the pictures belonging to the Artists' Fund Society produced fair prices. We give the names and prices of the pictures which brought $50 and upward, without the frames: . . . Skirmish in the Wilderness, by Homer. . . . 165.00.
"Sales of the Artists' Fund Pictures," *The New-York Times*, 1 January 1865.

PROVENANCE William Parsons Winchester Dana (1864-?);* The Union League Club, New York (1870-1938); [sale, Parke-Bernet Galleries, New York, 24 March 1938, no. 76]; [F. Schnittzer, New York]; [Vose Galleries, Boston]; New Britain Museum of American Art, New Britain, Conn.

*Union League Club records state that William P. W. Dana purchased *Skirmish in the Wilderness* directly from the Artists' Fund Society exhibition, but states further that the work was purchased by the Club "at the sale of Caldwell estate in 1870." "The Entire Collection of Paintings Belonging to Mrs. S. B. Caldwell, Brooklyn, L. I." was auctioned in New York by Leavitt, Strebeigh & Co. on 13 May 1870; this sale did not include any works by Homer. Mrs. Caldwell's estate *did* include several other Civil War pictures, including Sanford Gifford's *Sunday Morning, Camp of the Seventh Regiment (near Washington D.C., Meridan Hill)*, which eventually did become part of the Union League Club's collection and is known today by the title *Sunday Morning at Camp Cameron, Near Washington, in May 1861*.

EXHIBITIONS PRIOR TO 1876 November 1864, New York, Artists' Fund Society, "Fifth Annual Exhibition," no. 47.

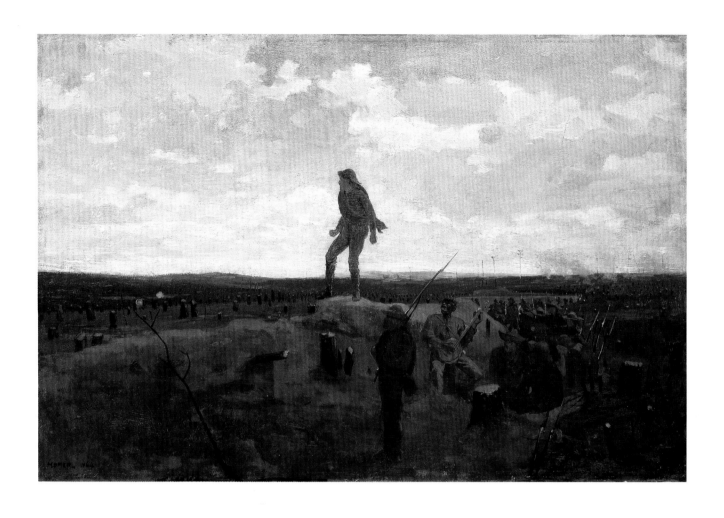

10. Inviting a Shot before Petersburg, Virginia, 1864

(Also called *Defiance* [1899],
Defiance: Inviting a Shot before Petersburg)
Oil on panel, 12 × 18 inches
Signed and dated lower left: HOMER 1864
Signed and inscribed on verso (now eradicated): *Inviting a Shot
before Petersburg, Va., 1864. W Homer.*
The Detroit Institute of Arts
Gift of Dexter M. Ferry, Jr. (51.66)

A sole Confederate private challenges the Union troops massed behind the fortifications in the distance. Two shots ring out in response — the orange flash to the left and the puff of smoke to the right signal the double fire aimed at the young gallant (and, as in the late painting *Right and Left* [*fig. 10.1*], troublingly aimed at the viewer). The dark, complicated silhouette of the soldier stands out against the light sky, providing a visual equivalent of the energy and drama of his action. Still hidden behind the earthworks, the soldier's fellows, perhaps attracted in part by the sound of the first shot, turn to note his bravura. A black laborer, playing a banjo, stares upward, eyes and mouth held wide. The simple composition gathers its energy in these darkened soldiers to the right, a swirling force that, finding expression in the defiance of the shouting Confederate, breaks forth across the cleared landscape. Through massing and pose, Homer gives form to the Confederate's yell.

Inviting a Shot before Petersburg, Virginia stands apart from the bulk of Homer's early work on several counts. On the most basic level of materials, the painting is on panel rather than canvas, his earliest major work on that support. It appears as though Homer were intent on broadening his brief acquaintance with all the traditions of picture-making. More important, the subject is seen from the Confederate point of view — the only painting (excepting *Near Anderson-*

ville) in which Homer places himself and the spectator away from the Union side.[1] While early in the war artists and correspondents did sometimes move to the opposing camps, by the time of Petersburg such friendly comings and goings were rare.[2] It is, therefore, most likely that the scene grew as Homer imagined rather than saw it.[3] The relationship to *Right and Left* thus grows all the stronger, stringing these two works from the extremes of his career on one taut wire — the artist's poignant identification with the hunted.

The siege at Petersburg was the ultimate action of the war in Virginia, as attrition and hunger gradually wore down Lee's splendid Army of Northern Virginia. Petersburg, twenty-odd miles south of Richmond, was the vital rail center for supplies and communication, and the three roads leading south and southwestward from it formed the links between Lee, entrenched around the city, and the deep South. By severing the links, Grant reasoned that starvation and lack of munitions would finally force the Army of Northern Virginia into the open, away from its fortifications, where by virtue of superior numbers he could destroy it. The capitulation of Richmond and the end of the war would follow. Thus in early June 1864 he began his campaign. By 15 June Grant's leading elements could have easily swept through the small Virginia city, which in spite of its impressive defenses was largely unmanned. Yet as had happened so frequently before to the Army

fig.10.1 *Right and Left*, 1909. Oil on canvas,
28¼×48⅛ in. National Gallery of Art, Washington, D.C. Gift of the Avalon Foundation (1951.8.1)

of the Potomac, through a failure of communications and a lack of initiative in its officers, an opportunity for a quick and decisive battle was overlooked on that evening, when 10,000 Union men faced a defending force of barely 2,200 men stretched out over miles of trenches.[4] Instead, Union delay allowed Lee to bring up reinforcements. When an attack was finally made late the next afternoon, it was repulsed, inflicting heavy Union casualties. Except for the spectacular Petersburg mine, exploded under a section of the Confederate line on 30 July (where again the Union army had an opportunity for decisive action that instead turned into a total rout), the two armies settled into a siege that lasted for nearly ten months, with sickening loss of life on both sides. Only after Lee under cover of night abandoned the defenses of Petersburg on 2 April 1865 did the Union forces take the city. A week later on 9 April, Lee surrendered the Army of Northern Virginia to Grant at Appomattox Courthouse.

At the beginning of the siege the terrain around Petersburg was rapidly turned into a wasteland, "so beclouded with dust and smoke of burning forests, and so unrelieved by any green grass, or water, that the heat is doubled."[5] In short order a constantly expanding series of wood-lined trenches, bomb-shelters, and covered tunnels to the rear of both armies snaked across the front. *Riding along our lines of defensive and offensive earthworks, you are lost in wonder at the immensity of their extent and the vastness of their strength. From the Appomattox River, on the right, to the Peebles Farm, on the left, our intrenchments extend in almost unbroken line. Forts, parallels, lunettes, covered ways, saps and ravellins, are piled on, one after another, until one is utterly bewildered in the maze.*[6]
Homer's drawing of the barren, constructed site (*cat.no.10a*) – although a beautiful object in itself, with its softened black lines figuring the parallel burrows and ripples of the land, echoing one another to the distant horizon like portions of a

10a. Defiance (Stumps at Petersburg), 1864.
Pencil, black crayon, and white chalk on brown
paper, 9 ½ × 13 ⅛ in. Cooper-Hewitt Museum, the
Smithsonian Institution's National Museum of
Design, New York. Gift of Charles Savage Homer
(1912-12-272)

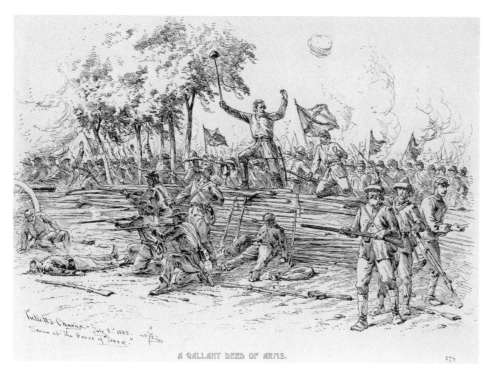

A GALLANT DEED OF ARMS. 175

fig. 10.2 Edwin Forbes (1839-1895). *A Gallant Deed of Arms*, 1865, reproduced from *Thirty Years After: An Artist's Story of the Great War* (New York: Fords, Howard, and Hulbert, 1890), 2: 175. Photograph courtesy of the New York Public Library

monumental earthwork of the 1960s – is a haunting memento of the destruction. The drawing does not include, however, the factors of summer's heat, winter's cold, mud, disease, and the ever-vigilant enemy that turned the opposing trenches, sometimes as close together as one hundred fifty yards, into what one Pennsylvania soldier called, simply, "hell itself."[7]

Death came to Petersburg's unwary in many forms. Both miles-long lines bristled with sharp-shooters ready and able to hit anything that appeared over the edge of the trench (". . . every finger, or cap, or point of a gun that shows above the works, is instantly shot at"),[8] or even blocked momentarily the chinks that served as rifle slits: *The correspondent of the New York* Commercial *before Petersburg, relates another case which occurred recently. A soldier got sight of a rebel sharpshooter, and fired through one of the rifle-holes on the breastworks, merely large enough to*

put the muzzle of his musket through and sight his object. Having fired, he withdrew his weapon to observe what effect he had made, when, from a distance of about three hundred yards, a ball passed through the hole, entering his head and killing him instantly.[9]

Mortar fire was a constant companion – one that later prompted the cool and dry-witted to reflect: *But, harmless as they usually were to our side, they yet often enlisted our warm personal interest. . . . [W]e would watch the shells closely as they mounted the sky. If they veered to the right or left from a vertical in their ascent, we cared nothing for them as we then knew they would go to one side of us. If they rose perpendicularly, and at the same time increased in size, our interest intensified. If they soon began to descend we lost interest, for that told us they would fall short; but if they continued climbing until much nearer the zenith, and we could hear the creaking whistle of the fuse as the*

shell slowly revolved through the air, business of a very pressing nature suddenly called us into the bomb-proofs; *and it was not transacted until an explosion was heard.*[10]
Mortar, rifled artillery, and sharpshooter fire combined sometimes took a toll as high as twelve percent of the frontline soldiers in one month.[11]

But amid this war of attrition, where death from afar could come at any moment or during any activity, there were moments of active, personal heroism (or willful self-sacrifice). Tales of independent combat, of battles between men rather than mechanized armies where individual courage, honor, and gallantry still weighed in the outcome of the contest, grew like scarlet flowers from the trenches of Petersburg. Writing on 20 June 1864 from a nearby hospital, John Gardner Perry recounted one chivalrous duel: *Towards noon yesterday, weary, I suppose, of the inaction, a Confederate sharpshooter mounted his earthwork and challenged any one of our sharpshooters to single combat. Lieutenant G—, a fine fellow, standing at least six feet two in his stockings, accepted the challenge, and they commenced what to them was sport. Life is cheap in this campaign! Both fired, and the Confederate dropped.* Lieutenant G— had a series of successful combats that day and, laboring under the delusion that he bore a charmed life, began the same sport the next morning. With his first duel, however, as both combatants were taking aim, *a man from another part of the Confederate line fired and shot G— through the mouth, the ball lodging in the spinal vertebrae, completely paralyzing him below the head. We dragged the poor, deluded fellow to his tent, where, after uttering inarticulately, "I hit him anyway, Doctor," he died.*

We then heard a tremendous uproar outside, and found that our men were claiming the murderer of their lieutenant; but the Confederates shouted that they had already shot him for a cowardly villain, and then came praises across the line for Lieutenant G—'s pluck and skill.[12]
The bravado of the young soldier in *Inviting a Shot before Petersburg* who, defiant, bored, desperate with fury at the Yankee invader and the ever-receding prospect of victory,[13] was one of the few subjects from Petersburg demonstrating dramatic, individual action.[14] Homer's device for heroicizing the action, silhouetting a single figure against a luminous sky, is one that recurs throughout the next thirty years; stoic fisherwoman and stolid Adirondack guide alike stand defiantly before the buffeting of nature.[15]

The Confederate's position on the rampart, golden hair and red havelock streaming behind him, is an iconic pose for showing leaders inspiring men onward during an attack. Homer's fellow artist/correspondents used close variants in works such as Edwin Forbes's *A Gallant Deed of Arms — Pickett's Charge-July 3, 1863* (*fig. 10.2*). Yet Homer's young man does not seek to rally his comrades for an attack. His stance and clenched fists are a challenge to his enemies and to the gods, testimony to the changing rules of warfare encountered by the soldiers of the Civil War. Still responsive to codes of chivalry and courage,[16] as witnessed by the fate of the man who shot Lieutenant G—, men found everywhere around them the evidence that bravery and honor more often led to futile death rather than victory. For the Civil War's generation of soldiers the actions of machines ripped the veil of romance from battle. The majority of the men in the trench, like the cut trees of the battlefield, were simply fuel to be used in the new war of attrition.[17] Homer's painting of the massed men, abbreviated brown lines without differentiating characteristics, underlines this similarity. He who stands apart from the mass challenges fate. In no other work by Homer is this despair of modern warfare, and the resultant invitation of almost certain death for no end other than for the sake of action itself, so clearly expressed.

M.S.

1. *A Shell in the Rebel Trenches*, a wood engraving published in *Harper's Weekly* on 17 January 1863 demonstrates Homer's imaginative power. The text accompanying the engraving reads, "The Secesh chivalry generally places their negros in the post of danger; and when our gunners get the range of their works and drop a well-aimed shell into them, the skedaddle which ensues is such as Mr. Homer has depicted" (7, no. 316:34). *Harper's* had earlier published an illustration of *A Rebel Captain Forcing Negroes To Load Cannon under the Fire*

of Berdan's Sharp-Shooters. The accompanying article claimed that the view was observed by Union officers through a telescope from behind their own lines (6, no. 280 [10 May 1862]: 289, 299).

2. Alfred Waud, for example, although he traveled with the Union forces and sometimes took a combatant's part in battle, in September 1862 was able to sketch members of the first Virginia Cavalry, a Confederate regiment (William P. Campbell, *The Civil War: A Centennial Exhibition of Eyewitness Drawings*, exh. cat. (Washington, D.C.: National Gallery of Art, 1961), 37.

3. While some scholars, notably Hendricks (*Life and Work*, 55), have questioned whether Homer even saw Petersburg during the 1860s, Goodrich (*Winslow Homer*, 17) and Giese (*Painter of the Civil War*, 251-52, 257, 298, 301) rightly note that the spirit of the painting and its related drawing (*cat.no.10a*), "suggest on-site observation."

4. *Catton's Civil War*, 570.

5. Lyman, *Meade's Headquarters*, 179 (letter dated 25 June 1864). The correspondent from *The New-York Times* noted:

As one passes to and fro over the new ground held by our troops, he cannot fail to perceive the destruction that is constantly going on in the woods. Every sapling that has a crotch on its stem is doomed at sight, and those who have any pretension to straightness likewise fall beneath the sharp edge of the soldier's hatchet. Young trees of a vigorous growth are no exception. . . . From daylight until dark the remorseless blows of the ringing axe and pertinacious chipping of the hatchet can be heard unceasingly. None but the giants of the forest will be able to withstand so furious an onslaught, and even they are beginning to shake and tremble ("The Army of the Potomac. What it has Done and What it is Doing. . ." *The New-York Times*, 30 October 1864).

6. "The Army of the Potomac."

7. Ketchum, *American Heritage Picture History*, 469.

8. Lyman, *Meade's Headquarters*, 181.

9. "Astonishing Skill of Sharpshooters," *The Portrait Monthly* 2, no. 17 (November 1864): 70. Such testaments of skill, some reeking with sentiment, abounded:

A touching incident occurred here [Petersburg] which is worthy of mention, to show that in an instant all our plans can be dashed to pieces by cruel war. A brave soldier, whose term of three years hard service was out, with his discharge in his pocket was ready to go home and rest on the laurels he had so dearly won, and enjoy the comforts of "home, sweet home." But alas, for all his plans for the future, he never leaves Fort Hell alive. He had shaken hands and bid his comrades good-bye, and starts to leave the fort on his homeward march, but a thought strikes him, and he turns back and tells his comrades that he must have one more look at the Johnnies before he leaves. His comrades expostulate with him not to go near the portholes again;

that now he has his discharge in his pocket and ought to be satisfied with what sights he has seen; but all to no purpose; he must have one more look, and goes to the port hole and looks through, but it is his last look on this earth, for he falls back a corpse in the arms of his weeping comrades (D. G. Crotty, *Four Years Campaigning in the Army of the Potomac* [Grand Rapids, Mich.: Dygert Bros. & Co., 1874], 153).

10. Billings, *Hardtack and Coffee*, 60.

11. *Catton's Civil War*, 588.

12. B[enjamin] A. Botkin, ed., "Sharpshooter's Duel," in *A Civil War Treasury of Tales, Legends, and Folklore* (New York: Random House, 1960), 384-385.

13. The Confederate artillerist E. P. Alexander wrote in his memoirs, "However bold we might be, however desperately we might fight, we were sure in the end to be worn out. It was only a question of a few months, more or less." Quoted in Stephen W. Sears, ed., *American Heritage Century Collection of Civil War Art* (New York: American Heritage, 1974), accompanying pl. 309.

14. Theodore Gerrish and John S. Hutchinson recorded one daredevil who mounted the works, waved his cap, and was struck square in the forehead by an enemy bullet. His apparently lifeless body was taken to the rear. Amazingly, however, the bullet had not penetrated the skull and the soldier eventually recovered. Quoted in Williams, *The Artists' Record*, 82.

15. See, for example, *A Light on the Sea* (1897, The Corcoran Gallery of Art, Washington, D.C.) and the watercolor of *The Woodcutter* (1891, private collection).

16. See especially Linderman, *Embattled Courage*, 7-61. Linderman writes of the emotional transition the soldiers underwent as they moved from sporadic battles to the trench warfare of Cold Harbor and Petersburg. The war of courage and chivalry for some became instead simply an arena for carrying out the duty of killing (146-155).

17. Colonel Theodore Lyman wrote from Petersburg in a letter home of 6 August 1864: "And this is the grand characteristic of this war — waste. We waste arms, clothing, ammunition, and subsistence; but, above all, men." *Meade's Headquarters*, 207.

PROVENANCE Frederick S. Gibbs, New York (before
1899-1903);* [Gibbs sale, New York, American Art
Galleries, 25 February 1904 (no. 157)]; Thomas R. Ball
(1904-1919); [Ball sale, New York, American Art Associa-
tion, 4 March 1919 (no. 96)]; [Knoedler & Co., 1919-
1927]; [New York, American Art Association, 6 January
1927 (no. 132)]; Edward Ward McMahon (1927-1929);
[McMahon sale, New York, American Art Association, 24
January 1929 (no. 79)]; Pascal M. Gatterdam (1929-
1931); [Macbeth Gallery, New York, 1931]; Whitney
Museum of American Art (1931-1950); [Knoedler & Co.,
New York, 1951]; The Detroit Institute of Arts.

 *No more appropriate owner could be imagined. Gibbs
served with the 148th New York Volunteers from 1862
until the close of the war,
*when he was brevetted first lieutenant "for gallant and
meritorious services." He received a severe gun-shot wound
in the face during the battle of Cold harbor [sic], June 3,
1864, and before Petersburg, April 2, 1865, was again
wounded by a piece of shell which struck him in the leg; yet
he remained with his regiment and witnessed the surrender
of Lee at Appomattox court house* (The National Cyclopae-
dia of American Biography [New York: James T. White,
1904], 12:533).

EXHIBITIONS PRIOR TO 1876 None are known.

CHANGES IN THE COMPOSITION Painting was examined
using infrared reflectography; x-radiographs not avail-
able. The pose of the soldier was slightly different, with
the back arm more bent and raised; mount on which the
soldier stands was extended to clarify position in space;
stump in foreground has been narrowed; two inch-long
parallel lines above the horizon have been covered by the
sky; horizon line was one-half inch lower along left;
mountain behind figure has been added over the sky. The
entire sky was initially brighter, providing higher con-
trasts; it has been scumbled over with thin grays and
pinks. The entire area of the ground below the horizon at
the left, extending into the middle lower foreground,
was originally a bright green — the artist has scumbled an
orange-brown across this area; the banjo player's proper
right foot, which is now obscure, was clearly drawn.

COLLECTED REFERENCES PRIOR TO 1876
None are known.

11. Portrait of Albert Post, ca. 1864

Oil on panel, 12 ½ × 10 ½ inches
Signed lower left: Homer
Private collection

Homer is not remembered today as a portraitist. From the onset of his painting career, he seems to have deliberately chosen the path of a genre painter – a painter of general incidents rather than specific personnages.[1] As that path developed to include consideration of the larger relationships between man and nature, Homer's emphasis increasingly shifted toward nature, until, with the late Prout's Neck seascapes of 1890 and after, the human figure disappears almost entirely from Homer's art.

Still, Homer's Civil War paintings give ample evidence of the interest that the human figure held for the artist. The face of the invalid seated at the center of *Playing Old Soldier* (*cat.no.5*) is modeled with care and sensitivity; the primary group of Zouaves in *Pitching Quoits* (*cat.no.14*) is described with features so precise and characteristic that they have often been assumed to be portraits of individual soldiers rather than (as is much more likely) the studio models that Homer relied upon throughout his career. And despite his apparent avoidance of the genre, Homer did paint a few portraits in his lifetime, with varying results. One of his very first portraits, exhibited at an Artists' Reception in the Dodworth Studio Building in 1864, met harsh criticism:
The portrait of a lady showed a determination to get the truth but the execution was coarse and the attitude stiff and unnatural.[2]
Homer's portrait of fellow artist Homer Dodge Martin (ca. 1867, National Academy of Design, New York) is routine and unexciting. Yet the portrait of artist Helena de Kay (ca. 1873, Thyssen-Bornemisza Collection, Lugano) is a sensitive, brooding work that offers insight into character as

well as likeness. Homer also sketched several portraits of family and friends,[3] intimate, informal essays not meant for public distribution.

Yet even from these admittedly infrequent examples of Homer's portrait style, the portrait of Albert Kintzing Post stands as something of an anomaly. Its closest counterpart is *Officers at Camp Benton* (*fig.11.1*), a work of 1881 in which Homer agreed to reconstruct a patron's war-time photograph to create "an elaborate, idealized oil."[4] The painting's source is readily betrayed by the stiff, literal transcription of the figures; the likenesses are accurate but the composition dull. In contrast, the portrait of Albert Kintzing Post, which also derives from a photograph and occasionally calls attention to its source (for example, Post's feet are not fully anchored to the ground, despite the shadow cast behind them), maintains a unity and presence not evident in *Officers at Camp Benton*. Much of the figure's poise and self-confidence can be attributed to the original tintype, but the atmosphere and breadth of the setting, the brilliantly sunlit tent and the smoke of a blue gray camp fire so convincingly rendered, is the result of Homer's own skill. Unlike *Officers from Camp Benton*, the portrait of Post was executed while Homer's interest in the Civil War was still fresh and his desire to test out his new profession strong.[5]

The original tintype portrait of Post was most probably executed in the field.[6] Numerous photographers roamed the fronts and camps of the Civil War; along with the better-known names of Mathew Brady, Alexander Gardner, and Captain A. J. Russell, who produced some of the most haunting images of the war, several less illustrious

fig.11.1 *Officers at Camp Benton*, 1881. Oil on
canvas, 21 × 33 in. Boston Public Library

and now-anonymous photographers brought
their equipment to the warfront, searching not
only for views but for soldiers willing to sit for
their cameras. Photographers' tents, wagons, and
makeshift studios appeared everywhere on the
front. A photographer in Huntsville, Alabama,
called his tent "The Gallery of the Cumberland."
The "Bergstresser's Photographic Studio," oper-
ated by three brothers from Pennsylvania who
attached themselves to the Fifth Corps of the
Army of the Potomac, charged one dollar for a
portrait and sometimes took 160 portraits in a
single day.[7] Although these portraits tended to be
ambrotypes or tintypes, deliberately the cheapest
of photographic processes then available in order
to fall within the range of a soldier's salary, the
camp photographer was often classed with the
sutler as an unsavory entrepreneur. Henry P.
Moore, for example, set up his gallery in the
camp at Hilton Head, South Carolina, in an area
along with sutlers and other camp followers that
soon became known as "Robber's Row."[8] Post
presumably gave in to one of these businessmen,
taking the opportunity to preserve for his family
and himself a memory of the service he paid
his country.[9]

Albert Kintzing Post (1843-1872) was the son of
Matilda Eaton and Abraham Kintzing Post, who
moved to Cuba with his mother and stepfather
after the death of his father in 1845. He soon

returned to the United States to attend school in
Bridgeport, Connecticut, and entered Harvard
College in 1859. Interrupting his studies in his
junior year, he enlisted in the Forty-fifth Massa-
chusetts Infantry and served for nine months in
North Carolina, participating in the early battles
of Kinston and Goldsborough. After fulfilling
the terms of his enlistment, he completed his
degree at Harvard and settled in New York; in
January 1866 he married Marie Caroline de
Trobriand, daughter of Comte Philippe Regis de
Trobriand, who began his service in the Civil War
as colonel of the Fifty-fifth New York Infantry
and was eventually brevetted major general. Post
became a member of the Century Club in 1866,
and worked in business while cultivating his
interests in art and literature. His widow sug-
gested that he "would undoubtedly have made a
career in these pursuits had he not met an early
and sudden death" while attempting to rescue a
young boy swept out to sea at Westhampton,
Long Island.[10] In recording the loss of its member,
the Century Club recalled the "gallant gentle-
manhood" of Albert Kintzing Post.[11]

Post could not have known Homer during his
Civil War enlistment, since his Massachusetts
regiment was not part of the Army of the Potomac
and his service in 1862 took him far from
Homer's location on the Yorktown peninsula.
However, the Post family remembers that the oil
portrait was a gift from Homer to Post, offered in
repayment of a loan Post had made to the young
artist. Thus the work was probably finished in
Homer's New York studio, sometime between
Post's graduation from Harvard and Homer's
departure for Europe in December 1866.[12]

s.m.

1. Hermann Warner Williams, Jr., has defined genre
painting as the "artist's commentary on a commonplace
everyday activity of ordinary people, painted in a realistic
manner. The artist must be contemporary with the scene
depicted. . . . The true theme of a genre painting is not
the incident, but the human condition." *Mirror to the
American Past: A Survey of American Genre Painting:
1750-1900* (Greenwich, Conn.: New York Graphic Society,
1973), 17. Williams points out in this introduction that
"while Winslow Homer is rarely termed a genre painter,
almost all his work (except his pure landscapes) falls into
this subject category."

2. "Fourth Artists' Reception," *The New-York Daily Tribune*, 26 March 1864.

3. See Hendricks, *Life and Work*, figs. 85, 97, 200.

4. Hendricks, *Life and Work*, 44-45. In the 1880s, Homer returned to several of his Civil War sketches while working on a project for *The Century* magazine, *Battles and Leaders of the Civil War*. Homer's involvement in this project is described in Lloyd Goodrich and Abigail Gerdts, *Winslow Homer in Monochrome*, exh. cat. (New York: Knoedler, 1986), 20; and Giese, *Painter of the Civil War*, 260-268.

5. Much of Homer's work for Bufford's in Boston and *Harper's Weekly* in New York involved translating daguerreotype and other photographic images into line drawings so that they could be reproduced as wood engravings on the pages of the magazines. See Hendricks, *Life and Work*, figs. 13, 25, 49, 53. While surely such transcriptions were part of the drudgery that led Homer to swear that he would never again work for another master, these works exhibit both skill and a careful effort which raises them above the level of hack work.

6. Several Civil War portraits seem to have been posed in a studio setting with a false camp scene set up as a background; one such photograph appears in Captain C. A. Stevens, *Berdan's United States Sharpshooters in the Army of the Potomac, 1861-1865* (St. Paul, Minn.: The Price-McGill Co., 1892), opp. 448. Presumably Post's portrait was not one of these studio productions.

7. Frederic E. Ray, "The Photographers of the War," in *Shadows of the Storm; The Image of War, 1861-1865*, vol. 1, ed. William C. Davis (Garden City, N.Y.: Doubleday, 1981), 437. Photographs of these studios as well as several other related images can be seen in Ray, 415-447. See also the sketch *Taking Photographs*, by Arthur Lumley, special artist for *Frank Leslie's Illustrated Newspaper*, illustrated in William Campbell, *The Civil War: A Centennial Exhibition of Eyewitness Drawings*, exh. cat. (Washington, D.C.: The National Gallery of Art, 1961), 41.

8. Ray, 414, 442.

9. Despite family efforts to locate the original tintype, it has not been found.

10. Marie Caroline de Trobriand Post, *The Post Family* (New York: Sterling Potter, 1905), 209. Information on Albert Kintzing Post has been taken from pages 208-211.

11. *"The Century" Reports, 1872: Report of the Board of Management of "The Century"* (New York: Martin's Steam Printing House, 1873), 12.

12. Post and Homer were both members of the Century Club, but could have met earlier through any number of channels, including (but not restricted to) the following: Post's father-in-law, Comte Regis de Trobriand, served with McClellan during the Peninsular Campaign of April-May 1862, and could have met Homer during that time. Post's second cousin once removed, Henry A. V.

Post, served as colonel of the Second Regiment of Hiram Berdan's United States Sharpshooters and also participated in the Peninsular Campaign (see Stevens, 28-29). Post lived at 23 Waverly Place in New York; his neighbor at 17 Waverly Place was Joseph A. Dean, owner of *The Last Goose at Yorktown* (see *cat.no.3*). Waverly Place was in especially close proximity to Homer's studio in the University Building. The similarity of the panel on which Post's portrait was painted to that on which *Inviting a Shot before Petersburg, Virginia (cat.no.10)*, was done suggests a similar date (1864) for the two works.

PROVENANCE Albert Kintzing Post (ca. 1864-1872); his widow, Marie Caroline de Trobriand Post; their eldest son, Waldron Kintzing Post (d. 1955); his eldest son, Charles Kintzing Post; his brother, Langdon Ward Post; present collection.

EXHIBITIONS PRIOR TO 1876 None are known.

CHANGES IN THE COMPOSITION Painting was examined without using infrared reflectography; x-radiographs were available. Post's cheek was made thinner on the right side. The second tent from the right was originally taller.

COLLECTED REFERENCES PRIOR TO 1876 None are known.

12. Halt of a Wagon Train, ca. 1864

(Possibly *At Rest* [1866])
Oil on canvas, 12 × 10 ¼ inches
Signed lower left: Homer
The Lyndon Baines Johnson Library-Museum (68.70.1)

Languor and relaxation characterize *Halt of a Wagon Train*. At the left, a single figure lounges against a post while a group of other men reclines in a circle at the center of the painting. Mules unharnessed from their wagons calmly stand at the fringes of the composition, enjoying, one assumes, their share of the bale of hay that has been thrown to them. Such teamsters seemed to hold a special appeal to Homer, as they did to many other observers and soldiers alike. The fifer Charles Bardeen found the wagon drivers a "good natured lot," and believed that it "was an easy life these wagoners led, and the night encampment was a lark to me . . . it was fun to sit about the fire and hear their yarns."[1] Likewise, Walt Whitman professed that he "was among the army teamsters considerably, and indeed, always found myself drawn to them."[2] Years after the war ended, Robert Carter recalled the pleasures of those wagon encampments:

Our bivouac that night . . . was [in] Frederick's loveliest surroundings, and lives yet in our memories. . . . Wagons were parked, their long rows of white canvas tops reflected in the moonlight; horses were at the picket ropes, mules at the wagon tongues. The former were neighing their shrillest notes; the latter weehawing their loudest brays; men were bringing in forage and armfuls of rails, and soon the expectant sounds gave way to munching, and with coffee-cup in hand all were happy, man and beast, regardless of to-morrow's dangers and duties.[3]

Wagons and their contents, in fact, sat at the heart of military strategy. "An army marches on its stomach," so Napoleon is believed to have said, and General Ulysses S. Grant demonstrated his

recognition of this principle first at Vicksburg and later at Petersburg: by cutting off the enemy's supplies, it was possible to starve that army into surrender. While attempting to cut Confederate supply lines, Grant in Virginia and William T. Sherman in the West ensured that Union troops maintained their own, utilizing existing rail structures and having engineers lay new tracks to facilitate distribution. "The quicker you build the railroad, the quicker you'll get something to eat," Sherman told his troops in 1863.[4] But if military historians remember these generals' brilliant use of the rail system, to the common soldier of the Civil War "*the* trains of the army were *wagon*-trains."[5] Supply wagons were "the travelling depot or reservoir from which the army replenished its needs" for equipment, provisions, clothing, ammunition, and entrenching tools; it was "a welcome sight to the soldiers when rations drew low or were exhausted, to see these wagons drive up to the lines."[6]

At the beginning of the war, wagon trains accompanied individual regiments according to that regiment's dictates. General Sherman recalled that when the Army of the Potomac gathered around Washington in 1861, he saw a multitude of soldiers, dressed in uniforms "as various as the states and cities from which they came,"

so loaded down with overcoats, haversacks, knapsacks, tents, and baggage, that it took from twenty-five to fifty wagons to move the camp of a regiment from one place to another.[7]

The disadvantages of such excess quickly became apparent when the army began to move, wagons taking the roads while the soldiers marched

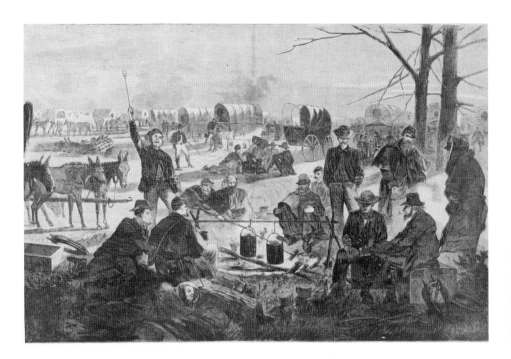

12a. Halt of a Wagon Train.
Wood engraving, 13⅛ × 20⅜ in.
Harper's Weekly 7, no. 371 (6
February 1864): 88-89. Peggy
and Harold Osher Collection.
Courtesy of the Portland
Museum of Art, Portland,
Maine

alongside them. Weary soldiers would attempt to ride on the wagons or cast their overstuffed knapsacks onto them. An order from McClellan soon put a stop to this, and as the severity of warfare set in and the length of marches increased, soldiers pared down their belongings willingly.[8] Likewise, the number of wagons accompanying each regiment was reduced; in August 1862 an order restricted a regiment's allotment to six wagons, one of these an ambulance. By the final campaign of Petersburg, Grant was allowing a maximum of only three wagons per regiment, and only one wagon per field battery.[9] Still, with four to nine regiments making up a brigade, two to four brigades making up a division, and three to four divisions making up a corps,[10] it becomes obvious that wagon trains retained an enormous presence. By one estimate, some four thousand wagons followed the Army of the Potomac into the rugged terrain of the Wilderness; another officer suggested that if all the trains "requisited to accompany the army of the Wilderness Campaign [had] been extended in a straight line, it would have spanned the distance between Washington and Richmond."[11] Not surprisingly, this vast amount of equipment, vehicles, animals, and

personnel was difficult to organize, and indeed, one soldier of the Tenth Massachusetts recalled that "the war was more than half finished before they were brought into a satisfactory system of operations."[12]

Whether on march or in camp, the enormous lines of wagon trains must have been a sight to behold. A correspondent for *The New-York Times*, reporting from the Headquarters of the Fifth Corps of the Army of the Potomac near the Weldon Railroad south of Petersburg, found the wagon parks an especially impressive sight:

It will be readily believed the number of wagons and ambulances requisite for the use of an army like this is necessarily large. . . . I cannot begin to make an estimate, but there must be at least twelve hundred. . . . *The wagons are all ranged in rows, each vehicle in perfect line with its fellows, and they form with their white covers and tongues impudently erect in the air a very pleasing picture. . . . One cannot imagine a more picturesque scene than the parks daily to be met with.*[13]

Homer seems to have agreed that the sight of parked trains would make "a very pleasing picture." A wood engraving entitled *Halt of a Wagon Train* appeared in *Harper's Weekly* on 6 February

1864 (*cat.no.12a*), and Homer's oil of the same subject probably dates to the same year.[14] The painting exhibits the same distillation of anecdote and tightening of composition that can be seen in other paintings related to wood engravings, for example, *The Sutler's Tent* (*cat.no.6*) and *Thanksgiving in Camp* (*cat.no.6b*). Homer's wood engraving of a wagon train's halt depicts a well-populated scene of drivers, teamsters, and an occasional soldier relaxing from their march.[15] The dominant focus of the print—the foreground group of men lounging around the comforting warmth of a fire—has been eliminated in the painting. The smaller circle of resting drivers remains at the center of the oil, and the rhythm of wagon tops, covered or with their ribs exposed, defines the horizon of both. The huddled, blanketed figure at the right of the engraving (who will later reappear in the 1871 painting, *A Rainy Day in Camp* [*cat.no.22*]) has been replaced by the single soldier, pipe in mouth, who leans nonchalantly against a post, perhaps a telegraph pole. The model for this figure was a youthful cavalry soldier whom Homer sketched in 1862 (*cat.no.12b*); inserted into a painting two years later, he appears as a faceless bearded man, separated from the rest of the drivers, alone with his thoughts.

Homer's interest in wagoners is demonstrated not only by *Halt of a Wagon Train* but by *The Bright Side* of 1865 (*cat.no.13*), which shows black teamsters resting outside a tent. Unlike that later painting, Homer shows little interest in the actual characters or situation of the drivers in *Halt of a Wagon Train*, beyond presenting a scene of the boredom and inactivity that characterize so many of his Civil War paintings. *Halt of a Wagon Train*, however, more than any other of these works, shows Homer's interest in trying out the elements of his newly declared profession as a painter; a loosely painted sketch, it seems to show Homer experimenting with different tones, colors, contrasts, and textures. Light falls at the center of the painting and along the canvas tops of the wagons, but does not model the fore- and middleground figures. Unlike the brightly lit, carefully drawn Zouaves in *The Brierwood Pipe* (*cat.no.8*), these

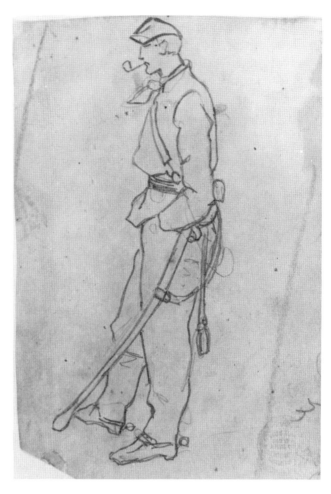

12b. Soldier with Sword and Pipe, 1862. Pencil, 5 1/8 × 3 1/2 in. Cooper-Hewitt Museum, the Smithsonian Institution's National Museum of Design, New York. Gift of Charles Savage Homer (1912-12-159)

drivers are brushed in with thin touches of paint, and their position in space is determined only by the long shadows they cast or the backlighting that throws their contours into relief. Complementary patches of red and green, blue and orange appear throughout the composition, as if Homer were testing their effects; the golden orange that describes the inside edges of the wagons is especially dazzling as it is set against the blue sky. Homer's interest in suggesting various textures is revealed by the dry, brushy impasto that defines the haystack at center; the artist has scratched lines into the wet paint to imitate the individual straws. Above this coloristic but somewhat unresolved scene of rest, Homer has painted a splendid sky with puffy clouds that have been fully realized in a manner unlike most of the composition below it.

Fittingly, *Halt of a Wagon Train* belonged for many years to Major General Stewart Van Vliet, quartermaster for the Army of the Potomac, whose duties were to ensure the delivery and distribution of the soldiers' supplies – provisions, clothing, and equipment, in short all the contents of a wagon train. Van Vliet's family tells the story that the general (brevetted after the war "for faithful and meritorious service") received the painting from "a young artist during the Civil War."[16]

S.M.

1. Bardeen, *Little Fifer's War Diary*, 93-95.

2. Walt Whitman, *Specimen Days* (1892) in *Complete Poetry and Collected Prose*, 776.

3. Captain Robert Goldthwaite Carter, *Four Brothers in Blue, or, Sunshine and Shadows of the War of the Rebellion: A Story of the Great War from Bull Run to Appomattox* (1913; Austin: University of Texas Press, 1978), 106-107.

4. Ketchum, *American Heritage Picture History*, 411.

5. Billings, *Hardtack and Coffee*, 351.

6. Billings, *Hardtack and Coffee*, 364.

7. Quoted in Billings, *Hardtack and Coffee*, 353-354.

8. Preparing for his first battle in 1864, Frank Wilkeson was advised to reduce his belongings "to a change of underclothing, three pairs of socks, a pair of spare shoes, three plugs of navy tobacco, a rubber blanket, and a pair of woolen blankets." Wilkeson, *Recollections of A Private Soldier in the Army of the Potomac* (New York: G. P. Putnam's Sons, 1887), 40.

9. Billings, *Hardtack and Coffee*, 357-358, 362.

10. In theory, a single army corps consisted of three divisions, each containing three brigades, each of which was to be made up of five regiments. As casualties reduced the size of individual regiments, these figures required adjustment. (My thanks to Lockwood Tower for this information.)

11. Billings, *Hardtack and Coffee*, 364.

12. Billings, *Hardtack and Coffee*, 355.

13. "The Army of the Potomac. What it has Done and What it is Doing . . . ," *The New-York Times*, 30 October 1864. Timothy O'Sullivan's photograph of a wagon park at Brandy Station, Virginia, appears in Alexander Gardner, *Gardner's Photographic Sketch Book of the War*, 2 vols. in 1 (1865-1866; New York: Dover, 1959).

14. Lloyd Goodrich suggested that Homer may have painted the oil "before he drew the illustration and that he first called the painting 'Halt of an Army Train,' and later corrected it perhaps when he made the illustration. . . . all of which is surmise." Curatorial files, Lyndon Baines Johnson Library-Museum, Austin, Texas.

15. An illustration appearing in Bardeen, *Little Fifer's War Diary*, 92, also entitled *Halt of a Wagon Train*, shows the same characters that appear in Homer's wood engraving, although in slightly different positions and engaged in slightly different activities. The original source of this illustration has not been located, but the print seems to indicate that Homer observed this scene in a wagon park firsthand, in the company of another artist; it might also signify that another artist admired Homer's original so much that he reworked it slightly to make it his own narrative.

16. Curatorial files, Lyndon Baines Johnson Library-Museum, Austin, Texas. For Van Vliet, see Frederick Phisterer, *New York in the War of the Rebellion, 1861 to 1865*, 3rd ed. (Albany: J. B. Lyon Co., 1912), 1:429, 5:4257-4259, 4309. Van Vliet apparently commissioned paint-

ings from other artists upon the end of his army service; in July 1866, *The Round Table* reported: "We have lately seen in the studio of W[illiam] O[liver] Stone, a very clever portrait of General van Vliet. The subject is one of that florid temperament upon which Mr. Stone works, usually, with the greatest success, and the head is more forcibly treated than any of that artist's which we have seen" (3, no. 46 [14 July 1866]: 439).

PROVENANCE [If *At Rest*, then Sale, New York, Somerville Art Gallery (Miner and Somerville, Auctioneers), 19 April 1866, no. 76]; Major General Stewart Van Vliet; descended in family; Lyndon Baines Johnson Library-Museum, Austin, Texas.

EXHIBITIONS PRIOR TO 1876 None are known.

CHANGES IN THE COMPOSITION Painting was examined using infrared reflectography; no x-radiographs were available. Homer originally planned the right side of the composition to be wider; a strip of canvas ⅝-¾ inch wide has been turned over the stretcher at the right edge; it shows underpainting and the edge of a blanket hung over the rope that is tied to the upright pole. The head of the right-most mule was initially drawn larger. The signature was initially painted in vermillion, but was painted out and replaced by a black signature, whose style differs from other Homer signatures.*

 *Gordon Hendricks points out that Homer was practicing various signatures in the 1860s; considering the experimental quality of this oil, the odd signature should not be considered unusual or suspicious. See Hendricks, *Life and Work*, 46.

COLLECTED REFERENCES PRIOR TO 1876
None are known.

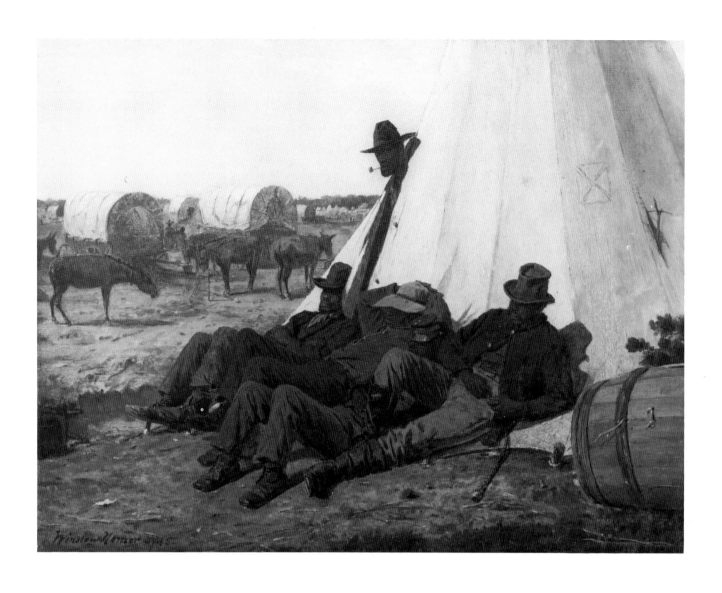

13. The Bright Side, 1865

(Also called *Light and Shade* [1865, 1888];
The Sunny Side [1865, 1888])
Oil on canvas, 13 1/4 × 17 1/2 inches
Signed, dated, and inscribed lower left: Winslow Homer NY-65
The Fine Arts Museums of San Francisco
Gift of Mr. and Mrs. John D. Rockefeller 3rd (1979.7.56)

The Bright Side shows a Union teamsters' campsite – supply wagons and mules dominate the middleground and distance – with a group of muleteers in the foreground lounging in the sunshine. Four men, caught in poses of great naturalness, bask in the sun on "the bright side" of their tent, while a fifth pokes his head through the tent flap and directly confronts the viewer. Homer has paid considerable attention to distinguishing the five men from one another, making each an individual rather than a stereotype. Since these are the first mature black men that Homer painted, a group whose occupation as muleteers defined them in the popular imagination simultaneously as humorous caricatures and as foulmouthed ruffians, his objective viewpoint is a considerable accomplishment.

The project of *The Bright Side* was an important one for Homer. Although the painting is small-scaled, Homer prepared for the work by making a detailed tonal study of the central group on brown paper (*cat.no.13a*), which includes details such as the precise placement of one man's foot against a tent-peg that are carried directly into the painting. This was partially traced over to provide the basis for a fairly complete oil study, a vigorous and fresh blocking-in of colors, that is dated 1864 (*cat.no.13b*). *The Bright Side* is the only project of the Civil War works for which these types of studies are now known to exist. The artist gathered background elements from his sketchbooks and camp drawings of years earlier, including small pencil and gray-wash drawings that suggested the groupings and placement of the mules unhitched before their wagons (*cat.nos.13c, 13d*), and a notecard containing pictures of mules in two characteristic poses. He chose the top version for the mule to the left of the finished work (*fig.13.1*); the bottom mule appears six years later as a late addition to *A Rainy Day in Camp* (*cat.no.22*).

In spite of the documentably composite nature of the whole design, Homer testified to a friend and colleague that the scene was one that he had actually witnessed. He noted in particular the serendipity of his completing the reclining figures at the same instant that "that darky poked his head out of the tent door and looked at me."[1] When later he spoke to a reporter from *Our Young Folks*, a magazine that in July 1866 carried an amended and abbreviated wood engraving "copied by the artist from the original painting" (*cat.no.13e*), he had a further tale to tell of the work's development:

While Mr. Homer was engaged on this canvas, he suddenly found himself in want of a model for one of the figures. . . . In one of the cross-streets near the University lives a colored person whom we shall call Mr. Bones, – if we were to use his real name he might resent it as a liberty. Mr. Bones (formerly) "belonged to one of the first families of Virginia," but when the Rebellion broke out he selected New York as his residence, and, at the time of which we are writing, was engaged in the lucrative profession of bootblack, – a profession of which he is still a shining ornament.

With all puns intended, the writer continued to narrate how the artist could not successfully explain his purpose to the man, "If Mr. Bones's head had been iron-clad, it couldn't have resisted a new idea more successfully." Eventually, however, Homer lured the uncomprehending, but

13a. Sketch for "The Bright Side," ca. 1864. Pencil and wash on brown paper, 6⅝ × 9¾ in. Inscribed lower left: *No. 8.* The Harold T. Pulsifer Memorial Collection on loan to Colby College, Waterville, Maine.

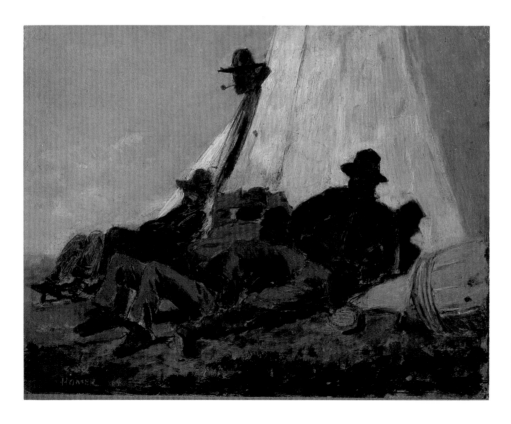

13b. Study for "The Bright Side," 1864. Oil on paper, 6½ × 8¼ in. Signed and dated lower left: HOMER 64. Collection of J. Nicholson

suspicious, Mr. Bones to his studio. Upon entering it, Homer quietly locked the door.

No sooner did Mr. Bones perceive this movement than he gave vent to a series of unearthly shrieks, and proceeded to roll himself up into a ball. . . .

Mr. Bones bounced round the narrow apartment so furiously, and continued to shriek so lustily, that the astonished painter made haste to throw open the door. Mr. Bones instantly ricocheted over the threshold like a huge cannon-ball, and was heard bounding down stairs, five steps at a time.

The cause of this singular conduct on the part of Mr. Bones was afterwards accounted for. It appears the simple fellow had somehow conceived the idea that the artist was "a medicine-man," (i.e. an army-surgeon,) and that he had lured him, Mr. Bones, into his den for the purpose of relieving the said Mr. Bones of a limb or two, by the way of practice.[2]

If such an incident actually occurred (and it sounds suspiciously like studio lore, especially because the artist's biographer recounts a comparable incident involving an older black woman in the next decade),[3] it took place before mid-March 1865. By then the painting, "a capital specimen," was reported as finished in his studio[4] and was exhibited at the Brooklyn Art Association at the end of the month, where it was probably purchased by William H. Hamilton. In April *The Bright Side* was shown (with *Pitching Quoits* [*cat.no.14*] and *The Initials* [1865, private collection]) at the National Academy of Design. There it was favorably received by the press and by Homer's peers; on the basis of his submissions he was elected a full Academician.[5]

It was probably about this time that Lawson Valentine[6] grew fascinated with *The Bright Side.* He was unable to acquire the original painting, but as compensation eventually acquired the drawing on brown paper, the oil study, and Homer's slightly varied copy of the painting now known as *Army Teamsters,* finished in 1866 (*cat.no.13f*). Even though *Army Teamsters* was a copy of a critically acclaimed painting, Homer still experimented with its format. In addition to a broader painting, with increased incident at the edges, he also added wholly new elements to

the work, such as the resting mule at the left, based on an earlier drawing (*cat.no.13g*). Still visible as a pentimento is a horse at the far right side that the artist later decided to cover over. The reason for Valentine's attachment to the image is unknown, but it was clearly strong; years later he issued a superbly printed chromolithograph of *Army Teamsters,* "With the compliments of Lawson Valentine" (*fig.13.2*).

The teamsters manned the supply lines of the army, providing munitions and food to the men at the front. Several of the artist/correspondents featured them in their illustrations.[7] Walt Whitman wrote of them, briefly, "I was among the army teamsters considerably, and, indeed, always found myself drawn to them." Or again, "The teamsters have camps of their own, and I go often among them."[8] Their work was arduous, difficult, and often dangerous.[9] Much of the difficulty arose from two sources: the miserable roads throughout Virginia that they were expected to negotiate, and the source of their locomotion – the army mule.

The roads were a major obstacle for the Union offensive in Virginia; depending on the weather a traveler could expect choking dust or seemingly bottomless mud.[10] Anywhere but at the head of a column, conditions were pitiful. But the Corps of Engineers could corduroy the roads or clear new ones, in some way at least giving the men the illusion that the obstacle was being dealt with. The army mule, on the other hand, was a living, calculating beast that seemed to delight in causing difficulties for one and all. Entire chapters in soldier's memoirs are filled with details of the mule's cussed obstinence and other winning characteristics:

It is doubtful if the virtues of that much suffering animal, the traditional army mule, will ever be sufficiently extolled. The long-eared and brazen-voiced quadruped, at times cursed and belabored, and again coaxed and cajoled. . . . was never particular as to his diet, which consisted of oats or hay, cornstalks or oak leaves, wagon boxes, stray overcoats and blankets, the tail or mane of some social and too confiding horse, or whatever else his fancy dictated or the fortunes of camp threw within his reach.[11]

13c. *Resting Mules Tethered to Wagon*, 1862. Pencil and gray wash; 4½ × 6⅝ in. Cooper-Hewitt Museum, the Smithsonian Institution's National Museum of Design, New York. Gift of Charles Savage Homer (1912-12-172)

13d. *Army Wagon and Mule*, 1862. Pencil and wash on blue paper, 5⅛ × 8½ in. Cooper-Hewitt Museum, the Smithsonian Institution's National Museum of Design, New York. Gift of Charles Savage Homer (1912-12-150)

At this bivouac, on the edge of Frederick, the writer thought he would be safer and secure better sleep, perhaps avoid a wetting, by getting under one of the wagons. A mule is not particular whether he eats a wagon pole, the harnesses or the canvas cover, chews his mate's tail or – regales himself on a recruit. They were very hungry, had been pushed all day, and gave vent to their uneasiness and weariness by the longest drawn-out brays, groans, and wee-hawings.

Finally, one of them, after vainly endeavoring to masticate his iron-bound feed-box, smelled the writer, this fresh recruit, and seizing him by the blouse, dragged him forth for a better chance at him.[12]

His reputation as a kicker is world-wide. He is the Mugwump [or grand independent] of the service. The mule that will not kick is a curiosity.[13] These facts of course led to some reactions in the men responsible for the mules:

An educated mule-driver was, in his little sphere, as competent a disciplinarian as the colonel of a regiment. Nor did he always secure the prompt and exact obedience above described by applications of the Black Snake [the long whip, prominently displayed by the driver nearest the viewer in The

Bright Side] alone. . . . [O]ld soldiers will sustain me in the assertion that the propulsive power of the mule-driver was increased many fold by the almost unlimited stock of profanity with which he greeted the sensitive ears of his muleship when the latter was stubborn. . . .

In all seriousness, however, dealing only with the fact, without attempting to prove or deny the justification for it, it is undoubtedly true that the mule-drivers, when duly aroused, could produce a deeper cerulean tint in the surrounding atmosphere than any other class of men in the service.[14]
Some sense of this verbal ability (albeit with the threat of implicit violence) on the part of mule-teers may account for the humorous responses that *The Bright Side* generated when it was exhibited in New York – the sense of a blue streak about to break forth from one of the men.

But there was a serious side to *The Bright Side*, although few critics alluded to it in their comments. For throughout the north, particularly in New York, there was considerable hostility toward blacks on the part of labor, symbolized best by the draft riots of 1863 during which blacks were lynched or otherwise murdered, and an orphanage for black children set afire by angry mobs.[15] Much of this hostility, according to some labor

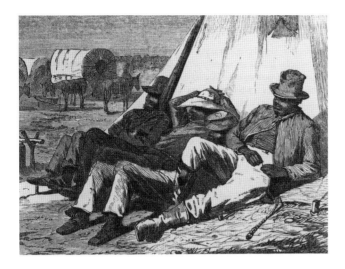

13e. The Bright Side. Wood engraving, 2³/₄ × 3⁵/₈
in. *Our Young Folks* 2, no. 6 (July 1866): 396.
Achenbach Foundation for Graphic Arts, The Fine
Arts Museums of San Francisco. Gift of Dr. and
Mrs. Robert A. Johnson (1983.1.46)

historians, grew from fear of the increased com-
petition that the emancipated slaves would pro-
vide in the market.[16] As the *New York Daily News*
editorialized:

*It is a strange perversion of the laws of self-
preservation which would compel the white laborer
to leave his family destitute and unprotected while
he goes forth to free the negro, who, being free, will
compete with him in labor. Let the laboring popu-
lation assemble peaceably in mass meetings, and
express their views upon the subject.*[17]

Although there was certainly a tradition in Amer-
ica (dating back to at least the 1840s)[18] in the
fine and the popular arts of showing blacks at
rest, Homer's concern with showing the muleteers
during moments of indolence may have reflected
a sensitivity to this more immediate issue.

The painting, like many of Homer's Civil War
works, portrays the life in the camps, with the
feelings of boredom, routine, humor, and longing
to be found there. Its straightforward, direct
style seems congruent to the ordinariness of the
observation. But the issues alluded to within *The
Bright Side* far exceed the limits of Homer's
observations of camp life; encompassing the war
and the relations between races, the painting is
a précis of the most serious issues facing Ameri-
cans of the 1860s.[19] M.S.

1. James E. Kelly papers, box 9, The New-York Histori-
cal Society.

2. T. B. Aldrich, "Among the Studios. III," *Our Young
Folks* 2, no. 6 (July 1866): 396-397.

3. Downes, *Life and Works*, 88-89.

4. George Arnold, *The New York Leader* 11, no. 10 (11
March 1865): 5.

5. Homer was elected Academician in 1865, although
the diploma from the National Academy of Design is
itself dated 9 May 1866 (see Chronology, this volume).

6. Valentine, whose family had lived near Homer's
boyhood home in Cambridge, was a business colleague of
Homer's older brother Charles, a chemist. He would
prove to be a crucial early patron of the artist, most
notably with his invitation in 1876 to the artist to spend
time at Houghton Farm.

7. See *Scene at the Crossing of Kettle Run*, by Edwin
Forbes in *Frank Leslie's Illustrated Newspaper* 17, no. 424
(14 November 1863): 116; and "Teamster of the Army,"
Frank Leslie's Illustrated Newspaper 17, no. 432 (16
January 1864): 265.

8. Whitman, *Complete Poetry and Collected Prose*, 776,
1181.

9. "Shooting Negro Teamsters," *The Evening Post*, 5
January 1863. In 1864 Homer drew a wagon train under
attack, a charcoal drawing now in the National Gallery of
Art (1982.4.1.b).

10. Writing of August 1862, Charles Fuller wrote: "I
well remember this march from the dust experience.
It exceeded anything I ever heard of. We would march for
long distances when a man could not see his file leader –
the dust so filled the air as to prevent seeing. Of course,
the men had to breath this air. The nostrils would become
plugged with the dust so moistend as to make slugs.
Every now and then the men would fire them out of their
noses almost as forcibly as a boy snaps a marble from
his fingers." *Personal Recollections of the War of 1861*
(Sherburne, N.Y.: News Job Printing, 1906), 49.

The mud in Virginia was so notable that whole articles
and cartoons appeared on the subject. On 22 February
1862, *Harper's Weekly* published a large illustration of
The Army of the Potomac in the Mud. Its accompanying
text noted that the engraving was:

*a fair representation of the condition of the roads on the line
– axle-deep in mud, and abounding in holes, from which it
requires the combined efforts of several teams and vast
amount of cursing to drawing a single wagon* (6, no. 269:
119).

A lighter tone was struck on 21 March 1863, with a
cartoon entitled "Rappahannock Mud," showing a man
on an embankment addressing a soldier sunk up to the
waist in mud. It bore the caption:

*Picket: "Hallo, Comrade! you must find it pretty bad
walking on the Roads hereabouts."*

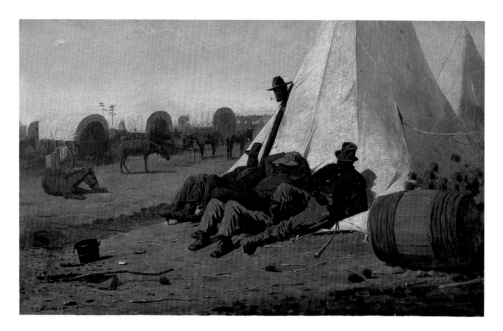

13f. *Army Teamsters*, 1866. Oil on canvas, 17 ½ × 28 ¼ in. Signed and dated lower left: *Homer 66*. The Harold T. Pulsifer Memorial Collection on loan to Colby College, Waterville, Maine

fig.13.1 Two Studies of Mules Resting, 1862. Pencil, 3⅝ × 4⅞ in. Collection of Lois Homer Graham

fig.13.2 Army Teamsters, 1889. Chromolithograph, 17 × 25 ½ in. Colby College Museum of Art, Waterville, Maine. Gift of Lee Fernandez (74-G-[21]57)

13g. *Resting Mule*, 1862. Pencil and wash, 3⅝ × 4⅞ in. Cooper-Hewitt Museum, the Smithsonian Institution's National Museum of Design, New York. Gift of Charles Savage Homer (1912-12-146v)

Man in the Mud: "Walking? I ain't walking. I'm General Hooker's Orderly, and I've got a right smart horse under me, I tell you!" (Harper's Weekly 7, no. 325: 192). Elsewhere in the South, the army found mud in vast profusion. See "The Carnival of Mud," *Frank Leslie's Illustrated Newspaper* 14, no. 349 (14 June 1862): 168-169.

11. Charles W. Cowtan, *Services of the Tenth New York Volunteers (National Zouaves) in the War of the Rebellion* (New York: Charles H. Ludwig, 1882), 142-143.

12. Captain Robert Goldthwaite Carter, *Four Brothers in Blue, or Sunshine and Shadows of the War of Rebellion* (1913; Austin: University of Texas Press, 1978), 105–106.

13. Billings, *Hardtack and Coffee*, 286.

14. Billings, *Hardtack and Coffee*, 285-286.

15. *The stain of the late riots on the history of the city of New York is indelible. The utter meanness of the hunting and bloody massacre of the most unfortunate class of the population is not to be forgotten. The burning of an orphan asylum is infamous beyond parallel in the annals of mobs. And how entirely undeserved this mad hatred of the colored race is, every sober man in this country knows. No class among us are and have been so foully treated as the black, yet none furnishes, in proportion, so few offenders against the laws. Proverbially a mild, affectionate, and docile people, they have received from us, who claim to be a superior race, a treatment which of itself disproves our superiority.* "The Old Story," *Harper's Weekly* 7, no. 344 (1 August 1863): 482. See also 483 and 492 in the same issue.

16. Williston H. Lofton, "Northern Labor and the Negro during the Civil War," *The Journal of Negro History* 34, no. 3 (July 1949): 251-253. A general prelude to the draft riots had earlier occurred when twelve blacks were attacked by several hundred whites in New York. "As soon as the disturbance became known, the mob, for the purpose of showing their ill will towards the negroes generally, began chasing and stoning every negro who came near them." "Serious Riot in South Street," *New York Herald*, 14 April 1863.

17. 13 July 1863. Quoted in Lofton, 264.

18. See, for example, *Vanity Fair's* 2 August 1862 "Our Latest Scare," wherein three blacks are holding a meeting, two reclining, one sitting, and all three soundly asleep, and Simpson, this volume, *fig. 9*. See also James G. Clonney, *Sleeping Negro* (1835, private collection); William Sidney Mount, *Farmers Nooning* (see Cikovsky, this volume, *fig. 2*); Edwin Forbes, *Mess Boy Asleep* (1867, Wadsworth Atheneum, Hartford, Conn.), all illustrated in Marvin Sadik, *The Portrayal of the Negro in American Painting*, exh. cat. With an essay by Sidney Kaplan (Brunswick, Me.: The Bowdoin College Museum of Art, 1964), cat. nos. 24, 18, 48.

19. For a detailed discussion of the painting's connections to issues of race, see Giese, *Painter of the Civil War*, 72-87.

PROVENANCE William H. Hamilton (1865–); Thomas B. Clarke (by 1886-1899); [Clarke sale, New York, American Art Association, 1899, no. 123]; S. P. Avery, Jr. (1899); William Augustus White, Brooklyn, New York (by 1911-1917); [Macbeth Galleries, New York (1917-1918)]; Julia E. Peck, Port Huron, Mich. (1918-1959); Mrs. Richard Andrae, Port Huron, Mich. (1959); [Du Mouchelle Art Galleries, Detroit, Mich. (1971)]; [Schweitzer Gallery, New York (1971-1972)]; Mr. and Mrs. John D. Rockefeller 3rd (1972-1979); The Fine Arts Museums of San Francisco.

EXHIBITIONS PRIOR TO 1876 22-25 March 1865, Brooklyn Art Association, "Spring Exhibition at the Academy of Music," no. 129; April 1865, New York, National Academy of Design, "Fortieth Annual Exhibition," no. 190; May 1867, Paris, Universal Exposition, no. 27 (as "Le côté clair"); 1867-1868, New York, National Academy of Design, "First Winter Exhibition," no. 673 in section presenting the works from the American Art Department of the Paris Universal Exposition.

CHANGES IN THE COMPOSITION There are no significant changes in the composition. Examined with infrared light and x-radiographs available for study.

COLLECTED REFERENCES PRIOR TO 1876
Homer has several pictures in progress. One is entitled "The Bright Side," and represents four or five negro teamsters sunning themselves on the outside of a tent, while another has his head thrust through the opening looking forth from the inside.
"A Visit to the Studios: What the Artists Are Doing," *The Evening Post*, 16 February 1865.

Homer's forte, as I think I have heretofore said in these columns, in speaking of his works in last year's Academy collection [the National Academy of Design Annual], is real, literal truth to nature. In this he excels beyond most of our young genre painters of to-day.
I saw a capital specimen in his studio, entitled "The Bright Side." A number of stalwart negroes are basking in the broad Southern sunlight against the side of a tent. Their faces are strikingly varied in character and expression, but they are all evidently choke-full of those two blessings – inseparable from the darkey idea of what we call freedom – warmth and idleness.
I would recommend Mr. Homer to paint a companion picture to this, showing the condition of the poor devils when they arrive here in the North, where they get no more army rations gratis, and find themselves condemned to saw wood and pile brick in the driving snow, in order to procure a somewhat more miserable subsistence than that of which a mistaken and ferocious philanthropy has deprived them.

The present work, however, has no political significance. It is simply a strikingly truthful delineation of Ethiopean comfort of the most characteristic, and therefore the most purely physical sort.
George Arnold, "Art Matters," *The New York Leader* 11, no.10 (11 March 1865): 5.

Mr. Winslow Homer is one of the very few young artists who appear to make progress. The others possibly are content to dream. In his no. 190, *The Bright Side*, we have a group of negro army teamsters in repose, grouped lazily on the ground, outside a tent, while through the opening another shows a grinning countenance. Good drawing and a broad sense of humour characterize this production.
"Fine Arts. The National Academy of Design. Third Notice," *The Albion* 43, no. 21 (27 May 1865): 249.

Mr. Winslow Homer, A[ssociate], exhibits a little picture called the "Bright Side," (No. 190,) a camp-study, representing a number of negro teamsters enjoying themselves on the sunny side of their tent. The idea is almost grotesque. It expresses, however, an accurate knowledge of African habits and peculiarities. Neither the coloring nor the drawing are so hard as we usually find in Mr. Homer's pictures.
"National Academy of Design, North Room," *The New-York Times*, 29 May 1865.

It is invigorating to find boldness and truth amidst the trivial and false. In the works of Winslow Homer we have a direct style and faithful observation of nature. The best example of Mr. Homer's talent is that called "Bright Side," a picture hanging in the north gallery, representing a group of negro mule-drivers dozing on the sunny side of an army-tent. There is in this work a dry, latent humor, and vigorous emphasis of character; and the episode of camp-life is told in a manly way. The painting throughout is intelligent and not labored, frank in its characteristics, and happily fitted to express the subject. . . . Mr. Homer is a young painter, but he has the manner of a practised hand, if we except refinement. We greet him as one of the most healthful among figure painters, and who brings to art just what redeems it from weakness and morbidness. Welcome this hearty energy of life; and if the painter shows that he observes more than he reflects, we will forget the limitation and take his work as we take nature, which, if it does not think is yet the cause of thought in us.
"National Academy of Design. Fortieth Annual Exhibition. Concluding Article," *The Evening Post*, 31 May 1865.

'Tis a pity not to have a page left for praising Mr. Homer, whose "Light and Shade" is excellent.
"National Academy of Design: Fortieth Annual Exhibition," *The New Path* 2, no. 6 (June 1865): 104.

Of the three first named, Mr. Vedder is the most original, Mr. Homer the most truthful, and Mr. Hennessy the most poetic. . . . Mr. Homer's [strong point in execution] lies in his drawing. . . .
Mr. Winslow Homer . . . chooses to rely solely upon nature as he sees it, without heeding the phantasmagoria of studio-dreams or the wild situations of ancient tradition. He evinces no contempt for the imaginative, however, and nearly all his works contain a grotesque element; witness particularly the comic old darkey with the pipe, poking his head through the tent-opening, in No. 160 [*sic*], already favorably mentioned in a studio article in this paper. In fact, every one of these woolly-pated fellows is a study of the grotesque in himself.
George Arnold, "Art Matters," *The New York Leader* 11, no.22 (3 June 1865): 1.

No. 190, "The Bright Side," by Winslow Homer, A., is the most promising work in the whole collection; it is full of good qualities, and lacks only the mechanical finish which time will surely bring the conscientious artist. It represents a homely scene enough – a party of contraband mule-drivers sunning themselves on the bright side of a tent. It is as truthful as one of Gérôme's Arab studies, and lacks only his mechanical finish to make it worthy of him.
"The National Academy," *The Independent* 17, no. 862 (8 June 1865): 4.

[*Pitching Quoits*] is less individual than the "Sunny Side" in the east room, but in some respects it is better than that work.
"National Academy of Design. South Room," *The New-York Times*, 13 June 1865.

The "Bright Side" by the same artist, is worth all the admiration it has received. The lazy sunlight, the lazy, nodding donkeys, the lazy, lolling negroes, make a humorously conceived and truthfully executed picture. The sense of free open-air ness thoroughly possesses the beholder, and gives the picture one of its greatest charms.
"National Academy of Design. Seventh Article," *Watson's Weekly Art Journal* 3, no. 10 (1 July 1865): 148-149.

Mr. Winslow Homer's "Light and Shade" is a right sterling piece of work, most satisfactory and encouraging. It is altogether the best thing he has painted, and that is saying much, for, in many qualities, he is not excelled by any man among us. If he shall paint every picture with the loyalty to nature and the faithful study that marks this little square of canvas, he will become one of the men we must have crowned when the Academy gets officers that have a right to bestow crowns. Meanwhile, the public crowns the best chronicler of the war, so far, with smiling eye and silent applause.
"National Academy of Design," *The New-York Daily Tribune*, 3 July 1865.

The small picture No. 190, "The Bright Side," seems to us even better than "Pitching Quoits." It represents a group of negro teamsters lounging and dozing under the sunny wall of a Sibley tent; another teamster's black head, broad hat, and pipe are thrust out from between the tent folds; wagons and mules are in the background. No improvement could be suggested that would make this picture a more expressive work or more effective as a representation of the scene. The nearest man and the most distant mule are equally good, and both as true and full of expression as if Mr. Homer could paint like Gérome.
"The Fortieth Annual Exhibition of the National Academy of Design. Second Notice," *The Nation* 1, no. 2 (13 July 1865): 58-59.

Mr. Winslow Homer, too, is earning an honorable name. He sometimes makes us tremble a little; but such a picture as his "Light and Shade" would seem to make permanent distrust ridiculous.
"American Art and Artists," *The Round Table* n.s. 1, no. 3 (23 September 1865): 37.

Mr. Homer's picture of last year was not less representative or less valuable as a graphic rendering of the characteristic facts of the war. His picture called "The Bright Side," depicting a group of indolent negroes, teamsters perhaps in our army, sleeping on the sunny side of a tent, with the glimpse of the camp in the distance, should be placed with "Prisoners from the Front," and the two would make a comprehensive epitome of the leading facts of our war.
Sordello [pseud.], "National Academy of Design/Forty-first Annual Exhibition/First Article," *The Evening Post*, 28 April 1866.

The engraving which we print on this page, copied by the artist from the original painting entitled "The Bright Side," seems to us in his best manner. Of course the broad effect of sunlight attained by oil-colors cannot be reproduced in a wood-cut. Three picturesque-looking Contrabands, loving the sunshine as bees love honey, have stretched themselves out on the warm side of a tent, and, with their ragged hats slouched over their brows, are taking "solid comfort." Something to eat, nothing to do, and plenty of sunshine constitute a Contraband's Paradise. The scene is one that was common enough in our camps down South during the war; but the art with which it is painted is not so common.
T. B. Aldrich, "Among the Studios. III," *Our Young Folks* 2, no. 6 (July 1866): 396-397.

M. Winslow Homer n'aurait pas du, en bonne justice, passer inaperçu. . . . [N]ous aimons beaucoup aussi le *Côté clair (the bright side)*, qui montre un groupe de soldats étendus au soleil auprès d'une tente de voyage. C'est une peinture serrée, précise, à la Gérôme, mais avec moins de sécheresse. [Mr. Homer ought not, in all fairness, be passed by unnoticed. . . . We particularly also like *The Bright Side*, which shows a group of soldiers lying in the sun before a camp tent. This is a firm, precise painting, in the manner of Gérôme, but with less dryness.] Paul Mantz, "Les Beaux-Arts à l'Exposition Universelle," *Gazette des Beaux-Arts* 23 (1867): 230.

In *genre*, and scenes simply domestic, American painters, as might be anticipated, are more at home than in history. Certainly most capital for touch, character, and vigour, are a couple of little pictures, taken from the recent war, by Mr. Winslow Homer, of New York. These works are real; the artist paints what he has seen and known.
"Paris International Exhibition. No. VI. – National Schools of Painting," *The Art-Journal* [London] 19 (1867): 248.

WINSLOW HOMER's strongly defined war-sketches are examined with much curiosity.
"An intelligent critic of the Paris Exposition of 1867," quoted in Henry T. Tuckerman, "Introduction: Art in America," *Book of the Artists: American Artist Life . . .* (1867; reprint ed. New York: James F. Carr, 1967), 18.

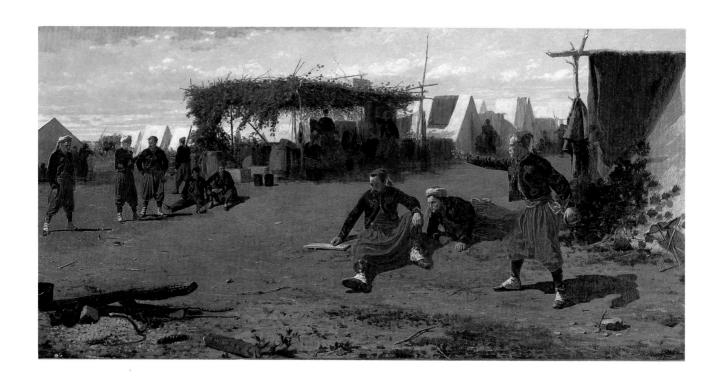

14. Pitching Quoits, 1865
(Also known as *The Quoit Players* [1866],
Zouaves Pitching Quoits [1878], *Pitching Horseshoes*)
Oil on canvas, 26¾ × 53¾ inches
Signed and dated lower right: Winslow Homer NY/1865
Harvard University Art Museums (Fogg Art Museum)
Gift of Mr. and Mrs. Frederic H. Curtiss (1940.298)

By far the largest and most complex painting Homer had attempted to date, *Pitching Quoits* announced the artist's heightened ambitions and developing artistic powers. Upon its exhibition at the National Academy of Design in 1865 (along with *The Bright Side* [*cat.no.13*] and *The Initials* [private collection]), the critic Russell Sturgis proclaimed that Homer had "found a class of subject worthy of his most careful painting," and declared *Pitching Quoits* to be proof that Homer would "retain the position, which we think he has already earned, of our first painter of the human figure in action."[1] Continuing to expand his repertoire of subjects and formats, Homer created a scene of camp life on an epic scale, centered around a group of Zouaves playing quoits – forerunner of the game known today as horseshoes.

In the right foreground, a Zouave, who has just thrown, stares at his horseshoe, which has fallen short of its mark; another tallies score while a third reclines beside him, idly watching the action. Across the prescribed distance from pitcher to stake (forty feet, according to most rulebooks) stands another group of soldiers, studying the fallen horseshoes, smoking, chatting, watching. Behind them, what appears to be a sentry with a rifle over his shoulder may actually be a soldier undergoing the punishment of "carrying the log" (see *cat.no.7*). In the center, another group of soldiers lounges beneath a bowered shelter; to the right and left lie the tents and structures of the encampment. Shadowed figures scattered throughout the composition suggest other soldiers attending to their daily routines. In the left foreground Homer has painted an exceptional still life of logs, branches, bucket, and a pair of army shoes apparently drying against a rock in the blue gray ashes of the campfire. Through a series of intersecting diagonals, the viewer's eye is led through this full and richly detailed scene.

Giving official sanction to what was surely common practice, The United States Sanitary Commission in 1861 recommended among its "Rules for Preserving the Health of the Soldier" that "amusements, sports, and gymnastic exercises should be favored among the men," and advocated quoit-playing along with wrestling, cricket, baseball, and football as a relief from drills or boredom.[2] The game of quoits became known as "the most fashionable" of the Army of the Potomac's camp recreations, "because so obtainable, the nearest cavalry or artillery forge furnishing the requisite set of old horseshoes."[3] No doubt the very adaptations to circumstance and convenience shown by Homer's Zouaves were responsible for the traditional sport of quoits eventually giving way to the modern game of horseshoes. But in 1865 the game was still known by its original name, whether played with the standard quoit (a heavy metal ring, with one surface usually rounded and the other flat), a horseshoe, or even a ring of rope (which sailors used in playing deck-quoits).[4] Homer could have observed quoit games as easily in New York as in the army camps, since quoit-playing had been a popular sport in the city since the 1850s, when

three quoiting clubs were established in Manhattan. By the 1860s newpapers carried regular reports on quoit matches in Brooklyn, New Jersey, and New York, and in 1864 *The New-York Times* declared that "quoit playing of late years has become decidedly a most popular game among our admirers of athletic sports."[5] Newspaper correspondents reporting from army camps confirmed this estimation.[6]

Homer had shown both talent and proclivity toward the illustration of sport by his wood engravings of skating scenes and football matches that so frequently appeared on the pages of *Harper's Weekly* in the 1860s. An engraving that in many ways presages *Pitching Quoits* appeared in *Ballou's Pictorial* on 4 June 1859 (*fig.14.1*). *Cricket Players on Boston Common* shows that early on Homer was interested in the contrast between large foreground figures and smaller figures in the distance, and in spatial relationships manipulated by the device of a particular sport. Popular outdoor recreations continued to provide a vehicle for the artist's artistic development, as well as his exploration of contemporary life and social conventions. This is demonstrated in the series of croquet pictures that Homer developed between 1865 and 1869, and again in paintings of the 1870s that depicted resort communities such as Long Branch, New Jersey.[7] Like croquet, quoits was a game that imposed upon its participants a fair amount of waiting, watching, and standing still; these more static recreations, rather than the lively, crowded situations depicted in the illustrations, seem to have appealed especially to Homer's painterly ambitions and studio practices.

By 1864 Homer's desire to achieve something larger and more ambitious than his previous efforts is indicated by several highly finished drawings—clearly studio productions rather than field sketches.[8] Among the most accomplished of these are several studies of Zouaves. With *The Brierwood Pipe* of 1864 (*cat.no.8*), Homer had declared his interest in these colorful regiments of Union soldiers who took their name and costume from the Algerian Berbers who fought alongside the French army in the Crimean War.

Few of the on-site drawings that Homer made during his visits to McClellan's Army of the Potomac depict those regiments in any more than the sketchiest of terms;[9] Homer's primary knowledge of their costume and demeanor was derived from the studio, as a colleague of Homer's later recalled:

[Homer] had painted a sketch of a Z[o]uave which I remember vaguely—I spoke of it to him. Yes he said I got the uniform from a fellow who I saw just as he came from the front[.] I spoke to him and took him in a store and baught [sic] him a new suit for his uniform.[10]

Presumably, Homer was in New York at the time of the much-publicized and highly celebrated return of New York's most famous Zouave regiments, the Fifth and Ninth New York Volunteers, known also as Duryee's and Hawkins' Zouaves respectively, who were mustered out of service in May 1863. The parades which welcomed these troops back to their native city may have been the occasion on which Homer found his Zouave uniform.[11] In any event, Zouaves assume a much greater presence in Homer's Civil War work in 1864, first in large-scale studio drawings and in the lithograph series *Life in Camp*, and later in finished works such as *The Brierwood Pipe* and *Pitching Quoits*.

Among the studio works from 1864 are two carefully drawn and shaded drawings of Zouaves (*cat.nos.14a,14b*), studies of what are most likely costumed models. Homer transferred these drawings almost directly onto the canvas of *Pitching Quoits*, along with an oil study of a single Zouave standing against a tent, smoking a pipe (*cat.no.14c*). While these figures are convincingly rendered as a result, they also retain some of the stiffness of their original studio pose. Likewise the Zouaves at the far right of the composition (for whom no drawings are known to exist) demonstrate a debilitating precision in detail; so successfully caught in action, they are frozen in their poses. Homer has not combined these individual studies with complete success into a large-scale painting. His choice of a long horizontal format and two-point perspective system extends and diffuses focus, rather than unifying the

-CRICKET PLAYERS ON BOSTON COMMON.

fig. 14.1 Cricket Players on Boston Common. Wood engraving, 5 ½ × 9 ½ in. *Ballou's Pictorial* 16, no. 23 (4 June 1859): 360. Collection of the Library of Congress

several compositional elements. Despite the convincing description of detail and the evocation of the hot sunlight that casts short, hard shadows and causes non-sporting Zouaves to seek shade, the composition does not entirely resolve into an integrated whole. This must be a function of the painting's studio genesis, as well, perhaps, of an artistic reach that yet exceeded this young painter's grasp.

At the same time, Homer may have realized his limitations and chosen the slower action and standing postures of a recreational scene as best suited to his ambitions and abilities in 1865. The static poses of the soldiers in *Pitching Quoits* manage to underline the inherent boredom of camp life and the numbing routines that even the most colorful costumes and pleasant recreations could not enliven. Theodore Lyman, biding time between battles in late 1863, was familiar with the mood:

The life here is miserably lazy. . . . The weather is fine, to be sure, and everybody, nearly, is well; but that is all the more reason for wishing something done. . . . If only one could be at home, till one was wanted, *and then be on the spot; but this is everywhere the way of war; lie still and lie still; then up and manoeuvre and march hard; then a big battle; and then a lot more lie still.*[12]

Homer was completing *Pitching Quoits* during the last grueling stages of the war, whose climax at Appomattox Courthouse on 9 April 1865 occurred only days before the Academy exhibition was to open. Having consciously chosen to work on a camp scene more reminiscent of the early days of the war, Homer must have been aware that his painting would strike certain nostalgic chords. But at the same time his work anticipates the future by its emphasis on "real" men, not "dusky, characterless, dreamy, impossible *muchachos*, but real things, instinct with life and warm with the glory of God's sunshine,"[13] involved in one of the leisure activities that would continue to occupy Americans after the war as surely as it provided a diversion for soldiers during it.

S.M.

1. [Russell Sturgis, Jr.], "Fine Arts. The Fortieth Annual Exhibition of the National Academy of Design. Second Notice," *The Nation* 1, no. 2 (13 July 1865): 58.

2. "Rules for Preserving the Health of the Soldier. Report of the U.S. Sanitary Commission," *Harper's Weekly* 51, no. 243 (24 August 1861): 542.

3. "The Army of the Potomac. What it has Done and What it is Doing . . . ," *The New-York Times*, 30 October 1864.

4. Parke Cummings, ed., *The Dictionary of Sports* (New York: A. S. Barnes and Company, 1949), 335.

14a. *Zouave*, 1864. Black and white chalk on olive
green paper, 15⅞ × 7⅝ in. Initialed and dated
lower right: w.h./1864. National Gallery of Art,
Washington, D.C. John Davis Hatch Collection,
Avalon Fund (1982.4.2)

14b. *Zouave*, 1864. Black and white chalk on blue
green paper, 16⅞ × 7½ in. Initialed lower left: wh.
Cooper-Hewitt Museum, the Smithsonian Institu-
tion's National Museum of Design, New York.
Gift of Charles Savage Homer (1912-12-109)

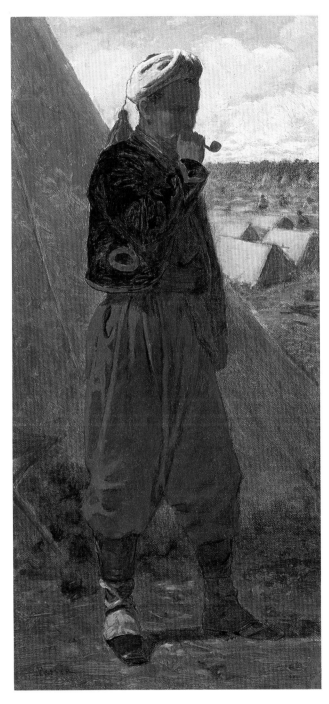

14c. *Zouave*, 1864. Oil on canvas, 14 × 6¾ in.
Signed lower left: HOMER. Private collection

5. Melvin L. Adelman, *A Sporting Time: New York City and the Rise of Modern Athletics, 1820-70* (Urbana: University of Illinois Press, 1986), 262; "Quoit Playing," *The New-York Times*, 5 October 1864.

6. See *The New-York Times* article cited above, or in a description of "The Army at Wait:" "he plays at quoits in the sunset on the hard trodden ground before his door, as he used to by the blacksmith shop at home." "Army of the Potomac. A Look at the Field on the Eve of a Great Movement . . . ," *The World*, 16 April 1864. This article is cited by Giese, *Painter of the Civil War*, 294.

7. See David Park Curry, *Winslow Homer: The Croquet Game*, exh. cat. (New Haven, Conn.: Yale University Art Gallery, 1984).

8. On the basis of several other studio sketches, showing cavalry soldiers or infantrymen in action, Lucretia Giese suggests that Homer may also have been considering a major battle painting in late 1863-1864. *Painter of the Civil War*, 247-250.

9. For example, the drawing "Gun Crew Loading a Cannon" (Cooper-Hewitt Museum, the Smithsonian Institution's National Museum of Design, New York, no. 1912-12-134, verso) in which the Zouave costume is identifiable primarily by the tasseled headdress and baggy trousers, not by any distinctive decoration on jackets or spats on shoes.

10. James E. Kelly papers, box 9, The New-York Historical Society.

11. For these parades, see *cat. no. 8*. By comparison with nineteenth-century illustrations as well as present-day histories, the uniform worn by Homer's Zouaves is that of the Fifth New York Volunteers, or Duryee's Zouaves. See Alfred Davenport, *Camp and Field Life of the Fifth New York Volunteer Infantry (Duryee Zouaves)* (New York: Dick and Fitzgerald, 1879), frontispiece, as well as Philip J. Haythornthwaite, *Uniforms of the American Civil War, 1861-65* (Poole, Dorset: Blandford Press, 1975), 148-149 and pl. 18. At least one reviewer of the painting in 1865 identified the uniforms as those of the Fifth New York Volunteers (see Collected References Prior to 1876).

12. Lyman, *Meade's Headquarters*, 40-41 (letter dated 1 November 1863).

13. "The Academy Exhibition. Second Article," *The New York Leader* 10, no. 18 (30 April 1864): 1.

PROVENANCE [Sale, New York, Somerville Art Gallery (Miner & Somerville, Auctioneers), 19 April 1866, no. 61, as "The Quoit Players"]; Abijah Curtiss, Yonkers-on-Hudson, New York (by 1870 or 1873, according to family recollection); his son, Frederic H. Curtiss, Boston (by 1911); Fogg Art Museum, Harvard University.

EXHIBITIONS PRIOR TO 1876 April 1865, New York, National Academy of Design, "Fortieth Annual Exhibition," no. 460.

CHANGES IN THE COMPOSITION Painting was examined using infrared reflectography; no x-radiographs were available. The horizon line of the tents was changed, as were the lengths and angles of the beam and forked branch that support the tent at the right of the composition. The sentry/punished soldier's rifle/log was originally in a different position, and some drawing near his foot has been painted out. The horseshoe was originally drawn to loop around the stake, but as painted, it falls short. The silhouetted figures seated at the left edge of the canvas were originally drawn in a standing position. A canteen was initially drawn to hang along with the coat on the tent stake at the right. The log at the center left foreground did not originally extend all the way to the front edge. The small lean-to structure at the left horizon line was added later, over the ground color and the sky.

COLLECTED REFERENCES PRIOR TO 1876
Homer has several pictures in progress. . . . Another is also a scene from the war, and depicts a party of Zouaves pitching quoits.
"A Visit to the Studios. What the Artists are Doing," *The Evening Post*, 16 February 1865.

Mr. Homer has also in progress a larger painting: a scene in a camp of Zouaves, where a group of sunburned and stalwart veterans are pitching quoits, a favorite camp amusement. It is difficult to judge of a work so little advanced as this, but from what can be seen of the foreground figures, it will be full of action, life and power.
George Arnold, "Art Matters," *The New York Leader* 11, no. 10 (11 March 1865): 5.

A larger picture [than *The Bright Side*] by Homer hangs in the south gallery, representing Zouaves pitching quoits. This is somewhat rudely painted, but it is full of energy and graphic force. Mr. Homer is a young painter, but he has the manner of a practised hand, if we except refinement. We greet him as one of the most healthful among figure painters, and who brings to art just what redeems it from weakness and morbidness. Welcome this hearty energy of life; and if the painter shows that he observes more than he reflects, we will forget the limita-

tion and take his work as we take nature, which if it does not think is yet the cause of thought in us.
Sordello [pseud.], "National Academy of Design. Fortieth Annual Exhibition," *The Evening Post*, 31 May 1865.

[Homer's] larger picture is not so good [as *The Bright Side*], but there is much in it that is not unworthy of the painter of the first. There is a point in the "Playing at Quoits" which shows a little carelessness of observation. The pitchers are pitching with the sun in their eyes, and even such tough fellows as these would hardly be able to hit the mark under such a disadvantage.
"National Academy of Design. Fortieth Annual Exhibition," *The New Path* 2, no. 6 (June 1865): 104.

. . . a more ambitious work of Mr. Homer's [than *The Bright Side* is] "Pitching Quoits," No. 460. It is a camp scene, with a party of Zouaves playing at quoits with horseshoes – army fashion. The drawing of the figures, and the character, varied and forcible, expressed in the faces, are remarkably fine. The coloring is hardly so harmonious as in No. 190 [*The Bright Side*], though it errs in the right direction – that of strength – and seems to call for study and experience only. Moreover, the subject demands much of the flaming scarlet and blue with which some departmental lunacy has clothed a large portion of our heroes. And it is a thankless task to search for errors in a work so sincerely, so honestly and healthfully fancied. You may go far through many exhibition galleries, without seeing a human figure so full of real life and action as the Zouave in the foreground who is just delivering his quoit; and Mr. Homer cannot draw many such without finding himself famous.
George Arnold, "Art Matters," *The New York Leader* 11, no. 22 (3 June 1865): 1.

WINSLOW HOMER – (No. 460). The sky of this picture is painted with great truth. But the effect of trodden ground is not successfully hit. The grouping of the figures is not artistic. With the exception of the principal figure, their attitudes are unnecessarily graceless. The artist seems to have aimed at an air of *nonchalence* [sic]. But *nonchalence* is not awkwardness.
"National Academy of Design. Third Article," *Watson's Weekly Art Journal* 3, no. 6 (3 June 1865): 85.

No. 460, "Pitching Quoits," by WINSLOW HOMER, A[ssociate], is a subject taken from the camp: – a company of red-breeched Zouaves, with broad and bumpy heads and Henri-Quatre beards, are playing at the ancient and respectable game of quoits, but with horse-shoes instead of the well-known rings. The action and drawing are good, and the picture tells its little story plainly and forcibly. It is less individual than the "Sunny Side" in the east room, but in some respects it is better than that work.
"National Academy of Design. South Room," *The New-York Times*, 13 June 1865.

Perhaps in another season Mr. Homer, who is a promising young artist, may be induced to vary a little from the Zouaves, whose colours and costumes he so strongly affects in his military reminiscenses [*sic*]. His *Pitching Quoits*, no. 460, tells another camp story neatly enough.
"Fine Arts. National Academy of Design. Concluding Notice," *The Albion* 43, no. 24 (17 June 1865): 285.

Mr. Winslow Homer has found a class of subjects worthy of his most careful painting, and is, in this, wiser or more fortunate than most of his contemporaries. He paints the scenes and incidents of our great war, and paints them well, with a true perception of their character and meaning, and with unusual technical skill. "Pitching Quoits," No. 460, is a large picture of Zouaves, apparently of the Fifth New York Volunteers, some in the foreground engaged in the standard amusement which gives name to the picture, with horse-shoes for their missiles, others looking on, keeping tally of the game, smoking, and, in the background, cooking and lounging. The improvement in the technical skill and force in Mr. Homer's work is, from year to year, very noticeable. He promises to retain the position, which we think he has already won, of our first painter of the human figure in action. An honorable position!
"Fine Arts. The Fortieth Annual Exhibition of the National Academy of Design. Second Notice," *The Nation* 1, no. 2 (13 July 1865): 58.

An auction sale of pictures by American artists will take place tonight, at Miner & Somerville's gallery. . . . The "Quoit Players" was one of the attractions at the Academy exhibition last year. . . .
"Sale of Pictures," *The Evening Post*, 19 April 1866.

The auction sale of pictures by American artists took place last evening. The following named pictures brought one hundred dollars and upwards: . . . The Quoit Players, by Homer: $355.
"Sale of Pictures by American Artists," *The Evening Post*, 20 April 1866.

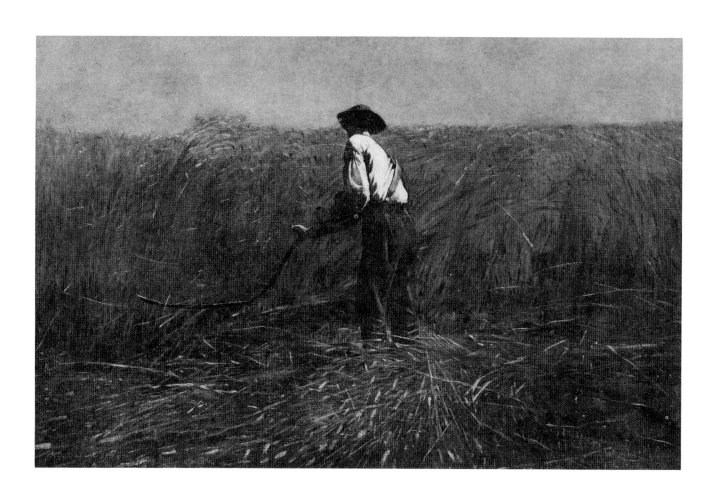

15. The Veteran in a New Field, 1865

Oil on canvas, 24⅛ × 38⅛ inches
Signed and dated lower left: Winslow Homer 65
Initialled lower right (on canteen): w. h.
The Metropolitan Museum of Art
Bequest of Miss Adelaide Milton de Groot, 1967 (67.187.131)

A single man, his back to us, finishes the sweep of his scythe. The golden stalks of cut wheat fly upward or lie strewn upon the ground at his feet. Before him, the field of wheat stretches without interruption toward the horizon. Over all is a steely, blue gray sky. Composed of only these few pastoral elements, *The Veteran in a New Field* is nonetheless a brooding work, one of Homer's "most subtle and provocative paintings,"[1] resonant with many of the issues and emotions that occupied the nation at the close of the Civil War.

Homer's reaper is a young, lean man – his shirt gathers in loose folds and his pants would sag but for his suspenders. He is washed with a strong, hot light. His dark army jacket lies discarded behind him, along with a canteen – marked with the regimental insignia of the Army of the Potomac's First Division of the Second Corps – to refresh him. This is one of the men "returned to their old fields," who by peacefully dissolving the Union Army provided "one of the surest proofs of the stability of the political system."[2] The image accrues allusions to biblical, classical, and popular literature as its stark simplicity welcomes a thoughtful imposition of meaning. More crucially, like Walt Whitman's blooming lilac and warbling thrush, Homer's solitary reaper embodies the bittersweet twining of a nation's celebration of peace and the sobering remembrance of those sacrificed for it.[3]

When the painting was first exhibited in November 1865, and again when it was auctioned in November 1866, even critics who praised the work tempered their approval by noting that it was a "hasty sketch," complaining of its "slap-dash execution" and characterizing it as "hasty and slight."[4] But concern with the painting's lack of finish could not compromise the admiration they felt for the vigor of the brushwork and the power of the composition. "It is a style that belongs to great epochs and to great masters in art," wrote the critic for *The Evening Post*. Another writer, noting the native and homey subject matter, found the painting to be an exemplar of what "can be called truly a school of American art."[5]

The reaper is perhaps derived from a drawing that shows a man at the beginning of his swing of the scythe (*cat.no.15a*). Homer, largely self-taught and without a professional painter as mentor, by showing the reaper at the extreme of his action seems instinctively to have known what Thomas Eakins nearly a decade later had to be told by Jean-Léon Gérôme: in order to convey a sense of motion in an active figure, "Two moments are to be chosen by us painters, the two extreme phases of action . . . an intermediate point [leads to] immobility."[6] Homer turned often to figures of reapers over the next decade and more.[7] In paintings, drawings, and wood engravings, the reapers appear either at the extremes of their swings or at rest.[8]

Few of these later harvest scenes have the impact of *The Veteran in a New Field*. To a degree this is due to the anonymity of the reaper in the early work, although the elegance of the painting's composition also contributes mightily to its power. This stark composition results from Homer's deliberate honing of the image. When the painting was first exhibited the critic for *The Nation* wrote of "suggested trees" and mocked at

15a. Man with a Scythe, ca. 1865. Pencil and gouache, 5⅝ × 14⅛ in. Cooper-Hewitt Museum, the Smithsonian Institution's National Museum of Design, New York. Gift of Charles Savage Homer (1912-12-258)

the height of the wheat: "And such grain! six feet high are its shortest stalks."[9] A wood engraving published in July 1867 (although likely prepared much earlier, since Homer was abroad for the year from December 1866) indicates how the painting – or at least its middle section – probably appeared in November 1865 (*cat.no.15b*). Trees loom over the top of the field to the left of the reaper and branches snake in from the right edge. The wheat itself reaches up over the brim of the reaper's hat, with the tops of individual stalks waving well over his head. In the left foreground the still-rooted stubble of the cut wheat sticks up, making the ground resemble a bed of nails. There is no jacket or canteen.

Close examination of the painting confirms that it at one time looked like the wood engraving: trees at the horizon on both sides have now been painted over, and nearly two inches at the top of the wheat and a number of stray stalks have been covered with blue and then light gray paint. Homer himself apparently made these changes, perhaps after the painting failed to sell at the Artists' Fund Society Exhibition in November. And although it is counter to the received view of

Homer that he would amend a work in response to published criticism, it is a telling coincidence that the elements changed are the very ones that the critic for *The Nation* mentioned.

The critic for *The Nation* noted one further problem with the composition:
Moreover, we are inclined to quarrel with the veteran for having forgotten, in his four years or less of campaigning, that it is with a cradle, and not with a scythe alone, that he should attack standing grain.
In some regards this was an unfair comment,[10] for Homer had apparently included a cradle in the initial stages of the painting. Fully formed, with strands of wheat caught around the elements of its frame, the cradle was the dominant form on the left side of the painting. Happily, however, Homer decided to paint it out; its ghost remains visible as a pentimento.[11] It is in part its lack of the up-to-date accoutrements that renders the image timeless, transforming it from a specific genre scene to a portentous, symbolism-imbued object. Moreover, one of the great strengths of Homer's composition is the simplicity of the lone figure and his balancing scythe, the way in which

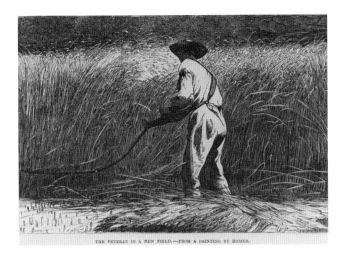

15b. *The Veteran in a New Field – from a Painting by Homer.* Wood engraving, 4¹/₈ × 6¹/₄ in. *Frank Leslie's Illustrated Newspaper* 24, no. 615 (13 July 1867): 268. Peggy and Harold Osher Collection. Courtesy of the Portland Museum of Art, Portland, Maine

the broad-rimmed hat and its shadow serve as the keystone to the arch formed by man and tool. Even in his later, more reportorial harvest scenes, Homer would not introduce the cradle.

The Veteran in a New Field, painted almost immediately after the war's end, is the precise opposite of the first of Homer's war paintings, *Sharpshooter (cat. no. 1)*. It is an image of productivity rather than destruction, a harmonious and natural reaping of the earth's bounty rather than the bringing of death to another man. And yet, in its concentration on a single man set amid nature and its awareness of the cycle of life and death, it shares with the earlier work the seeds of the heroic solitude that Homer would cultivate in his late sea paintings at Prout's Neck, Maine.

M.S.

1. Christopher Kent Wilson, "Winslow Homer's *The Veteran in a New Field*: A Study of the Harvest Metaphor and Popular Culture," *The American Art Journal* 17, no. 4 (Autumn 1985): 23.

2. "The Veteran in a New Field," *Frank Leslie's Illustrated Newspaper* 24, no. 615 (13 July 1867): 268.

3. For full discussions of this work, see Cikovsky, this volume; Wilson, "Winslow Homer's *The Veteran in a New Field*"; Natalie Spassky, *American Paintings in the Metropolitan Museum of Art* 2 (New York: The Metropolitan Museum of Art, 1985), 433-437; and John Wilmerding, "Winslow Homer's Creative Process," *Antiques* 108, no. 5 (November 1975): 965-971.

4. "The Sixth Annual Exhibition of the Artists' Fund Society of New York. II," *The Nation* 1, no. 21 (23 November 1865): 663. "American and Foreign Art. Pictures at the Artists' Fund Society Exhibition," *The Evening Post*, 23 November 1865. "Pictures on Exhibition," *Nation* 3, no. 73 (22 November 1866): 416.

In a fashion typical for early Homer (see Hoermann, this volume), while there is great vigor and dash in the larger portions of the painting, the artist has expended considerable effort on details almost too small to be perceived – the highlight of the scythe's blade has been carefully broken, and stalks of wheat twist around the tool. Coloristically, the white of the man's shirt is enriched with subtle pinks, greens, blues, and yellows, while its shadows have blues, olive greens, and oranges mixed in.

5. "The Veteran in a New Field," 268.

6. Letter of 10 May 1873, quoted in Lloyd Goodrich, *Thomas Eakins* (Washington, D.C.: National Gallery of Art, 1982), 1:114.

7. John Wilmerding has explored the series of scythe-wielding men in "Winslow Homer's Creative Process."

8. See, for example, *Song of the Lark* (1876, ex. coll. Hirschl & Adler Galleries), *Man with a Scythe* (1865, Cooper-Hewitt Museum, the Smithsonian Institution's National Museum of Design, New York), *Bob's Dilemma* (ca. 1881, Yale University Art Gallery, New Haven), *Making Hay* (*Harper's Weekly*, 6 July 1872).

9. "The Sixth Annual Exhibition of the Artists' Fund Society," 663.

10. Few of the mid-century artists who showed harvest scenes included the technologically correct but pictorially awkward cradle in their works. See, for example, Eastman Johnson's *American Farmer* (n.d., William A. Farnsworth Library and Art Museum, Rockland, Me.) or Edward Gay's *The Hillside, Harvest Time* (1868, Sotheby's New York, 3 December 1987, no. 70).

11. Reconstructing the chronology of these changes is a matter of observation and opinion. For a different interpretation, see Spassky. I would particularly like to thank Nicolai Cikovsky and Kristin Hoermann for their insights into this painting.

PROVENANCE [Sale, New York, Henry H. Leeds & Miner, 17 November 1866]; Adelaide Milton de Groot, New York (by 1936-1967); The Metropolitan Museum of Art.

EXHIBITIONS PRIOR TO 1876 November 1865, New York, Artists' Fund Society, "Sixth Annual Exhibition at the National Academy of Design," no. 300.

CHANGES IN THE COMPOSITION Painting was examined using infrared reflectography; x-radiographs were available. Scythe's catcher and blade have been painted over; sky has been extended down over wheat and to cover suggestions of trees.

COLLECTED REFERENCES PRIOR TO 1876
In July we called Mr. Homer our first painter of the human figure in action, and the hasty sketch of "The Veteran in a New Field" is confirmation of that judgment. It is a very insufficient and headlong piece of work, slap-dash execution enough in corn-field and suggested trees; and we do not sympathize with such work *when on public exhibition.* Moreover, we are inclined to quarrel with the veteran for having forgotten, in his four years or less of campaigning, that it is with a cradle, and not with a scythe alone, that he should attack standing grain. And such grain! six feet high are its shortest stalks. But the spirit of the single figure takes the eye from the consideration of faults and foibles. The returned soldier's back is turned to the spectator, his right shoulder is dropped, and his right arm brought well around as the scythe has reached the end of its swing and hangs for one instant at rest. Among all the frantic struggles in the big Alhambra picture [Emanuel Leutze, *The Triumph of the Cross,* 1864], noticed last week, there is not so much real human action as in this one man mowing.
[Russell Sturgis], "The Sixth Annual Exhibition of the Artists' Fund Society of New York. II," *The Nation* 1, no. 21 (23 November 1865): 663.

We pass from Mr. Gray's picture to stop before Mr. Winslow Homer's "Veteran in a New Field," unfortunately placed in the corridor. Mr. Homer's works show the force of new and young blood, a very happy superiority to the conventional, and a little of the audacity of power. One of our youngest men in art, he has produced pictures characterized by greater vigor and largeness of manner than any of our figure painters, and although simply seizing upon the obvious and characteristic of nature, he has done his work so frankly that its merits have been welcomed and its faults overlooked. Mr. Homer's contribution to the Artists' Fund Society ["*Army Boots,*" *cat.no.16*] shows a very pleasant talent for humorous characterization. . . . but we give our preference to the picture in the corridor, as it is the most significant of the painter's tendency.

The picture is without any delicate or refined qualities of color, without any gradation in form; it is even called a large sketch by those who insist upon finish and minuteness of touch in the delineation of nature. But this picture, apparently so rude and slight, is a powerful piece of work, and deficient only in the rendering of parts. We greet it as the promise of a style that will be an effective protest against a belittling and ignoble manner in art – as a sign of that large, simple and expressive style which has made the names of Couture and Millet, and our own Hunt, so justly honored. It does not give us works of great refinement or subtlety, but it corrects the timidity of weakness and destroys the despotism of details. It is pre-eminently a heroic style, and a school under its influence cannot produce the effeminate and demoralizing pictures of a Bauquiet, for instance. It is a style that belongs to great epochs and to great masters in art.
In Mr. Homer's picture we have admirable painting and drawing in the cut and uncut grain, and the representation of the local color is very successful. But few are capable of seeing nature so simple and general in aspect, and in fact only those who see the positive light and dark of objects are capable of painting such a work as Mr. Homer's "Veteran." It is what we would call the synthetic as opposed to the analytic style of treating nature. Mr. Homer does not make his picture out of parts, but he sees it as a whole, and then he finds the details, and he often finds them only to overlook them. This manner of painting is healthy and manly, and to master it one must be emancipated from the minute and unemotional style of a Meissonier; one must use nature, and not enslave themselves to the letter of the law.
As a matter of study it would be well for Mr. Homer to paint heads, life-size, and thus correct the coarse sweep of his brush, and refine his vigor of execution. For simple capacity to paint we know of no young painter who shows such striking power, and we hope to see his next work not less broad and confident, but a little more delicate in execution.
"American and Foreign Art. Pictures at the Artists' Fund Society Exhibition," *The Evening Post,* 23 November 1865.

There was a sale of pictures on Saturday last at Messrs. Leeds & Miner's new gallery, corner of Twelfth Street and Broadway. The catalogue was made up of pictures by Mr. Eugene Benson and Mr. Winslow Homer, and a preface to it announced that both these gentlemen are about to sail for Europe, where they propose to make a long stay. So far as Mr. Homer is concerned, we are sorry to hear it. His work is delightful and strengthening, and promises much; and although it may well be improved in many respects by residence and study abroad, it is much more likely to be injured. Mr. Homer can trust himself further than most of our younger painters; but

the mere fact of his desiring to go to France and study shows that he will put himself under the influence of surroundings and teachings of which we have a great dread. Concerning his pictures which were sold the other night, the more important of them were old friends. The "Brush Harrow" was there, and the admirable "Veteran in a New Field," which we hope brought a thousand dollars, hasty and slight as it is, and the "Waverley Oaks," noticed last week. There were nineteen pictures of his, but some of them were very small, and valuable mainly as curiosities or illustrations of practice. If Mr. Homer learns to finish some of his pictures, so much will be a gain from his studies abroad.
"Pictures on Exhibition," *The Nation* 3, no. 73 (22 November 1866): 416.

We give on this page an illustration of Mr. Homer's excellent and suggestive picture, "The Veteran in a New Field." One of the most conclusive evidences of the strength of a republican form of government is the way in which our army has disbanded, each man seeking again the sphere of usefulness which he left only temporarily, to aid the Government in its need. The taunts of our enemies in Europe, and the predictions they kept constantly uttering, that even if we escaped the danger of drifting into a military despotism, we would find, when the army was disbanded, that the country would be filled with men who had been demoralized by years spent in its service, shook the faith of even many thoughtful persons who believed in the republican system. Now, however, that the war is over, and all such fears are shown to be groundless, we can well congratulate ourselves upon the manner in which the veterans have returned to their old fields, or sought for new ones, since in this we find one of the surest proofs of the stability of our political system. Mr. Homer is to be warmly commended for the simple and truthful way in which he has told all this. His picture, too, is one which illustrates the new school that is growing up in this country – a school which seeks its subjects from the life, the thoughts and the feelings which are our own, which finds in them fitting subjects for illustration, and which alone can be called truly a school of American art.
"The Veteran in a New Field," *Frank Leslie's Illustrated Newspaper* 24, no. 615 (13 July 1867): 268.

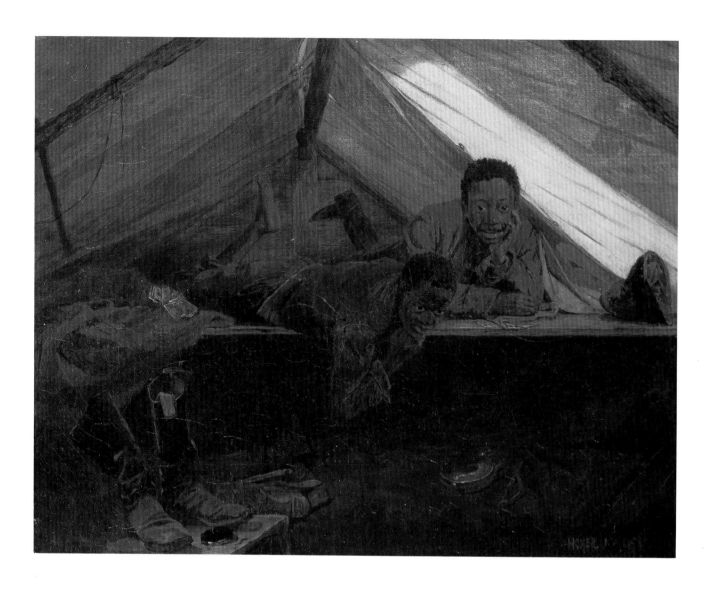

222

16. "Army Boots," 1865

(also called *Game of Cards*)
Oil on canvas, 14 × 18 inches
Inscribed lower right: HOMER NY 65
Hirshhorn Museum and Sculpture Garden
Smithsonian Institution
Gift of Joseph H. Hirshhorn Foundation, 1966 (1966.2941)

The two young black boys in *"Army Boots"* are among the earliest of Homer's paintings of children – a genre that would culminate a decade later in such masterworks as *Snap the Whip* (Cikovsky, this volume, *fig. 13*) and *Breezing Up* (1875, National Gallery of Art, Washington, D.C.). Even in this early work, however, Homer has shown the boys in poses of great naturalness, with legs kicking, bodies rutching, both of them displaying all the energy expended by children being still. They appear to be wearing cast-off parts of uniforms, the boy to the right a Confederate's butternut-colored coat, the one to the left a Zouave's blue jacket piped with red. The two are playing cards, a vice that was widespread in both commission and repentance throughout the army.[1] But they are readily distracted from their game by the presence of the artist/viewer.

In this readiness to note the viewer, *"Army Boots"* is a wholly self-conscious work, without the fiction of the invisible artist. As the critic in *The Nation* wrote, "the sitters do not try to 'make-believe' unconscious."[2] Just as in *The Bright Side*, one of the figures engages the viewer directly, seeking (and, because of his winning expression, probably eliciting) an immediate emotional response. There are no known drawings or studies relating to this work now extant.

The boys are probably contrabands – escaped slaves who attached themselves to the Union army. Timothy H. O'Sullivan's photograph of *Contrabands at Leisure* presents two young men in a setting comparable to that created by Homer (*fig. 16.1*). Their jauntiness and apparent good humor was testified to by numerous observers:

These boys are pretty tough specimens. They each have only one garment of a kind. When that gets dirty, they will take it off and wash it and either wait until it dries, or wear it and let it dry on them.[3]

In exchange for food and shelter, the contrabands provided various services for the men and officers of the camp:

The mantle of daily industry – "domestic work," as we may call it – fell upon the shoulders of the colored men or boys, for the drudgery of camp life came to them alone, and the most laborious duties were performed by them with a never-failing cheerfulness that is seldom found in positions of servitude.[4]

These duties could range from laundry and barbering to cooking and (as seems the case in Homer's work) shining shoes – a pair of skillfully drawn boots fills the lower left corner of the canvas.[5]

The care of army footwear was a fairly serious affair for soldiers. Memoirs and reminiscences are filled with accounts of the pain inflicted by the standard issue army shoe, and the greater pain encountered by those who did without it.[6] According to at least one cavalry private, "In the army a man's boots is his castle."[7] Contrabands were reputed to be particularly apt at taking care of the all-important footwear. According to the text of Alexander Gardner's photograph, *What do I Want, John Henry? Warrenton, Virginia, November, 1862*, the black servant possessed "an unusual capacity for the care of boots and other attentions" coupled with an aversion to "manual labor" (*fig. 16.2*).[8] But for the moment the two boys in

fig.16.1 Timothy H. O'Sullivan (1840-1882).
Contrabands at Leisure, 1863. Silver print (collodion
negative). Collection of the Library of Congress

fig.16.2 Alexander Gardner (1821-1882). *What do
I Want, John Henry?*, Warrenton, Virginia, Novem-
ber, 1862. Silver print (collodion negative). *Gard-
ner's Photographic Sketch Book of the War*,
(Washington, D.C.: Phil[i]p & Solomons, Publish-
ers, 1866), pl. 27. Collection of the Library of
Congress

"Army Boots" ignore this responsibility and simply
take their ease, lying in the heat of the tent which,
with its rich brown interior and touches of glowing
red, fosters the idea of a lazy warmth and comfort.

The interior of the tent is fairly elaborate,
signalling that it is in the midst of a settled camp,
where the time and expense of the improvements
could be justified. The boys lie upon a wooden
platform that served as bed, chair, and table for
two in the more comfortable of the common
soldiers' tents. A canvas tent forms the roof and
rests upon short plank walls and gable. To the
right the sunlight illuminates a red cloverleaf—
the sign of the First Division of the Second Corps
of the Army of the Potomac, the corps that Homer
visited in 1861 and 1862, and with which he
apparently identified since the red clover appears
throughout his Civil War work almost to the
exclusion of other insignia (see the tent in
fig.20.2).[9]

The painting was not an elaborate effort for
Homer, seemingly without preliminary studies
and not thoroughly worked over. Perhaps it was a

means of measuring himself against his col-
leagues: Eastman Johnson's National Academy
of Design diploma painting (*Negro Youth*, 1860,
National Academy of Design, New York) was a
similarly small-scale depiction of a black youth, a
canvas predominantly brown with the forms
molded from the neutral ground. Homer donated
"Army Boots" to the Artists' Fund Society of New
York, which helped support needy artists and
their families through the auction of donated
works. *"Army Boots"* was auctioned 29 December
1865. The annotated catalogue of the sale in the
New York Public Library notes that it was pur-
chased by "Graham" for $140. This notation
probably refers to James Lorimer Graham (1831-
1876), friend and patron of many artists and
writers, whose last years were spent in government
service in Italy.[10] M.S.

1. Bruce Catton writes: "From one end of the army to
the other, bivouacs were littered with discarded decks
of cards. Card games were held sinful in that generation,
and most men who were about to fight preferred not to
have these tangible evidences of evil on their persons
when they went out to face death" (*Catton's Civil War*,
157).

Charles Bardeen apologizes for his diary references to gambling, saying "but I am telling what did happen, not what ought to have happened." On the other hand, he notes: "Cards mean a great deal to the soldier. They while away many an hour that would otherwise be tedious, and a pack of cards will be about the last thing thrown away on a long march." *Little Fifer's War Diary*, 176-177.

Warren L. Goss states very simply, "playing cards was the greatest recreation of the soldiers." *Recollections of a Private. A Story of the Army of the Potomac* (New York: Thomas Y. Crowell, 1890), 329.

2. *The Nation* 1, no. 20 (16 November 1865): 631.

3. M. W. Tyler, writing of mess boys in general. *Recollections of the Civil War*, quoted in Williams, *The Artists' Record*, 90.

4. Edwin Forbes, *Thirty Years After: An Artist's Story of the Great War* (New York: Fords, Howard, & Hulbert, 1890), 149-150.

5. Ostensibly the source of the painting's title. But of course "boots" carries many meanings in English. In addition to footwear and he who keeps the footwear clean, other definitions of the term range from rescuing something from peril, to a shortened form of booty or plunder. All are relevant to this picture's subject.

To a surprisingly consistent degree, the boots worn by Homer's soliders throughout all the Civil War paintings are handsomely drawn and painted, and figure among the more finely finished portions of the canvases. See Hoermann, this volume.

6. See Bardeen, *Little Fifer's War Diary*, 79-80.

7. George W. Peck [pseud.] devotes an entire chapter to "A Short Story About a Pair of Boots, Showing the Monumental Gall of their Owner," in *How Private George W. Peck Put Down The Rebellion, or the Funny Experiences of a Raw Recruit* (Chicago: Belford, Clarke & Co., 1887), 313.

8. Quoted in Alan Trachtenberg, "Albums of War: On Reading Civil War Photographs," *Representations*, no. 9 (Winter 1985): 28.

9. See, for example, *Prisoners from the Front, Army Teamsters*, and *Veteran in a New Field* (cat.nos.20, 13f, 15).

10. Although *"Army Boots"* was not included in the New York sale of James Lorimer Graham's collection (Leavitt, 23-24 May 1876), Graham's residency in Italy at the end of his life, his known friendship with many of Homer's colleagues, and because the painting was reputed to come from an Italian collection when it entered the art market in 1940, suggest his ownership.

PROVENANCE [Sale, New York, Artists' Fund Society, 29 December 1865, no.46]; possibly James Lorimer Graham, New York and Florence (1865-1876); [William Heinemann (reputedly from an Italian collection, 1940)]; [M. Knoedler & Co., New York, 1940]; [Babcock Galleries, New York, 1941]; [Knoedler]; Joseph Katz, 1944- ; [Victor Spark, New York, by 1957]; William J. Poplack, 1958; [Victor Spark, New York, 1958]; [James Graham & Sons, New York, 1958]; [Victor Spark, New York, 1960]; [Hirschl & Adler, New York, 1961]; [James Graham & Sons, New York, 1964]; Joseph H. Hirshhorn, New York (1964-1966); Hirshhorn Museum and Sculpture Garden, Smithsonian Institution.

EXHIBITIONS PRIOR TO 1876 November 1865, Artists' Fund Society, "Sixth Annual Exhibition," no. 46.

CHANGES IN THE COMPOSITION The painting was examined without infrared reflectography; x-radiographs were not available. The date has been changed from 1864 to 1865; the red lining of the foremost hat on the right, and the bulge of a second behind it, were added later.

COLLECTED REFERENCES PRIOR TO 1876
Mr. Homer's "Army Boots," No. 46, is very slight and sketchy, but has a great deal of character in it. That is a wonderful black boy on the left. Both are evidently having their pictures taken, but that fact, which is fatal to nine-tenths of the portraits we see, does not hurt these portraits, because the sitters do not try to "make-believe" unconscious. Mr. Eastman Johnson's "Not Enough for Two," No. 49, is, on the whole, better than Mr. Homer's picture, and, therefore, best of the contribution pictures.
"Fine Arts. The Sixth Annual Exhibition of the Artists' Fund Society of New York," *The Nation* 1, no. 20 (16 November 1865): 631.

Mr. Homer's contribution to the Artists' Fund Society shows a very pleasant talent for humorous characterization. It is very fine in color, being clear and rich.
"American and Foreign Art," *The Evening Post*, 23 November 1865.

The pictures contributed by its members, and which are to be sold at auction for the benefit of the "Fund" form but a very small portion of this collection, being only fifty-nine in number, and we are sorry to say, are not by any means the most valuable or attractive feature of the exhibition. There are however a few honorable exceptions, such as "Army Boots," by Homer.
"Artists' Fund Society," *Watson's Weekly Art Journal* 4, no. 8 (9 December 1865): 114

17. Trooper Meditating beside a Grave, 1865

Oil on canvas, 16⅛ × 8 inches
Signed lower right: HOMER
Collection of the Joslyn Art Museum
Gift of Dr. Harold Gifford and Ann Gifford Forbes (1960.298)

A single soldier stands in a wood, contemplating before him the cross that marks another soldier's grave. His head is bent so that the visor of his kepi covers his eyes, casting his features in shadow. This position draws attention to the cavalry insignia on that cap, crossed sabers that offer an eerie contrast to the wooden grave markers about him.[1] Blades of grass spring from the brown-red earth beneath the trooper's feet; a small sapling to his left bears green shoots that counter the broken, dead limb lying beside the grave. These signs of nature's reclamation are small, and may even be ironic or cruel, as they are in Thomas Bailey Aldrich's poem, "By the Potomac:"

The soft new grass is creeping o'er the graves . . .
Ah with what delicate touches of her hand,
With what sweet voices, Nature seeks to screen
The awful Crime of this distracted land, –[2]

But Homer's soldier, lost in thought, his head down, his posture reserved and self-contained, does not seem to judge or comment.

Although small and seemingly rapidly painted, Homer's image was made with deliberation. A closely related drawing shows the attention Homer paid to the stance and posture of his soldier (*cat.no.17a*). Here shading and volume are emphasized above the particular features of costume or expression (compare, for example, a drawing of similar date, *cat.no.14b*). No cross or sign of setting appears in the drawing, but the soldier's feet are not indicated, as if Homer was already planning to have those feet sunk into grass. Once inserted into the painting, the natural and unassuming studio pose acquires the attributes of calm reflection. As he did in *"Home, Sweet Home"* (*cat.no.4*), Homer generalized the features of his soldier, obscuring specific details that might otherwise particularize and sentimentalize his image. Even the cavalryman's uniform, correct in its lines, has been painted in mute tones so that the Union blue of his jacket and trousers begins to resemble a Confederate gray. The impact gained from such direct simplicity becomes clear when Homer's painting is compared to other images of graveyards, such as the engraving after Edwin Forbes, *Soldiers' Graveyard* (*fig.17.1*) or G. H. Houghton's photograph of *Burial Place of 3rd Vt. Killed at Lee's Mills* (*fig.17.2*). Denied the opportunity to project specific emotions onto this soldier's figure or to create a particular narrative to accompany his situation, the viewer is left with a more abstract, universal image of a meditation on death.

And death was one of the most inexorable and stunning truths of the Civil War. The war's massive casualty figures – by best estimates, at least 623,026 soldiers died and another 471,427 were wounded[3] – only begin to tell the story. By fall 1863, following the devastating battles of Chancellorsville and Gettysburg, soldiers had begun to consider death not in terms of whether, but rather in terms of when. Not surprisingly, Civil War memoirs tend not to dwell on such sentiments; as James Dalzell, a private with the 116th Ohio regiment, pointed out, "As we old soldiers try to recall the experiences of our camp life, we always endeavor to keep the best, at least the gayest and most thoughtless side out [that is, visible]."[4] But the prospect of death was ever-present:
Night sheds her sable mantle over both armies,
which are confronting each other quietly. As soon
as morning comes we expect to have a terrible

17a. Trooper Meditating beside a Grave, 1865.
Black and white chalk on brown paper with pencil,
13½ × 6¼ in. Signed and dated lower right:
w.h. *18/6/5*. Robert Hull Fleming Museum, Uni-
versity of Vermont, Burlington. Bequest of Henry
Schnakenberg (1971.2.1)

*battle, and each man has his own thoughts and
reflections. We sit around the bivouac fires, and, as
is usual before a great battle, each tells the others
that in case he should fall what will be done in
regard to letting the loved ones at home know what
became of him, and what should be done with the
little effects that a soldier carries about him. Write
to my mother, says one, and tell her, if I fall, that
I always tried to do my duty to my country. Write
to my wife, says another, and should I fall, my last
thoughts were of her and my darling children.
Write to my brother, says another, and should I fall,
tell him to come and fill my place in the ranks. A
thousand and one things are talked about and
thought of the night before a great battle, which no
one can tell but those who have passed through
the sad ordeal.*[5]

If a soldier managed to avoid thinking of his own
mortality, he was everywhere reminded of it,
both in camp, where thousands of soldiers died of
disease, and on the battlefield, where slain as
well as wounded men might lie for a day or two
before receiving aid or burial.[6] The sight of the
dead after a battle was shocking. Charles Bardeen,
who served with the First Massachusetts, wrote
in his diary the day following the battle of Gettys-
burg, "July 5. Rainy. Went out on the Battlefield.
An awful sight. Men, horses, all lying in heaps
as far as the eye could reach."[7] A soldier walking
over the field of Antietam two days after that
battle described the scene to his father:
*The smell was offul . . . their was about 5 or 6,000
dead bodies decaying over the field and perhaps
100 dead horses . . . their lines of battle Could be
run for miles by the dead they lay long the lines like
sheavs of Wheat I could have walked on the boddes
all most from one end too the other.*[8]

Such massive and horrifying casualties pre-
sented difficulties when it came time for their
removal. If a man died in camp or in the hospital,
a suitable ceremony could be performed,[9] but on
the march or following a battle, there might be
few means and even less time to enact an elaborate
or individualized burial. A young boy who had
watched the Battle of Stones River (or Murfrees-
boro) in Tennessee, recalled that
it takes a lot of glory out of war to see the dead

fig.17.1 Edwin Forbes (1839-1895). *Soldiers' Graveyard in the Camp Near Falmouth, Va.* Wood engraving, 7 7/8 × 8 3/4 in. *Frank Leslie's Illustrated Newspaper* 15, no. 390 (21 March 1863): 401. Collection of the Library of Congress

fig.17.2 George Harper Houghton (ca. 1824-1870). *Burial Place of 3rd Vt. Killed at Lee's Mills.* Albumen print. Courtesy of the Vermont Historical Society

being buried. They would dig a ditch 6 feet wide, 2 feet deep and as long as was necessary, and would lay the poor boys, side by side, head to feet every other row, put their hat or cap down over the face and cover them up, putting a bit of board at each head with a number on it, to save the record.[10] Even such small niceties were not always possible. Robert Carter, a private in the Twenty-second Massachusetts, detailed on the burial party after Gettysburg, recalled "tumbling" as many as ninety bodies into a single trench, "with not a prayer, eulogy or tear to distinguish them from so many animals."[11] The fear of anonymous burial was very present, as Carter himself admitted: *I don't fear to go into battle . . . neither do I fear the wounds, or even death itself, for . . . that is what I came out for, if need be, to give up my life in defense of my country, but it is the thought that I shall be uncared for, that I shall be buried where no loving hand can strew flowers and shed tears of love over my grave.*[12] Even the simplest grave offered a soldier the

assurance that his sacrifice would be noted and his service remembered. Such assurances not only gave comfort to bereaved families but remained to fuel patriotic sentiments as well: *No matter where you go, the graves of the heroic dead meet your eye. In the vicinity of the hospitals, behind camps, in the covered ways leading to some important or exposed posts, beneath some wide-spreading tree, and by the dusty roadside. On every side, and at the most unexpected times, you come across these mute and melancholy testimonials to the awful loss of life that this accursed rebellion has brought upon the country.*[13]

Whatever patriotic or melancholy associations Homer's painting of a trooper meditating beside a grave might have evoked in the minds of its nineteenth-century viewers, this image also stands as a simple, but poignant reminder of the healing power of memory. Not so much a memorial to the collective dead, as are the many contemporary photographs of Civil War cemeteries and graveyards,[14] Homer's image focuses on the

living soldier, the man with sensibility and memory, whose meditation ensures the survival of its object. Whether the grave is identified or not (and the cross at the right edge of the canvas seems to bear the traces of an inscription of some sort), its occupant lives within the soldier's thoughts. Homer's emphasis on the cavalryman seems a direct response to President Abraham Lincoln's charge, expressed so eloquently in the short speech with which he dedicated the seventeen-acre military cemetery at Gettysburg, Virginia, on 19 November 1863:

But in a larger sense, we cannot dedicate, we cannot consecrate, we cannot hallow this ground. The brave men, living and dead, who struggled here have consecrated it far above our poor power to add or detract. . . . It is for us, the living, rather to be dedicated now to the unfinished work which they have, thus far, so nobly carried on.[15]

Rejuvenation is not the primary intent of this small, iconic image. Rather it is the assurance that through contemplation and memory, indeed, "these dead shall not have died in vain." It implies the hope, if not the challenge, "to us, the living," that such memories remain vivid, as they did with Walt Whitman:

> *Long, long I muse, then on my way go*
> > *wandering,*
> *Many a changeful season to follow, and many a*
> > *scene of life.*
> *Yet at times through changeful season and scene,*
> > *abrupt, alone, or in the crowded street,*
> *Comes before me the unknown soldier's grave,*
> > *comes the inscription rude in Virginia's woods,*
> *Bold, cautious, true, and my loving comrade.*[16]

<div align="right">S.M.</div>

1. These crossed sabers also feature prominently in Homer's painting *The Initials* (1864, private collection); they appear conspicuously carved into the tree trunk at the center of the composition. The Civil War context of this painting, and the similarity of its setting and mood to *Trooper Meditating beside a Grave* is discussed by Lucretia H. Giese in "Winslow Homer's Civil War Painting *The Initials*: A Little-Known Drawing and Related Works," *The American Art Journal* 18, no. 3 ([Summer] 1986): 4-19.

2. Thomas Bailey Aldrich, "By the Potomac," in Francis F. Browne, *Bugle-Echoes: A Collection of Poems of the Civil War, Northern and Southern* (New York: White, Stokes, & Allen, 1886), 179.

3. E. B. Long, *The Civil War Day by Day: An Almanac, 1861-1865* (Garden City, N. Y.: Doubleday, 1971), 711-712. Compare these figures to those of World War I, where 116,708 Americans died, or World War II, where 407,316 American lives were lost.

4. James Dalzell, *Private Dalzell: His Autobiography, Poems and Comic War Papers . . .* (Cincinnati: Robert Clarke & Co., 1888), 77.

5. D. G. Crotty, *Four Years Campaigning in the Army of the Potomac* (Grand Rapids, Mich.: Dygert Bros. & Co., 1874), 111.

6. Homer's drawing of a wounded soldier left on the field, inscribed "Three days on the Battlefield," illustrated in Julian Grossman, *Echo of a Distant Drum: Winslow Homer and the Civil War* (New York: Abrams, 1974), 84, fig. 60, demonstrates the artist's knowledge of such situations.

7. Bardeen, *Little Fifer's War Diary*, 237-238.

8. Quoted by Bell Irvin Wiley and Horst D. Milhollen, *They Who Fought Here* (New York: Macmillan, 1959), 264. The comparison of dead bodies to sheaves of wheat is especially telling in relation to *The Veteran in a New Field* (cat.no.15).

9. For examples of soldiers' funerals, see Crotty, 75-76; or a newspaper correspondent's report from the United States General Hospital at Fortress Monroe, Virginia, "How the Soldiers are Buried; How Their Remains May be Recovered," *The New-York Times*, 4 December 1864.

10. Quoted by Wiley and Milhollen, 265.

11. Captain Robert Goldthwaite Carter, *Four Brothers in Blue, or, Sunshine and Shadows of the War of the Rebellion: A Story of the Great War from Bull Run to Appomattox* (1913; Austin: University of Texas Press, 1978), 325. Images of the grim anonymity of mass burial include Alexander Gardner's photograph *A Burial Party, Cold Harbor, Va., April, 1865*, and the wood engraving after E. F. Mullen's drawing *The Siege of Petersburg – Burying the Dead before Cemetery Hill under a Flag of Truce, after the Repulse of the Ninth Army Corps*, appearing in *Frank Leslie's Illustrated Newspaper* 18, no. 466 (3 September 1864): 376.

12. Carter, 129. Another soldier writing to his brother in 1864 tried to ascribe anonymous burials to the enemy's practices, despite evidence that such distinctions could not be guaranteed: "When the dead of a battle are buried, a hole is generally dug where they fall, and sometimes the dirt is just thrown over them where they lay, and the first rain washes it off; but if your own men bury them, they are nearly always buried together, and boards put up by their companions to tell where they are." "Incidents in the Life of a Soldier," *The Portrait Monthly* 1, no. 11 (May 1864): 171.

13. "The Army of the Potomac. What it has Done and What it is Doing . . . ," *The New-York Times*, 30 October 1864.

14. For example, see the photographs reproduced in Wiley and Milhollen, 266, 269.

15. Lincoln's "second draft" of the Gettysburg Address, from which he spoke, is reproduced in Ketchum, *American Heritage Picture History*, 350.

16. Walt Whitman, "As Toilsome I Wander'd Virginia's Woods," first published in *Drum-Taps* (1865), in Whitman, *Complete Poetry and Collected Prose*, 442.

PROVENANCE Sanford Robinson Gifford (d. 1880); his brother Charles Gifford; his son Harold Gifford (ca. 1926); his daughter Ann Gifford (Mrs. John Ewing) Forbes, Rochester, New York (ca. 1946); her brother, Dr. Harold Gifford, Omaha, Nebraska; Joslyn Art Museum, Omaha, Nebraska.

EXHIBITIONS PRIOR TO 1876 None are known.

CHANGES IN THE COMPOSITION Painting was examined without using infrared reflectography; no x-radiographs were available. The foreground cross may have been originally planned as a rectangular slab; the highlight across its top edge once extended as far as the left cross-member, but was painted out. The soldier's shirt (appearing below and inside the jacket) was initially red.

COLLECTED REFERENCES PRIOR TO 1876
None are known.

18. Sounding Reveille, 1865

(Also called *Reveille*)

Oil on canvas, 13¼ × 19½ inches

Signed and dated lower right: WINSLOW HOMER/-1865-

Estate of William E. Weiss, Jr.

Homer's use and reuse of motives in his Civil War works – drawings, prints, and paintings – is well known. Certain of his paintings and wood engravings combined into their integrated compositions sketches and notations made in various locales over a wide span of time. This accords with standard artistic practices of the day.[1] In turn, the composites would generate portions of yet other, later works. Few of his paintings demonstrate his allegiance to this method of composition better than *Sounding Reveille*.

In the early dawn's light of the painting, two groups of figures share Homer's stage of bare earth (covered now back to the horizon with tents and the scraggly remnants of a pine forest). On the left two drummers and one bugler from the Sixty-first New York Infantry (to judge from the large 61 on the knapsack behind the bugler), face out of the composition playing their instruments, while to the right a group of lounging boys, their drums piled beside their tent, cluster around a campfire. For the figure of the bugler Homer relied on a drawing of ca. 1862 showing a bugler wearing a Zouave's cap standing before a substantial log-sided tent (*cat.no.18a*). Although he changes the background entirely, the figure in the painting largely follows the drawing.[2] Only in narrowing the trouser legs of the bugler does Homer deviate as he moves from drawing to painting.

Preliminary works for the two drummers are not now known, although in his face and the position of his head and feet the distant drummer is closely related to *Young Soldier*, an oil study apparently done in the studio to explore the painting of a somewhat over-sized costume

(*cat.no.18b*).[3] Visitors to Homer's studio during the 1860s remembered that uniforms littered the empty spaces, and that charcoal drawings filled the empty walls. Thomas Bailey Aldrich noted: *Mr. Homer's workshop is as scantily furnished as a shelter tent. A crayon sketch of camp-life here and there on the rough walls, a soldier's overcoat dangling from a wooden peg, and suggesting a military execution, a rusty regulation musket in one corner, and a table with pipes and tobacco-pouch in the other, – these are the homely decorations of Mr. Homer's chamber.*[4]

It seems that such a "crayon sketch" may be on the wall behind the young soldier – a large drawing of a soldier giving water to a wounded companion, a work that now exists in a carefully modulated charcoal and white chalk drawing dated 1864 (*cat.no.18c*).[5] The two drummers' final appearance in Homer's work occurs over twenty years later. Then, in *Beating the Long Roll*, commissioned by the Century Publishing Company to illustrate a portion of their massive *Battles and Leaders of the Civil War* (*fig.18.1*), he separated their figures and gave them two schematicized companions – one of them based on a handsome charcoal-and-chalk drawing of a drummer seen from the rear (*fig.18.2*).

The scene to the right in *Sounding Reveille* derives closely from a slight pencil sketch, enriched with brown wash, which is a field record probably dating to 1862 (*cat.no.18d*). This same drawing was the source – condensed and reversed – for the background of a wood engraving that appeared in *Harper's Weekly* on 3 December 1864 – *Thanksgiving-Day in the Army – After Dinner – The Wish-Bone* (*cat.no.18e*). From day-

18a. *Bugler Wearing Zouave's Cap*, ca. 1862.
Pencil on brown paper, 12⅝ × 9⅞ in. Cooper-
Hewitt Museum, the Smithsonian Institution's
National Museum of Design, New York. Gift
of Charles Savage Homer (1912-12-114)

*jarring on unwilling ears. In a few moments the
peaceful quiet is replaced by noise and tumult,
arising from hill and dale, from hill and forest.
Camp-fires, hitherto extinct or smouldering in dull
gray ashes, awake to new life and brilliance, and
send forth their sparks high into the morning air.
Although no gleam of sunrise blushes in the east
the harmless flames on every side light up the
scene, so there is no disorder or confusion.*

*The aesthetic aspects of this sudden change do
not, however, occupy much of the soldier's time.*[6]
Instead, the soldier was expected to tumble from
his bed for roll call and the assignment of duties —
he often appeared just as he had slept, clutching
blankets, or in slippers or overcoats. One disap-
proving recruit later recounted, "Some wore one
shoe and others appeared shivering in their linen.
They stood ludicrously in rank, and a succession
of short, dry coughs ran up and down the line."[7]
After roll call, while some soldiers washed or
prepared breakfast, others dived back for "a
morning nap before breakfast."[8]

The ones who generated all this commotion,
the buglers and the drummers, were often the
youngest members of a regiment — boys as young
as nine enlisted with parental consent until
March 1864, when sixteen became the minimum
age.[9] The music they provided not only regulated
life in camp from reveille to taps, but proved
vital during the course of a battle. As one bugler-
to-be wrote in 1862:

*at all events it is considered quite an honor to be
Bugler for a regt. When an army is advancing
through an enemies country it is frequently neces-
sary to send out a portion or a whole Reg to search
the woods a little in advance of the main army so
as not to meet with a sudden surprise from the
enemy. in skirmishing the Capts & Lieut stand
several paces behind their Cos the Col stands or
rather sits on his horse on an eminence where he
has a fair view of the men perhaps 50 or 100 rods
behind them. the Bugler stands near him he gives
orders to the Bugler & the Bugler sounds the call
used to represent the command. the Capts have to
be familiar enough with the calls so they can tell
one from another. they give the command to their
Cos. some of the calls are short & some are quite*

time rest and post-prandial nap, to early dawn's
rousing, the same grouping and pose served
the practical Homer over the months and years.

Reveille was the beginning of the soldier's day.
Descriptions of it fill numerous memoirs. One
of the best of these was published in 1865:
*The wind sweeping gently through the tall pines
over head only serves to lull to deeper repose the
slumbering soldier, who in his tent is dreaming of
his far-off northern home.*

*But in an instant all is changed. From some
commanding elevation the clear-toned bugle
sounds out the reveille, and another and another
resounds, until the startled echoes double and
treble the clarion calls. Intermingled with this
comes the beating of drums, often rattling and*

tunes I have learned to play nearly all of them.[10] In addition to conveying commands, anecdotes abound detailing how music could inspire the men to action. Walt Whitman, on reviewing his wartime diaries, found this note concerning music in battle:

When Kirkpatrick and his forces were cut off at Brandy Station (last of September, '63, or thereabouts,) and the bands struck up "Yankee Doodle," there were not cannon enough in the Southern Confederacy to keep him and them "in." It was when Meade fell back. K. had his large cavalry division (perhaps 5000 men,) but the rebs, in superior force, had surrounded them. Things look'd exceedingly desperate. K. had two fine bands, and order'd them up immediately; they join'd and play'd "Yankee Doodle" with a will! It went through the men like lightning – but to inspire, not to unnerve. Every man seem'd a giant. They charged like a cyclone, and cut their way out. Their loss was but 20.[11]

When not playing music, the drummer boys and buglers served many functions in camp, working as barbers and valets or, more seriously, on burial details. They were crucial members of any regiment, boys turned to men too soon by the nature of their experiences and the rough company of the camps. In an age that idealized childhood, however, even the coarsened drummer boy became the stuff of sentimental ballads and saccharine paintings – Eastman Johnson's *The Wounded Drummer Boy* (1871, The Union League Club, New York) epitomizes the best of these productions that, although depicting noble and valorous behavior, yet seems essentially false and theatrical.[12]

Homer, by contrast, depicts the atmosphere of the camp through rounded forms that emerge from a more tonal palette than Johnson's. If the artist was familiar with the humorous, unofficial words to reveille – "I can't get 'em up," etc. – he did not in this work seek to call upon that knowledge in the viewer.[13] Nor does Homer use the reveille to symbolize the nation awaking to "the quick alarming drum," as Bret Harte would write.[14] Instead, Homer subsumes the potential sentimentality of *Sounding Reveille* within his objective vision of these young men seen in the dawn light. M.S.

18b. Young Soldier, ca. 1864. Oil, gouache, and pencil on canvas, 14 1/8 × 7 1/8 in. Inscribed center-right edge: *piece/peace*. Cooper-Hewitt Museum, the Smithsonian Institution's National Museum of Design, New York. Gift of Charles Savage Homer (1912-12-110)

18c. Wounded Soldier Being Given a Drink (Soldier Giving Water to a Wounded Companion), 1864. Charcoal and white chalk on green paper, 14⅜ × 19½ in. Signed and dated lower left: HOMER *1864*. Cooper-Hewitt Museum, the Smithsonian Institution's National Museum of Design, New York. Gift of Charles Savage Homer (1912-12-100)

1. Artists as distinct from one another as Frederic Church and Edgar Degas are documented as working in this fashion, and Homer was no exception. For a detailed discussion of his practice, see Giese, *Painter of the Civil War*, 206-277.

2. Homer would ultimately transform the masculine, military version of the figure into the woman who stands in the same pose, her back to the viewer, in *The Dinner Horn* (wood engraving in *Harper's Weekly*, 11 June 1870 and paintings of 1870, private collection, and 1873, The Detroit Institute of Arts).

3. To the left of the soldier are the edges of a Zouave's britches and tasseled hat – perhaps a sketch of the right-hand figure in the *The Brierwood Pipe (cat.no.8)*. This portion of the canvas would seem to confirm the date of the *Young Soldier* to 1864.

4. T. B. Aldrich, "Among the Studios. IV," *Our Young Folks* 2, no. 9 (September 1866): 574.

5. The image of a wounded soldier being given a drink from a comrade's canteen was a resonant one. Private Miles O'Reilly wrote a poem on the theme, "We've Drank from the Same Canteen," reprinted in Billings, *Hardtack and Coffee* (with illustration), 223-224. Such incidents were not always pietistic. Moore reprints an anecdote of a Rhode Island soldier giving drink to a dying Rebel:

18d. *Drummers Resting before Tents*, 1862. Pencil and brown wash, 6¾ × 9¾ in. Inscribed lower left: *Black/Blue/Laque/ White*. Cooper-Hewitt Museum, the Smithsonian Institution's National Museum of Design, New York. Gift of Charles Savage Homer (1912-12-202)

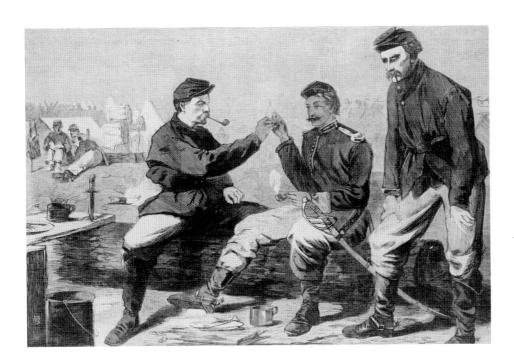

18e. *Thanksgiving-Day in the Army – After Dinner – The Wish Bone*. Wood engraving, 9¼ × 13⅞ in. *Harper's Weekly* 7, no. 414 (3 December 1864): 780. Full caption reads: DRAWN BY W. HOMER. Peggy and Harold Osher Collection. Courtesy of the Portland Museum of Art, Portland, Maine

fig.18.1 *Beating the Long Roll*, reproduced from *Battles and Leaders of the Civil War* (New York: The Century Company, 1884), 4: 179. Collection of the Library, University of California at Berkeley

fig.18.2 *Drummer Seen from the Rear*, ca. 1864. Charcoal and white chalk on blue paper, 16 ³/₄ × 11 ³/₈ in. Cooper-Hewitt Museum, the Smithsonian Institution's National Museum of Design, New York. Gift of Charles Savage Homer (1912-12-108)

"And now," said the manly fellow [from Rhode Island], "I have given you water from my canteen, when its drops are more precious than diamonds. If you had found me in this state, what would you have done?" The eyes of the dying man gleamed, as the soldier said, like those of a basilisk, and he [the Rebel] replied, "I would have put my bayonet to your heart." In a few moments he went into eternity, and the Rhode Islander resumed his place on the battle-field (Moore, *Anecdotes, Poetry, and Incidents*, 511).

6. Bardeen, *Little Fifer's War Diary*, 270, quoting Nichols.

7. George A. Townsend, quoted in Wiley, *Billy Yank*, 45.

8. George Grenville Benedict, *Army Life in Virginia: Letters from the Twelfth Vermont Regiment. . .* (Burlington, Vermont: Free Press Association, 1895), 64.

9. At age nine John L. Clem tried to enlist in May 1861. Although he was refused admission to the Twenty-second Michigan official muster, the officers of the regiment contributed to his salary and he "went along with the regiment just the same as a drummer boy, and though not on the muster roll, drew a soldier's pay of thirteen dollars a month." For bravery in battle Clem was promoted to sergeant at age twelve. He retired from the army in 1916 with the rank of major general. See Wiley, *Billy Yank*, 297-298.

10. Corporal Dan Owen Mason, quoted in B. A. Botkin, ed., *Civil War Treasury of Tales, Legends, and Folklore* (New York: Random House, 1960), 65.

11. Whitman, *Complete Poetry and Collected Prose*, 1178.

12. For typical prose and verse examples, see "Little Eddie the Drummer-Boy: A Reminiscence of Wilson's Creek" and "The Dead Drummer Boy," both reprinted in Moore, *Anecdotes, Poetry, and Incidents*, 6-7, 51.

13. As opposed to the handsome painting of ca. 1863, *"Home, Sweet Home"* (cat. no. 4), where the yearning and sentimentality of the well-known song is consciously recalled by the painting's title and design. Homer did call "Reveille" to mind in the drawing *War Songs* (1861, Library of Congress), although it was excised from the wood engraving in *Harper's Weekly* of 23 November 1861 that is based on that drawing (*fig. 4.1*).

14. Harte begins his poem, "The Reveille,"

Hark! I hear the tramp of thousands,
And of armed men the hum;
Lo! a nation's hosts have gathered
Round the quick alarming drum –

Francis F. Browne, ed., *Bugle-Echoes: A Collection of the Poetry of the Civil War, Northern and Southern* (New York: White, Stokes, & Allen, 1886), 29-30.

The image was a popular one. Citizens of both sides spoke of the war's beginning as "the mighty reveille," trumpeting:

Reveille! Reveille!
And a nation awoke: – . . .
.
Give Strength to our hands,
And the future shall tell
How ye saved our broad lands; –
So ring out every bell!
Reveille! Reveille!

Vanity Fair 4, no. 81 (13 July 1861): 23.

PROVENANCE Theodore Russell Davis (1894); his daughter, Mrs. Cullen W. Parmelee, Urbana, Illinois (by 1936); [Plaza Galleries, New York, 1957]; [James Graham and Sons, New York, 1957]; [Wildenstein & Co., New York, 1958]; Mr. and Mrs. Norman Woolworth, New York, 1959; Cecil D. Kaufmann; [Wildenstein & Co., New York, 1971]; William E. Weiss, Jr., 1971-1987; the Estate of William E. Weiss, Jr.

EXHIBITIONS PRIOR TO 1876 7 October 1871, New York, Century Association, no. 11.

CHANGES IN THE COMPOSITION Painting was examined using infrared reflectography; x-radiographs were available. A background of blue hills extending as high as the pole (through the sight-line of the bugler) was replaced by a cloudy sky less intensely colored than the original; date change from 1871 to 1865;* general shift in tonality involving significant repainting, from brighter to more mute, crepuscular colors.

*The style of the painting is definitely that of the mid-1860s. The signature was first applied in light gray. Sometime later it was strengthened with black, at which time perhaps the date of 1871, which is also very dark, was added. This might have been on the occasion of its first exhibition (at the Century Club), or perhaps when Homer presented it to Theodore R. Davis, an artist-correspondent for *Harper's* who had twice been wounded in the Civil War. It seems that Homer changed his mind about the date, possibly deciding that an execution rather than an exhibition date was in order, covered the first date with orange, and added the 1865 date on top of it.

COLLECTED REFERENCES PRIOR TO 1876
None are known.

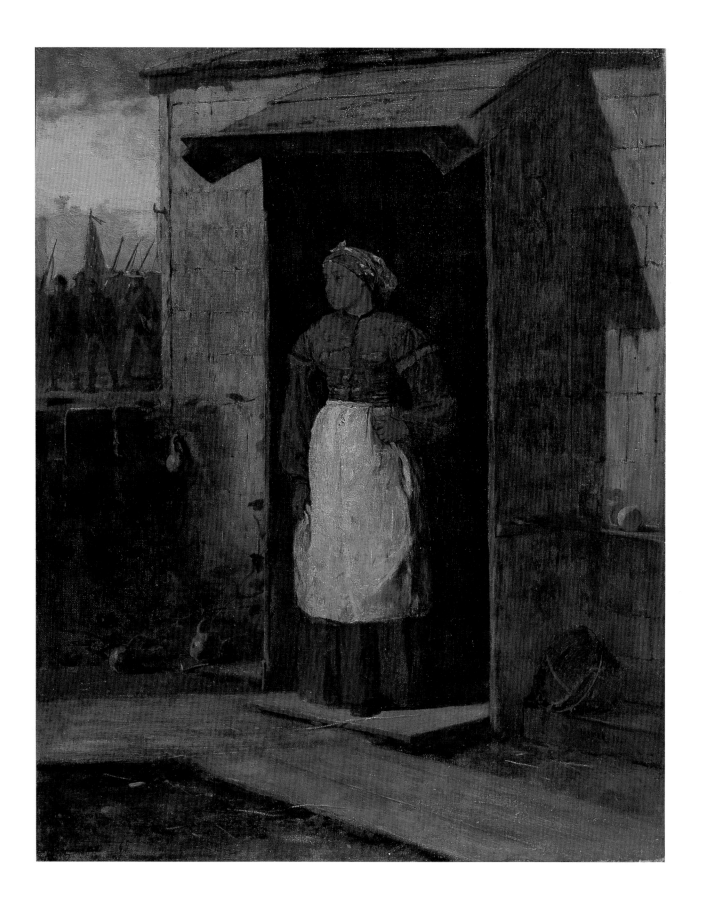

19. Near Andersonville, 1865-1866

[also called *At the Cabin Door* and *Captured Liberators*]
Oil on canvas, 23 × 18 inches
Signed and dated, lower left: HOMER 65
lower right: HOMER 1866
Collection of The Newark Museum
Gift of Mrs. Hannah Corbin Carter; Horace K. Corbin, Jr.;
Robert S. Corbin; William D. Corbin;
and Mrs. Clementine Corbin Day
in memory of their parents,
Hannah Stockton Corbin and Horace Kellogg Corbin, 1966
(66.354)

A young black woman, richly dressed in an elaborate, deep-colored day-gown with ornamental piping, stands at the door of a simple wooden cabin. In the distance two Union soldiers, now prisoners-of-war, are escorted by a band of armed Confederate soldiers, the Southern flag leading them through this secessionist land. The young woman is an extraordinary creation for Homer: serious, pensive, with individualized rather than stereotyped features, she is among the earliest of Homer's quiet and stoic women, a subject that over the next several decades he would find equally among the blacks of Virginia and the fishing folk of the North Atlantic.

Although the figure presages future accomplishment, Homer's conception of the grave and handsome black woman associates him with a number of New York genre painters active in the 1850s and 1860s. Artists such as Thomas Waterman Wood and Eastman Johnson (who in the 1860s had a studio in the University Building with Homer) achieved considerable fame with their carefully drawn, sentimental depictions of blacks.[1] Even the method of Homer's work, with the forms of people and objects emerging from the tenebrous brown of the background stroke by stroke, links him to the older and (at the time) better-known Johnson. Another tradition having at least a tangential relationship to the painting

was the illustrated press.[2] The short-lived but much-appreciated humorous weekly, *Vanity Fair*, in 1862 published a cartoon that bears a strong compositional resemblance to *Near Andersonville*: a well-dressed black stands to the right while behind him to the left marches a group of whites, some of them bearing arms (*fig. 19.1*). Of course, the derogation of the subject of *Drafts* is the diametric opposite of Homer's sympathetic portrayal. Closer in theme to Homer's painting, although with the Yankees as victors rather than prisoners, is a cartoon of 1865 from *Harper's Weekly* (*fig. 19.2*). The object of the drawing and caption is to point out the simplicity and childish wonder of the older woman:

Our artist sends us a portrait from life of one of the "colored population," who watched, hour after hour, the endless columns of Blue-Coats cheerily filing by the plantation, from which, probably, she was never ten miles in her life, and finally broke out: "Is all dem Yankees dat's passing?"[3]

Homer's painting, while it resembles the cartoon in structure, has a different message. The cartoonist invites one to smile at the naivete of the Georgia woman, but Homer's portrayal of the calm, turbaned head and statuesque form of the woman at her cabin door prompts one to ask in awe, along with Walt Whitman in "Ethiopia Saluting the Colors," "Who are you dusky woman?"[4]

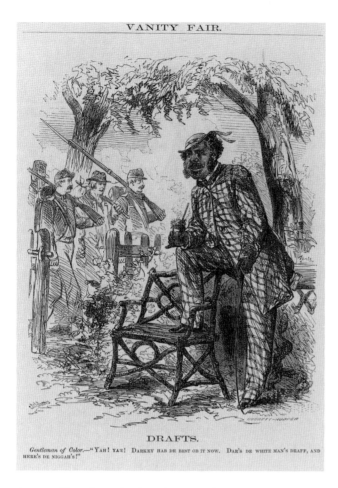

DRAFTS.

Gentleman of Color.—"YAH! YAH! DARKEY HAB DE BEST OB IT NOW. DAR'S DE WHITE MAN'S DRAFF, AND HERE'S DE NIGGAH'S!"

fig.19.1 Henry Louis Stephens (1824-1882). *Drafts*. Wood engraving, 9⁵⁄₄ × 7 in. *Vanity Fair* 6, no. 155 (26 July 1862): 43. Collection of the Library, University of California at Berkeley

Who she is depends to a great degree on where she is. And for that, the painting's history and title are crucial. Unfortunately, the recorded history of this work is scant. The known provenance of the painting rests entirely within the family of Mrs. Elijah Kellogg (née Martha Banks Crane) until 1966, when her descendants donated the painting to The Newark Museum. Until recently, the earliest record of the painting was a photograph of the dining room in the Kellogg home in Elizabeth, New Jersey. According to family members, the photograph dated from no later than 1884 and the paintings portrayed (Homer's is one of three that appears) had all been in the family for fifteen or more years when the photograph was taken.[5] When the painting came to light in 1962, a dealer gave it the title *Captured Liberators*, making literal the poignancy of the scene. Lloyd Goodrich, noting that such a literary conceit was unlike Homer, suggested *At the Cabin Door* as an appropriate, albeit synthetic, title for the work, and it has been known by this since.[6]

On 19 April 1866, however, Homer sold six paintings at an auction held by the firm of Miner & Somerville. Among these, all apparently of Civil War scenes, was a painting entitled *Near Andersonville* (no.92). A writer in *The Evening Post* wrote a brief notice of the sale, mentioning two paintings by Homer:

Homer gives life and character to the surrounding landscapes by the contrast of his vivid scenes of army life. The "Quoit Players" was one of the attractions at the Academy exhibition last year; while his picture entitled "Near Andersonville," depicting a negro woman standing at the door of her cabin, gazing at Union prisoners as they pass, is full of significance.[7]

Near Andersonville is clearly the Newark painting. The significance of image and title together was profound.

Andersonville, a small village in southwest Georgia, was the site of the most infamous Confederate prisoner-of-war camp. The brutal shortages of food and shelter, the lack of medical care, the contaminated water sources, and the unregulated violence toward and among the

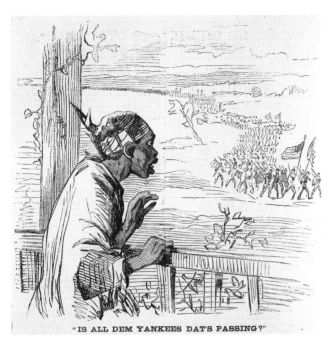

fig.19.2 Unidentified artist. *Is All Dem Yankees Dat's Passing?* Wood engraving, 4³/₄ × 4³/₄ in. *Harper's Weekly* 9, no. 419 (7 January 1865): 16. Collection of the Library of Congress

fig.19.3 *Black Children and Woman by a Log Cabin*. Pencil on pasteboard, 3¹/₂ × 4³/₄ in. Cooper-Hewitt Museum, the Smithsonian Institution's National Museum of Design, New York. Gift of Charles Savage Homer (1912-12-181)

prisoners resulted in the deaths there during 1864 of 13,000 Union men.[8] At the end of the war in early 1865, these statistics – compounded by the sight of prisoners liberated from the Southern camps – enflamed the passions of the North:

The Andersonville obituary record, which we publish to-day, is one of the saddest ever published. It is well enough to forget the past, when forgetting is not a crime against the memory of the martyred dead. The story of Andersonville can never be forgotten. Here, in this bald list of names and dates, we have that story. There is no other such infamy in the times of civilization.[9]

More personally, Walt Whitman, largely inured to physical misery by his years of nursing the wounded in Washington, saw the returning prisoners and exclaimed:

Can these be men *– those little livid brown, ash-streak'd, monkey-looking dwarfs? – are they really*

not mummied, dwindled corpses? . . . Probably no more appalling sight was ever seen on this earth. (There are deeds, crimes, that may be forgiven; but this is not among them. It steeps its perpetrators in blackest, escapeless, endless damnation. Over 50,000 have been compell'd to die the death of starvation – reader, did you ever try to realize what starvation actually is? – in those prisons – and in a land of plenty.) An indescribable meanness, tyranny, aggravating course of insults, almost incredible – was evidently the rule of treatment through all the southern military prisons.[10]

By entitling a work *Near Andersonville*, Homer would have necessarily conjured up for his audience the blackest villainies of the war.[11] But as if to say that his brush was inadequate to the true horror of the site, he alludes to rather than describes the fate that awaits the two Union prisoners. Instead, he focuses attention on the noble but enslaved black woman, for whom slavery is the spiritual parallel to the harrowing ordeal of Andersonville. No drawings are known for this composition, although there is a slight pencil study in the Cooper-Hewitt Collection (*fig. 19.3*) that shows young black children and a woman staring over a fence at a troop of marching men. Perhaps this quickly sketched observation, probably noted in Virginia, represents an early notion of the imagined but emotionally charged *Near Andersonville*.

M.S.

1. See, for example, Wood's *Moses: The Baltimore News Vender* (1858, The Fine Arts Museums of San Francisco) or Johnson's *The Chimney Corner* (1863, Munson-Williams-Proctor Institute, Utica, New York).

2. John Wilmerding has already explored the influence on Homer's later compositions exerted by the works of the English cartoonist George Du Maurier. See "Winslow Homer's English Period," *The American Art Journal* 7, no. 2 (November 1975): 60-69.

3. *Harper's Weekly* 9, no. 419 (7 January 1865): 16.

4. Whitman's poem, from *Drum-Taps* (1865), conjures forth an old woman ("so ancient hardly human, / With your woolly-white and turban'd head,") who greets the Yankees marching with Sherman to the sea. *Complete Poetry and Collected Prose*, 451.

An episode reprinted by Moore seems to parallel Whitman's poem:
A couple of officers were advancing some distance apart from their men, when they were hailed by an old negro woman standing in the door of her rude cabin. "Bless de Lord, bless de Lord," she exclaimed as loud as she could, "yer's come at last, yer's come at last! I've looked for yer these many years, and now yer's come. Bless de Lord." Nothing could exceed the old woman's delight at seeing the Yankees. This means something, and how much! In the childish delight of that old woman what a history is suggested. Long years had she waited to see this deliverance. Slave she was, and the slow years dragged their weary lengths past her youth, and still hope whispered that the hour would come when the bondage would be broken. At last it comes, when the spring of life is gone, and yet her aged lips are eloquent with joy (Anecdotes, Poetry, and Incidents, 545).

5. Commentary (dated 7 February 1962) by Charles Kellogg Corbin, who recalled the visit of the photographer to the house, are in the curatorial files of The Newark Museum, with photograph.

6. Notes from Lloyd Goodrich, 15 November 1962, photocopy of typescript in The Newark Museum curatorial files.

7. *The Evening Post*, 19 April 1866. Alfred Harrison, who is at work on an annotated collection of art criticism from *The Evening Post*, very generously provided us with this and a number of further references from that paper.

8. James I. Robertson, Jr., *Tenting Tonight: The Soldier's Life* (Alexandria, Va.: Time-Life Books, 1984), 110-135.

9. *The New-York Times*, 4 November 1865 (Supplement). See also the front page article from *The New-York Times* of three weeks later, which closed its first paragraph with the line, "Of all the blood, bravery, patience, horror and death of this terrible war, nothing stands out in bolder relief, corroborative of 'man's inhumanity to man,' than the true history of Andersonville" (26 November 1865). Mathew Brady had earlier documented starved

Union soldiers released from Libby Prison in Richmond. Both *Harper's Weekly* and *Frank Leslie's Illustrated Newspaper* carried graphic wood engravings of these grisly documents on the covers of their 18 June 1864 issues, accompanied by mocking texts referring to "Rebel Chivalry."

10. Walt Whitman, *Specimen Days*, in *Complete Poetry and Collected Prose*, 765.

11. The commandant of Andersonville, Captain Henry Wirz, was eventually tried and found guilty of war crimes; he was hung on 10 November 1865. Robertson, 135. See also "Henry Wirz," *Harper's Weekly* 9, no. 465 (25 November 1865): 738-739.

PROVENANCE [Sale, New York, Somerville Art Gallery, Miner & Somerville Auctioneers, 19 April 1866, no. 92]; Mrs. Elijah Kellogg (perhaps by 1869); her daughter, Clementina Kellogg Corbin (to 1929); her son, Horace Corbin (to 1960); his heirs; The Newark Museum.

EXHIBITIONS PRIOR TO 1876 None are known.

CHANGES IN THE COMPOSITION Painting was examined using infrared reflectography; x-radiographs were not available. Tall pine trees in the background to the left of the cabin have been painted over; details of the cabin have been altered. The sky was initially bright blue; a cloud was painted over this open sky at the top edge.

COLLECTED REFERENCES PRIOR TO 1876
An auction sale of pictures by American artists will take place to- night. . . . [T]he picture entitled "Near Andersonville," depicting a negro woman standing at the door of her cabin, gazing at Union prisoners as they pass, is full of significance.
"Sale of Pictures," *The Evening Post*, 19 April 1866.

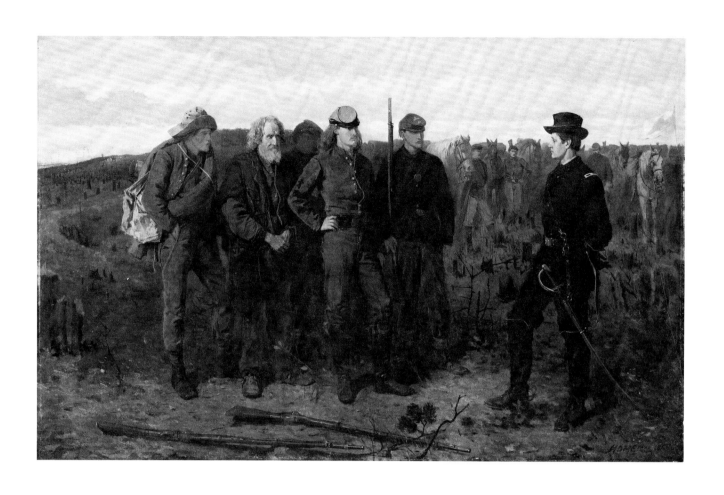

20. Prisoners from the Front, 1866

(Also called *Confederate Prisoners from the Front* [1867])
Oil on canvas, 24 × 38 inches
Signed and dated lower right: HOMER 1866
The Metropolitan Museum of Art
Gift of Mrs. Frank B. Porter, 1922 (22.207)

The image is one of Homer's most powerful: with the now quiet field of battle spread behind them, three Confederate prisoners under guard appear before a Northern general.[1] The four principal figures are detailed and individualized – each having the force of a specific portrait, and yet (at least for the viewers of the 1860s) each representing a type:

On one side the hard, firm-faced New England man, without bluster, and with the dignity of a life animated by principle, confronting the audacious, reckless, impudent young Virginian, capable of heroism, because capable of impulse, but incapable of endurance because too ardent to be patient; next to him the poor, bewildered old man, perhaps a spy, with his furtive look, and scarcely able to realize the new order of things about to sweep away the associations of his life; back of him "the poor white," stupid, stolid, helpless, yielding to the magnetism of superior natures and incapable of resisting authority.[2]

Valor and courage are evident on both sides, but they are no longer at issue. It is now the bald confrontation of regional character that Homer portrays. For his contemporaries no less than for twentieth-century writers, the work "is nothing short of a pictorial synopsis of the entire war."[3]

In composing his work Homer used several drawings to assist him, although no drawing now exists for any of the protagonists' full figures or for the composition as a whole.[4] The Union officer's head and shoulders, the insignia on the Confederate officer's sleeve, and the ravaged landscape to the left, all are on the recto and verso of one sheet that dates to 1864

(*fig.20.1, cat.no.10a*). The landscape drawing, which also portrays the setting of *Inviting a Shot before Petersburg, Virginia* (*cat.no.10*), is a particularly haunting evocation of the land stripped and shaped by the two opposing armies. A highly detailed drawing of boots relates to those worn by the Union officer (*cat.no.20a*). The Confederate officer corresponds to the dapper officer portrayed in Homer's frontispiece illustration to John Esten Cooke's *Surry of Eagle's-Nest* (*cat.no.20b*), a book published in February 1866 and hence probably worked on before or simultaneously with *Prisoners from the Front*. But for the change in the regimental number from 28 to 61, the top left figure of *Six Studies of Soldiers' Heads* (*cat.no.20c*) leads directly to that of the guard who stands between the Union and Confederate officers. This composite nature of the work suggests that, in spite of contemporary testimony that it showed "an actual scene,"[5] the painting is in truth Homer's amalgam of observed details and an imagined whole. As Nicolai Cikovsky, Jr., has theorized, Homer

achieved this effective synthesis by drawing for each major and most meaningful part of the picture upon the best exemplification of its character and meaning that he knew of and had at his disposal.[6]

From its earliest viewing the identity of the Union officer was recognized:

There is great individuality of character in the group of wild and haggard Confederates, their escort, and the youthful general before whom they are brought. The latter, is we believe, a portrait of General Barlow.[7]

Francis Channing Barlow (1834-1896) was "one

fig.20.1 Bust Portrait of an Officer, 1864 (verso of *cat.no.10a*). Pencil, 13⅛ × 9½ in. Inscribed center: *(110)*. Cooper-Hewitt Museum, the Smithsonian Institution's National Museum of Design, New York. Gift of Charles Savage Homer (1912-12-272v)

20a. Cavalry Officer's Boots, 1862. Pencil, 6⅝ × 4¾ in. Inscribed center; *high Light*. Cooper-Hewitt Museum, the Smithsonian Institution's National Museum of Design, New York. Gift of Charles Savage Homer (1912-12-113)

of the most conspicuous soldiers of the war—one of its most heroic and romantic figures."[8] Harvard educated (he shared the valedictory honors in the class of 1855, the same class as Homer's brother Charles), Barlow was a lawyer and occasional editor/journalist when the war erupted in 1861. Refusing a commission as a lieutenant, he enlisted as a private on 19 April 1861 and quickly rose to positions of increased responsibility, within seven months being promoted to lieutenant colonel of the Sixty-first New York Infantry, to colonel on 14 April 1862 (at about the time Homer visited the regiment, staying with Barlow),[9] and to brigadier general in September 1862. A member of the Sixty-first New York later recounted of him: *He was not at first sight an impressive looking officer. He was of medium height, of slight build, with a pallid countenance, and a weakish drawling voice. In his movements there was an appearance of loose jointedness and an absence of prim stiffness. At once schools and drills were established . . . and rumor credited Barlow with their establishment. Discipline became stricter; the duties of the soldier were better explained, and the men sensibly improved. There was no doubt to whom is due the credit for the change. In a short time there was a feeling in the air that the strength of the regiment lay in the person of the Lieut.-Colonel. . . . At first, from his exacting requirements and severity he was quite disliked, if not well hated; but, as time went on, and it was seen he knew more than any other man, or set of men, in the regiment—that he knew how to work his men to the best advantage, and would see that they had what the regulations prescribed, and, that, when the danger was at hand, he was at the head leading them, this animosity was turned into confidence and admiration.*[10]

In spite of his being a firm disciplinarian,[11] Barlow had an almost whimsical style in dress and manner. In contrast to the formal rigidity that Homer depicts,[12] photographs of the time (*fig. 20.2*) and documents such as the letters of Theodore Lyman, staff officer to General Meade, testify to Barlow's appealing nonconformity:

As we stood there under a big cherry tree, a strange

20b. The Autumn Woods. Wood engraving, 4¾ × 3½ in. Initialed lower right (in block): H. Frontispiece for John Esten Cooke, *Surry of Eagle's Nest* (New York: Bunce and Huntington, 1866). Peggy and Harold Osher Collection. Courtesy of the Portland Museum of Art, Portland, Maine

20c. *Six Studies of Soldiers' Heads*, 1862. Pencil,
9½ × 11⅜ in. Cooper-Hewitt Museum, the Smith-
sonian Institution's National Museum of Design,
New York. Gift of Charles Savage Homer
(1912-12-112)

*figure approached; he looked like a highly inde-
pendent mounted newsboy; he was attired in a
flannel checked shirt; a threadbare pair of trousers,
and an old blue képi; from his waist hung a big
cavalry sabre; his features wore a familiar sarcastic
smile. It was General Barlow, commanding the
1st division of the 2d Corps, a division that for fine
fighting cannot be exceeded in the army [20 May
1864].*[13]

Along with his youthful appearance, rigorous
discipline, and military savvy (demonstrated in
abundance during the Peninsular Campaign,
and at Chancellorsville, Gettysburg, the Wilder-
ness, Spotsylvania, Cold Harbor, and Petersburg),
Barlow also possessed great personal courage. In
spite of being severely wounded at Antietam
and Gettysburg, "The Boy General" (as journal-
ists called him)
did not know what personal, bodily fear was. . . .

*. . . I made this remark to him: "I never went
into a battle without an effort of my will, and
always expected to be wounded or killed." He said
in his quiet way, "I never felt so, I never had an
impression that I was to be hurt."*[14]
The wound he received at Gettysburg was perhaps
the most desperate of his trials. Only the gallantry
of a Confederate officer and the impetuosity of
Barlow's wife, Arabella, who rushed onto the field
in the midst of battle to recover her husband,
saved him.[15] For months he was incapacitated.

When Barlow returned to active service in
spring 1864, it was to command the First Division
of the Second Corps, which included his old
regiment, the Sixty-first New York. It is, as Cikov-
sky has observed, crucial to recognize that all the
details of Homer's painting, from Barlow's regu-
lation uniform and the guard's corps badge, to
the division flag in the background (which Homer

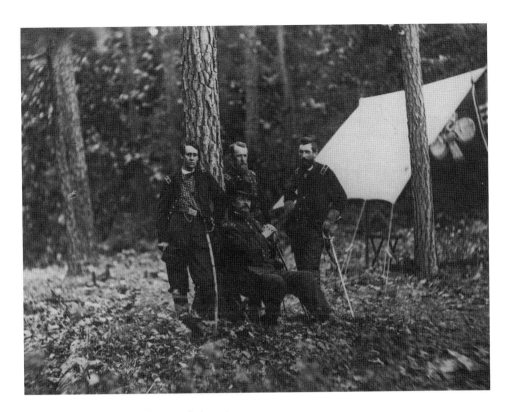

fig.20.2 Attributed to Mathew Brady (1822/23-1896). *Left to right*: Generals Barlow, Hancock, Gibbon, and Birney, 1864. Silver/salt print. Photograph courtesy of the National Archives

initially painted as a forked headquarters flag but later amended to the correct rectangular shape) signal that the scene depicted in the painting takes place sometime while Barlow held this post – between April and August of 1864.[16]

Scholars have noted that Homer's drawing of Barlow shows "his emaciated features [that] reflect the wound he suffered at Gettysburg the previous summer, from which he had not fully recovered and which would compel him to resign his command in August 1864."[17] But Barlow suffered another type of wound during the summer of 1864:

In speaking of General Barlow, whose portrait we published a few weeks since [9 July 1864], we said that the men of his division would never forgive his biographer who should omit to record the unwearied service in the hospitals and among the wounded and dying soldiers from the beginning of

the war to this day, of his faithful and devoted wife, and that for no woman in the land did more earnest prayers ascend from suffering lips and grateful hearts than for Mrs. General Barlow. Those prayers no longer avail. On the 27th of July Mrs. Barlow died in Washington of typhus fever contracted in the military hospital.[18]

Arabella, who had risked her life for him at Gettysburg and had served with him since the beginning of the war, fell victim to the risks of her position. Only after this did Barlow take a long leave. Seven months and a trip to Europe later, Barlow returned to service and was at Appomattox for Lee's surrender.[19]

Francis Channing Barlow is the moral center of *Prisoners from the Front.* His election in November 1865 as New York's secretary of state – *The New-York Times* carried the headline on its front page, "GREAT VICTORY/Glorious Republican

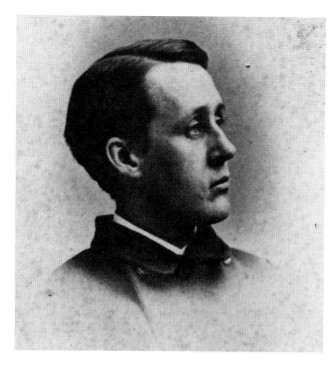

Triumph in New-York/Gen. Barlow Elected by 30,000 Majority" – inaugurated a distinguished and honorable career of public service.[20] As Homer's friend (Homer owned a *carte de visite* of Barlow [*fig.20.3*]), one of the North's more famous soldiers, a man who had suffered serious wounds and personal loss, and the recently elected secretary of state, it is perhaps understandable that the artist modeled his ideal Union officer after Barlow. And yet the painting is not about Barlow, and (in spite of ingenious theories) seems not to be about any specific incident in Barlow's glorious career.[21]

Rather, Barlow is placed at the side of the composition and in profile. It is the young, unknown Southern officer at the center of the canvas who compels attention and admiration. The ideal cavalier, his defiance and poise signal a spirit untrammeled by capture:

These Rebels are not half-starved and ready to give up – a more sinewy, tawny, formidable-looking set of men could not be. . . . Their great characteristic is their stoical manliness; they never beg, or whimper, or complain; but look you straight in the face,

with as little animosity as if they had never heard a gun [18 May 1864].[22]

Homer's great feat, it seems, is to present the "stoical manliness" of the Confederate prisoner, without the advantage of a specific or well-known model.

It is the appeal of both young men – the known Union officer with his serious, self-possessed fulfillment of duty, and the idealized Confederate with his dash and fervor for an ignoble and doomed cause – that provides the work's dynamic tension. The viewer (and, by implication, the artist) both know the "right" side and where sympathy ought to concentrate. But due to centrality, frontality, and height, the Confederate officer commands an equal share of interest along with Barlow. When the writer for *Harper's New Monthly Magazine* wrote of the painting, his intellectual partiality for the Yankee is clear, but his emotional enthusiasm seems to lie with the Confederate:

The central figure of the group is a young South Carolinian of gentle breeding and graceful aspect, whose fair hair flows backward in a heavy sweep, and who stands, in his rusty gray uniform, erect and defiant, without insolence, a truly chivalric and manly figure. . . . Opposite this group stands the officer with sheathed sword. His composed, lithe, and alert figure, and a certain grave and cheerful confidence of face, with an air of reserved and tranquil power, are contrasted with the subdued eagerness of the foremost prisoner. The men are both young; they both understand each other. They may be easily taken as types, and, without effort, final victory is read in the aspect of the blue-coated soldier.[23]

And so the painting is structured. It is this balance, this "judicial impartiality" on Homer's part that allowed a writer in 1888 to note that, "the influence of this picture was strong on the side of brotherly feeling, and of a broad humanity in the way of regarding the great struggle."[24]

A portion of the painting's appeal also resides with Homer's extraordinary and accomplished paint handling, the fruit of less than four years' experimentation. Even those writers who criticized "the harshness of his touch," found that the

"very abruptness of his manner, and the slight gradations of his color, do not mar, but add, to the effect and truth of his rendering of an episode of war."[25] The hands and faces of the four principals are fully detailed and specific (in contrast to the more stereotypical forms of the guards, one of whom [to the left] has not even been given a full complement of feet). Still-life elements, such as sword, scabbard, and especially the rifles (both held and on the ground), are minutely worked with variegated highlights and complex reflection patterns. The knapsack carried by the youngest Confederate is modeled not by paint alone, but by the untouched ground of the canvas – negative spaces that become the foremost highlights. In a broader and more summary fashion, Homer has scattered touches of bright color across the surface of the canvas – the green of pine and holly branches in the foreground and the brilliant blue at the left horizon are particularly notable. These spots of color animate the entire surface of the canvas, providing points of interest throughout. And yet it is the faces of the four men, stretched along a line that parallels the horizon, that dominate the scene and compel attention. Here can be seen "the instinct of genius" praised by Homer's critics, the selection and execution that "distinguish [*Prisoners from the Front*] as the most valuable and comprehensive art work that has been painted to express some of the most vital facts of our war."[26] M.S.

1. For thorough and rich discussions of this work, see Nicolai Cikovsky, Jr., "Winslow Homer's Prisoners from the Front," *Metropolitan Museum Journal* 12 (1978): 155-172; and Natalie Spassky, "Winslow Homer. Prisoners from the Front," *American Paintings in the Metropolitan Museum of Art* (New York: The Metropolitan Museum of Art, 1985), 437-445.

2. Sordello [pseud.], *The Evening Post*, 28 April 1866. Robert F. Lucid has analyzed Northern anecdotes about Confederate soldiers; his summary of them provides a reasonable description of Homer's trio: "Three general types are presented: the gentleman, from Virginia and elsewhere, who is brave, fiery, and somewhat childishly petulant; the common soldier, who is a figure in the stories of fraternization, and who is indistinguishable from the Northern infantryman, except for the occasional

presence of a drawl in his speech; and the hill-dweller, West Virginian or East Tennessean, who is crude, illiterate, and *per se* funny." "Anecdotes & Recollections," *Civil War History* 2, no. 3 (September 1956): 39.

3. Julian Grossman, *Echo of a Distant Drum: Winslow Homer and the Civil War* (New York: Abrams, 1974), 117.

4. For a summary of the sources proposed as the origins of the composition, ranging from the work of Baron Gros to an anonymous artist for *Harper's Weekly*, see Christopher Kent Wilson, "A Contemporary Source for Winslow Homer's *Prisoners from the Front*," *Source* 4, no. 4 (Summer 1985): 37-40.

5. Henry T. Tuckerman, *Book of the Artists. American Artist Life . . .* , (1867; New York: James F. Carr, 1967), 491.

6. Cikovsky, 171-172.

7. "Fine Arts. National Academy of Design. II," *The Albion* 44, no. 19 (12 May 1866): 225.

8. "General F. C. Barlow," *Harper's Weekly* 8, no. 393 (9 July 1864): 445.

9. David Tatham, "Winslow Homer at the Front in 1862," *The American Art Journal* 11, no. 3 (July 1979): 86-87.

10. Charles A. Fuller, *Personal Recollections of the War of 1861* (Sherburne, N.Y.: News Job Printing House, 1906), 9-10. Fuller later recounts (39-40):
A member of our regiment, who had been much of the time detailed, and had acted as hostler for some of the field officers, but was now with company, came up to Colonel Barlow with a woe-begone countenance and told him he was sick and not able to be in the ranks, and said that the doctor thought he ought to be allowed to go to the rear. No doubt Barlow had noted the use this man had been put to, and, where he believed a soldier was managing to escape danger and find a soft place, he always endeavored to make it as unpleasant for that man as possible. The Colonel was not in an amiable frame of mind. He was on foot, old "Billy" [Barlow's horse] had been killed the night before, and he felt like having a dialogue with someone. He asked this man some questions which satisfied him he was a coward. His wrath broke out vehemently. He cursed and swore at him and called him a variety of unpleasant and detestable things and then he began to punch him with his fist wherever he could hit. Finally he partly turned him around, and gave him a hearty kick in the stern and said: "Damn you, get away from here! You're not fit to be with my brave men.". . . I believe every man of us preferred to meet the rebels rather than the vocal scorn and denunciation of Barlow.

11. *Under the ruined porch was Barlow, in his costume d'été – checked shirt and old blue trousers, with a huge sabre, which he says he likes, because when he hits a straggler he wants to hurt him* (Lyman, letter of 12 July 1864, *Meade's Headquarters*, 189).

But one thing we had learned that inspired us with a

new confidence. We found that we had a colonel who cared no more for bullets than for snowballs. He and his horse were models of coolness; and he came through the ranks after the firing had ceased, speaking in his calm, cool way, and praising us for our soldierly conduct. From that day the 61st New York, while still grumbling sometimes at his strict notions of discipline, admired their colonel and affection-ately dubbed him "Billy Barlow," and were ever proud to remember, in the later years of the war, that the distin-guished Major-General Francis C. Barlow had once been their colonel, and had made them a fighting regiment that never broke or lost its colors* (Major William H. Spencer, "How I Felt in Battle and in Prison," *War Papers Read Before the Commandery of the State of Maine, Military Order of the Loyal Legion of the United States* [Portland, Me.: Lefavor-Tower Co., 1902], 2: 128).

12. Several times in the late 1930s Barlow's son asserted that Homer conflated the body of Major General Nelson Miles (who served with Barlow) and the head of Barlow, "apparently merely because my father held higher rank than Miles. At any rate Miles was seriously annoyed" (quoted in Spassky, *American Paintings*, 438. See also 443). Although an entertaining story, given the recorded presence of lay figures and costumes in the artist's studio, and supposing that the work was painted in late 1865 and early 1866, when Miles was the custodian of former Confederate president Jefferson Davis, who was impris-oned at Fortress Monroe, it seems unlikely.

13. Lyman, *Meade's Headquarters*, 107. Other refer-ences include:
I found that eccentric officer [Barlow] divested of his coat and seated in a cherry tree. "By Jove!" said a voice from the branches, "I knew I should not be here long before Meade's staff would come up. How do you do, Theodore, won't you come up and take a few cherries?" (13 June 1864).

I paid a visit to Brigadier-General Barlow, who, as the day was hot, was lying in his tent, neatly attired in his shirt and drawers, and listening to his band, that was playing without. With a quaint hospitality he besought me to "take off my trousers and make myself at home"; which I did avail of no further than to sit down. He said his men were rested and he was ready for another assault! – which, if of real importance, he meant to lead himself; as he "wanted no more trifling." His ideas of "trifling," one may say, are peculiar. It would be ludicrous to hear a man talk so, who, as De Chanel says, "a la figure d'un gamin de Paris," did I not know that he is one of the most daring men in the army ([7 July 1864]; 158, 186).

14. Fuller, 39-40.

15. Confederate Major General John B. Gordon of Georgia found the badly wounded Barlow on the field. Gordon stopped and offered assistance, including sharing with the wounded officer brandy and water from his flask. Gordon asked if there were anything he could do to help. Barlow responded: *"You can do nothing more for me; I am dying."* Then, after a pause, he said, *"Yes, you can; my wife is at the headquarters of General Meade. If you survive the battle, please let her know that I died doing my duty."*

General Gordon replied, *"Your message, if I live, shall surely be given to your wife. Can I do nothing more for you?"* After a brief pause, General Barlow responded: *"May God bless you! Only one thing more. Feel in the breast pocket of my coat – the left breast – and take out a packet of letters."*

As General Gordon unbuttoned the blood-soaked coat, and took out the packet, the seemingly dying soldier said: *"Now please take out one, and read it to me. They are from my wife. I wish that her words shall be the last I hear in this world."*

. . . As the reading of the letter ended, General Barlow said: "Thank you. Now please tear them all up. I would not have them read by others."

After complying with this request, Gordon directed a letter to Mrs. Barlow, telling her where her husband could be found, and had the letter carried to her under flag of truce. She went out on the field while the battle still raged, had Barlow borne to hospital, and nursed him again to health (T. J. Mackey, "An Incident of Gettysburg: How General Gordon Gave Aid and Comfort to His Enemy General Barlow," *McClure's Magazine* 3 [June 1894]: 69-70).
Note however, that when Barlow's eulogist wrote of the incident, he recounts Barlow saying, "General Early, I will live to whip you yet." *In Memoriam: Francis Chan-ning Barlow, 1834-1896* (Albany: J. B. Lyon, 1923), 13.

16. Cikovsky, 161-162.

17. Cikovsky, 164.

18. "Death of Mrs. General Barlow," *Harper's Weekly* 8, no. 388 (13 August 1864): 515. A soldier from Barlow's regiment later recounted his own experiences with Mrs. Barlow during 1862:
[After being wounded, imprisoned, and exchanged] I confess I didn't think so much about the Stars and Stripes as I did about the clean cabin and the welcome presence of woman once more in the person of Mrs. Barlow, our colonel's wife, who brought me some dainties to eat, and still better, her words and tones of sympathy and tenderness. . . . I have often wondered if that heroic woman, who, nearly one year later, went through the lines of both armies at Gettysburg in the midst of the battle, to reach the side of her wounded husband, had the faintest idea how much good she did me in the four or five minutes that day on the James River (Spencer, 148).

19. Declining later in April a commission in the regular army, he resigned his Volunteer commission as major general in November 1865. In 1867 he married Ellen Shaw, whose brother Robert Gould Shaw, killed in 1863, was colonel of the Fifty-fourth (Colored) Massachusetts regiment. *In Memoriam*, 132-136.

20. 8 November 1865. In 1869 President Grant appointed Barlow United States Marshal for the southern district of New York. In 1871 Barlow was one of the founders of the Bar Association and the next year was elected attorney general of New York.

21. Cikovsky suggests that the painting alludes to the surrender of Confederate forces to Barlow at Spotsylvania on 12 May 1864, although showing neither the setting nor the conditions of that day's battle. He further posits that the Confederate officer "corresponds in essential terms" to General "Jeb" Stuart (171). More recently D. R. Lauter has posited that the painting represents the capture of Confederate Colonel John A. Baker of the Third North Carolina Cavalry on 21 June 1864 ("Civil War Buff Uncovers Clues To Re-explain Homer's Works," *Richmond Times-Dispatch*, 3 February 1980). See also Spassky, 437, 445.

22. Lyman, *Meade's Headquarters*, 100.

23. "Editor's Easy Chair," *Harper's New Monthly Magazine* 33, no. 193 (June 1866): 118.

24. Clarence Cook, *Art and Artists of Our Time* (New York: Selmar Hess, 1888), 6: 257.

25. E. B. [Eugene Benson?], "About 'Figure Pictures' at the Academy," *The Round Table* 3, no. 36 (12 May 1866): 295.

26. Sordello [pseud.], "National Academy of Design. Forty-first Annual Exhibition. First Article," *The Evening Post*, 28 April 1866.

PROVENANCE [Samuel P. Avery, New York, 1866]; John Taylor Johnston, New York, 1866-1876; [Johnston Sale, Robert Somerville, New York, 20 December 1876, no. 181]; Robert Lenox Kennedy, New York, 1876-1887; his sister, Mary Lenox Kennedy, New York, 1887-1917; her great-grandniece, Rachel Lenox Kennedy Porter, New York, 1917-1922; The Metropolitan Museum of Art.

EXHIBITIONS PRIOR TO 1876 April 1866, New York, National Academy of Design, "Forty-first Annual Exhibition," no. 490; May 1867, Paris, Universal Exposition, no. 26; 1867-1868, New York, National Academy of Design, "First Winter Exhibition," no. 662 in section presenting the works from the American Art Department of the Paris Universal Exposition.

CHANGES IN THE COMPOSITION Painting was examined using infrared reflectography; x-radiographs were available. Barlow's far hand was initially planned to rest within his coat front, Napoleon-like; Barlow's legs were initially very different – the distance from knee to ankle being shorter, the proper left boot more in profile while the proper right boot originally continued more along the line of the upper leg, with less of a bend at the knee; the hat of the Confederate officer had a different shape, resembling that of the officer in the wood engraving from *Surry of Eagle's Nest* (cat. no. 20b); the side of his face was correspondingly wider, again like the wood engraving; the division flag in the right background was a forked headquarters flag and appeared higher in the composition; the horizon line at the center was altered to create more variation and irregularity.

COLLECTED REFERENCES PRIOR TO 1876
Opposite to Mr. Hennessey is the studio of Mr. Winslow Homer. Mr. Homer is at work on a picture representing a group of rebel prisoners brought before a Federal officer to be examined. The subject is one well calculated to engage Mr. Homer's talent in the rendering of positive character, and he has already advanced his work far enough to express much of the force of the subject itself. Mr. Homer's walls are crowded with drawings and sketches in o[i]l of incidents and episodes of war, and his work is faithful and varied.
"Art Feuilleton," *The New York Commercial Advertiser*, 20 February 1866.

Opposite to Mr. Hennessey is the studio of Winslow Homer – the walls covered with drawings of soldiers and girls, and battles, and episodes of the camp and march. At present Mr. Homer is engaged in painting a group of rebel prisoners before an officer, and being questioned, during the progress of a battle. It promises to be one of Mr. Homer's best works, and it may be made a very powerful picture. But we cannot linger long in Mr. Homer's room, for we wish to see the work of other young men, who, with energy and pluck, are working to develop the artistic spirit.

"About New York Painters: Works Now on Their Easels,"
The Evening Post, 21 February 1866.

A picture by Homer represents a Union officer – an excellent portrait of General Barlow – receiving a group of rebel prisoners who have evidently just been brought in from the front. The group of prisoners must have been painted from life, for the men are thoroughly characteristic of their class.

"Fine Arts. Opening of the National Academy of Design,"
The Evening Post, 17 April 1866.

Neither Leutze, nor Lang, nor Rossiter, nor Bierstadt, appears in the catalogue, and Church has only one very small canvas, and Durand but one; but Eastman Johnson has three admirable pictures, J. F. Weir has his great performance, the "Gun Foundry at Cold Spring," and Winslow Homer his truly Homeric reminiscence of the war, which he calls "Prisoners from the Front." These are the three strong points of the exhibition; they would, in themselves, constitute an exhibition worthy of popular demonstration, and they give assurance of a true feeling for art, and not a doubtful importation, which may or may not be genuine.

"National Academy of Design. Forty-First Annual Exhibition," *The Independent* 18, no. 908 (26 April 1866): 4.

For integrity of purpose and directness of statement it would be difficult to find any work to match Mr. Homer's episode of the war ("*Prisoners from the Front*,") placed in the west gallery. There is a force in the rendering of character, and a happy selection of representative and at the same time local types of men, in Mr. Homer's picture, which distinguish it as the most valuable and comprehensive art work that has been painted to express some of the most vital facts of our war.

It is easy enough to place one's hand on the defects of Mr. Homer's painting, but they are defects that do not affect the veracity of his work, and scarcely touch its artistic merit; for Mr. Homer's execution, which in any other subject would be obtrusive and coarse, is admirably adapted to render episodes of war where character and positive force are in the ascendant, and where we are neither introspective nor sentimental, nor much given to the delicacies of life.

If there was a desire to encourage art, to advance it independent of the ostentation of having a work by a poor painter with a great name, Mr. Homer's picture would certainly occupy a place in the Union League Club or in the Century Club. It is a genuine example of true historical art – the only kind of historical art which is trustworthy in its facts, free from flimsy rhetoric and barbaric splendor; sensible, vigorous, honest.

The more we consider Mr. Homer's very positive work the more suggestive it is. On one side the hard, firm-faced New England man, without bluster, and with the dignity of a life animated by principle, confronting the audacious, reckless, impudent young Virginian, capable of heroism, because capable of impulse, but incapable of endurance because too ardent to be patient; next to him the poor, bewildered old man, perhaps a spy, with his furtive look, and scarcely able to realize the new order of things about to sweep away the associations of his life; back of him "the poor white," stupid, stolid, helpless, yielding to the magnetism of superior natures and incapable of resisting authority. Mr. Homer shows us the North and South confronting each other; and looking at *his* facts, it is very easy to know why the South gave way. The basis of its resistance was ignorance, typified in the "poor white," its front was audacity and bluster, represented by the young Virginian – two very poor things to confront the quiet, reserved, intelligent, slow, sure North, represented by the prosaic face and firm figure and unmoved look of the Union officer.

In our judgment Mr. Homer's picture shows the instinct of genius, for he seems to have selected his material without reflection; but reflection could not have secured a more adequate combination of facts, and they that think more must admit this natural superiority which enabled the painter to make his work at once comprehensive and effective.

. . . So much for the *meaning* of Mr. Homer's work and its relation to our national life; as an example of painting it is simply and strongly painted, a little black in color, a little rude in execution, but vital, vigorous, and with no defect of manner which Mr. Homer may not conquer.

Sordello [pseud.], "National Academy of Design. Forty-first Annual Exhibition. First Article," *The Evening Post*, 28 April 1866.

Mr. Winslow Homer exhibits two characteristic pictures – one, "Prisoners from the Front," and the other, "Brush-Harrow." Both are marked by the simplicity and honest genuineness which are the solid backbone of Mr. Homer's healthy talent. Look at any of his pictures – either little episodes of camp life, military experiences, or some simple detail of a farmer's occupation; you will touch in them the originality which exists in the vigor and the simple expression of a true sentiment. All of Mr. Homer's compositions are simple and very happy in their arrangement; and his execution, which is broad and rapid, promises to be an admirable adjunct to his love of the picturesque. His "Prisoners from the Front" we should like to own, if only for the pleasure of looking at manly faces, each one of them wearing the expression of a distinct individuality, and so capitally characteristic. We love to see how conscientious a student of Nature, Mr. Homer is; and that, too, in the right way; and in looking at his pictures we feel sure that he never would paint ready-made impressions, or situations, and incidents of

life, but asks of his brush only what his mind has perceived or his heart has felt. And finding him on so safe a track, we wish him a rapid sailing toward the not far off happy isles of artistic celebrity.
Masquerade [pseud.], "Pictures at the Academy of Design. Third Article," *The New York Commercial Advertiser*, 7 May 1866.

Mr. Winslow Homer has two pictures, and the military one, No. 490, "Prisoners from the Front," seems to be as popular as it deserves to be. We think Mr. Homer one of our first draughtsmen, in some respects unequalled, but this picture is not wholly in his best manner in execution. In the greater matters of meaning and expression it is hardly to be bettered. Those are real men – the officer with the star on his shoulder, the two soldiers with shouldered muskets, and the three prisoners. The Southern officer and the Northern officer are well contrasted, representing very accurately the widely differing classes to which they belong.
"Fine Arts. The Forty-first Exhibition of the National Academy of Design. [First Notice]," *The Nation* 2, no. 47 (10 May 1866): 603.

Among the figure pieces in this collection, one prominent for excellence is "*Prisoners from the Front*," No. 490, by Winslow Homer. There is great individuality of character in the group of wild and haggard Confederates, their escort, and the youthful general before whom they are brought. The latter, is we believe, a portrait of General Barlow. As in some other of Mr. Homer's pictures seen by us, there is in this one a certain leadenness of tone, or want of light; but it is, in other respects, a work of very considerable merit.
"Fine Arts. National Academy of Design. II," *The Albion* 44, no. 19 (12 May 1866): 225.

Winslow Homer's picture, named "Prisoners from the Front," is by far the best painting of its class yet given us by any American artist. Its number is 490, and it represents an officer in the Union army receiving a batch of Confederate prisoners. The variety of character in the heads and figures of these men is admirably discriminated, the drawing is satisfactorily good, the color gravely powerful without being sombre, and the execution ably sufficient in ease, without the slightest approach to carelessness. The contrast between the various slouching and insolent attitudes of the prisoners, and the erect and manly bearing of the Union officer, is admirably rendered by Mr. Homer, who, if he continues to progress as rapidly as he would appear to be doing, will very certainly take rank ere long as our best military painter. In its positive excellence, this canvas might very fairly have exchanged places with Mr. May's "Lear and Cordelia." Both would have been benefitted, as Mr. May's somewhat chalky

luminousness would have lost nothing and gained much by hanging in the comparative shadow which injures Mr. Homer's picture.
The New York Leader 12, no. 15 (12 May 1866): 1.

Mr. Winslow Homer's work is the most remarkable. The picture called "Prisoners from the Front" attracts the attention of the public and of amateurs. Painters see in it downright force of hand and uncommon talent to delineate men. For strength of effect, expressive grouping of figures, capacity to paint the subject very much as it appeared in nature, and at the same time freedom from any servile traits, we know of no American figure picture superior to it. We know of pictures more finished in manner, more delicate in gradation of color, but none more sincere, none more vigorous, none more original; it is *the* figure picture of the exhibition. It expresses, in a graphic and vital manner, the conditions of character North and South during the war – the South, ardent and audacious at the front, like the young Virginian rebel; bound to the past, and bewildered by the threatened severance of that connection with the past, like the poor old man nervously holding his hat; resting on ignorance and servile habits, as expressed by the "poor white," the third prisoner of the group. These are confronted by the dry, unsympathetic, firm face of the Federal officer, who represents the reserved but persistent North.
It is unnecessary to define and characterize at greater length what almost every visitor of the Academy must readily understand and admire, for there is nothing occult in Mr. Winslow Homer's work; his methods are direct and plain. We have to warn Mr. Homer against his tendency to blackness and opacity in color, and express a wish that he will soften the harshness of his touch. Happily for him, in this present example of his work the very abruptness of his manner, and the slight gradations of his color, do not mar, but add, to the effect and truth of his rendering of an episode of war.
If it is not too late for George Lambdin to learn, he might be taught a few truths by Mr. Homer's mode of study and unsentimental treatment of masculine themes.
E. B. [Eugene Benson?], "About 'Figure Pictures' at the Academy," *The Round Table* 3, no. 36 (12 May 1866): 295.

Mr. Homer's color is still immature. The figures in this picture are good in drawing and excellent in the rendering of expression. In the indication of character, Mr. Homer promises to stand very high among American artists.
American Art Journal 5 (14 June 1866): 116 [quoted in Spassky, 441].

Near by hangs Mr. Winslow Homer's "Brush Harrow." The tone of this picture is very low – too low, it seems to us – but the healthful reality of all Mr. Homer's works is

delightful. Indeed his other contribution, "Prisoners from the Front," is to many the most thoroughly pleasing picture in the Exhibition. It is not large, but it is full of character and interest. A group of rebel prisoners confront a young Union General, who questions them. The central figure of the group is a young South Carolinian of gentle breeding and graceful aspect, whose fair hair flows backward in a heavy sweep, and who stands, in his rusty gray uniform, erect and defiant, without insolence, a truly chivalric and manly figure. Next him, on the right, is an old man, and beyond him the very antipodal figure of the youth in front – a "corn-cracker" – rough, uncouth, shambling, the type of those who have been true victims of the war and of the slavery that led to it. At the left of the young Carolinian is a Union soldier – one of the Yankees, whose face shows why the Yankees won, it is so cool and clear and steady. Opposite this group stands the officer with sheathed sword. His composed, lithe, and alert figure, and a certain grave and cheerful confidence of face, with an air of reserved and tranquil power, are contrasted with the subdued eagerness of the foremost prisoner. The men are both young; they both understand each other. They may be easily taken as types, and, without effort, final victory is read in the aspect of the blue-coated soldier. It will not diminish the interest of the picture if the spectator should see in the young Union officer General Barlow.
"Editor's Easy Chair," *Harper's New Monthly Magazine* 33, no. 193 (June 1866): 117-118.

In his "Prisoners from the Front," Mr. Homer has painted the best picture we have yet seen from his hand; we were not quite prepared for so clever a study of character. We had feared, indeed, that he might degenerate into a mere caricaturist, but this picture reassures us. It is not easy to say how the two sides in our late war could have been better epitomized than in this group of three Southern prisoners brought up before a Northern officer. The leaders are contrasted, not merely without exaggeration, but, one may almost say, with judicial impartiality. The two other prisoners, the old man and the boy, are keys to explain the issue of the struggle; they indicate the real weakness of the South, which lay in the character of the people. An ignorant and brutalized society, truly typied [sic] by these figures, as all of us who saw Southern prisoners can testify, is no real strength, and accordingly the strength of the South lay, not in her people but in her officers; while ours lay, not in our officers but in our people. So Mr. Homer has made these leaders confront one another, and we should be puzzled to know what decided the victory between enthusiasm and intellect unless we saw the base material that enthusiasm had to depend upon.
"The National Academy of Design. Forty-first Annual Exhibition," *The New York Daily Tribune*, 4 July 1866.

We do not think there are more than three [canvases] which can be called 'excellent'. . . . These three pictures are – Mr. Well's [Weir's] 'Gun Foundery [sic],' Eastman Johnson's 'Fiddling His Way,' and Mr. Homer's 'Prisoners from the Front.' We should like to see these pictures in the great French Exhibition of 1867.
American Art Journal 5 (5 July 1866): 169, citing an article in *The New York Daily Tribune* [quoted in Spassky, 441].

One of the most characteristic of the paintings exposed is by Winslow Homer, and gives the "Prisoners at the Front." There they are, four in all, the real types of Southern chivalry – the old man who fought because he knew no better, the yellow-haired, lank son, the acute bushwackers, all peering sullenly into the face of the Yankee Captain who is deciding what to do with them. This is right out of nature, and would there were more of such pictures from America.
"The Exposition and its Visitors," *Boston Evening Transcript*, 14 May 1867.

In the American list, "*The Confederate Prisoners from the Front,*" by Mr. Homer of New York, who shows in his treatment a noble sympathy with the gallant enemy. It is a family group of one old and two young human lions, who look very dilapidated, and have evidently got the worst of it, but from the proud and defiant air and erect walk, do not appear to think any the worse of themselves on that account.
Peregrinus [pseud.], "An Early Peep at the Show," *Blackwood's Edinburgh Magazine* 101, no. 619 (May 1867): 629.

Homer Winslow's [sic] "Prisoners from the Front" is much admired.
"The Great Show at Paris," *Harper's New Monthly Magazine* 35, no. 206 (July 1867): 248.

M. Winslow Homer n'aurait pas dû, en bonne justice, passer inaperçu. Il y a de la physionomie et de la finesse dans ses *Prisonniers confédérés*. [M. Winslow Homer ought not, in good justice, be passed over unnoticed. There is physiognomic accuracy and delicacy in his *Prisoners from the Front*.]
Paul Mantz, "Les Beaux-Arts à l'Exposition Universelle," *Gazette des Beaux-Arts* 23 (1867): 230.

Certainly the most capital for touch, character, and vigour, are a couple of little pictures, taken from the recent war, by Mr. Winslow Homer of New York. These works are real: the artist paints what he has seen and known.
"Paris International Exhibition. No. VI. National Schools of Painting. Pictures from America," *The Art Journal* [London] 29 (1867): 248.

On trouve aussi, dans la salle anglaise, une scène de la dernière guerre aux États-Unis, *Prisonniers confédérés*, par M. Winslow Homer, de New-York. C'est plus franc que les idylles militaires de M. Protais ou que les épopées de M. Yvon. [One also finds, in the English gallery, a scene of the late war in the United States, *Prisoners from the Front*, by Mr. Winslow Homer. It is more honest than the military idylls of Mr. Protais or the epics of Mr. Yvon.]
T[héophile] Thoré, *Salons de W. Bürger. 1861 à 1868* (Paris: Librairie de Vᵉ Jules Renouard, 1870), 2: 413.

Winslow Homer's strongly defined war-sketches are examined with much curiosity, expecially the well-known canvas, 'Prisoners to the Front'. . . . There are not many *genre* pictures in the exposition that excel these. They have the merit, too, of being true and faithful transcripts of American life, or of a phase of it which, as it has now passed away, can only be recalled by the pencil of the artist [citing "an intelligent critic"].
Homer's "Prisoners to the Front," an actual scene in the War for the Union, has attracted more attention, and, with the exception of some inadequacy in color, won more praise than any genre picture by a native hand that has appeared of late years.
Henry T. Tuckerman, *Book of the Artists* (1867; New York: James F. Carr, 1967), 18-19, 491.

American historical art is still mortifying to us, save in the example by Mr. Winslow Homer, the "Prisoners from the Front," which, in spite of its rough execution, and because of its truth and vigor, arrested the attention of polished Parisians, and fixed itself in the memory of so many of us as an actual and representative group out of our recent struggle, and which alone, of all our contemporary paintings, has the first claim to a place at Washington as a true bit of history, without animosity or partisanship, but frankly expressive of the elements in our Southern society that fomented and fed the rebellion against a beneficent and unaggressive Government. We must all regret that it is not permanently placed on the walls of the Capitol.
But historical art in America does not mean such undazzling and unpretending pictures as the "Prisoners from the Front;" it means rather the composed, the invented, the false, the conventional paintings which we shall not have the bad taste to mention, but which have won appropriations from Congress, and are the disgrace of the nation.
E. Benson, "Historical Art in the United States," *Appleton's Journal of Literature, Science, and Art* 1, no. 2 (10 April 1869): 46.

Most of our New York painters are represented in Mr. Johnston's gallery. First and best of the American figure-pictures is Winslow Homer's 'Prisoners at the Front.' . . . No gallery in New York offers us anything more interesting, any thing more genuine and significant, than Mr. Johnston's, in Winslow Homer's 'Prisoners at the Front' — the best record, the most striking characterization in art of the elements in our great struggle with slavery, that has as yet been made by any American painter.
"Pictures in the Private Galleries of New York, II, Gallery of John Taylor Johnston," *Putnam's Magazine* 6, no. 31 (July 1870): 86-87.

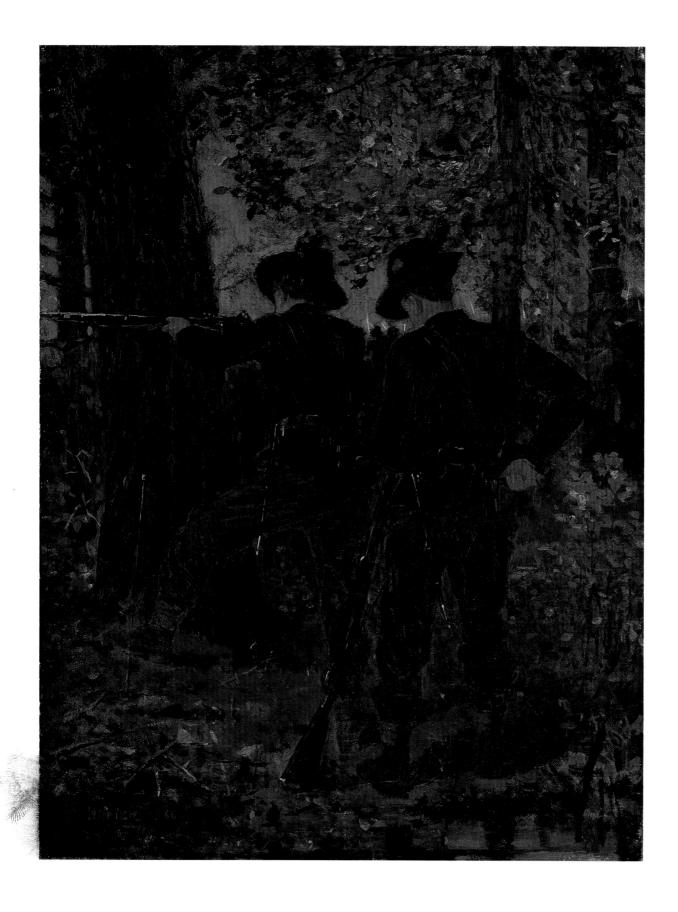

21. The Sharpshooters, 1866
(Possibly *On the Picket Line* [1866])
Oil on canvas, 17 × 13 inches
Signed and dated lower left: HOMER 66
Mr. and Mrs. Joe L. Allbritton

Two soldiers seen from behind stand in a wood, one with his rifle raised to his shoulder, the other pausing to reload his weapon. Small flecks of gray in the left soldier's hair serve to distinguish him from his companion and perhaps to establish the relationship between the two. Behind the soldiers lies a pool of water, mirroring the reflections of the younger soldier's legs; above them hangs the golden brown foliage of late summer. This strangely quiet, almost static composition seems at odds with the potential violence of the left soldier's stance. But unlike Homer's *Sharpshooter* of 1862/63 (*cat.no.1*), in which an eventual shot is assured by the intense concentration of both subject and image, these figures are curiously relaxed, their setting undefined, and the object of their focus unexplained.

No drawings are known that specifically relate to *The Sharpshooters*, but the image itself seems related to Homer's painting of 1864, *Skirmish in the Wilderness* (*cat.no.9*).[1] In the earlier painting, Homer had shown Union skirmishers firing from behind the protection of a tree; the central group includes one man bent forward with his rifle aimed, while a man to his right holds his elbow drawn back. But those soldiers are clearly in the midst of a dreadful conflict; the puffs of smoke, the presence of wounded and dying men, the tense, angular postures of the soldiers in action, all denote the presence of warfare that is hardly evident in *The Sharpshooters*. Even the woodland setting, so similar to that described in *Skirmish*, with its thick tree trunks, glistening foliage, and uneven contours of ground, appears in the later painting more benign, less tangled with branches, and open to the sky.

Another image seemingly related to *The Sharpshooters* is Homer's illustration of a pair of soldiers in the lithograph souvenir card *A Shell Is Coming* (*fig.21.1*). But unlike those two fearful, huddled men, the soldiers in the painting exhibit little tension in their attitudes. Their calm, mechanical postures hardly suggest imminent danger or a deadly foe opposite their aim.

It may be that the men shown are not sharpshooters. They neither wear the green uniforms of the Berdan Sharpshooters, nor carry the telescopic sight rifles that would immediately identify them as members of those two regiments.[2] Moreover, the red cloverleaf on the soldiers' hats identifies them as members of the First Division of the Second Corps of the Army of the Potomac; this division included no regiments of sharpshooters.[3] But most importantly, the significant action of this painting—two soldiers working as a team, one shooting while the other reloads, demonstrates a practice that the Sharpshooters did not use—at least, not after they received the breech-loading rifles that their colonel, Hiram Berdan, had requisitioned for them late in 1861. These breech-loading rifles did not require the complicated routine of reloading that is suggested by the soldiers in Homer's painting. After firing his standard issue rifle, the typical Civil War soldier was required to drop his gun butt, seize a paper cartridge from the box attached to his belt, empty the powder into the barrel, seize his ramrod, press the bullet down the barrel, replace the ramrod, raise the gun while bringing the hammer to half-cock, and shift the gun to the carry position on his right shoulder.[4] Sharpshooters with their breech-loading rifles had no need for ram-

A SHELL IS COMING.

fig.21.1 *A Shell Is Coming*, 1864. Lithograph from
Life in Camp (part 1), 4⅛ × 2½ in. The Butler
Institute of American Art, Youngstown, Ohio

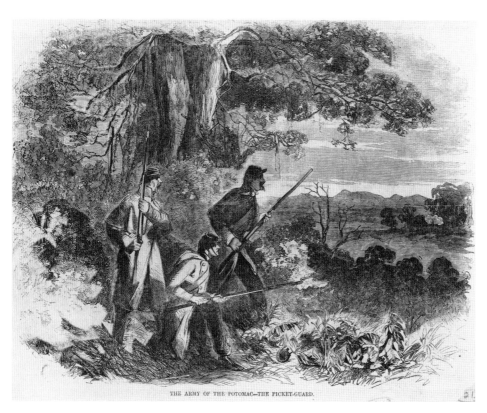

THE ARMY OF THE POTOMAC—THE PICKET-GUARD.

fig.21.2 Unidentified artist. *The Army of the
Potomac – The Picket-Guard*. Wood engraving,
7⅛ × 9¼ in. *Harper's Weekly* 5, no. 253 (2 November
1861): 694. Collection of the Library of Congress

OUR OWN ARTIST SKETCHING "A VIEW OF GEN. BANKS' ARMY ON THE SPOT, FROM A DRAWING BY OUR SPECIAL ARTIST."

fig. 21.3 Benjamin Henry Day, Jr. (1838–1916). *Our own Artist sketching "A view of Gen. Banks' Army on the spot, from a drawing by our Special Artist."* Wood engraving, 5½ × 4½ in. *Vanity Fair* 4, no. 90 (14 September 1861): 130. Collection of the Library, University of California at Berkeley

rods such as the one that appears prominently to the left of this painting. Nor would these marksmen ever have appeared in such relatively exposed surroundings; they would have been nestled up among the tree branches or hidden low behind a breastwork.

These soldiers are most likely pickets, sentinels on active guard rather than reserves resting in a bivouac camp as do the soldiers in *In Front of Yorktown* (*cat. no. 2*). On picket duty, men became "the outpost, one of the antennae of the army,"[5] ever alert to suspicious noises or movements about them. Small groups of soldiers were sent forward from the main army encampment, to station themselves close to enemy lines and warn the camp of any suspect activity or advances. From

the main body of picket reserves, sentinels or vedettes would be sent even further forward while the remainder of the group relaxed or slept in anticipation of their turn for sentry duty. Soldiers' descriptions of sentinel duty often refer to solitary vigils, but it is clear from contemporary illustrations that sentinels often worked in teams (*fig. 21.2*), "stationed within hailing distance of each other."[6] Indeed, the shadowy figures around the two soldiers, rather than appearing threatening, seem more like comrades. The dark figures of men at the center horizon carry bayonets (indicated only by needle-thin gleams of silver), but they wield them upright, not in the thrust-forward posture of attack. Homer's image is remarkably close to the description of the picket line that

Theodore Lyman came across in the Wilderness in June 1864, while traveling between lines on a mission to establish a short armistice with the opposition:

We floundered through a little swampy run, brushed through some brush, and came on a little clearing, at the other side of which was a gentleman, with a cocked musket, eyeing us suspiciously, but who withdrew on seeing our color. There we came on what is always a pretty sight, a picket line in a wood. The men are dotted along, ten or fifteen feet apart, with stronger parties on the roads; and you see them indistinctly, as they stand, half-hidden among trees and bushes.[7]

By the later stages of the war, the rules of picketing – fire warning shots only, not shots to kill – sometimes broke down so that picket lines became in effect skirmish lines.[8] This might explain the left soldier's ready stance, and the right soldier's need to reload his weapon.

For all its presence as an outdoor scene, Homer's painting was certainly a studio production. The depiction of certain inconsistencies with general practice, as well as the relatively unclear narrative, argue for this studio genesis. For example, while the soldiers are costumed in the standard garb of Union infantrymen, they wear black felt hats – an item rarely used after the beginning of the war, since most soldiers found them too ornate and much preferred to wear the kepi or forage cap.[9] Homer seems to have fitted his models (or manikins) with authentic studio props and surrounded them with a familiar but non-specific landscape setting. Such practice had its pitfalls. If the painting's narrative is unclear, the positioning of the figures in the landscape cannot be accomplished in reality: if the left soldier actually did have his legs spread so far apart, with the back leg apparently resting on much lower ground than the forward one, he could not then steady his rifle against the trunk of the tree. Homer was certainly not the first artist to depict the Civil War soldier in action from the comfort of his studio; such attempts at "off-the-spot" reporting were lampooned in *Vanity Fair* in September 1861 (*fig.21.3*) and again on 31 May 1862, in an illustration of an artist sketching the "Explosion

of the 'Merrimac,' or Any Other Ship." Homer's painting, of course, does not pretend to portray a specific battle or incident. Like *Halt of a Wagon Train (cat.no.12)*, *The Sharpshooters* seems most clearly a demonstration of the artist's experimentation with composition, technique, and painterly effects.

S.M.

1. Lucretia Giese has argued for a much closer relation between the two paintings than resemblance, suggesting that the drawings for the central group in *Skirmish in the Wilderness* were once again referred to in the composition of *The Sharpshooters* (Giese, *Painter of the Civil War*, 341).

2. Although the telescopic sight rifle was the weapon most readily associated with the Berdan Sharpshooters (see *fig.1.3*), their weapons were not limited to such. The telescopic rifle was "very heavy – from 15 to 30 pounds . . . [and] generally used for long-range shooting." The other gun used by the Sharpshooters was an "open-sighted Sharps rifle, using linen or "skin" cartridges, 52 caliber, conical ball," deemed "the best breech-loading gun at that time, . . . combining accuracy with rapidity, just what a skirmish line needed for effective work." Captain C. A. Stevens, *Berdan's United States Sharpshooters in the Army of the Potomac, 1861-1865* (St. Paul, Minn.: The Price-McGill Co., 1892), 6-7.

3. By 1865 there were several regiments of sharpshooters in addition to the famous First United States, or Berdan Sharpshooters, but none of these was ever part of the First Division of the Second Corps. See Philip R. N. Katcher, *Army of the Potomac* (Reading: Osprey Publishing Ltd., 1975), 32-34. Katcher also describes the system of corps insignia instituted by Major General Joseph Hooker in 1863 (28-29).

4. Bell Irvin Wiley and Hirst D. Milhollen, *They Who Fought Here* (New York: Macmillan, 1959), 38-39. This procedure was shouted out in nine commands by an officer in charge of a line of troops; the commands preceded the familiar calls of "Ready, Aim, Fire." Despite the complexity of the process, practiced soldiers learned to load and fire their rifles twice a minute from a standing position. Loading from a prone position was more difficult, since it required the soldier to roll over, but as more and more fighting occurred from behind low breastworks, soldiers became adept at this method of loading, too.

5. Bardeen, *Little Fifer's War Diary*, 50.

6. George Grenville Benedict, *Army Life in Virginia. Letters from the Twelfth Vermont Regiment . . .* (Burlington, Vt.: Free Press Association), 93. For other illustrations of pickets working in teams, see Bardeen, *Little Fifer's War Diary*, 50, 53, 55, 56.

7. Lyman, *Meade's Headquarters*, 171.

8. "When the enemy are fairly within sight and disguise is thrown off, pickets fight in the open and the contest may become a skirmish. They still protect themselves behind trees as they move along, but lose no chance of a shot at the enemy, whom they strive to pick off, one by one." Bardeen, *Little Fifer's War Diary*, 57; also 62. Soldiers considered such shooting among pickets "Assassination," or "guerrilla warfare." See *cat.no.2*.

9. Bell Wiley quotes a soldier's complaint to his family: "My new hat looks as near like the pictures that you see of the pilgrim fathers landing on plymouth, tall, stiff, and turned up on one side with a feather on it. . . . I dont wear it any more than I am obliged to" (Wiley, *Billy Yank*, 59). Francis Lord recounts a story of the 111th Pennsylvania Infantry, whose train carrying them to Washington in 1861 halted briefly on a bridge spanning the Shenandoah River. The men "saluted the historic stream by pitching their hated hats into the river," and wore forage caps from that point on. (Lord, *Uniforms of the Civil War* [New York: Thomas Yoseloff, 1970], 43-44.) One group who proudly wore the plumed hats was General John Gibbon's Iron Brigade, renowned for their valor and fighting abilities. The red cloverleaf of the Second Corps rules out the possibility that Homer's soldiers might be members of that brigade, which belonged to the First, and later the Fifth Corps of the Army of the Potomac. See *Catton's Civil War*, 226-228; Katcher, 32-35.

CHANGES IN THE COMPOSITION Painting was examined without using infrared reflectography; no x-radiographs were available. The signature was painted out at least twice, with changes in size and location, not information. Some branches around the head of the left soldier have been painted out, to give a greater sense of silhouette against the sky.

COLLECTED REFERENCES PRIOR TO 1876
None are known.

PROVENANCE [Possibly sale, New York, Somerville Art Galleries (Miner & Somerville, Auctioneers), 19 April 1866, no. 85, as *On the Picket Line*];* [Babcock Galleries, New York (by 1936)]; [Cecil Doward, Royal Galleries, New York]; [Macbeth Gallery, New York, 1937]; Francis P. Garvan (1937-1946); Garvan Estate; [Wildenstein Galleries, New York (1946-1966)]; [Hirschl & Adler Galleries, New York (1966-1970)]; [Sale, Christies, Houston, 1970]; Mr. and Mrs. Joe L. Allbritton.

*Abigail Gerdts (to Marc Simpson, 31 January 1988) questions that a painting dated 1866 would appear in an April 1866 auction. However, throughout his early career, Homer seems eager to sell his paintings quickly (see notices of exhibition and auction activity, Chronology), and of the six paintings that Homer sent to that April auction, at least one other bears an 1866 date (*Near Andersonville, cat.no.19*).

EXHIBITIONS PRIOR TO 1876 None are known.

22. A Rainy Day in Camp, 1871

Oil on canvas, 19⅞ × 36 inches
Signed and dated lower right: WINSLOW HOMER / 1871,
and lower left, on barrel: HOMER
The Metropolitan Museum of Art
Gift of Mrs. William F. Milton, 1923 (23.77.1)

Amid an almost deserted cavalry encampment, five soldiers wrapped in their greatcoats huddle around a fire, seeking company and warmth against a falling rain. Their tethered mounts and a solitary mule seem equally discomfited. Rain slants in from the left, its drops splashing in the pools of collected water atop a group of barrels. Here and there, sunlight breaks through the clouds and the wet campground glistens with reflected light. Six years after the Civil War's end, Homer had returned once more to the subject of camp life and soldiers at rest – themes he had developed so successfully before his trip to Europe in 1866-1867. As if to reassert his preeminence in the genre, as well as exercise the lessons of his Parisian sojourn, Homer assembled a group of familiar field sketches and studio drawings, and created a work unlike his earlier paintings for its breadth of composition and vibrancy of color and atmosphere. An event common to every Civil War soldier's memory – a soggy, rainy day in camp – served to epitomize Homer's interest in the Civil War subject as well as a new confidence in his career as a painter. Philip Beam has perceptively noted that *A Rainy Day in Camp* "illustrates Homer's determination to finish any project he started; his insistence on tying up the loose ends of a period before he left it for another – the same tenacity which later drove him to finish at Prout's Neck the Tynemouth series he had brought from England."[1]

The painting is not large, yet it suggests enormous space. The focal group of soldiers is positioned slightly off center to the convergence of two receding diagonal lines – tents to the left and horses to the right. These rushing orthogonals suggest expansive depth, while the rectangular format and long horizon line establish broad width. Unlike the two-point perspective system that Homer had used (with only limited success) to consolidate the several elements of *Pitching Quoits* (*cat.no.14*), the dominant one-point perspective in *A Rainy Day in Camp* creates a convincingly spacious camp setting and provided Homer with an effective armature on which to hang the several studies he combined to make this one composition.

Nearly every element present in this painting had been studied separately and developed independently, in some cases through drawings made as many as nine years before. Homer observed a line of tethered cavalry mounts in his visit to the Army of the Potomac in spring 1862; his drawing of that group (*cat.no.6a*) first appeared in the 1862 wood engraving *Thanksgiving in Camp* (*cat.no.6b*) and soon afterward in the 1863 painting *The Sutler's Tent* (*cat.no.6*). In *A Rainy Day in Camp*, this line of horses is pitched at a steeper angle, receding into the horizon rather than being spread across it. A quick drawing of soldiers around a campfire, with a wagon and muleteer positioned behind them to the left (*cat.no.22a*), was first used in the 1863 lithograph *The Coffee Call* (*cat.no.22b*); the muleteer sitting outside his wagon reappears in *A Rainy Day in Camp*, but the central group of soldiers around a campfire was rethought and reformulated in a more carefully studied wash drawing (*fig.22.1*). The single braying mule, tethered alone and miserable at the right of the composition, was first

noted by Homer on a sketchbook page (*fig.13.1*), along with another distinctive mule that found its way into *The Bright Side* of 1865 (*cat.no.13*). Other figures cannot be connected with known preliminary drawings, but are yet familiar from previous applications in wood engravings or paintings: for instance, the huddled soldier with his hood thrown up about his head stands to the right of a similar campfire in the 1864 wood engraving *Halt of a Wagon Train* (*cat.no.12a*). Binding these several studies and distinct pictorial ideas is Homer's powerful composition, a series of receding diagonals and overlapping triangles, as well as his rich evocation of atmosphere, the blustery weather that colors the sky and affects man and beast alike.

Certainly among the most typical and univer-

sally shared experiences of the Civil War soldier
was that of misery on a rainy day. A cavalry officer
of the Fifth Iowa described a scene much like
that in Homer's painting when he wrote from
Camp Lowe, Tennessee, on 6 April 1862:

*It is a rainy day in camp – since morning it has
been rain, rain, rain. The camp seems deserted;
save here and there you see a man, with blanket
drawn close over head and shoulders, plod heavily
and slowly through the mud. The horses stand with
heads down, and drooping ears, stock still – noth-
ing moves but the rain, and that straight down. . . .
The tents are tired of shedding rain, and it oozes
through; there were no spades to trench them, and
it runs under. There is water above, and mud
beneath, and wet everywhere. No fun in soldiering
now.*[2]

On such days the mood was generally subdued,
sullen, with soldiers' spirits as sodden as the
ground beneath them. Much of their distress was
physical:

*Rain was the greatest discomfort a soldier could
have; it was more uncomfortable than the severest
cold in clear weather. Wet clothes, shoes, and
blankets; wet meat and bread; wet feet and wet
ground; wet wood to burn, or rather not to burn;
. . . a thousand other discomforts attended the rain.
There was no comfort on a rainy day or night
except in bed – that is under your blanket and oil
cloth.*[3]

Aggravating physical discomfort was the curtail-
ment of those everyday routines that, limited as
they were, enlivened the soldiers' day. David
Cronin recalled that "Rainy days in camp, when
there were no drills, were the most difficult to
dispose of agreeably." A young recruit with the
131st Pennsylvania recorded in his diary on 11
October 1862 that "It has been disagreeable all
day, raining all the time, and with a cold wind. . . .
There has been no drill in consequence of bad
weather, making camp very dull." And the fifer
Bardeen wrote succinctly in his diary on 29 July
1863, "Rainy. Nothing occurred."[4]

This familiar experience of soldier life offered
Homer an appropriate melody for a swan song to
the Civil War. It encompassed several themes that
he had previously explored: spells of inactivity in

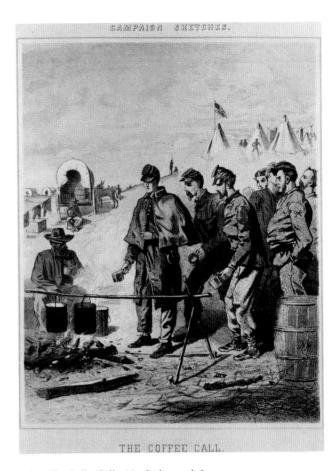

22b. The Coffee Call, 1863. Lithograph from
Campaign Sketches, 11 × 8¾ in. Initialed lower
right (on stone): HW. Amon Carter Museum, Fort
Worth, Texas (50.83)

fig.22.1 Soldiers around a Campfire. Pencil and
wash. Mead Art Museum, Amherst College
(accidentally destroyed 1961)

camp and the concomitant boredom, the frequent
discomfort of soldier and animal, subjects who
are waiting, doing nothing. He even inserted a sly
bit of humor; the mule to the right, one of the last
elements to be painted into the composition (and
the one most sketchy and caricaturish), bears
around his collar the word "JEFF," his discomfi-
ture and confinement alluding to the defeated
Confederate president Jefferson Davis.[5] But "a
rainy day in camp" also suggested several ele-
ments appropriate to the demonstration of
Homer's maturing painterly skills. With weather
itself as a character in his composition, Homer's
heightened interest in depicting light and atmo-
sphere becomes dramatically evident. The artist's
powers of observation can still be noted in the
tight depiction of details such as the barrel staves
and cavalry insignia, but they can be seen as
well in the broad atmospheric effects. The confi-
dent dashes of unblended pigment, brushed in
a bright, mosaic-like tangle on the surface of the
canvas, resolve with distance into clouds, puddles,
mud patches, and indications of the ground

contours. This new freedom in the handling of
paint, and the splendid evocation of the glistening
effects of broken light and water on sand, prefig-
ure Homer's later success with the rocky seascapes
of Prout's Neck. At the same time, *A Rainy Day
in Camp* replays the scenario of one of his very
first oil paintings, *In Front of Yorktown (cat.no.2)* –
a group of soldiers around a campfire, now
exposed beneath a broad, expansive sky rather
than contained within a dark woodland setting.
Coming full circle, *A Rainy Day in Camp*
announces the conclusion of Homer's interest in
the Civil War subject, and his confident move into
new directions and concerns.

S.M.

270

1. Philip C. Beam, *Winslow Homer at Prout's Neck* (Boston: Little, Brown, 1966), 7-8. Homer returned sporadically to Civil War themes after painting *A Rainy Day in Camp*, in works such as *Contraband* (1875, watercolor, Canajoharie Library and Art Gallery, Canajoharie, New York), *Foraging* (exhibited at the Century Club, 1875 and the National Academy of Design, 1876, unlocated), and the series of illustrations for the four-volume *Battles and Leaders of the Civil War* (New York: The Century Co., 1887). *Contraband* shows a single Zouave in the company of a young black boy who is familiar from other watercolors of the 1870s; the *Battles and Leaders* illustrations are stiff renditions of Homer's on-site sketches from 1862; neither can be considered a serious essay into Civil War subject matter for the purpose of exploring style, technique, or expression.

2. Charles C. Nott, *Sketches of the War: A Series of Letters to the North Moore Street School of New York*, 3rd ed. (New York: Anson D. F. Randolph, 1865), 56.

3. Carlton McCarthy, quoted in Bardeen *Little Fifer's War Diary*, 153.

4. David E. Cronin, *The Evolution of a Life, Described in the Memoirs of Major Seth Eyland . . .* (New York: S. W. Green's Son, 1884), 198; "A Young Soldier in the Army of the Potomac: Diary of Howard Helman, 1862," ed. Arthur W. Thurner, *The Pennsylvania Magazine of History and Biography* 87, no. 2 (April 1963): 144; Bardeen, *Little Fifer's War Diary*, 257.

5. In his comic memoirs, "George Washington Peck" includes the tale "I Capture 'Jeff'," and describes how he acquired a splendid horse whose rebel master had been shot in a skirmish. "The horse was a Confederate at heart, and he naturally had no particular love for Yankees," but upon the kind admonitions of the private, "Jeff" is swayed to the Federal side. *How Private George W. Peck Put Down the Rebellion . . .* (Chicago: Belford, Clarke & Co., 1887), 73-77.

PROVENANCE William F. Milton, New York and Pittsfield, Mass., 1871-1905; his wife, Mrs. William F. Milton, 1905-1923; The Metropolitan Museum of Art.

EXHIBITIONS PRIOR TO 1876 April 1872, New York, National Academy of Design "Forty-Sixth Annual Exhibition," no. 334.

CHANGES IN THE COMPOSITION Painting was examined using infrared reflectography; no x-radiographs were available. The mule's tail was shortened. The heads of two horses were lowered to create more variation in the horizon line. The present signature lies on top of two previous signatures, one dark, the other in orange, and a previous date, of which only "187" can be deciphered.

COLLECTED REFERENCES PRIOR TO 1876
None are known.

Selected Bibliography

These sources are used in the Introduction,
Chronology, and catalogue entries.

*Manuscript Collections, Periodicals, and Newspapers
Consulted*

The Albion
Archives of American Art, Smithsonian Institution
(microfilm records provided by the West Coast Regional
Center, San Francisco)
Bowdoin College, Winslow Homer papers
The Evening Post [New York]
Frank Leslie's Illustrated Newspaper
Harper's Weekly
Harper's New Monthly Magazine
The Independent [New York]
The Nation
The New York Commercial Advertiser
The New-York Daily Tribune
The New-York Historical Society, James E. Kelly papers
The New-York Illustrated News
The New York Leader
The New-York Times
*Our Young Folks: An Illustrated Magazine for Boys and
Girls*
The Portrait Monthly of The New York Illustrated News
The Round Table
Vanity Fair
Watson's Weekly Art Journal

Books and Exhibition Catalogues

Adelman, Melvin L. *A Sporting Time: New York City and
the Rise of Modern Athletics.* Urbana: University of
Illinois Press, 1986.
Bailey, Ronald H. *Forward to Richmond: McClellan's
Peninsular Campaign.* Alexandria, Va.: Time-Life
Books, 1983.
Banks, Reverend Louis Albert. *Immortal Songs of Camp
and Field.* Cleveland: The Burrows Brothers Company,
1899.
Barber, Lucius W. *Army Memoirs of Lucius Barber.*
Chicago: J. M. W. Jones Stationery and Printing Co.,
1894.
Bardeen, C[harles] W. *A Little Fifer's War Diary.* Syra-
cuse, N.Y.: C. W. Bardeen, 1910.

Beam, Philip C. *Winslow Homer at Prout's Neck.* Boston:
Little, Brown, 1966.
————. *Winslow Homer's Magazine Engravings.* New
York: Harper & Row, 1979.
Bellard, Alfred. *Gone for a Soldier: Civil War Memoirs of
Private Alfred Bellard.* Ed. by David H. Donald. Boston:
Little, Brown, 1975.
Benedict, George Grenville. *Army Life in Virginia. Letters
from the Twelfth Vermont Regiment. . . .* Burlington,
Vt.: Free Press Association, 1895.
Bennett, Edwin Clark. *Musket and Sword, or The Camp,
March, and Firing Line in the Army of the Potomac.*
Boston: Coburn Publishing Co., 1900.
Bermingham, Peter. *American Art in the Barbizon Mood,*
exh. cat., The National Collection of Fine Arts. Wash-
ington, D.C.: Smithsonian Institution Press, 1975.
Billings, John D. *Hardtack and Coffee, or, The Unwritten
Story of Army Life. . . .* 1887. Reprint. Williamstown,
Mass.: Corner House Publishers, 1973.
Botkin, B[enjamin] A., ed. *A Civil War Treasury of Tales,
Legends, and Folklore.* New York: Random House, 1960.
Brett, David. *"My Dear Wife . . .": The Civil War Letters
of David Brett, 9th Massachusetts Battery, Union Can-
noneer.* Comp. ed. Frank Putman Deane, 2d. Little
Rock, Ark.: Pioneer Press, 1964.
Browne, Francis Fisher. *Bugle-Echoes: A Collection of the
Poetry of the Civil War, Northern and Southern.* New
York: White, Stokes, & Allen, 1886.
Campbell, William P. *The Civil War: A Centennial
Exhibition of Eyewitness Drawings,* exh. cat. Washing-
ton, D.C.: The National Gallery of Art, 1961.
Carter, Captain Robert Goldthwaite. *Four Brothers in
Blue, or, Sunshine and Shadows of the War of the
Rebellion: A Story of the Great Civil War From Bull Run
to Appomattox.* 1913. Reprint. Austin: University of
Texas Press, 1978.
Castle, Henry A. *The Army Mule, and Other War Sketches.*
Indianapolis: Bowen-Merrill, 1898.
"Catalogue of the Private Art Collection of Thomas B.
Clarke, New York, to be sold . . . February 14, 15,
16, and 17 at Chickering Hall . . . and . . . February 15,
16, 17, and 18 at the American Art Galleries . . . ,"
auction cat. New York: The American Art Association,
1899.

Catalogue of the Thomas B. Clarke Collection of American Pictures, exh. cat. Philadelphia: The Pennsylvania Academy of the Fine Arts, 1891.

Catton, Bruce. *Bruce Catton's Civil War: Three Volumes in One (Mr. Lincoln's Army* [1951], *Glory Road* [1952], *A Stillness at Appomattox* [1953]*)*. New York: The Fairfax Press, 1984.

[The Century Association]. *"The Century" Reports, 1872: Report of the Board of Management of "The Century."* New York: Martin's Steam Printing House, 1873.

[———]. *The Century, 1847-1946*. New York: The Century Association, 1947.

Clark, Eliot. *History of the National Academy of Design, 1825-1953*. New York: Columbia University Press, 1954.

Clark, Kenneth. *Landscape into Art*. 1949. Reprint. New York: Harper & Row, 1986.

Cook, Clarence. *Art and Artists of Our Time*. Vol. 6. New York: Selmar Hess, 1888.

Cooke, John Esten. *Surry of Eagle's-Nest; or, The Memoirs of a Staff-Officer Serving in Virginia*. New York: Bunce and Huntington, 1866.

Cowdrey, [Mary] Bartlett, ed. *National Academy of Design Exhibition Record, 1826-1860*. 2 vols. New York: The New-York Historical Society, 1943.

Cowtan, Charles W. *Services of the Tenth New York Volunteers (National Zouaves,) in the War of the Rebellion*. New York: Charles H. Ludwig, 1882.

Cox, Kenyon. *Winslow Homer*. New York: privately printed, 1914.

Cronin, David Edward. *The Evolution of a Life, Described in the Memoirs of Major Seth Eyland, Late of the Mounted Rifles*. New York: S. W. Green's Son, 1884.

Crotty, D[aniel] G. *Four Years Campaigning in the Army of the Potomac*. Grand Rapids, Mich.: Dygert Bros. & Co., 1874.

Cummings, Parke, ed. *The Dictionary of Sports*. New York: A. S. Barnes & Company, 1949.

Cummings, Thomas S[eir]. *Historic Annals of the National Academy of Design . . . from 1825 to the Present Time*. 1865. Reprint. New York: Kennedy Galleries, Inc. and Da Capo Press, 1969.

Curry, David Park. *Winslow Homer: The Croquet Game*, exh. cat. New Haven, Conn.: Yale University Art Gallery, 1984.

Dalzell, James M. *Private Dalzell: His Autobiography, Poems and Comic War Papers*. Cincinnati: Robert Clarke & Co., 1888.

Dannett, Sylvia G. *A Treasury of Civil War Humor*. New York: Thomas Yoseloff, 1963.

Davenport, Alfred. *Camp and Field Life of the Fifth New York Volunteer Infantry (Duryee Zouaves)*. New York: Dick and Fitzgerald, 1879.

Davis, Charles E. *Three Years in the Army: The Story of the Thirteenth Massachusetts Volunteers from July 16, 1861 to August 1, 1864*. Boston: Estes & Lauriat, 1894.

Davis, Melinda Dempster. *Winslow Homer: An Annotated Bibliography of Periodical Literature*. Metuchen, N.J.: Scarecrow Press, 1975.

Dornbusch, C[harles] E., comp. *Regimental Publications and Personal Narratives of the Civil War*. Vol. 1, *Northern States*. New York: The New York Public Library, 1961.

Downes, William Howe. *The Life and Works of Winslow Homer*. Boston: Houghton Mifflin, 1911.

Exman, Eugene. *The House of Harper: One Hundred and Fifty Years of Publishing*. New York: Harper & Row, 1967.

Fairfield, Francis Gerry. *The Clubs of New York*. 1873. Reprint. New York: Arno Press, 1975.

Foner, Jack D. *Blacks and the Military in American History: A New Perspective*. New York: Praeger, 1974.

Forbes, Edwin. *Thirty Years After: An Artist's Story of the Great War*. 2 vols. New York: Fords, Howard & Hulbert, 1890.

Fuller, Charles Arthur. *Personal Recollections of the War of 1861* Sherburne, N.Y.: News Job Printing House, 1906.

Gardner, Albert Ten Eyck. *Winslow Homer, American Artist: His World and His Work*. New York: Bramhall House, 1961.

Gardner, Alexander. *Gardner's Photographic Sketch Book of the War*. 2 vols. in 1. 1865-1866. Reprint. New York: Dover, 1959.

Giese, Lucretia Hoover. *Winslow Homer: Painter of the Civil War*. Ann Arbor: University Microfilms, 1986.

Goodrich, Lloyd. *The Graphic Art of Winslow Homer*, exh. cat. New York: The Museum of Graphic Art, 1968.

———. *Winslow Homer*. New York: published for the Whitney Museum of American Art by Macmillan, 1944.

———. *Winslow Homer*, exh. cat. New York: The Whitney Museum of American Art, 1973.

Goodrich, Lloyd, and Abigail Gerdts. *Winslow Homer in Monochrome*, exh. cat. New York: Knoedler, 1986.

Goss, Warren L. *Recollections of a Private. A Story of the Army of the Potomac*. New York, Thomas Y. Crowell, 1890.

Green, Samuel M. *The Harold Trowbridge Pulsifer Collection of Winslow Homer Paintings and Drawings at Colby College*. Waterville, Me.: Colby College Press, 1949.

Grossman, Julian. *Echo of a Distant Drum: Winslow Homer and the Civil War*. New York: Abrams, 1974.

Guernsey, Alfred H., and Henry M. Alden. *Harper's Pictorial History of the Great Rebellion*. Orig. 2 vols. 1866-1868. Reprint. New York: The Fairfax Press, 1977.

Haythornthwaite, Philip J. *Uniforms of the American Civil War, 1861-65*. Poole, Dorset: Blandford Press, 1975.

Hendricks, Gordon. *The Life and Work of Winslow Homer*. New York: Abrams, 1979.

Hills, Patricia. *Eastman Johnson*, exh. cat. New York: Clarkson N. Potter, Inc. in association with The Whitney Museum of Art, 1972.

Huizinga, J[ohan]. *Homo Ludens: A Study of the Play-Element in Culture*. 1950. Reprint. Boston: The Beacon Press, 1970.

Humphreys, Charles Alfred. *Field, Camp, Hospital, and Prison in the Civil War, 1863-65*. Boston: Press of Geo. H. Ellis Co., 1918.

An Introduction to Homer, exh. cat. New York: Macbeth Gallery, 1936.

Johnson, Allen, et al., eds. *Dictionary of American Biography*. 11 vols. 1928-1937. Reprint. New York: Scribner's, 1946?-1958.

Johnson, Robert Underwood, and Clarence Clough Buel, eds. *Battles and Leaders of the Civil War*. 4 vols. New York: The Century Co., 1887.

Joinville, [François Ferdinand Philippe Louis Marie d'Orléans], Prince de. *The Army of the Potomac: Its Organization, Its Commander, and Its Campaign*. New York: Anson D. F. Randolph, 1862.

Katcher, Philip R. N. *Army of the Potomac*. Reading, Berkshire: Osprey, 1975.

Ketchum, Richard M., ed. *American Heritage Picture History of the Civil War*. New York: American Heritage, 1960.

Kobbé, Gustav. *Famous American Songs*. New York: Thomas Y. Crowell, 1906.

Lancour, Harold, comp. *American Art Auction Catalogues, 1785-1942: A Union List*. New York: The New York Public Library, 1944.

Leech, Margaret. *Reveille in Washington*. 1941. Reprint. New York: Carroll & Graf, 1986.

Levitt, Stan. *The Cracker-Barrel Papers*. Chicago: Contemporary Books, 1977.

Linderman, Gerald F. *Embattled Courage: The Experience of Combat in the American Civil War*. New York: The Free Press, 1987.

Long, E[verette] B[each]. *The Civil War Day by Day: An Almanac, 1861-1865*. Garden City, N.Y.: Doubleday, 1971.

Lord, Francis A. *Civil War Sutlers and Their Wares*. New York: Thomas Yoseloff, 1969.

———. *Uniforms of the Civil War*. New York: Thomas Yoseloff, 1970.

Lyman, Theodore. *Meade's Headquarters, 1863-1865: Letters of Colonel Theodore Lyman from the Wilderness to Appomattox*. Ed. George F. Agassiz. Boston: Atlantic Monthly, 1922.

Marlor, Clark S., ed. *A History of the Brooklyn Art Association with an Index of Exhibitions*. New York: James F. Carr, 1970.

Moat, Louis S., ed. *Frank Leslie's Illustrated History of the Civil War. . . .* New York: Mrs. Frank Leslie, Publisher, 1895.

Moore, Frank, ed. *Anecdotes, Poetry, and Incidents of the War: North and South, 1860-1865*. 1865. Reprint. New York: Arundel Press, 1882.

Murdock, Eugene C. *The Civil War in the North: A Selective Annotated Bibliography*. New York: Garland Publishing, Inc., 1987.

Murphy, Alexandra R. *Winslow Homer in the Clark Collection*, exh. cat. Williamstown, Massachusetts: The Sterling and Francine Clark Art Institute, 1986.

National Cyclopedia of American Biography. 62 vols. New York: James T. White, ca. 1891-1984.

Naylor, Maria, comp. and ed. *The National Academy of Design Exhibition Record, 1861-1900*. 2 vols. New York: Kennedy Galleries, Inc., 1973.

New York (State) Monuments Commission for the Battlefields of Gettysburg, Chattanooga and Antietam. *In Memoriam: Frances Channing Barlow*. Albany, N.Y.: J. B. Lyon Co., 1923.

Nott, Charles C. *Sketches of the War: A Series of Letters to the North Moore Street School, of New York*. 3rd ed. New York: Anson D. F. Randolph, 1865.

Parry, Ellwood C. *The Image of the Indian and the Black Man in American Art, 1590-1900*. New York: Braziller, 1974.

Payne, John Howard. *Home Sweet Home*. Boston: Lee and Shepard, 1880.

Peck, George Washington [pseud.]. *How Private George W. Peck Put Down the Rebellion, or the Funny Experiences of a Raw Recruit*. Chicago: Belford, Clarke & Co., 1887.

Phisterer, Frederick. *New York in the War of the Rebellion, 1861-1865*, 3rd ed. 5 vols. Albany, N.Y.: J. B. Lyon Co., 1912.

Post, Marie Caroline de Trobriand. *The Post Family*. New York: Sterling Potter, 1905.

Ray, Frederic E. *Alfred R. Waud, Civil War Artist*. New York: Viking, 1974.

Robertson, James I. *Tenting Tonight: The Soldier's Life*. Alexandria, Va.: Time-Life Books, 1984.

Robertson, Robert Stoddard. *From the Wilderness to Spottsylvania: A Paper Read Before the Ohio Commandery of the Military Order of the Loyal Legion of the United States . . . December 3, 1884*. Cincinnati: Robert Clarke & Co., 1888.

Ruskin, John. *The Crown of Wild Olive. Four Lectures on Work, Traffic, War, and The Future of England*. New York: Thomas Y. Crowell, 189[?].

Sadik, Marvin S. *The Portrayal of the Negro in American Painting*, exh. cat. With an essay by Sidney Kaplan. Brunswick, Me.: Bowdoin College Museum of Art, 1964.

Sears, Stephen W., ed. *American Heritage Century Collection of Civil War Art*. New York: American Heritage, 1974.

Sheldon, George W. *American Painters*, enlarged ed. 1881. Reprint. New York: Benjamin Blom, Inc., 1972.

Spassky, Natalie. *American Paintings in the Metropolitan Museum of Art*. Vol. 2. New York: The Metropolitan Museum of Art in association with Princeton University Press, 1985.

Stevens, Captain C[harles] A[ugustus]. *Berdan's United States Sharpshooters in the Army of the Potomac, 1861-1865*. St. Paul, Minn.: The Price-McGill Co., 1892.

Swinton, William. *Campaigns of the Army of the Potomac: A Critical History of Operations in Virginia, Maryland and Pennsylvania from the Commencement to the Close of the War, 1861-1865*. 1866. Revised ed. New York: Scribner's, 1882.

Thompson, W. Fletcher, Jr. *The Image of War: The Pictorial Reporting of the American Civil War*. New York: Thomas Yoseloff, 1959.

Thoré, T[héophile]. *Salons de W. Bürger. 1861 à 1868*, 2 vols. Paris: Librairie de Vᵉ Jules Renouard, 1870.

Trobriand, [Philippe] Regis [Denis de Keredern, Comte] de. *Four Years with the Army of the Potomac*. Trans. George K. Dauchy. Boston: Ticknor and Company, 1889.

Tuckerman, Henry T. *Book of the Artists. American Artist Life. . . . 1867*. Reprint. New York: James F. Carr, 1967.

United States Army. *The "battle order" of the Army of the Potomac. General order no. 10, Headquarters Army of the Potomac, March 7, 1865*, in *History of the First Maine Cavalry, 1861-1865* by Edward P. Tobie. Boston: Press of Emery & Hughes, 1887.

Van Rensselaer, Mariana. *Six Portraits*. Boston: Houghton, Mifflin, 1889.

Wallace, David H. *John Rogers: The People's Sculptor*. Middletown, Conn.: Wesleyan University Press, 1967.

Whitman, Walt. *Complete Poetry and Collected Prose*. New York: Library of America, 1982.

[———]. *Walt Whitman and the Civil War: A Collection of Original Articles and Manuscripts*. Ed. Charles I. Glicksberg. Philadelphia: University of Pennsylvania Press, 1933.

Whittredge, Worthington. *The Autobiography of Worthington Whittredge, 1820-1910*. Ed. John I. H. Baur. New York: Arno Press, 1969.

Wiley, Bell Irvin. *The Life of Billy Yank: The Common Soldier of the Union*. Indianapolis: Bobbs-Merrill, 1952.

Wiley, Bell Irvin, and Hirst D. Milhollen. *They Who Fought Here*. New York: Macmillan, 1959.

Wilkeson, Frank. *Recollections of A Private Soldier in the Army of the Potomac*. New York: G. P. Putnam's Sons, 1887.

Williams, Hermann Warner, Jr. *The Civil War: The Artists' Record*, exh. cat. Washington, D.C.: Corcoran Gallery of Art, 1961.

———. *Mirror to the American Past: A Survey of American Genre Painting, 1750-1900*. Greenwich, Conn.: New York Graphic Society, 1973.

Wilmerding, John. *Winslow Homer*. New York: Praeger, 1972.

Wilmerding, John, and Elaine Evans Dee. *Winslow Homer, 1836-1910: A Selection from the Cooper-Hewitt Collection, Smithsonian Institution*, exh. cat. Cooper-Hewitt Museum of Decorative Arts and Design, Smithsonian Institution, New York. Washington, D.C.: Smithsonian Institution Press, 1972.

Winslow Homer Memorial Exhibition (Catalogue of a Loan Exhibition of Paintings by Winslow Homer), exh. cat. New York: Metropolitan Museum of Art, 1911.

Yarnall, James L., and William H. Gerdts, comps. *The National Museum of American Art's Index to American Art Exhbition Catalogues, From the Beginning Through the 1876 Centennial Year*. 6 vols. Boston: G. K. Hall & Co., 1986.

Articles

Note: Brief articles and exhibition reviews appearing in newspapers or periodicals have not been listed in this bibliography. Critical reviews of individual paintings have been cited in full in those catalogue entries; short articles of a topical nature are cited in the notes.

Adams, Henry. "Mortal Themes: Winslow Homer," *Art in America* 71, no. 2 (February 1983): 112-126.

Aldrich, T[homas] B[ailey]. "Among the Studios. III." *Our Young Folks* 2, no. 6 (July 1866): 395-398.

———. "Among the Studios. IV." *Our Young Folks* 2, no. 8 (September 1866): 573-574.

"The Army of the Potomac. What it has Done and What it is Doing – The Roads, Fortifications and Camps – The Railroad, Wagons and Ambulances – Among the Darkeys – Incidents of Camp Life – Scenes on Picket, in the Trenches and at the Stations, &c., &c." *The New-York Times*, 30 October 1864.

Barlow, Major-General Francis Channing. "Capture of the Salient, May 12, 1864, Read January 13, 1879." In "The Wilderness Campaign May-June 1864." *Papers of the Military Historical Society of Massachusetts*, vol. 4, 245-262. Boston: The Military Historical Society of Massachusetts, 1905.

Boeger, Palmer H. "Hardtack and Burned Beans." *Civil War History* 4, no. 1 (March 1958): 73-92.

Bolton, Theodore H. "The Art of Winslow Homer: An Estimate in 1932." *The Fine Arts* 18, no. 3 (February 1932): 23-28, 52-55.

Calo, Mary Ann. "Winslow Homer's Visits to Virginia During Reconstruction." *The American Art Journal* 12, no. 1 (Winter 1980): 4-27.

Cikovsky, Nicolai, Jr., "Winslow Homer's Prisoners from the Front." *Metropolitan Museum Journal* 12 (1977): 155-172.

Cooney, Charles F. "War Letters From an Artist." *Civil War Times Illustrated* 14, no. 2 (May 1975): 34-40.

Giese, Lucretia H. "Winslow Homer's Civil War Painting *The Initials*: A Little-Known Drawing and Related Works." *The American Art Journal* 18, no. 3 ([Summer] 1986): 4-19.

Gordon, Seth C. "Reminiscences of the Civil War from a Surgeon's Point of View, Read March 4, 1891." In *War Papers: Read Before the Commandery of the State of Maine, Military Order of the Loyal Legion of the United States*, vol. 1, 129-144. Portland, Me.: The Thurston Print, 1898.

Helmon, Howard A. "A Young Soldier in The Army of the Potomac: Diary of Howard Helmon." Ed. Arthur W. Thurner. *Pennsylvania Magazine of History and Biography* 87, no. 2 (April 1963): 139-155.

Hovey, Eugene B. "A Soldier's Sketchbook." *Civil War Times Illustrated* 8, no. 5 (August 1969): 34-37.

"Incidents in the Life of a Soldier." *The Portrait Monthly of the New York Illustrated News* 1, no. 11 (May 1864): 171.

Kaplan, Sidney. "The Negro in the Art of Homer and Eakins." *The Massachusetts Review* 7 (Winter 1966): 105-120.

Klemroth, Edgar H. "Shenandoah Sketchbook." *Civil War Times Illustrated* 14, no. 8 (December 1975): 11-17.

Knauff, Christopher W. "Certain Exemplars of Art in America. IV. Elliott Daingerfield – Winslow Homer." *The Churchman* 78, no. 4 (23 July 1898): 123-125/128.

Lofton, Williston H. "Northern Labor and the Negro During the Civil War." *Journal of Negro History* 34, no. 3 (July 1949): 251-273.

Lucid, Robert F. "Civil War Humor: Anecdotes and Recollections." *Civil War History* 2, no. 3 (September 1956): 29-48.

Mackey, T. J. "An Incident at Gettysburg." *McClure's Magazine* 3, no. 1 (June 1894): 68-70.

Matthews, Brander. "The Songs of the War." *The Century Magazine* 34, no. 4 (August 1887): 619-629.

Monaghan, Jay. "Civil War Slang and Humor." *Civil War History* 3, no. 2 (June 1957): 125-133.

Montignani, John B. "Winslow Homer: Artist-Correspondent." *Bulletin of the Metropolitan Museum of Art* 37, no. 6 (June 1942): 153-157.

Nardin, James T. "Civil War Humor: The War in 'Vanity Fair.'" *Civil War History* 2, no. 3 (September 1956): 67-85.

"A New Winslow Homer." *Civil War Times Illustrated* 12, no. 1 (April 1973): 30-31.

Prown, Jules D. "Winslow Homer in His Art." *Smithsonian Studies in American Art* 1, no. 1 (Spring 1987): 31-46.

Quick, Michael. "Homer in Virginia." *Los Angeles County Museum of Art Bulletin* 24 (1978): 60-81.

Ray, Frederic E. "The Civil War Artist – As He Saw Himself." *Civil War Times Illustrated* 6, no. 5 (August 1967): 22-25.

———. "The Photographers of the War." In *Shadows of the Storm. The Image of War, 1861-1865*, ed. William C. Davis, vol. 1, 409-455. Garden City, N.Y.: Doubleday, 1981.

Richardson, E[dgar] P. "Three Early Works by Winslow Homer." *Bulletin of the Detroit Instiutute of Arts* 31, no. 1 (1951-1952): 6-9.

[Sheldon, George W.]. "American Painters: Winslow Homer and F. A. Bridgman." *The Art Journal* [New York] 4 (August 1878): 225-227.

Sherman, Frederic Fairchild. "The Early Oil Paintings of Winslow Homer." *Art in America* 6, no. 4 (June 1918): 201-208.

Shurtleff, R[ussell] H. "Correspondence. Shurtleff Recalls Homer." *American Art News* 9, no. 3 (29 October 1910): 4.

Spassky, Natalie. "Winslow Homer at the Metropolitan Museum of Art." *The Metropolitan Museum of Art Bulletin* 39, no. 4 (Spring 1982): 4-48.

Spencer, Major William H. "How I Felt in Battle and in Prison." In *War Papers: Read Before the Commandery of the State of Maine, Military Order of the Loyal Legion of the United States*, vol. 2, 122-149. Portland, Me.: Lefavor-Tower Co., 1902.

Stone, James. "War Music and War Psychology in the Civil War." *The Journal of Abnormal and Social Psychology* 36, no. 4 (October 1941): 543-560.

Tatham, David. "Winslow Homer at the Front in 1862." *The American Art Journal* 11, no. 3 (July 1979): 86-87.

———. "Winslow Homer's Library," *The American Art Journal* 9, no. 1 (May 1977): 92-98.

Thompson, W. Fletcher, Jr., "Illustrating the Civil War." *Wisconsin Magazine of History* 45, no. 1 (Autumn 1961): 10-20.

Trachtenberg, Alan. "Albums of War: On Reading Civil War Photographs." *Representations*, no. 9 (Winter 1985): 1-32.

Troyen, Carol. "Innocents Abroad: American Painters at the 1867 Exposition Universelle, Paris." *The American Art Journal* 16, no. 4 (Autumn 1984): 3-29.

W[ehle], H. B. "Early Paintings by Homer." *Bulletin of The Metropolitan Museum of Art* 18, no. 2 (February 1923): 38-41.

Weinberg, H. Barbara. "Thomas B. Clarke: Foremost Patron of American Art from 1872-1899." *The American Art Journal* 8, no. 1 (May 1976): 52-83.

Weitenkampf, Frank. "The Intimate Homer: Winslow Homer's Sketches." *The Art Quarterly* 6, no. 4 (Autumn 1943): 306-321.

Wilmerding, John. "Winslow Homer's Creative Process." *Antiques* 108, no. 5 (November 1975): 965-971.

———. "Winslow Homer's English Period." *The Ameri-*

can *Art Journal* 7, no. 2 (November 1975): 60-69.

———. "Winslow Homer's *Right and Left*." *Studies in the History of Art*, vol. 9, 59-85. Washington, D.C.: National Gallery of Art, 1980.

Wilson, Christopher Kent. "Winslow Homer's *The Veteran in a New Field*: A Study of the Harvest Metaphor and Popular Culture." *The American Art Journal* 17, no. 4 (Autumn 1985): 2-27.

———. "A Contemporary Source for Winslow Homer's *Prisoners from the Front*." *Source* 4, no. 4 (Summer 1985): 37–40.

"A Winslow Homer Miscellany." *Art in America* 24, no. 4 (April 1936): 84-85.

Index

Page numbers in italics refer to illustrations.

Winslow Homer: Paintings of the Civil War *was produced by the Publications Department of The Fine Arts Museums of San Francisco. Ann Heath Karlstrom, Publications Manager. Karen Kevorkian, Editor.*

The book was designed by Jack Werner Stauffacher of The Greenwood Press, San Francisco, California. Display type is Berthold Walbaum, hand set at The Greenwood Press. In the text, all headings are Walbaum, and running text is Linotype Walbaum, set on a Linotron 202. Digital composition by Wilsted & Taylor Publishing Services, Oakland, California. Printed by Village Craftsmen / Princeton Polychrome Press, New Jersey. Text paper is Centura Dull 80#.